*The Princeton Series
in Nineteenth-Century
Art, Culture, and Society*

Painting and the *Journal*
of Eugène Delacroix

Painting and the *Journal* of Eugène Delacroix

MICHELE HANNOOSH

PRINCETON UNIVERSITY PRESS

Copyright © 1995 by Princeton University Press
Published by Princeton University Press, 41 William Street,
Princeton, New Jersey 08540
In the United Kingdom: Princeton University Press, Chichester, West Sussex

Library of Congress Cataloging-in-Publication Data
Hannoosh, Michele, 1954–
Painting and the Journal of Eugène Delacroix / Michele Hannoosh.
p. cm. — (The Princeton series in nineteenth-century art,
culture, and society)
Includes bibliographical references and index.
ISBN 0-691-04394-9 (acid-free paper)
1. Delacroix, Eugène, 1798–1863—Psychology. 2. Ut pictura poesis
(Aesthetics) 3. Delacroix, Eugène, 1798–1863. Journal.
I. Delacroix, Eugène, 1798–1863. II. Title. III. Series.
ND553.D33H36 1995
759.4—dc20 94-25302

This book has been composed in Caslon Old Face 2
by The Composing Room of Michigan, Inc.

Princeton University Press books are printed on acid-free paper
and meet the guidelines for permanence and durability of the
Committee on Production Guidelines for Book Longevity of the
Council of Library Resources.

Printed in the United States of America

10 9 8 7 6 5 4 3 2 1

DESIGNED BY LAURY A. EGAN

FOR ISABELLE ANN LAYOUN KFOURY

CONTENTS

LIST OF ILLUSTRATIONS — xi

ABBREVIATIONS — xv

PREFACE — xvii

INTRODUCTION — 3

CHAPTER ONE. *On the Boundaries of the Arts and the True Power of Painting* — 23

CHAPTER TWO. The Image in Time: The Writing of the *Journal* — 55

CHAPTER THREE. A Language for Painting: The *Dictionnaire des Beaux-Arts* — 93

CHAPTER FOUR. A Painter in the House of Letters — 128

CHAPTER FIVE. The Ambiguities of History: The Apollo Gallery — 161

CHAPTER SIX. The Treasure of the Temple: Saint-Sulpice — 181

CONCLUSION — 199

BIBLIOGRAPHY — 205

INDEX — 215

List of Illustrations

1. Delacroix. Pages from the *Journal*, 28–29 January 1857. Paris, Bibliothèque d'Art et d'Archéologie, Fondation Jacques Doucet.

2. Delacroix. Pages from the *Journal*, 20 November 1857. Paris, Bibliothèque d'Art et d'Archéologie, Fondation Jacques Doucet.

3. Delacroix. Pages from the *Journal*, 23 March 1855. Paris, Bibliothèque d'Art et d'Archéologie, Fondation Jacques Doucet.

4. Deputies' Library, general view. Paris, Palais Bourbon. ©Arch. Phot. Paris/SPADEM.

5. Delacroix. *Orpheus Civilizes the Greeks*. Paris, Palais Bourbon. Photo Courtauld Institute of Art.

6. Delacroix. *Attila and his Hordes Overrun Italy and the Arts*. Paris, Palais Bourbon. Photo Courtauld Institute of Art.

7. Delacroix. *John the Baptist Beheaded*. Paris, Palais Bourbon. ©Arch. Phot. Paris/SPADEM.

8. Delacroix. *The Babylonian Captivity*. Paris, Palais Bourbon. ©Arch. Phot. Paris/SPADEM.

9. Delacroix. *Adam and Eve*. Paris, Palais Bourbon. ©Arch. Phot. Paris/SPADEM.

10. Delacroix. *The Tribute Money*. Paris, Palais Bourbon. ©Arch. Phot. Paris/SPADEM.

11. Henri Lehmann. *Theology*. Paris, Musée Carnavalet. Cliché Photothèque des musées de la Ville de Paris, © by SPADEM 1994.

12. James Barry. *A Harvest Home, or Thanksgiving to Ceres and Bacchus*. RSA, London. Photo Paul Mellon Center for British Art.

13. James Barry. *Elysium*. RSA, London. Photo Paul Mellon Center for British Art.

14. James Barry. *Elysium*, detail: Tartarus. RSA, London. Photo Paul Mellon Center for British Art.

15. Delacroix. *Archimedes Killed by the Soldier*. Paris, Palais Bourbon. Photo Courtauld Institute of Art.

16. Delacroix. *Aristotle Describes the Animals Sent by Alexander*. Paris, Palais Bourbon. Photo Courtauld Institute of Art.

17. Delacroix. *Hippocrates Refuses the Gifts of the Persian King*. Paris, Palais Bourbon. ©Arch. Phot. Paris/SPADEM.

18. Delacroix. *Alexander and the Poems of Homer*. Paris, Palais Bourbon. ©Arch. Phot. Paris/SPADEM.

19. Delacroix. *The Death of Seneca*. Paris, Palais Bourbon. ©Arch. Phot. Paris/SPADEM.

20. Delacroix. *Socrates and his Genius*. Paris, Palais Bourbon. ©Arch. Phot. Paris/SPADEM.

21. Delacroix. *Cicero Accuses Verres*. Paris, Palais Bourbon. Photo Courtauld Institute of Art.

22. Delacroix. *Ovid among the Scythians*. Paris, Palais Bourbon. ©Arch. Phot. Paris/SPADEM.

23. Delacroix. *The Education of Achilles*. Paris, Palais Bourbon. ©Arch. Phot. Paris/SPADEM.

24. Delacroix. *The Chaldean Shepherds, Inventors of Astronomy*. Paris, Palais Bourbon. ©Arch. Phot. Paris/SPADEM.

25. Delacroix. *Demosthenes Declaiming by the Seashore*. Paris, Palais Bourbon. Photo Courtauld Institute of Art.

26. Delacroix. *The Death of Pliny the Elder*. Paris, Palais Bourbon. ©Arch. Phot. Paris/SPADEM.

27. Delacroix. *Numa and Egeria*. Paris, Palais Bourbon. ©Arch. Phot. Paris/SPADEM.

28. Delacroix. *Herodotus Consults the Magi*. Paris, Palais Bourbon. ©Arch. Phot. Paris/SPADEM.

29. Delacroix. *Lycurgus Consults the Pythia*. Paris, Palais Bourbon. ©Arch. Phot. Paris/SPADEM.

30. Delacroix. *Hesiod and the Muse*. Paris, Palais Bourbon. Photo Courtauld Institute of Art.

31. Delacroix. *Dante and the Spirits of the Great*. Paris, Palais du Luxembourg. Photo Courtauld Institute of Art.

32. Delacroix. *Alexander Preserves the Poems of Homer*. Paris, Palais du Luxembourg. Photo Courtauld Institute of Art.

33. Delacroix. *Alexander Preserves the Poems of Homer*, detail: dead warrior. Paris, Palais du Luxembourg. Photo Courtauld Institute of Art.

34. Delacroix. *Alexander Preserves the Poems of Homer*, detail: captive Persians. Paris, Palais du Luxembourg. Photo after Editions du Temps.

35. Delacroix. *Dante and the Spirits of the Great*, detail: the Homer group. Paris, Palais du Luxembourg. ©Arch. Phot. Paris/SPADEM.

36. Delacroix. *Dante and the Spirits of the Great*, detail: the Orpheus group. Paris, Palais du Luxembourg. ©Arch. Phot. Paris/SPADEM.

37. Delacroix. *Dante and the Spirits of the Great*, detail: the Greek group. Paris, Palais du Luxembourg. ©Arch. Phot. Paris/SPADEM.

38. Delacroix. *Dante and the Spirits of the Great*, detail: the Roman group. Paris, Palais du Luxembourg. ©Arch. Phot. Paris/SPADEM.

39. Delacroix. *Apollo Slayer of the Serpent Python*. Paris, Musée du Louvre. ©Arch. Phot. Paris/SPADEM.

40. A. Renard de Saint-André, after Le Brun. *Apotheosis of Louis XIV*. Engraving from *La Petite Galerie du Louvre*, Paris, 1695. Photo Bibliothèque d'Art et d'Archéologie, Fondation Jacques Doucet.

41. Ingres. *Apotheosis of Napoleon*. Paris, Musée du Petit Palais. Cliché Photothèque des musées de la Ville de Paris, © by SPADEM, 1994.

42. E. Baudet, after Le Brun. Escalier des Ambassadeurs, Versailles, detail of vault: Apollo and Python. Engraving from L. C. Le Fèvre, *Grand Escalier du château de Versailles, dit Escalier des Ambassadeurs*, Paris, 1725. Photo Getty Center for the History of Art and the Humanities.

43. Le Brun. *Apollo*. Cartoon for the ceiling of the Escalier des Ambassadeurs, Versailles. Paris, Musée du Louvre, Département des Arts Graphiques. Cliché des Musées Nationaux–Paris.

44. Le Brun. *Monster*. Cartoon for the ceiling of the Escalier des Ambassadeurs, Versailles. Paris, Musée du Louvre, Département des Arts Graphiques. Cliché des Musées Nationaux–Paris.

45. Delacroix. *Saint Michael Defeating the Devil*. Paris, Church of Saint-Sulpice. Photo Bulloz.

46. Raphael. *Saint Michael*. Paris, Musée du Louvre. Cliché des Musées Nationaux–Paris.

47. Delacroix. *Heliodorus Driven from the Temple*. Paris, Church of Saint-Sulpice. Photo Bulloz.

48. Raphael. *Heliodorus Driven from the Temple*. Vatican, Stanza d'Eliodoro. Photo Courtauld Institute of Art.

49. Delacroix. *Jacob Wrestling with the Angel*. Paris, Church of Saint-Sulpice. Photo Bulloz.

50. Delacroix. Sketch for *Heliodorus Driven from the Temple*. Chantilly, Musée Condé. Photo Giraudon.

51. Delacroix. Sketch for *Jacob Wrestling with the Angel*. Musée de Grenoble. Photo Musée de Grenoble.

52. Delacroix. Sketch for *Heliodorus Driven from the Temple*. Paris, Musée du Louvre, Département des Arts Graphiques. Cliché des Musées Nationaux–Paris.

53. Delacroix. Sketch for *Jacob Wrestling with the Angel*. Cambridge, Mass., The Fogg Art Museum, Harvard University Art Museums.

54. Delacroix. *The Abduction of Rebecca*. New York, The Metropolitan Museum of Art.

ABBREVIATIONS

All quotations from the *Journal* come from the manuscript sources I have used in the preparation of my new edition, forthcoming with Macula. For convenience, however, references here are to the edition in three volumes by André Joubin (Paris: Plon, 1931–32). The scholarly works most frequently cited are listed below with their abbreviations.

B.N. Est. Bibliothèque Nationale, Cabinet des Estampes

B.N. ms. Bibliothèque Nationale, Manuscripts

Corr. Delacroix, Eugène. *Correspondance générale.* Ed. André Joubin. 5 volumes. Paris: Plon, 1935–38.

Further Corr. Delacroix, Eugène. *Further Correspondence.* Ed. Lee Johnson. Oxford: Clarendon Press, 1991.

Getty ms. Getty Center for the History of Art and the Humanities, Special Collections

Johnson Johnson, Lee. *The Paintings of Eugène Delacroix: A Critical Catalogue.* 6 vols. Oxford: Clarendon Press, 1981–89. References are to catalogue number, except for the mural paintings, which are referred to by volume (usually V) followed by page number.

Louvre Cabinet des Dessins. *Inventaire général des dessins. Ecole française. Dessins d'Eugène Delacroix.* Ed. Maurice Sérullaz, A. Sérullaz, L.-A. Prat, and C. Ganeval. 2 vols. Paris: Réunion des Musées Nationaux, 1984. References are to catalogue number.

O.L. *Oeuvres littéraires.* Ed. Elie Faure. 2 vols. Paris: G. Crès, 1923.

PREFACE

ONE OF THE GREATEST PLEASURES of writing this book was to see the look of genuine delight that came over the face of anyone, and everyone, at the mere mention of Delacroix's *Journal*. The reasons seem obvious enough: in the perspicacity of so many of its insights, the thoughtfulness of its reflections, and the wide range of issues it considers, the *Journal* is a work of absorbing interest. The record of a life at once private and public, a great piece of literature in its own right, it provokes a consistent admiration and respect, even when one disagrees with its opinions or finds its attitudes remote. But in that delight there is yet something more: the writings of a painter—such a rarity in our tradition— exert a kind of fascination; in that exchange of medium lies the precious union of material and abstract, the meditations of an artist who, as Robert Motherwell put it, is preoccupied, when not making art, with thinking about what it *is*. It is just such a pleasure that Delacroix called charm, and considered the purpose of art itself.

Writing on the *Journal* was for me a pleasure too, not least because of the many people who supported and encouraged me in what must have seemed a most idiosyncratic idea. To Irving Lavin I owe special thanks for recognizing in a very rough *premier jet* the germ of a worthy, and worthwhile, project. As a literary import into the domain of art history, I benefitted greatly from his help during a term at the Institute for Advanced Study, Princeton, in 1991. The group of art historians there at the same time taught me much, as well, at our weekly seminars or in conversation over lunch or dinner: Nina Athanassoglou-Kallmyer, Horst Bredekamp, Lauren Weingarden, Sarah Brett-Smith, Jim Marrow, Marilyn Aronberg Lavin, and Oleg Grabar. The readers of the manuscript— Christopher Braider, Victor Brombert, Jacques de Caso, and one who remains anonymous—deserve special mention for their careful, penetrating readings, critical in the best sense; I am grateful to Elizabeth Powers, Fine Arts editor at Princeton University Press, for her enthusiasm and her commitment to the project at every stage.

My research has taken me to many libraries, collections, and institutions in the U.S. and abroad, including the Bibliothèque Nationale, the

British Library, and the libraries of Cambridge University, the University of California, Davis, and UCLA. The extraordinary holdings of the Getty Center for the History of Art and the Humanities in Santa Monica, California, have been invaluable. I would like to thank the President of the Assemblée Nationale for permission to work in the Library, and Mme. Monet for her gracious welcome; likewise MM. Alain Saillard and Philippe Martial of the Library of the Sénat. Most important was the kind cooperation of the staff of the Bibliothèque d'Art et d'Archéologie, Paris, who went well beyond the call of duty in facilitating my work on the manuscripts of the diary, even during the recent move of the library to its new premises: to the director, M. Jean-Luc Gautier Gentès, and Mme. Claire Tissot go special thanks.

Libraries, as Delacroix knew, are sites of survival, and remembrance. While working during the autumn of 1990 in the Duke University library, whose resources were made available to me as a Visiting Scholar through the gracious agency of the French Department and its Chairman, Jean-Jacques Thomas, I often appreciated the extraordinarily complete collection of books on Delacroix at my disposal there. One day I realized, from a bookplate, that they had belonged to the scholar Sara Lichtenstein, whose monograph *Delacroix and Raphael* I had occasionally consulted. From there it was only a short distance to a sad story covering many miles. Sara Lichtenstein had been an Assistant Professor in the Department of Art History. As a child, she had been imprisoned in a Nazi concentration camp, from which she carried the bodily scars for the rest of her life. She had survived, studied at the Courtauld Institute, written her dissertation on Delacroix and Raphael, joined the department at the university, pursued her scholarship in earnest; in 1977, she died of cancer at the age of 46. The publication of her thesis was overseen by a cousin; the copy I saw carried the sobering dedication, "To my parents, who have no marked grave." The photographs in the present volume are largely hers, left, with other papers, in the department for someone who might one day need them; I would like to thank Elizabeth Nashold, Keeper of the Slide Library, for bringing them to my attention, and offering them for my use.

I am indebted to my colleagues in the Department of French and the Program in Comparative Literature at the University of California, Davis, for seven inspiring years, in which real interdisciplinary research and teaching were encouraged and supported. As I prepare to leave Davis for University College London, I am grateful for the intellectual and professional growth which those years brought. I also received summer funding from the Davis Office of Research, which permitted me to work in Paris, and a President's Research Fellowship in the Humanities from the University of California for 1990–91.

It was during this latter year that I went to consult the manuscripts of the *Journal* in the Bibliothèque d'Art, since numerous non-sequiturs and inconsistencies in the standard three-volume edition of the *Journal* by André Joubin (Paris: Plon, 1931–32) had led me to question its reliability. There I found that this edition indeed contained many mistakes and omitted a great deal of material. As will be clear from the following pages, all quotations from the *Journal* come from my own readings of the original manuscripts and other manuscript sources that I have since discovered. I have not called attention to the changes, except in a few instances which might otherwise lead to confusion. A major new critical edition which I have prepared, incorporating all the textual additions and corrections, as well as a substantial apparatus of notes and annotations, will be published shortly by Macula. In the meanwhile, and not wishing to delay the publication of the present book any longer, I have provided the correct text and date (often different from the available editions), and for the convenience of readers have referred to the Joubin edition in parentheses.

Family and friends have been much a part of my life, sometimes tragically, while this book was being written. Some who meant much to me will not see it appear: Charles and Helen, Mitchell, Marion. Others— my parents, my husband Richard, my long-time friend Susan—deserve thanks for many things. It is dedicated to one who loves poetry, and inspired the same in me.

Davis, California
30 May 1994

Painting and the *Journal*
of Eugène Delacroix

Introduction

Tuesday, 3 September 1822—I am carrying out my plan, formulated so many times, of writing a diary. What I want most keenly is not to lose sight of the fact that I am writing it for myself alone; thus I will be truthful, I hope; I will become the better for it. This paper will reproach me for my variations. (I, 1)

[Mardi 3 septembre 1822—Je mets à exécution le projet formé tant de fois d'écrire un journal. Ce que je désire le plus vivement, c'est de ne pas perdre de vue que je l'écris pour moi seul; je serai donc vrai, je l'espère; j'en deviendrai meilleur. Ce papier me reprochera mes variations.]

FOR ALL THE CLARITY of purpose of its opening statement, the *Journal* of Eugène Delacroix soon betrays some of the paradoxes and complexities that develop over the course of its nine hundred pages. It is a diary but lacks the regularity of day-to-day entries, skipping as it does over days, weeks, months, and even, at one point, twenty-three years.[1] The careful indications of date, place, hour, and situation with which it here begins later give way to a temporal and spatial freedom frequently difficult to follow. In contrast to the steady progression characteristic of the journal form, emphasized by the commercial printed "agendas" that he used for all except the first three years, Delacroix's bears witness to an erratic, wayward temporality, both within each entry and between the different ones: he jumps ahead, looks back, cross-references the entries, jumbles the chronological sequence, rereads earlier notes and inserts his later comments on them. The personal nature of the diary is counterbalanced by Delacroix's stated awareness of the public value of its reflections on art and aesthetics. Indeed the *Journal* will furnish all the material, and most of the language, of his never-completed treatise on the fine arts, the *Dictionnaire*

[1] The early diary runs from 1822 to 1824, the later one from 1847 until his death in 1863.

des Beaux-Arts. A diary is normally considered the space of private thoughts, jotted down freely in the fire of their first inspiration, but here we encounter a ubiquitous process of selection and choice: Delacroix refers to events deliberately suppressed and information expressly withheld; and he makes clear throughout that the *Journal* is already a reworking of first impressions, written or sketched in pocket notebooks.[2] For a reader, a diary promises intimacy, but in Delacroix's we sense an incongruous and intriguing reserve; for the anticipated pleasure of the *voyeur* it substitutes a vague discomfort, and even disappointment, as though the secret has not been disclosed, the "true" self not fully revealed. Most important, the standard purpose of any diary, set out in the opening entry quoted above—to collect and recollect the self—is here belied by the very language in which it is stated. "Thus I will be truthful, *I hope*": perhaps what this wilful self-exhortation acknowledges most clearly is the uncertainty, or lack of control, underlying the effort, a qualification undercutting the ostensible confidence and resolve expressed by the sequence of future tenses. The *Journal* seems to recognize the ungraspability of the self it allegedly seeks to capture, the mobility of a self it wishes to stabilize, and which escapes at every moment the words that try to contain it. "This paper will reproach me for my variations": the *Journal* cannot be a reproach, but only a record, a testimony of those variations, and the effort to rein in the mobility of the imagination equally an act of giving freer rein to it.

Perhaps the most striking paradox of the *Journal* lies in its relation to the aesthetic ideas it expresses, and which it would seem, by its form, to contradict or undermine.[3] The *Journal* preaches unity, proportion, com-

[2] There are too many instances to list here, but as a sampling see 16 September 1849 (I, 308), 14 May 1850 (I, 366), 7 July 1850 (I, 376–7), 14 July 1850 (I, 385), 6 August 1850 (I, 400), 9 May 1853 (II, 40–43), 5 August 1854 (II, 227–28), 12 April 1860 (III, 289). The entry for Sunday, 16 September 1849, provides an interesting example. Noting that he took a delightful walk in the forest, he remarks simply: "I saw the ant hill about which I amused myself writing in my notebook" (I, 308). Subsequently, in the entry for 5 August 1854 (II, 227–28), he copies out the notebook's passage in its entirety: that single, terse sentence had replaced nearly two pages of text, on the repetition of forms in radically different phenomena in nature.

[3] While the *Journal*'s ideas have been freely and unproblematically applied to Delacroix's work, little attention has been paid to what is happening in the diary proper, and the concept of self and time it embodies. Jean-Pierre Guillerm's interesting essay deals with the *Journal* in its own right, but takes a broadly psychoanalytical approach and argues for the fundamental difference of its aesthetic from that of the paintings (*Couleurs du noir. Le Journal de Delacroix*). Alain Girard devotes a chapter to Delacroix's diary in *Le Journal intime*, 397–423. See also Anne Larue, "Byron et le crépuscule du "sujet" en peinture. Une Folie littéraire du jeune Delacroix," in which the *Journal* is seen as intermediary between literature and painting (29).

positional order, and the importance of the pictorial *ensemble*, but does so in the freest, least unified, most arbitrarily ordered of autobiographical forms; unlike narrative autobiography, a diary denies any totalizing *vue d'ensemble*, any overall structure by which to interpret the place and meaning of a single event. Delacroix describes the virtues of finish and of concentration of effect in a form by nature unfinished and meandering. He advances a pictorial aesthetic of instantaneity, the whole grasped all of a piece and all at once, but in a form for which this is an impossibility, a form fragmented and strung out over much of the subject's life. He criticizes the abuse of details in contemporary painting, literature, and photography, but does so in a work which might itself seem to consist of an accumulation of details. The *Journal* argues for the value of hierarchy, the subordination of some elements of the composition to its central ideas, but represents the total disruption of hierarchy, with seemingly trivial incidents taking precedence over more apparently important ones. It asserts that a work of art should not everywhere betray the presence of its creator, lest it become a mere *tour de force*, a virtuoso performance interesting us more in the artist than in the art; yet it does so in a form where the author, the *je*, is always present, at once author, narrator, primary character, and even reader—subject, object, and means. It argues for intelligibility but confounds traditional literary patterns of representation and communicability: succession, transition, and a properly narrative coherence. Details and accessories must, in Delacroix's view, have a pictorial *raison d'être*, but a diary, unlike autobiography or memoirs, has no inherent structure of causality whatsoever—no logic of necessity, as Roland Barthes put it.[4] To its stated ideal of compositional order and harmony, the *Journal* offers the example of a form discontinuous, free-floating, fragmented and lawless, a form by definition unfinished and open-ended, which closes only with death.[5]

This is not just a matter of literary form, but of philosophy. Delacroix was preoccupied with the diary's particular kind of writing, and in this respect he constitutes a very special case. He theorizes its fragmentary, essayistic aesthetic repeatedly, and in practice takes it to the extreme: the later diary in particular, written from 1847 onward, embodies a temporal order in which chronology and narrativity are contravened at every turn. This book will consequently deal primarily with that period; the early years, a mere fraction of the whole, have none of the radically innovative features and none of the philosophical reflection on writing and painting

[4] "Délibération," 16.

[5] Cocheyras, "La Place du journal intime dans une typologie linguistique des formes littéraires," 232.

of the later ones. In its original state, especially, the diary is an exceptionally free and composite document.[6] A given entry will consist of notes from several dates distant in time, reflecting an ongoing process of rereading, rethinking, and recommenting. Passages are recopied from one date to another and reworked according to the new context. Corrections, revisions, and remarks added in different ink or pencil, as well as summary headings scrawled later across the top of the pages to designate the subject of the entry,[7] testify repeatedly to this activity; the inside covers sometimes indicate contents of the volume, as though for ready reference.[8] An elaborate and extensive system of cross-references brings together disparate and far-flung entries, and confronts them with one another with no causal or explanatory transition. Clippings from newspapers—articles, advertisements, notices, reviews—are interleaved among the pages, along with recipes, addresses, train schedules, accounts and investments, copies of his letters, notes for his work on the Municipal Council, and other "paraphernalia": discreet fragments of his life and thought alongside the more explicit reflections of the text proper. Although this elaborate and complex order was abridged and simplified by the editors and much of the textual paraphernalia suppressed altogether, both are crucial to Delacroix's oft-stated conception of his enterprise as non-narrative, non-cumulative, varied and inclusive, capable of accommodating multiple points of view and even outright contradiction. In theory and practice, the diary as a mode of writing thus has important implications for his larger aesthetic concerns. As I shall argue, it responds to Delacroix's search for a "painter's" writing, adequate to a "pictorial" vision of the world. In so doing, it reflects a particular notion of art, and of time, experience, and history too.

It is perhaps Delacroix's awareness of this important relation between the aesthetic of the *Journal* and his art and thought which made him consider now and again the question of publication. Although he definitely did not want the *Journal* to be published in its entirety during his lifetime, he was ambivalent about what should become of it after his death. In 1853 he allowed the art critic Théophile Silvestre to copy large portions of it, material which Silvestre quoted at length in his essays on the artist in

[6] This is not as evident from the available printed versions, which have omitted much material and reorganized numerous entries. My new edition restores the temporal and structural complexities of the original.

[7] For example, "Le monde n'a pas été fait pour l'homme" (21 September 1854); "Sur Shakespeare" (25 March 1855); "Sur le beau et le vague. Obermann" (20 March 1857); "Jacob" (25 April 1857).

[8] For example, a note on the title page of the 1855 diary indicates a discussion of the English school and the artist Janmot, to be found under 18 June; on the inside cover for 1860, he writes: "For Charlet see under 26 January."

1854 and 1864.[9] If he recoiled at the thought of its trivial, common details appearing in print,[10] he also acknowledged the absorbing, all-consuming interest of the personal, everyday lives of famous people, the great seen *en déshabillé*, studied "through a magnifying glass" (15 May 1853; II, 49). His own taste for writings of this kind is telling: he read avidly in the the memoirs, journals, confessions, biographies and auto-biographies of others—from Bossuet, Rousseau, Saint-Simon, and Ca-sanova, to contemporaries like Dumas, Sainte-Beuve, and George Sand. In particular, his special fascination for the personal writings of "illus-trious" individuals—Caesar, Marcus Aurelius, Leonardo da Vinci, Mon-taigne, Voltaire, Napoleon, Byron—reflects on his own activity as a diarist, and his understanding of the almost inevitable "public" value of this most private and personal enterprise.

The problem of the *Journal*'s aesthetic is posed specifically in the con-text of one of its most recurrent topics, and one of the major challenges of Romantic art theory: the relation between painting and literature. Less-ing's famous statement from the *Laokoon* of 1766, "Succession in time is the province of the poet, coexistence in space is that of the artist," had fixed the essential distinction and provided the material for arguments on both sides of the debate.[11] Painting consists of form and color in space, literature consists of sounds articulated over time; a painting is perceived all at once and at a glance, whereas reading occurs in a temporal sequence;

[9] *Histoire des artistes vivants français et étrangers; Eugène Delacroix: Documents nouveaux.*

[10] "Il y a nécessairement dans des notes de ce genre, écrites en courant, beaucoup de choses qu'on aimerait plus tard à n'y pas retrouver. Les détails vulgaires ne se laissent pas exprimer facilement, et il est naturel de craindre l'usage que l'on pourrait faire, dans un temps éloigné, de beaucoup de choses sans intérêt et écrites sans soin"(3 April 1858; III, 182).

[11] *Laokoon*, 129. Delacroix read Lessing (*pace* Mras, *Eugène Delacroix's Theory of Art*, 28 n. 60) in the Vanderbourg translation of 1802, as a jotting in a notebook dating from around 1821 attests (Louvre, 1741, f. 43 verso). Another manuscript records the French title of Lessing's work: "Laokoon, ou bornes de la peinture et de la poésie, par Lessing" (photograph in B.N. Est., R111227). Lessing aimed to undermine the pictorial (or sculptural) literary ideal promulgated by Winckelmann and to reclaim for poetry its own sphere; but his distinctions also set the terms for the extraordinary interartistic practice that characterized Romantic aesthetics in France, as poets sought to appropriate within a tem-poral art the instantaneous, static, material qualities of the visual image. See David Scott, *Pictorialist Poetics: Painting and the Visual Arts in Nineteenth-Century France.* Cf. Anne-Marie Christin, "L'Ecrit et le visible: le dix-neuvième siècle français," and "L'Espace et la lettre"; Martin Meisel, *Representations: Narrative, Pictorial, and Theatrical Arts in Nineteenth-Century England;* Elizabeth Abel, "Redefining the Sister Arts: Baudelaire's Re-sponse to the Art of Delacroix." Roy Park, however, traces a hostility to pictorialism in some Romantic literary criticism, and calls attention to a transformation in the *ut pictura poesis* analogy ("Ut pictura poesis: The Nineteenth-Century Aftermath").

with a painting, the eye has its object always present to it, while in literature the ear loses what it has heard and must recall it through an effort of the memory; the signs of painting are natural, while those of literature are arbitrary.[12]

As the sole painter of the nineteenth century to write at any length on the relation of painting to literature, Delacroix represents a unique and highly interesting case. He had a passion for literature and a powerful literary imagination, as the *Journal*'s record of his voracious reading and the predominance of literary subjects in his *oeuvre* attest. But here we encounter one of the *Journal*'s greatest and most recurrent contradictions, for Delacroix insists on the differences—and always the differences—between the two arts. He everywhere affirms his preference for the *arts silencieux*, the visual arts, those not dependent, as are literature, stage drama, or music, on a temporal discourse—a preference stated with almost comical irony through the very medium to which it is opposed, words, and many words at that: the nearly nine hundred pages that comprise the extant *Journal*. The question is not merely theoretical, however; the relation of painting to literature is also a major issue in his artistic practice. This interpreter of Ariosto, Byron, Goethe, Walter Scott, Shakespeare, Tasso, Dante, Chateaubriand, Cervantes, and Sand, to name only some of the literary sources of his work, this foremost creator of narrative mural paintings of the nineteenth century, in short this most "literary" of painters, as many called him,[13] insists throughout on the superiority of painting *over* literature. The *Journal*'s seemingly unequivocal preference for painting encounters everywhere a pictorial *oeuvre* which belies and even flouts this, an *oeuvre* rooted in literature and the literary, consisting predominantly of works on literary subjects and of narrative decorative cycles. To explore this paradox is to go to the very heart of Delacroix's aesthetic, the theoretical and practical relations between writing and painting, literary and pictorial, narrative and image; to reconsider and redefine the "literary" aspect of his art and its relation to more purely pictorial qualities of color and form; and to illuminate his idea of pictorial perception and interpretation. It suggests another way in which to consider what Baudelaire called Delacroix's "devilish spirit of rivalry with the written word," to appreciate that art by which he "translated" the literary word by

[12] *Laokoon*, 114; 129; 123; 59, 122. On Lessing's distinctions, see David Wellbery, *Lessing's Laocoon: Semiotics and Aesthetics in the Age of Reason*, 103.

[13] E.g. Baudelaire, *Exposition universelle de 1855*, *Oeuvres complètes* II, 596. Cf. E. Véron, *Les Artistes célèbres: Eugène Delacroix*, 104; Théophile Gautier, "Eugène Delacroix," in *Histoire du romantisme*, 205f.; and more recently, Philippe Berthier, who describes him as a painter "in perpetual dialogue with the world of writing" ("Des Images sur les mots, des mots sur les images: A propos de Baudelaire et Delacroix," 905).

means of visual images, "wrote his thoughts on a canvas" and "painted" them, in his many writings, on paper.[14]

For Delacroix, a work of literature is indiscreet, importunate, demanding one's undivided attention from first page to last for perhaps only a few outstanding ideas, unable to sustain the same degree of pleasure and interest throughout; a painting is more reserved, even more honest, presenting itself all at once, keeping one's attention through its immediate charm and not through a promise—often unfulfilled—of producing it. The writer's materials, words, are abstract but overwhelm by their abundance and proliferation; painting is more material but leaves more unsaid, and thus reaches further into the mind and soul of the individual viewer. Narrative literature obscures the whole in a mass of detail and thus weakens the effect of the art; more limited in time and space, painting privileges the *ensemble*, preserves its force, concentrates the effect, and thus ensures the aesthetic emotion that art is meant to provoke. Delacroix compares the act of reading to a visit to a picture gallery (30 December 1853; II, 416):[15] the viewer of such a succession of individual paintings cannot sustain the same level of attention and interest, and perceives only a fraction of the total possible beauty.[16] Delacroix thus counterpoises the duration of narrative and the instantaneity of the image; the temporal succession of words a reader must follow and the all-of-a-piece quality of a picture; the ongoing delay, or deferral, of pleasure and understanding in reading, and the sensation of presence, the reality, the here and now, of viewing; the conventional, limited, linear order of discourse and the infinitely more suggestive, less restrictive possibilities of color.

Behind Delacroix's stated theoretical preference for painting, however, stands the *Journal* itself, an effort to explore his own impressions and thoughts through the allegedly inferior medium of words. Indeed if the *Journal* poses the problem of the relations between painting and literature, it also provides by its example a certain solution, bringing together the benefits of the one with those of the other. Delacroix's response, as we shall see, lies in a literary form having minimal temporality, no nar-

[14] "L'Oeuvre et la vie d'Eugène Delacroix" (*Oeuvres complètes* II, 743, 746, 754).

[15] The note was composed on 11 December 1855 but written into the entry of 30 December 1853, as pertinent to the issue of pictorial unity there discussed—the property of painting to be seen "all at once." Cf. the note on the length of operas at 16 May 1857 (III, 101).

[16] The analogy is traditional. Cf. Diderot, who sees the succession of moments in poetic description as comparable to a "longue galerie de peinture" (*Pensées détachées sur la peinture*, 774); also Lessing, *Laokoon*, 107, and below, chapter 1, 48. For Watelet and Levesque, too many figures in a picture produce a fatigue like that of visiting a picture gallery: we want to see each and every one; we would like to stop at some but are attracted by others (*Dictionnaire des arts de peinture, sculpture et gravure*, article "Peinture," IV, 140).

rativity, and consisting of units at once discrete and interrelated. The relative brevity and autonomy of a journal entry are qualities traditionally associated with the image. The diary form removes from the metaphorical experience of the picture gallery, to which reading is compared, the inevitable cause of boredom and *ennui*, i.e., the ineluctable rule of succession. The *Journal* relies on a more complex pattern of relations among its entries, not subject to a single temporal movement nor dependent on one for their sense. As Delacroix conceives of it in both theory and practice, it accords the reader the freedom of the viewer of images: it may be taken up and put down at will, dipped into at any moment regardless of the intervening entries; the entries may be confronted, compared, and contrasted in innumerable combinations; it leaves one at liberty to choose as many standpoints as one may wish, and indeed imposes this multiple perspective by its numerous cross-references and anachronistic insertions. The only temporal organization is the conventional one of the calendar, bounded by the subject's death—a temporality without narrativity, without causality, and with no restrictions but the end of life itself. The *Journal* thus allows within the temporal duration of discourse the instantaneity of the visual image, and within the domain of fleeting time the simultaneity otherwise denied to the human mind. It is a painter's writing, outside the discursive tradition, disavowing the prominence of that tradition in painting itself. It is a writing which has the qualities of painting, and, as I shall argue, of Delacroix's painting in particular, thus countering the long critical tradition which makes his writing in every way the inverse of his pictorial art. [17]

The *Journal* does not merely realize a "pictorial" aesthetic in language, however, but represents Delacroix's conception of the pictorial itself. Against the classic notion of the image as static, intended to be seen from a single perspective and according to a single design, the *Journal* suggests a more variable notion, consistent with what he considered the inherent fullness and freedom of the image: a more complex system linking one scene to another, part to whole, accessory to principal images; and a freer conception of the viewer's perspective. Its rejection of literary narrative as exclusive, unambiguous, limited, and univocal suggests a concept of narrative painting that would avoid these defects. His works may thus be read not as linear, teleological narratives, but as networks of interconnected, ambiguous, and even contradictory relations, thus preserving— or asserting—the variety and complexity of the subject that he expressly considered one of painting's chief benefits. The most interesting writing

[17] See chapter 3, 93 and n. 1.

for him, indeed his acknowledged literary model, was Montaigne's *Essais*, "the moving picture of a human imagination"[18]—a pictorial writing, as the metaphor attests, having the mobility of the *Journal*'s. Thus can the pictorial incorporate the temporal, defined in the irregular, free, and even repetitive manner of the diary. The traditional struggle against time—the effort to preserve a fleeting experience that belongs to the rhetoric of both painting and the diary as a genre—becomes through the *Journal* and, as I shall argue, his paintings too, an effort to incorporate time within painting, reconcile the temporality of literature with the instantaneity of the visual arts, and thus escape time's worst devastation: not death, but too much time, time without value, *ennui*.[19]

"The terrible enemy," *ennui* is the shadow of death within the life of mankind, threatening human existence at every moment.[20] The *Journal* is haunted by it as Delacroix seeks ever to conjure it. "All my life I have found time too long":[21] *ennui* is the ongoing menace to life, a languor all too natural which grips us at every moment, and prevents tranquillity, contentment, and happiness. "I have never been able to fill my days as I see so many people do who do not even give themselves the time to eat and breathe. . . . Although I only do things which I enjoy, they do not manage to occupy all my moments, and *ennui* often slips into the intervals."[22] *Ennui* is a kind of illness, a monster, an "indifference" and "torpor."[23] It is the opposite, or absence, of pleasure and charm, those two effects which it is the business of painting to produce.[24] It is also a distinctly modern

[18] "Le tableau mouvant d'une imagination humaine" (III, 447).

[19] The problem was of central importance to Romanticism. Cf. Senancour's *Obermann*, one of Delacroix's favorite readings, cited frequently in the 1857 diary: "Quand la tête a été dérangée par l'imagination, l'observation, l'étude, par les dégoûts et les passions, par les habitudes, par la raison peut-être, croyez-vous que ce soit une chose facile d'avoir assez de temps, *et surtout de n'en avoir jamais trop?*" (*Obermann* II, 217, letter 88, my emphasis).

[20] 11 August 1854 (II, 242, printed under the 25th; see following note), and 10 October 1855 (II, 402).

[21] Composed on 25 August 1854, but written by Delacroix into the entry of 11 August, as relevant to the discussion of *ennui* there.

[22] Letter copied in the *Journal* but omitted from earlier editions (6 December 1856), and printed, with some variants, in *Corr.* III, 346ff.

[23] *Ibid.*; *Corr.* IV, 205, 327, 159; *Journal* 6 June 1856 (II, 453).

[24] On the importance of charm, one of the most recurrent words in Delacroix's aesthetic vocabulary, see 1 October 1855 (II, 396). The emphasis on pleasure and charm as the purpose of painting is made by Dolce in his *Aretino* dialogue, which Delacroix knew well (*Dolce's "Aretino" and Venetian Art Theory of the Cinquecento*, ed. Mark Roskill, 149, 174); he copied out a passage from the work on the power of painting to attract and please the eye (25 August 1850; I, 414–15). He cites approvingly Poussin's definition of beauty

problem, linked to modernity's obsession with saving time: "we are marching toward that happy time when space will have been abolished but not *ennui*, considering the ever-increasing necessity of filling up the hours which used to be occupied, at least in part, by coming and going" (27 August 1854; II, 244). Modern inventions all have this purpose: machines which relieve the farmer of work increase the burden of time; the dazzling rapidity of the railway negates the benefit that travel should have, that is, drawing us out of *ennui* by making us see other places and peoples (6 June 1856; II, 453). The only antidote to it, and thus the sole source of true pleasure, is work, and work defined as "the *mind* constantly at work" (9 October 1853; II, 82), having ideas and seeking ways to produce them. "The secret of not having *ennui*, for me at least, is to have ideas. Thus I can never look too hard for ways of giving birth to them" (14 July 1850; I, 385).

All Delacroix's creative activity shares this premise and purpose: "Work is as always my protection against *ennui*."[25] Without work, the human machine ceases to function;[26] when in June of 1863 his illness prevents him from working and abandons him to *ennui*, death is only two months away.[27] For the painter, the self-renewal necessitated by the stifling action of *ennui* may be had "by taking up one's brushes and canvases again" (10 October 1855; II, 402). And for the painter-diarist, such self-renewal may also be had through writing the diary: "I eagerly seize every occasion to occupy my mind, even by speaking about that *ennui* which I seek to ward off" (11 August 1854; II, 242).[28] Indeed, the *Journal* represents especially well the ongoing, periodic, ever-renewed activity of the mind that staves off *ennui*, as the writing, in a sense, staves off the death that lies at its boundary; at the same time it fulfills the precious role of producing ideas, "food for thought," the most necessary sustenance: "I feed on the memory of my own feelings" (24 March 1855; II, 320). After one session of writing in the diary, he remarks: "The nourishment which [the mind] requires is more necessary to my life than that which my body needs" (14 July 1850; I, 385). The traditional product of idleness and leisure, the diary here becomes the record and example of work in Delacroix's sense, a work like painting, in which the mind is freed from the domination of time, from an anxiety about time, reversing the corrosive

as "delectation," and also Voltaire's: beauty is that which causes pleasure and admiration to the soul and the senses (1 January 1857; III, 1–2).

[25] *Corr.* IV, 359.

[26] *Corr.* IV, 214. Cf. *Further Corr.*, 54 (29 October 1860): "l'absence de travail est pour moi une espèce de maladie."

[27] *Corr.* IV, 377.

[28] Regarding the dating of this note, see above, n. 21.

action of time by giving it value: "The purpose of work is not only to produce, it is to give value to time" (19 August 1858; III, 212).

Delacroix's open rejection of literary discourse was a personal, but also polemical gesture, for it went against some of the deepest currents of the Western pictorial tradition, and of the philosophical and cultural systems of which they were part.[29] The history of art criticism and of the theory of painting from at least the Renaissance onward, formalized especially in the doctrines and curricula of the French Academy, demonstrate everywhere the prominence of the literary: not simply in their constant application of literary criteria from tragedy, epic, and rhetoric, but more important, in their emphasis on narrative as the means of achieving the ends of painting—themselves drawn from literature—to please and instruct.[30] Delacroix's treatment of the subject should be seen against this background. From ancient theories of rhetoric (notably Cicero and Quintilian) and treatises on poetry (Horace and, as a later discovery, Aristotle), the humanist writers on painting derived a vocabulary and a system adaptable to a different art. In the great effort of codifying knowledge which characterized the Renaissance, poetry and rhetoric became models for representation in general, which, with allowances made for differences of medium, could apply to the other arts as well, a semiotic system valid for all.[31] While some theorists maintained the distinctions between writing and painting, the tradition which came to dominate through the Academy sought to appropriate for painting the cultural status of literature: its claims to truth and ideality, and its association with rationality.[32]

[29] On the ramifications of this in an earlier age, see Jacqueline Lichtenstein, *La Couleur éloquente. Rhétorique et peinture à l'âge classique*.

[30] See See Michael Baxandall, *Giotto and the Orators*, esp. 35ff., 131ff.; Rensselaer Lee, *Ut pictura poesis: The Humanistic Theory of Painting;* Thomas Puttfarken, *Roger de Piles' Theory of Art;* David Rosand, "Ekphrasis and the Renaissance of Painting"; John Spencer, "Ut rhetorica pictura: A Study in Quattrocento Theory of Painting"; Louis Marin, "Towards a Theory of Reading in the Visual Arts"; David Summers, *Michelangelo and the Language of Art*, 42ff.; J. Lichtenstein, *La Couleur éloquente*. Lichtenstein, however, distinguishes between *ut pictura poesis* and *ut pictura rhetorica:* while the former was based on the primacy of the discursive, the latter recognized the crucial role of non-discursive elements such as gesture, action, and silence (220ff.).

[31] See Baxandall, *Giotto and the Orators*, part 3. The systematizing effort continued well into the eighteenth century. See Charles Batteux, *Les Beaux-Arts réduits à un même principe* (1747), which sought to find the fundamental laws governing all the arts. Painting was so analogous to poetry that their rules were interchangeable: "Les deux arts ont entr'eux une si grande conformité, qu'il ne s'agit, pour les avoir traités tous deux à la fois, que de changer les noms, et de mettre Peinture, Desseing, Coloris, à la place de Poësie, de Fable, de Versification" (256).

[32] Puttfarken (*Roger de Piles' Theory of Art*, x and 3) discusses the literary theorizing of the Academy under Le Brun and its official historiographer, Félibien, as an attempt to

The keystone of this system was the Aristotelian conception of art as the representation of human action and the primary importance of plot, the working out of the action, in his theory of poetry.[33] Art theory concentrated on overcoming the contradiction of "narrative painting," simulating succession in an instantaneous art, repressing the full presence of painting to feign the serial character of writing. The painting/literature analogy was used to affirm the values of neoclassical aesthetics within the context of an absolute monarchy which officially sponsored its adherents:[34] painting, like poetry, should represent human action by taking the form of narrative history painting, that privileged category in the hierarchy of genres. Such action implied progression and succession, a beginning, middle, and end like an Aristotelian plot, an exposition and a "dénouement," a temporal sequence to be rendered through pictorial disposition.[35] It is the *historia* of the early theorists, the narrative treatment of the subject; for Alberti it is the chief business of the painter, to be achieved through a pictorial rhetoric which, on the model of Ciceronian rhetoric, would please, persuade, and move the viewer.[36] The analogy with rhetoric could also ensure instruction: the educative aims of painting depended on a certain progression of the argument, leading the viewer through a logical and rational series of cumulative steps to a final conclusion. Hence the ascendancy of "narrative" line (likened to plot) over "pictorial" color, particularly by the seventeenth century.[37] Color was

raise itself to the level of the Académie Française. Cf. Summers, *Michelangelo and the Language of Art*, 468 n. 22; and J. Lichtenstein, *La Couleur éloquente*, 154ff.

[33] As J. Lichtenstein argues, it is ironic that Aristotelian theory was used in this way, for by introducing pleasure into the concept of mimesis, Aristotle in fact provided the means by which painting could be defended against the accusations of Plato and the metaphysical tradition. See *La Couleur éloquente*, 68ff.

[34] Ibid., 162f.

[35] E.g. Fréart de Chambray on Raphael's *Judgment of Paris:* "[le peintre] nous a montré tout à la fois une suite de tant de choses diverses" (*Idée de la perfection de la peinture*, 30); Watelet and Levesque, *Dictionnaire des arts de peinture, sculpture et gravure*, III, 648, article *ordonnance:* "une belle composition doit être enchaînée"; Félibien, "Preface," *Conférences*, V, 313 (quoted in Puttfarken, *Roger de Piles' Theory of Art*, 5f.): "comme dans les pièces de théâtre la fable n'est pas dans sa perfection, si elle n'a un commencement, un milieu et une fin pour faire comprendre tout le sujet de la pièce; l'on peut aussi dans de grands ouvrages de peinture pour instruire mieux ceux qui les verront, en disposer les figures et toute l'ordonnance, de telle sorte qu'on puisse juger de ce qui aura même précédé l'action que l'on représente." On Aristotle's conception of plot, see *Poetics* 1450b, 1451a, 1459a.

[36] *De pictura* 40. See Rosand, "Ekphrasis and the Renaissance of Painting", 148; Spencer, "Ut rhetorica pictura", 38; Baxandall, *Giotto and the Orators*, 130ff.; Lichtenstein, *La Couleur éloquente* (174ff.)

[37] Aristotle had compared plot to an image sketched in black and white, and character to shapeless daubs of color (*Poetics*, 1450b1).

considered a mere material, lacking expressive power of its own; line was linked with cognition and intelligibility.[38] As Le Brun argued, color depended on matter and was less noble than line, which comes from the mind alone.[39]

For Dolce, whose highly influential dialogue on painting, the *Aretino*, Delacroix cites, the plan or plot of the composition constituted a pictorial version of literary *inventio*, both the choice of subject and the order and disposition of figures, which must be joined in a single and logical progression: "As for order, it is necessary that the artist move from one thing to another following the sequence of the narrative [*historia*] he has undertaken to paint, and with such propriety that the viewers judge that this action could not have happened other than as he depicted it."[40] Seventeenth-century French theorists, notably Le Brun, insisted on this preeminence of "linear" plot. Painting had a rational order which a viewer would perceive through proceeding from one figure or group to another in a causal, if not purely "temporal" sequence, substituting for the passage of time *as such* a narrative and causal relation of images.[41] The order was single and reasonable, unambiguous, stable, and controlled, leading to the main idea. Le Brun compared the painter who did not do this to a historian who does not conduct a narrative from beginning to end, but merely gives the conclusions.[42] The painter should communicate a pro-

[38] These analogies remained remarkably stable even when the values were reversed: thus Diderot likens line to logic and, at best, oratory, color to poetry (*Essais sur la peinture*, 674); Baudelaire associates line with philosophical abstraction, color with epic poetry (*Salon de 1846, Oeuvres complètes* II, 426).

[39] "Sentiment sur le discours du mérite de la couleur par M. Blanchard," 6 January 1672, in *Conférences inédites*, ed. Fontaine, 36 (quoted in J. Lichtenstein, *La Couleur éloquente*, 169).

[40] The rule is attributed to Aristotle in the *Poetics*. See Roskill, *Dolce's "Aretino" and Venetian Art Theory of the Cinquecento*, 120f. and note p. 268ff. The English translator of the dialogue in 1770 was even less restrained: "Invention is to the painter, what the plot is to the writer" (*Aretin: A Dialogue on Painting*, 81). The dialogue first appeared in 1557. Delacroix read the French translation of 1735.

[41] See Le Brun's famous lecture on Poussin's *Gathering of the Manna*, in which the order proceeds from left foreground, to right foreground, to center, and finally to the background (Jouin, *Conférences de l'Académie Royale de Peinture et de Sculpture*, 51; discussed in Puttfarken, *Roger de Piles' Theory of Art*, 9f.).

[42] "Il est quelquefois nécessaire qu'il joigne ensemble beaucoup d'incidents qui aient précédé, afin de faire comprendre le sujet qu'il expose, sans quoi ceux qui verroient son ouvrage ne seroient pas mieux instruits que si cet historien au lieu de raconter tout le sujet de son histoire se contentoit d'en dire seulement la fin" (Jouin, *Conférences de l'Académie Royale de Peinture et de Sculpture*, 62f., cf. Puttfarken, *Roger de Piles' Theory of Art*, 8f). Poussin's painting is described in the Aristotelian terms used for drama or narrative, complete with unity of action, episodes, and *peripeteia:* "Ce savant peintre a montré qu'il était un véritable poète, ayant composé son ouvrage dans les règles que l'art de la poésie

gressive action by substituting a plurality of incidents for the succession of words that characterizes poetry and arranging them so as to lead the viewer from one part of the work to another, as though the objects were presented successively in this order.[43] The linear progression was meant to correspond both to the single order of discursive language (as opposed to the multi-directedness of the image) and to the rationality and logicality of thought which language (notably French) was thought to represent.[44] The sequence of images in a painting should strive to be unambiguous and irreversible, like the syntactical progression of the non-declined French language, and the order of reason itself.

This literary conception of the pictorial had been challenged by Roger de Piles, whose emphasis on the visual nature of painting gained prominence in the Academy after 1699,[45] but it had been revived by the early nineteenth century through the historical, linear, neoclassical emphasis of the Academy and its secrétaire-perpétuel, Quatremère de Quincy; it still held in Delacroix's time.[46] The *Journal*'s distinctions undermine literary notions of legibility and intelligibility, and in doing so define the purposes of painting differently. No longer patterned on a narrative model in which the viewer follows, to use Delacroix's metaphor, a fixed and single discursive "route," painting presents, rather, a "panoramic" variety of choices and alternatives. Moreover, this is not simply Lessing's "pregnant moment," pointing ahead to what will happen: Delacroix takes advantage of what he considers the inclusiveness inherent in the image, to open up the pictorial narrative, suggest its tensions and ambiguities.[47] This does not mean that he abandons a guiding pictorial syntax: intelligibility and simplicity had positive aesthetic value for him. Rather, he multiplies the

veut qu'on observe aux pièces de théâtre . . . l'on voit que ces groupes de figures, qui font diverses actions, sont comme autant d'épisodes qui servent à ce que l'on nomme péripéties, et de moyens pour faire connaître le changement arrivé aux Israélites quand ils sortent d'une extrême misère, et qu'ils rentrent dans un état plus heureux" (Jouin, *Conférences de l'Académie Royale de Peinture et de Sculpture*, 64). Artistic practice was less rigid than academic theory: on Poussin's presentation of different narratives within a single image, see David Carrier, "Blindness and the Representation of Desire in Poussin's Paintings."

[43] Cf., later, Samuel F. B. Morse (*Lectures on the Affinity of Painting with the Other Arts*, 62f.), who conceived of this succession of images almost cinematically, as "passing in review before the imagination." See also Louis Marin, *Etudes sémiologiques. Ecritures, peintures*, 20.

[44] See Puttfarken, *Roger de Piles' Theory of Art*, 13ff.

[45] Ibid., xii, 125ff.; J. Lichtenstein, *La Couleur éloquente*, chapter 6.

[46] See Albert Boime, *The Academy and French Painting in the Nineteenth Century*, 18ff.

[47] Uve Fischer ("Das literarische Bild im Werk Eugène Delacroix," 203ff.) sees Delacroix's narrative painting as profoundly different from Poussin's: the action compressed into an instant, without the traditional dramatic pattern of development and climax.

syntax, calling attention to the different ways in which the subject may, and indeed should, be interpreted, bringing out the complexities and contradictions within the subject itself, or suggesting the dramatic uncertainty of the outcome. Painting thus refuses any desire for uncomplicated meanings and neat explanations, any tendency to blindness and self-delusion, the simplistic vision which he so scathingly criticizes in his comments on politics and society; it highlights the multiple points of view which historical narrative, presenting itself as objective and true, unmarked by contingency or conditionality, theoretically seeks to suppress.[48] Instead, it imposes a more extensive, expansive vision: different perceptions of one same object, or different conceptions of a given event.[49] For Delacroix, the purpose of a work of art is not to state a single message but to provoke thought.[50] It calls into question our understanding of the world, and indeed our mode of understanding itself, offering alternative possibilities to the very message it might seem to convey.

Delacroix was not only a "literary" painter, but an important writer on painting, indeed the only major painter of the nineteenth century to write significantly on the arts. In his notes for a projected treatise on the fine arts, the *Dictionnaire des Beaux-Arts*, we encounter the same aesthetic that governs the *Journal*. (The work was never completed, but the material of the diary was recycled into it; for much of 1857, in particular, the *Journal is* the *Dictionnaire*.) As with the diary, he was aware of the generic choices available and was deeply concerned with the form his treatise should take. These issues are discussed at length as he drafts the introduction and many of the dictionary's entries. He opts for the form of the dictionary because of its fragmentation, freedom, inclusiveness, and variety, as opposed to a narrative line, methodical organization, consistency, and rigid systematization, precisely the same terms by which he distinguished painting from literature, diary from autobiography. And it shares the diary's purposes: it confers upon the reader a freedom from the constraints of time, and in a few short entries provides the material for a long and fruitful meditation (16 January 1860; III, 252), an abundant stock of armaments against the "terrible enemy," materials for the "face of steel" to put up to *ennui*.[51]

To some extent the stockpile consists, as in all autobiographical writing, in memory: "I reopen in my memory a book in which many chapters are

[48] See Benveniste's theory of the historical mode (*récit*), in which events seem to "narrate themselves" (*Problèmes de linguistique générale*, chapter 19); Louis Marin, "Towards a Theory of Reading in the Visual Arts," 67.

[49] Cf. R. R. Bernier's discussion of this in late-nineteenth-century painting, in "The Subject and Painting: Monet's 'Language of the Sketch,'" 318.

[50] See *Journal*, Supplement (III, 447).

[51] Note dating from 25 August 1854 (II, 241), but written under the 11th.

already closed, and I find delightful moments in it":[52] the cliché of memory as a storehouse for the artist's thoughts and experiences, and of the work at hand, too, as a record and repository of those, informs the autobiographical tradition in its various guises from Saint Augustine onward. Delacroix too regards the *Journal* as an extension of, even a substitute for, his faulty memory, a means of preserving thoughts, sensations, and experiences which his memory would betray, desert, or abandon to the oblivion brought about by time: "It seems to me that these little trifles, written on the wing, are all that I have left of my life, as it goes by. My faulty memory makes them necessary to me" (11 March 1854; II, 147). But if the *Journal*, as I argue, liberates the reader from the limiting progress of time within the bounds of life, allowing a freer, more variable temporality, an instantaneity and simultaneity, the first reader to benefit is the diarist-reader himself. Indeed Delacroix's notion of time reflects the peculiar temporality of the *Journal*: the past preserved in it is not a fixed, dead entity, buried in the memory, or in the text, as in a tomb, to be unearthed like some ancient skeleton, in keeping with a certain strain of Romanticism.[53] The past, rather, is ever alive, always at hand to enrich and qualify the present: hence he rereads his old diaries, copies bits of one entry into another, inserts pages from a different date, intercalates a comment from a later time, and so on; similarly, the *Dictionnaire des Beaux-Arts* begins like a retrospective of the *Journal*, nearly every heading containing at least one reference to a diary entry of some other date. Delacroix approaches his past—the memories recorded in the *Journal*—as he does any other text, to be read and reread, and thus reactivated: for as the diary attests on page after page, reading is the occasion for relating a work to oneself, making it live again through the life of the reading subject, and conversely, redefining the subject through it. The long passages copied out of countless literary, historical, and philosophical works, and "ephemeral" newspapers and periodicals, reflect the situation of the reader-Delacroix himself in one way or another, are reborn into the present in which he reads them and applies them to his own life; in turn, they qualify that life, the subject's very present. "One should always read with pen in hand. There is not a day that goes by, that I do not find in the most

[52] Letter of 6 December 1856 (see above, n. 22).

[53] Cf. *Obermann* I, 213: "Mes jours perdus s'entassent derrière moi; ils remplissent l'espace vague de leurs ombres sans couleur; ils amoncèlent leurs squelettes atténués; c'est le ténébreux simulacre d'un monument funèbre." Delacroix expressed impatience with a Romantic morbidity which he considered untrue to real life: "Le romantisme chez Lamartine et en général chez les modernes est une livrée qu'ils endossent semblable à ces manteaux de deuil et à ces pleureuses dont on s'affuble aux enterrements" (unpublished note, 18 March 1853). Cf. 14 February 1850 (I, 340).

worthless newspaper something interesting to note down" (12 May 1857; III, 97). And the process is ongoing: "Not only can I find in the writings of others the material for new writings interesting to my own point of view, but the very account that I have myself just produced I will do in twenty different ways" (23 August 1850; I, 414). Indeed, the past recorded in the *Journal* is ever material for renewal and reusage, the memories returned to, reconsidered, and integrated into the now; writing takes on the time of the visual arts, the present.[54]

In the cultural terms of Delacroix's age, the rejection of literary narrative to which his writings and paintings bear witness reflects a refusal of the dominant nineteenth-century notion of time and history, the ideology of progress. His well-known hatred of progress, attested repeatedly in the *Journal*, may thus be due not only to the effects of industrialization and democratization, as is usually argued, but also to the notion of time that progress assumes. A progressive conception of history presupposes a narrativized time, in which the past is recounted, and indeed defined, in view of a particular end, and as leading causally toward it. Unlike the interconnected, multi-directed patterns of the *Journal*'s entries, such a conception does not allow the past to live in the present but confines it to the tomb. As Leonardo maintained before him, writing depends on death, the extinction of its successive parts.[55] In the terms of the painting–literature dichotomy, progress allows for no simultaneity and no "panoramic" multiplicity, but has the false teleological quality of narrative, the exclusive linearity of writing, taking humanity not to its apotheosis, as was promised, but to the "intolerable void" of *ennui*, or, even, as the political events of his time sometimes made him believe, to barbarism. The aesthetic of the *Journal* is consistent, as we shall see, with Delacroix's philosophy of time, history, and experience as non-progressive, non-teleological, not linked in any causal relation, but rather haphazard and unpredictable, ever subject to reversal or even annihilation. "Mankind always begins everything anew, even in his own life. He can mark no progress" (4 April 1849; I, 280): human time is marked not by progress but, for better or worse, by change, as the oft-noted maxim from Job suggests, *"nil in eodem statu permanet"*.[56]

[54] For a discussion of the time of the arts, see J. Lotman, *Semiotics of Cinema*, 77. E. Marty makes the important distinction between diary-writing, which "makes present," and reminiscing, which is oriented toward the past (*L'Ecriture du jour*, 12).

[55] "Can you not see that in your science . . . each part is born successively after the other, and the succeeding one is not born if the previous one has not died?" (*Leonardo on Painting*, 26).

[56] 23 April 1849 (I, 290); Supplement (III, 369); see also "Des Variations du beau" (*O. L.* I, 43).

The consequences of Delacroix's conception of time are worked out in the *Journal* itself, in the great mobility and fluctuation of the self within the repetitive, periodic movement of the day to day, in the discontinuity of the entries within the rich network of recurring motifs and deliberate cross-references, in the pictorial aesthetic by which a painting or an entry is familiar and yet new each time one views it again, in the effect of simultaneity created within the temporal domain of diachronic discourse. Through its essential difference from painting, writing may have provided a space in which to explore this aesthetic and to elaborate a highly original practice. The experience is not without parallel in Delacroix's career. Just as, in his view, he could best realize the potential of his art by taking as his subjects works from foreign literatures;[57] just as his conception of light, color, and form would be transformed by his voyage to Morocco; just as he would "cease seeing with the eyes of others" through an experience brutally disruptive to vision itself, photography: so, by its liberating separateness, writing became the space of reflection, and perhaps even transformation, for painting.

The following pages will examine this aesthetic and its implications in Delacroix's diary, painting, and writing on art, so as to focus attention on what was for him a central, almost obsessive, and certainly lifelong, concern: the relation of pictorial to literary as forms of expression and modes of thought. To do so is to suggest as well this painter's confrontation with a major aspect of his era, his challenge to the dominance of narrative in institutions of the nineteenth century—its conceptions of history, its social philosophies, and its primary art form, the novel. From among his paintings, I have chosen to concentrate primarily on his decorative cycles or series, for they are the most explicitly "narrative" of his works, and thus represent the most striking cases of his innovative approach, consistent with the aesthetic of the *Journal*.[58] Moreover, as public decorations they suggest the wider dimensions of this aesthetic. It is indeed in monumental painting that the great narratives of the nineteenth century—the evolution of history and humanity—were interpreted: in Chenavard's Panthéon, Ziegler's Madeleine, Henri Lehmann's Galerie des Fêtes (now destroyed)

[57] "Il est des artistes qui ne peuvent choisir leurs sujets que dans des ouvrages étrangers qui prêtent au vague. Nos auteurs sont trop parfaits pour nous . . . Peut-être que les Anglais sont plus à l'aise en prenant leurs sujets dans Racine et dans Molière que dans Shakespeare et Lord Byron" (30 January 1860; III, 257).

[58] Although the works were commissioned by the state, Delacroix benefited from great freedom in the choice and treatment of the subjects. State commissions during the July Monarchy, at least, involved little intervention by the authorities, except over the schedule of completion. Delacroix's finished product was always markedly different from the drawings originally submitted for approval by the Inspector of Fine Arts. See Bruno Foucart, *Le Renouveau de la peinture religieuse en France*, 81.

in the Hôtel de Ville.[59] Delacroix believed that monumental painting should reflect the highest ideals of the nation, not by repeating and confirming those most current, but by recalling its viewers to a more comprehensive view, a self-critical consideration of their values, assumptions, and place within history. In a passage which he quoted from Ludovic Vitet and underlined in the diary, he acknowledges explicitly the function of art to jolt us out of customary habits of thought, "confound our judgment," thwart our traditions, throw the anticipated narrative off course: "The property of true masterpieces is to cause these kinds of surprises. They catch us unawares, disturb us in our routine admirations; . . . thus they make us see in a new way, and reduce to a lower level, everything which reigned supreme before them" (3 February 1860; III, 262).[60]

The crisis in the relations between text and image provoked by Romantic theory—the complete division and irreconcilability of the two—was not so much resolved by Delacroix as pushed to its limits; the result was a text that proposed, in its very form, a particular concept of the pictorial as it incorporated the qualities of the pictorial itself. The *Journal* works out a pictorial language in the literal, and not merely metaphorical, sense, a language consistent with many of the features of Delacroix's art. It represents a kind of writing and reading equivalent to a kind of painting and viewing, and to a kind of reflection on painting (the *Dictionnaire des Beaux-Arts*) as well. And in so doing, it identifies and formulates a major current of nineteenth-century art and thought, running through some of the most innovative works of the century.

"Where have I seen that there are animals . . . which, cut up into pieces, make as many separate creatures, each having its own existence, as there are fragments?" (5 August 1854; II, 227). Delacroix's observation on nature confirms the wholeness and autonomy of not only the *partie*, but also the *pensée, détachée,* the "dismembered" writing of the *Journal*. The next work of any significance to do likewise, and in strikingly similar terms, describing both a new concept of art and a new method of reading, appeared in 1862:

> My dear friend, I send you a little work of which it cannot be said, without being unfair, that it has neither head nor tail, since everything in it, on the contrary, is at once head and tail, alternately and reciprocally. . . . We can cut wherever we like, I my reverie, you the

[59] See ibid., 215f., 267; Marius Vachon, *L'Ancien Hôtel de Ville de Paris*, 62ff.; Jean Borreil, "Légende et apothéose de l'humanité."

[60] Cf. Delacroix's article of 1857, "Des Variations du beau": "ne peut-on, sans paradoxe, affirmer . . . que cette face nouvelle des choses révélées par [un grand artiste] nous étonne autant qu'elle nous charme?" (*O. L.* I, 54).

manuscript, the reader his reading; for I do not hang the reader's restive will on the interminable thread of some superfluous plot. Remove one vertebra, and the two pieces of this tortuous fantasy will join up effortlessly. Chop it up into numerous fragments, and you will see that each portion can exist separately. In the hope that some of these pieces will be lively enough to please and amuse you, I dare to dedicate to you the entire serpent.[61]

This variable, protean work, as its prologue tells us, "with neither head nor tail," dismembered like Delacroix's ideal writing; able to be read in any order, not forcing the reader to follow the "interminable thread" of a plot, and in which the whole may be carved up and reshaped at will; this truncated serpent, like his truncated animals, in which each part is a whole in itself, is not a diary, nor a dictionary, nor a cycle of paintings, but a collection of prose poems, a landmark in the history of modernity, Baudelaire's *Le Spleen de Paris*.

[61] "Mon cher ami, je vous envoie un petit ouvrage dont on ne pourrait pas dire, sans injustice, qu'il n'a ni queue ni tête, puisque tout, au contraire, y est à la fois tête et queue, alternativement et réciproquement. . . . Nous pouvons couper où nous voulons, moi ma rêverie, vous le manuscrit, le lecteur sa lecture; car je ne suspends pas la volonté rétive de celui-ci au fil interminable d'une intrigue superflue. Enlevez une vertèbre, et les deux morceaux de cette tortueuse fantaisie se rejoindront sans peine. Hachez-la en nombreux fragments, et vous verrez que chacun peut exister à part. Dans l'espérance que quelques-uns de ces tronçons seront assez vivants pour vous plaire et vous amuser, j'ose vous dédier le serpent tout entier."

CHAPTER ONE

On the Boundaries of the Arts
and the True Power
of Painting

"AT THE DECAMPS SALE . . . When one takes up a pen to describe such expressive objects, one senses clearly, at one's inability to give any idea of them by this means, the limits that mark the scope of the different arts" (21 April 1853; II, 23). It was the practical experience of writing, and of writing about images, which determined Delacroix's conviction of the differences between the arts. Confronted with a work by Decamps, or the countryside around his house at Champrosay, or even a mental image in his memory, Delacroix the writer records a recurrent and insurmountable *impuissance*,[1] the inadequacy of prose to translate the visual image. Sometimes the result was silence, as with his experience here of the works of Decamps, which he can only describe imperfectly, despite their vividness in his memory: "So I will say no more about them." More often the result was one of the innumerable sketches which fill his pocket notebooks or occasionally adorn the diary. But perhaps the most consistent consequence was the *Journal's* ongoing effort to theorize and justify the distinction between literary and pictorial, and the relative merits of each.

By literary he does not mean poetic: "Painting lives especially through forms, through the exterior of objects: line, color, effect, all qualities which have nothing in common with a literary idea—I did not say with a poetic[2] idea, which is an entirely different matter" (29 October 1857; III, 133–34). "Poetry" and "poetic" are general and specific at the same time, denoting the

[1] As in the sentence just quoted: "Quand on prend une plume pour décrire des objets aussi expressifs, on sent nettement, à *l'impuissance* d'en donner une idée de cette manière, les limites qui forment le domaine des arts entre eux." Cf. 24 October 1853 (II, 100).

[2] The published editions wrongly print "politique" rather than "poétique."

highest quality of all the arts, but not a hierarchy of the arts: "Whoever says art says poetry. There is no art without a poetic purpose."[3] Painting has been subordinated to literature because of a linguistic imprecision:

> This word "poetry," which one has to use even when dealing with painting, reveals a deficiency in the language which has brought about a confusion in the prerogatives and privileges of each of the fine arts. This word being applied to mean the quality *par excellence* of all the arts, and designating at the same time the art of painting with words, would seem to indicate that the latter art is the art *par excellence*, since the dominant quality in the other arts is only, in a sense, a borrowing from it. (29 October 1857; III, 134)[4]

> [Ce mot de poésie, qu'il faut bien employer même quand il est question de peinture, révèle une indigence de la langue qui a amené une confusion dans les attributions, dans les privilèges de chacun des beaux-arts. Ce mot étant appliqué à signifier la qualité par excellence de tous les arts et désignant en même temps l'art de peindre avec la parole, semblerait indiquer que ce dernier art est l'art par excellence puisque la qualité dominante dans les autres arts n'est en quelque sorte qu'un emprunt qui lui est fait.]

"Literary," rather, denotes the qualities of narrative prose, which may apply to painting by analogy, but are foreign to its essential nature: thus there are "peintres-prosateurs" like David and Poussin, lacking the instantaneous effect proper to painting, and "peintres-poètes" like Rubens.[5]

Delacroix regards as peculiarly French this propensity to the literary and discursive: "It is a gift, or a defect, of our race: the intellect has to be mixed up in everything" (29 October 1857; III, 133). He attributes to it the poverty of French taste in the visual arts: "A nation has taste only in the things at which it succeeds. The French are good only at what is spoken or read. They have never had any taste in music or in painting" (26 February 1852; I, 461).[6] He criticizes his friend Chenavard's view of

[3] *O.L.* I, 63.

[4] Delacroix does recognize an analogy between painting and poetry in its more restricted sense: poetic conventions, such as rhyme and the cadence of the verse, corresponding to painterly ones such as the balance of lines and tonal echoes (19 September 1847; I, 239–40).

[5] 19 September 1847 (I, 239–40); 24 September 1850 (I, 417).

[6] Delacroix returned to this note the following year in writing his article on Poussin: "Une nation n'a de goût que dans les choses où elle réussit naturellement. . . . On aime par-dessus tout, en France, le raisonnement, le discours, en un mot la pensée exprimée par les écrits ou par la parole; . . . mais, en revanche, les Phidias et les Apelles ne fleurissent pas aussi spontanément dans ce pays éloigné du soleil" (*O.L.* II, 86f.).

the superiority of literature to convey ideas: "His is a mind of the typically French sort: for him ideas have to be the kind that words can express; as for those before which language is powerless, he cuts them out of the domain of the arts."[7] Ideas, rather, are not the preserve of language, which frequently proves inadequate to express them: "Before a painting or a symphony that you have to describe in words, you will easily give a general idea in which the reader will understand more or less of the thing; but you will not really have given any precise idea of that symphony or that painting. One must see things that are made for the eyes" (20 May 1853; II, 56). From its earliest pages, the diary records Delacroix's impatience with the literary prejudice of nineteenth-century aesthetics: "When I have painted a beautiful picture, I have not 'written' a thought. That is what they say. How simple-minded they are! They deprive painting of all its advantages" (8 October 1822; I, 17).

In this he followed an illustrious precedent. "It would be a curious thing to write a commentary on Leonardo's *Treatise on Painting*. Embroidering upon that dryness would provide material for everything you could want" (3 April 1860; III, 284). Indeed the *Journal*'s reflection on the differences between the two arts is in many respects a long and nuanced development of Leonardo's defense of painting against the dominant theory of *ut pictura poesis*.[8] The *Treatise on Painting* contrasts the temporality of writing with the instantaneity of the image, and draws out the implications of this: "Now, see what difference there is between hearing an extended account of something that pleases the eye and seeing it instantaneously, just as natural things are seen. Yet the works of the poets must be read over a long span of time. . . . But the work of the painter is instantaneously accessible to its spectators."[9] The temporal unfolding of literature consigns it to a perpetual dismemberment, its parts irrevocably separate like the words separated by "voids,"[10] and never seen together as a whole to delight the imagination and the senses:

There is the same difference between the representation of corporeal things by the poet and painter as between dismembered and intact

[7] 20 May 1853 (II, 56). Cf. "Des Variations du beau" (*O.L.* I, 52): "C'est une manie toute française qui tient sans doute à notre penchant pour tout ce qui ressort de la parole. Le peintre, chez nous, veut plaire à l'écrivain; l'homme qui tient le pinceau est tributaire de celui qui tient la plume."

[8] For other writers on this debate between 1490 and 1510 with ideas similar to Leonardo's, see John Onians, "On How to Listen to High Renaissance Art," 412ff. For the *ut pictura poesis* question in the Renaissance generally, see Baxandall, *Giotto and the Orators*; Lee, *Ut Pictura Poesis: the Humanistic Theory of Painting*; and J. Lichtenstein, *La Couleur éloquente*.

[9] *Leonardo on Painting*, 23.

[10] Ibid., 24.

bodies, because the poet in describing the beauty or ugliness of any figure shows it to you bit by bit and over the course of time, while the painter will permit it to be completely seen in an instant. . . . Alternatively, something made by the poet may be likened to a beautiful face which is shown to you feature by feature and, being made in this way, cannot ever satisfactorily convince you of its beauty, which alone resides in the divine proportionality of the said features in combination. Only when taken together do the features compose that divine harmony which often captivates the viewer.[11]

Moreover, for Leonardo, the spatial and material qualities of painting ensure for it a truth that literature lacks: a painting gives the same satisfaction as things in the world, conveying its essence as objects in nature do.[12] Painting is a body, poetry only its cast shadow, an imagined form "born in the darkness of the inner eye."[13] Painting is a reality in itself, a "surrogate" or "substitute,"[14] breaking down the mimetic structure of original and copy, as the latter elicits the same sensual reactions as the former: a picture of the beloved will make the lover kiss it and speak to it.[15] It may even inspire rapture, enchantment, and lust, arousing the desire of the viewer—a sensual meaning *independent* of its representational one, and sometimes contradictory to it:

It previously happened to me that I made a picture representing a holy subject, which was bought by someone who loved it and wished to remove the attributes of its divinity in order that he might kiss it without guilt. But finally his conscience overcame his sighs and lust, and he was forced to banish it from his house. Now, poet, attempt to describe a beauty . . . and arouse men to such desires with it.[16]

Relative to painting, poetry is "slow," "long," "tedious,"[17] capable of inducing boredom,[18] exhausting and debilitating the senses rather than

[11] Ibid., 37.

[12] "Painting gives satisfaction as nature does herself" (ibid., 19); "Painting . . . gives as much pleasure as anything created by nature" (ibid., 23); "The poet is not able to present in words the true configuration of the elements which make up the whole, unlike the painter, who can set them before you with the same truth as is possible with nature" (ibid., 37).

[13] Ibid., 23.

[14] Ibid., 24.

[15] Ibid., 26.

[16] Ibid., 27f. On the capacity of painting to supply the absent object of desire, and on the mythological connection between painting and eros, see J. Lichtenstein, *La Couleur éloquente*, 132ff.

[17] *Leonardo on Painting*, 26.

[18] Ibid., 24.

stimulating them: "Your pen will be worn out before you have fully described something that the painter may present to you instantaneously. . . . And your tongue will be impeded by thirst and your body by sleep and hunger, before you could show in words what the painter may display in an instant."[19]

Delacroix makes all these points, and more. "Painting, among other advantages, has that of being more discreet; the most gigantic picture is seen in an instant" (11 March 1849;[20] I, 275): in its capacity to be grasped all at once, painting possesses a discretion and reserve, guards its distance, leaves its viewers their independence. With a painting we are not held hostage to the threat of *ennui*, for with even the most tiresome work we need only turn away our gaze.[21]

Indeed, in allowing us our freedom, it may exercise an even greater attraction, as we become conscious of the extraordinary power which draws us in: "The sight of a masterpiece checks you in spite of yourself, captivates you in a contemplation to which nothing bids you except an invincible charm" (23 September 1854; II, 277). Delacroix uses a language tinged with eroticism and the psychology of desire: painting and sculpture play hard to get, display an enticing silence, mystery, and restraint—"One must go to them" (23 September 1854; II, 276).[22] Writing, on the other hand, is something of a nuisance, ever seeking one out and striking up a conversation. It "grabs one by the throat,"[23] forces one to stay with it to the end, listen to its arguments, follow its opinions, turn over each successive page in a seemingly endless series. It must be pursued from start to finish to be understood and judged, and for pleasure to be had from it.[24] A reader's interest can never be sustained at the same level throughout: "Its beauties are not sufficiently detached to excite constantly an equal pleasure. They are linked too much with all the other parts which, because of the connections and the transitions, cannot offer the same interest" (23 September 1854; II, 277); and elsewhere, "This novel is charming at the beginning, then, as usual, come the tiresome [*ennuyeuses*] parts" (25 March 1855; II, 322).

[19] Ibid., 28.

[20] The context of this discussion is another temporal art, music.

[21] This point is made repeatedly in the *Journal:* 11 March 1849 (I, 275); 23 September 1854 (II, 277); 23 April 1863 (III, 333).

[22] The pronoun is of course feminine: "Il faut aller à elles."

[23] 23 April 1863 (III, 333). He applies the same metaphor to composition: a poet is "tyrannized" by a "domineering" rhyme which grabs one by the throat, while a painting is a good friend to whom one can confer one's thoughts when one likes (*O. L.* I, 75).

[24] 23 September 1854 (II, 276). Cf. the same idea, stated with comical irony, in *O.L.* I, 74: "Il faut l'acheter d'abord, il faut le lire ensuite, page par page, entendez-vous bien messieurs? et bien souvent suer pour le comprendre."

This *ennui* haunts not only the reader but the writer too. Delacroix's preference for "works of brief compass," "ouvrages de courte haleine,"[25] is matched by his expressed difficulty in maintaining his interest while writing: "If it were only a matter of stitching thoughts to other thoughts, I would find myself more quickly armed and on the battlefield in the right position; but the sequel to observe, the plan to respect and not muddle up in the middle of one's sentences, that is what makes for the great difficulty, and checks the flow of thought" (21 July 1850; I, 393). The writer has the impossible task of keeping the whole in mind while setting it out in succession: "You see your picture in a single glance; in your manuscript, you do not even see the whole page, that is, you cannot take it in as a whole with your mind." What disappears in the process is the spirit and life which the artist's *own* interest gives to the work, "that warmth which enlivens the narrative." Writing dulls the force of the ideas and sensations it is meant to convey, quelling their fire, diluting their concentrated strength, forcing them into a mold that contains and restrains their power:

> To formulate ideas . . . one has to cut them, square them, pass them through a narrow opening which molds them in bringing them to light. Like glass which cools coming out of the furnace, and which, instead of the molten matter which bubbled in the burning pit, is now nothing more than a furnishing, a flask to be used for the lowest purposes, the idea alone, stark and cold, but precise and stamped, is no longer a burning lava, a flash which illuminates, it is a useful vessel which contains teachings or amusements for everybody and his brother. . . . So there is a book to be written about the book, and about the illusion we are under that it is a faithful echo of what strikes the mind of its author.[26]

The instantaneity of painting ensures a concentration of effect, which strikes the viewer in all its power "at the first glance" (19 September 1847; I, 240); the effect of literature is dissipated by the lapse of time necessary to perceive it. "I find all books too long": Delacroix's rather jokey quotation of Voltaire has a serious point.[27] Works which rely on temporal suc-

[25] 24 April 1854 (II, 170); 16 January 1860 (III, 252–3).

[26] Letter to Balzac, *Corr.* I, 344f.: "Pour formuler des idées . . . il faut les menuiser, les équarrir, les passer par une embouchure un peu rétrécie qui les moule en les mettant au jour. Semblable au verre qui se refroidit en sortant de la fournaise et qui, au lieu de la matière ardente qui bouillonnait dans le gouffre dévorant, n'est plus qu'un meuble, qu'une fiole à l'usage des plus vils besoins, l'idée toute nue, toute froide, mais précise et timbrée, n'est plus une lave brûlante, un éclair qui illumine, c'est un vase utile qui contient pour tout le monde des enseignements ou des amusements. . . . Il y a donc un livre à faire sur *le livre* et sur l'illusion où l'on est qu'il est un écho fidèle de ce qui frappe dans l'esprit de son auteur."

[27] 13 January 1857 (III, 8) although dating from later. The note is wrongly printed under 10 January in Joubin. The quotation comes from Voltaire's *Temple du goût*.

cession are almost always "too long," a recurrent complaint having special resonance for one who spends his life combatting the feeling that time itself is "too long": "What tragedy is it that does not become wearisome? So very much the more, a work like *Emile* or the *Esprit des lois*" (23 September 1854; II, 277). The modern novel is particularly implicated: "The long stretches in a book are a major defect. Walter Scott, all the moderns, etc." (13 January 1857; III, 8). The mind is "abused" (16 May 1857; III, 101), fatigued, subjected to the deadening effects of *ennui*—in the aesthetic system of investment and exchange, a risk not worth the return: "How often has one not regretted the attention one has had to give to a mediocre book, for a small number of ideas scattered here and there . . ." (23 September 1854; II, 276). In contrast, painting capti-vates the viewer and inspires "volumes" of ideas, as in the two Rubens sketches which Delacroix saw in the Nancy Museum in 1858: "I went from one to the other, but without being able to leave them. There is enough to write twenty volumes on the particular effect of these works."[28]

Delacroix's conception of the discreet silence, the dandyistic reserve of painting, is consistent with his observations on social behavior. "Silence is always imposing" (23 September 1854; II, 275): only fools indulge in the pleasure of hearing themselves talk at the expense of engaging with others. Delacroix, the dazzling conversationalist,[29] acknowledges the strength of the temptation, the attraction of vanity, the lure of performing a *tour de force* which overwhelms and silences one's interlocutor—particularly in those who possess, like himself, an active and powerful imagination. But such one-way conversation is narcissistic, causes *ennui* and inspires scorn; discre-tion favors dialogue, which is instructive and provocative, revealing the unknown or recalling the forgotten, moving the mind to thought.

Writing is this kind of talkative art, "un art bavard,"[30] fluid, facile, intemperate, numbing the mind of the reader, stunning it by the sheer abundance of words, like the tiresome chatter Delacroix so dreads at soci-ety soirées, or the unwanted conversation which "assassinates" him in the train (14 October 1853; II, 89). It accumulates the signs, says every-

[28] 10 July 1858 (III, 199). The works in question were *Jonas Thrown into the Sea* and *Christ Walking on the Water*.

[29] All his contemporaries testified to his brilliant conversation. See T. Silvestre: "De-lacroix est fort séduisant en conversation par le tour de ses récits, la finesse de ses observations, la promptitude de ses saillies" (*Histoire des artistes vivants*, 70); Silvestre further reports a remark of Count Nieuwerkerke, the superintendent of Fine Arts during the Second Empire, and not known for his amiability: "Je m'oublierais deux heures avec Delacroix sous la pluie battante" (ibid., 47). See also Baudelaire: "Il est inutile de parler de la conversation d'Eugène Delacroix, qui est un mélange admirable de solidité philosophique, de légèreté spirituelle et d'enthousiasme brûlant" (*Salon de 1859*, in *Oeuvres complètes* II, 611).

[30] O. L. I, 93f.

thing, "talks too much," attempting to compensate for its postponement of meaning and pleasure which are held out until the very end (8 October 1822; I, 17).[31] It is an art of self-absorption, flattering the vanity of the author as much as it enlightens the reader (16 January 1860; III, 251), like those loquacious *sots* who "think less about instructing their interlocutor than about dazzling him" (23 September 1854; II, 276). In the novels of Cooper and Scott, "it is necessary to read a volume of conversation and description to find one interesting passage; . . . so the mind wanders languidly in the midst of that monotony and that emptiness where the author seems to delight in talking to himself" (1 September 1859; III, 233). Painting, requiring only a momentary glance, provokes a special, silent dialogue with the viewer, who may freely explore the implications of the image and respond to its "charm."[32] And this provides, paradoxically, the means by which it may endure, inspiring new meanings and new pleasures at each repeated viewing: "This silent charm operates with the same force and seems to increase every time you cast your eyes upon [the work]" (23 September 1854; II, 277).[33] In contrast one finds in rereading a narrative, or in re-hearing a piece of music (the other art dependent on time), only increasing weariness, a decline in interest, a growing realization of the overall mediocrity which holds the occasional flashes of brilliance together (23 April 1863; III, 332–33). Writing paralyzes the mind; painting moves it to the ongoing activity that it craves, and which alone defers *ennui.*

"The thought of her, which will not pursue me like a passion, will be a lovely flower on my way and in my memory" (3 September 1822; I, 3). The "indiscretion" of writing, its coercive hounding of the reader, resembles the persistence and irresistibility of a passion, exhilarating and exhausting, imperious and absorbing, disrupting notably the subject's use of time; the restraint of painting provokes a more enduring pleasure, everrenewable, resembling the deeper pleasure of memory. Passion is a "savage tyranny" (12 October 1852; I, 493), linked to a perception of squandering time in meaningless distractions that provoke *ennui* (4 April 1824; I, 67). For Delacroix, a true distraction is *occupied*, in the etymological sense of the term which he takes pleasure in analyzing: "On the word

[31] Delacroix certainly found support for his position in his cherished Voltaire: "Le secret d'ennuyer est . . . de tout dire" (*Sept Discours en vers sur l'homme* VI, "Sur la nature de l'homme", ll. 174–75).

[32] Cf. Diderot, *Essais sur la peinture,* 719 (which Delacroix read): "Tes personnages sont muets, si tu veux; mais ils font que je me parle, et que je m'entretiens avec moimême."

[33] Cf. Dolce, *Aretino,* 148: "And this pleasure increases . . . the more the eye . . . returns to look."

'distraction.' It comes from *distrahere, to detach from, to wrest from* . . . to pull yourself out of the state of *ennui* or suffering in which you find yourself" (9 November 1857; III, 145). Painting is such a distraction, a "mistress" who incites the desire of the lover and leaves him with a memory of pleasure: "I set to work the way others run to their mistress, and when I leave it I carry away a delightful memory [*un souvenir charmant*] which resembles but little the agitated pleasure of lovers" (30 November 1853; II, 124–25).[34] Literature may also have this effect, and is thus a passion from which Delacroix will never refrain, one which he indulged with unabashed frequency, however disappointing the result sometimes was: "Even when one is languishing, . . . certain books can reopen the source through which the imagination pours out" (14 July 1850; I, 385–86). Good books, "civilization's antidotes," as he says (9 June 1823; I, 33), can generate ideas and draw one out of oneself, providing "a resource against the difficulty of living with [our]selves" (9 November 1857; III, 146). But the passion may overwhelm too, leaving the lover emptied of feeling, stunned, scornful toward the object, needful *to forget*, like Henry de Marsay in the ironical passage from Balzac's *Fille aux yeux d'or* which Delacroix copied into a notebook in 1835 (Supplement; III, 387).[35] Having gorged himself on pleasure with his mistress, de Marsay feels an intense desire for forgetfulness, lights a cigar and, hands in pockets, takes a stroll on the boulevards in an attitude "truly dishonorable." For Delacroix, this was not just a literary matter, as entries in the *Journal* confirm. Two deeply felt bereavements on two successive days in 1855 leave him, in between the two funerals, in a position not unlike de Marsay's:

> I went . . . to have a coffee and smoke in the café at the corner of the rue Montmartre. There I revelled lazily, and with a kind of philosophical pleasure, in the sight of that ignoble place, of those domino players and of all the common details of life of that crowd of automatons. . . . I even understood the pleasure that one can have in losing oneself to the point of degradation in these distractions. I went home in the same tranquil state, without thinking much about things, having closed the door on all emotion, between those I had felt in the morning, and those which awaited me the following morning. (20 June 1855; II, 347)[36]

[34] The metaphor of painting as a mistress comes from Michelangelo, quoted by Delacroix in his article on Prudhon: "La peinture, disait Michel-Ange, est une maîtresse jalouse: elle veut un homme tout entier" (*O.L.* II, 134). Cf. *Journal*, 7 November 1854 (II, 302): "La muse est . . . une maîtresse exigeante; elle vous abandonne à la moindre infidélité."

[35] The work was later dedicated to Delacroix.

[36] Cf. later, when reminded of his childhood by the countryside through which he was

[J'ai été . . . prendre du café et fumer dans le café qui fait l'angle de la rue Montmartre. J'ai joui là paresseusement, et avec une espèce de plaisir philosophique, de la vue de cet ignoble lieu, de ces joueurs de dominos et de tous les détails vulgaires de la vie de cette foule d'automates . . . J'ai conçu même le plaisir qu'on peut trouver à s'oublier jusqu'à la dégradation dans ces distractions. Je suis rentré avec la même tranquillité sans beaucoup réfléchir, ayant fermé la porte aux émotions entre celles de ma matinée et celles qui m'attendaient le lendemain matin.]

Painting is less like passion and more like love. "Love and genius, which have such a piercing gaze, grasp their subjects with a simple glance and take in the relations between them in one go. They see intuitively the final consequences in the very principles, and traverse in the wink of an eye the whole space of reasoning" (28 March 1862; III, 326).[37] As this passage which he copied out suggests, painting, like love, involves a totality of effect, permitting the viewer to see all at once, and to understand instantaneously, both cause and effect, principle and conclusion, without following the successive steps of reasoning. It affords the panoramic vision of a climber on a hilltop, who perceives in one glance a vast and varied landscape, "replete with woods, streams, meadows, dwellings, mountains" (Supplement; III, 433). Writing, in contrast, sends him on a single path where he will meet only one or another of the many natural riches available, and provides only a limited perspective which may in fact deny him the most important or interesting sights: "If he . . . takes one of the paths offered to him, he will arrive either at thatched cottages, or at forests, or at only some part of this vast landscape. He will see no more than that, and will often miss out on the principal and most interesting parts, for having set out wrongly in the beginning." Delacroix is discussing the writer but his words apply equally to the reader. Both may be easily duped and led astray: "The point of view which you had at the beginning, and from which all the rest will proceed, may have struck you by its meanest and least interesting aspect!" Through its linearity, writing offers only this single point of view: "In reading this preface, I said to myself: 'Why this point of view, and why not some other one, or why not both, or why not everything that can be said on the subject?" For all its abundance, it can produce only "fits and starts," "an imperfect communication," whereas painting encompasses a multiplicity of views and moments, which give an immediate impression of unity: "Painting has only

passing: "La force même de ces sentiments finit par les émousser et me cause une sorte de fatigue ou plutôt d'insensibilité" (17 September 1855; II, 379).

[37] Copied from Auguste Nicolas, *Etudes philosophiques sur le christianisme,* 1843–45.

one moment; but are there not as many moments as there are details, phases, so to speak, in a painting?"[38]

The paratactic style of the entry on the climber's view may constitute Delacroix's effort to replicate the panoramic *tableau* using the materials of the discursive *chemin*, but only points up the more the impossibility of doing so. It would take volumes to describe what the eye and the mind grasp in an instant (Supplement, 16 December 1843; III, 417). While for him the language of every art is imperfect relative to the complex of ideas and sensations it should "render" (21 July 1850; I, 394), description is especially so, delimiting and denaturing the object. Delacroix's example of watching some birds bathing in a puddle demonstrates the problem:

> I see before me some birds bathing in a little puddle of water formed by the rain running off the lead overhang of the roof. I see all at once a host of things that the poet can't even mention, far from being able to describe them, for fear of being wearisome and writing volumes only to describe them imperfectly. Note that I'm talking only about a single instant. The bird plunges into the water; I see its color, the silvery underside of its little wings, its delicate form, the drops of water that it splashes up in the sunshine. . . . Here you see the inadequacy of the poet's art. From among all these impressions, he must choose the most striking so as to make me imagine all the others. And I have spoken only of the little bird and what immediately concerns it. I have left aside the lovely impression of the rising sun, the clouds painted in this little pool as in a mirror, the impression of the greenery, the antics of the other birds attracted to the place, flying about or taking wing after having dipped their beak in the water, and all their gracious gestures amid these frolics, such as the flutter of wings, the little body with its feathers puffed out, the little head raised in the air after getting wet, a thousand other details that I see in my mind's eye, if not in reality. (Supplement, 16 December 1843; III, 417–18)

[J'ai sous les yeux des oiseaux qui se baignent dans une petite flaque d'eau qui se forme quand il a plu sur le plomb qui recouvre la saillie plate d'un toit. Je vois à la fois une foule de choses que non seulement le poète ne peut pas même mentionner, loin de les décrire, sous peine d'être fatigant et d'entasser des volumes pour ne rendre encore qu'imparfaitement. Notez que je ne prends qu'un instant. L'oiseau se plonge dans l'eau: je vois sa couleur, le dessous argenté de ses petites ailes, sa forme légère, les gouttes d'eau qu'il fait voler au soleil. . . .

[38] *O.L.* I, 74

Ici est l'impuissance de l'art du poète. Il faut que de toutes ces impressions il choisisse la plus frappante pour me faire imaginer toutes les autres. Je n'ai parlé que de ce qui touche immédiatement au petit oiseau ou ce qui est lui. Je passe sous silence la douce impression du soleil naissant, les nuages qui se peignent dans ce petit lac comme dans un miroir, l'impression de sa verdure qui est aux environs, les jeux des autres oiseaux attirés près de là, ou qui volent et et s'enfuient à tire d'aile après avoir rafraîchi leurs plumes et trempé leur bec dans cette parcelle d'eau, et tous leurs gestes gracieux au milieu de ces ébats, tels que ces ailes frémissantes, ce petit corps dont le plumage se hérisse, cette si petite tête élevée en l'air après s'être humectée, mille autres détails que je vois encore en imagination, si ce n'est en réalité.]

The examples of *praeteritio*—those aspects supposedly "passed over in silence"—give a tantalizing, and frustrating, glimpse of the "thousand other details" that the reader, as opposed to the viewer, misses; the lengthy, uninterrupted final sentence shows the principle in action, the imperfection of the image rendered, despite the "volumes" used to describe it. Description never succeeds in communicating the visual through literary means:

Is there a single one of these long and minute descriptions of places with which modern novels are replete, which gives a clear idea of what they claim to make us see? All of Walter Scott's talent cannot make me understand the scene of his characters' actions. I can see clearly neither his torrents, nor his rocks, nor his great halls so minutely described. . . . The simplest sketch of the most ordinary amateur will give a sharper idea of the site.[39]

[Est-il une seule de ces longues et minutieuses descriptions de lieux dont les romans modernes sont remplis qui donne une idée claire de ce qu'ils ont la prétention de nous faire voir? Tout le talent de Walter Scott ne peut me faire comprendre le théâtre des actions de ses personnages. Je ne vois clairement ni ses torrents ni ses rochers ni ses grandes salles minutieusement décrites. . . . Le plus simple croquis de l'amateur le plus vulgaire donnera d'un site une idée plus nette.]

As a writer, the diarist acknowledges this failure repeatedly:

[39] Unpublished note, Bibliothèque d'Art, Ms. 250, f. 31. See also "De l'enseignement du dessin" (1850), *O.L.* I, 13; and *Corr.* I, 126: "La plus exacte description ne vaut un trait effacé et confus." Cf. Leonardo, *Treatise on Painting* (see above, 27). But contrast Diderot, *Essais sur la peinture*, 681: "J'achève en une ligne ce que le peintre ébauche à peine en une semaine."

I only went out for about an hour, but I revelled in it with de-
light. . . . A thousand charming aspects of Trousseau, of the slope
of Champrosay, etc. It's there that one feels the impotence of the art
of writing. With a brush, I will make everybody feel what I saw,
while a description will show nothing to anybody. (24 October 1853;
II, 100)

[Je ne suis sorti qu'à peine une heure, mais j'en ai joui délicieuse-
ment. . . . Mille aspects charmants de Trousseau, de la pente de
Champrosay, etc. C'est bien là qu'on sent l'impuissance de l'art
d'écrire. Avec un pinceau, je ferai sentir à tout le monde ce que j'ai
vu, et une description ne montrera rien à personne.]

Even the immediacy of a journal cannot rival the fullness and expansive-
ness of the image:

Learn to draw, and you will carry away with you, coming back from
a trip, memories interesting in quite a different way from the way a
journal would be, where you forced yourself to consign every day
what you felt in front of every site. . . . That simple pencil line
which you have in front of you reminds you of not only the place
which struck you, but also of all the additional ideas which are at-
tached to it, what you did before or after, what your friend said at
your side, and a thousand delightful impressions of the sun, the
wind, the landscape itself, that the pen cannot translate.[40]

[Apprenez à dessiner, et vous emporterez avec vous, en revenant
d'un voyage, des souvenirs bien autrement intéressants que ne serait
un journal où vous vous efforciez de consigner chaque jour ce que
vous avez éprouvé devant chaque site. . . . Ce simple trait de crayon
que vous avez sous les yeux vous rappelle, avec le lieu qui vous a
frappé, toutes les idées accessoires qui s'y rattachent, ce que vous
avez fait avant ou après, ce que votre ami disait près de vous, et mille
impressions délicieuses du soleil, du vent, du paysage lui-même, que
le crayon ne peut traduire.]

Description is not simply inadequate to reproduce the visual, it falsifies
and distorts it: Delacroix notes that Rubens's *Hippopotamus Hunt* seems
inferior, from its description, to the *Lion Hunt*, but in fact is superior.
The latter lends itself more easily to description because it relies on those
literary building blocks, "discursive" line and detail, but it also suffers
from disorder and confusion. Through its composition, the former pre-
sents an image for the eye to grasp at once, and establishes its enduring

[40] "De l'enseignement du dessin", *O.L.* I, 12f.

hold on the imagination: "the imagination receives a shock, which is re-
newed every time one casts one's eyes upon it, just as, in the *Lion Hunt*, it
is always thrown into the same uncertainty by the dispersion of the light
and the uncertainty of the lines" (25 January 1847; I, 169).

The failure of description is linked to its reliance on detail, which
Delacroix rejects not in itself, but only in its excessive manifestation,
notably the modern novel: "The description which abounds in modern
novels is a sign of sterility: it is unquestionably easier to describe the
dress, the exterior of things, than to trace with care the development of
character and the portrayal of the heart" (9 April 1856; II, 441). Details
drown the ensemble and provoke *ennui;* they belong to the indiscretion of
literature introduced above, the "lack of tact" of George Sand, the lack of
"measure," "ensemble," and "proportion" in the novels of Balzac, the
"disorderly babbling" of Dumas, an "indiscreet abundance" which blunts
the imagination, dazzles vision, and confuses interpretation.[41] Delacroix's
ongoing critique of realism, which he called the very opposite of art, is
founded on this "literary" abuse of detail, this "pretense of rendering
everything" (1 September 1859; III, 233). Realism is a step-by-step "enu-
meration" of parts that should form a whole; Delacroix employs the archi-
tectural metaphor of a building under construction which is detailed piece
by piece, without any consideration of the place of each in the monument
(22 February 1860; III, 267–68). Details pose the same temptation as
talk in society, the attraction of shining in front of others rather than
engaging in the more restrained but enriching give-and-take of dialogue.
While literature tends necessarily to this flaw, even painting is not exempt
from it: "I only began to do something satisfactory, on my trip to Africa,
when I had sufficiently forgotten small details in order to recall, in my
paintings, only the striking, poetic side of things" (17 October 1853; II,
92). French painting, with its "literary" emphasis, suffers from this espe-
cially: "The slightest details, the most insignificant ones, are studied as
carefully, and presented without any sacrifices or any concern for the bad
effect of this clumsy conscientiousness" (29 October 1857; III, 141).
(French literature, paradoxically, has overcome the problem by develop-
ing "the art of being brief.") Details are "vain" (29 October 1857; III,
142) and "wearisome" (Supplement; III, 429), mute and "inert" (3 July
1858; III, 198) in reality; they can be energized and given expressive
power only through the artist's choice, which places them within a compo-
sitional dynamic. Delacroix thus emphasizes the need for pictorial sacri-
fices to ensure clarity and intensity of expression, as opposed to the

[41] 1 September 1859 (III, 233); 28 November 1853 (II, 123); 7 September 1854 (II,
255); 17 October 1853 (II, 94); 29 October 1857 (III, 142).

confusion, "dryness," and "coldness" which the eye encounters in an "accumulation" or a "sequence" of details (23 April 1854; II, 170). He evokes the well-known example of a gathering where everyone speaks at once, and no one is heard at all.[42]

The temporal causality of writing, the narrative chain, the gradual development of the argument, all impose a consistency false, cold, and paralyzing. Reflecting on the seemingly contradictory behavior of one of his acquaintances, Delacroix remarks:

> He is, like all men, a bizarre and inexplicable composite of opposites; that's what writers of novels and plays cannot understand. Their characters are all of a piece. There aren't any like that. There are ten men in a single man, and often, at certain moments, they show themselves at the same time. (7 December 1853; II, 127)

> [Il est, comme tous les hommes, un composé bizarre et inexplicable de contraires; c'est ce que les faiseurs de romans et de pièces ne veulent pas comprendre. Leurs hommes sont tout d'une pièce. Il n'en est pas de cette sorte. Il y a dix hommes dans un homme, et souvent ils se montrent dans la même heure, à de certains moments.]

Writing imposes a uniformity unfaithful to the individual's experience of self, other and world: "What could be more false than these characters, contrived and all of a piece?" (22 July 1860; III, 300). It is ironic that the art form based on time, literature, ends up being the most unfaithful to time, by creating a false harmony in things characterized by change: "No one is perfect, and the great creators of character show people as they are." Although Delacroix discusses this principally in the context of the realist novel with its use of types, it is a feature of literary narrative in general: "The lack of sincerity which any honest man will find in any book, or in almost any, comes from this ridiculous desire of making one's present

[42] 12 October 1853 (II, 85). The example here is his beloved Rubens; but Delacroix argues that Rubens's "prodigality" of detail is compensated for by the perfect, indeed "pictorial" simplicity of his conception and the directness of his execution. The analogy comes initially from Alberti, who, in the *De Pictura* (40), argues against painters who leave no space vacant, resulting in "dissolute confusion" and "tumult"; he applies to painting Varro's statement that no more than nine guests should be invited to a banquet, so as to avoid the "disorder" of crowds (Aulus Gellius XIII, xi, 1–3). Cf. Roger de Piles, *Cours de peinture* (quoted in Puttfarken, 82): "Plusieurs personnes qui parleraient dans un même lieu, en même temps et de même ton, feraient de la peine aux auditeurs qui ne sauraient auquel entendre. Semblable chose arrive dans un tableau, où plusieurs objets séparés, peints de même force et éclairés de pareille lumière, partageraient et inquiéteraient la vue, laquelle, étant attirée de différents côtés, serait en peine sur lequel se porter, ou qui voulant les embrasser tous d'un même coup d'oeil, ne pourrait les voir qu'imparfaitement." Cf. also Diderot, *Pensées détachées sur la peinture*, 795.

thoughts consistent with those of the night before" (Supplement; III, 447). Writing forbids the contradiction that is the essence of human nature:

A man who writes a book imposes upon himself the obligation of not contradicting himself. He is supposed to have weighed and balanced his ideas, so as to be consistent with himself. . . . All one can require of a writer, that is of a man, is that the end of the page be consistent with the beginning. (Supplement; III, 446–47)

[L'homme qui fait un livre s'impose l'obligation de ne pas se contredire. Il est censé avoir pesé, balancé ses idées, de manière à être conséquent avec lui-même. . . . Tout ce qu'on peut exiger d'un écrivain, c'est-à-dire d'un homme, c'est que la fin de la page soit conséquente avec le commencement.]

In terms of the temporality/instantaneity dichotomy, the effects of literature and painting are thus reversed. Dependent on time, writing provokes fixity and stasis, "numbing" the artist's mind and letting the reader's languish in *ennui* (16 January 1860; III, 251). Painting is by nature fixed and unchanging but sets the mind roaming freely, activates it, provokes it to compare and contrast the impressions of the eye with sensations and perceptions retained in memory: "[The mind] does not take account of everything the eye presents to it; it links the impressions it experiences to other, earlier ones, and its pleasure depends on its current disposition. That is so true that the same view does not produce the same effect, when perceived from different angles" (1 September 1859; III, 233).

Because its ideas are developed in succession, over the course of the work, literature is denied the entire domain of the sketch; in painting, the unfinished forms of the study and sketch can have a force as great as that of a finished picture (4 April 1854; II, 159). Writing requires a certain finish to be understood or appreciated, a definition, precision, and clarity —"approximations are unbearable in it"[43]—whereas a sketch may be as expressive as a finished composition, and has the advantage of giving full scope to the imagination. Indeed the *première pensée* may in some cases contain the whole work, as in Rembrandt and Rubens: "It seems that in these indications just barely traced, my mind outstrips my eye and grasps the thought almost before it has taken form" (25 January 1857; III, 36).

But literature is denied this freedom and lack of finish for another reason too. Writing has no materiality to enhance the ideas it expresses, or to compensate for confusion, and thus its message must be clear: "In literature it is necessary to be absolutely clear. Otherwise, that thought which pre-

[43] 4 April 1854 (II, 159): "L'à peu près y est insupportable."

sented itself to the mind of the poet does not escape from those black characters, which remain before our eyes like inexpressive hieroglyphs."[44] Painting, in contrast, will always have meaning and the potential to confer pleasure, simply by virtue of its materiality: "Even with the greatest imperfections, it is impossible that a painting or a sculpture not mean something, from the start."[45] Thus does Delacroix formulate the major, historical division between the materiality of painting and the abstraction of literature. Of the Rubens tapestries on the *Life of Achilles,* he wrote: "There you have Homer, and more than Homer, for the poet only makes me see his Hector with the eyes of the mind, and here I see him with those of the body" (27 January 1852; I, 446). If, like all art, painting is an art of signs and hieroglyphs, to use his terms, it has the advantage that the visible signs it uses do not simply stand for something else, but are themselves a source of delight, interest, and, for the artist, inspiration: "When I look at this paper filled with little black spots, my mind does not catch fire as quickly as it does at the sight of my picture, or even of my palette. My palette freshly prepared and brilliant with the contrast of colors, is enough to inflame my enthusiasm" (21 July 1850; I, 392). The representation itself partakes of reality, causing the same pleasure that the eye finds in objects and forms in the world.[46] And the aesthetic emotion it provokes is equally palpable: "This type of emotion proper to painting is tangible, in a way; poetry and music cannot produce it" (20 October 1853; II, 97). Visual images have material warmth and sensible value; writing is lifeless, composed of signs cold, hard, abstract, and with no expressive power of their own. They are symbolic (as opposed to iconic) in the Jakobsonian sense, associated with what they represent by convention, rather than through a shared quality, "letters arranged in an accepted order". Writing simplifies the aesthetic experience by removing the expressive autonomy of its signs, whereas painting complicates and enriches it: "independently of the idea, the visible sign, the speaking hieroglyph, a sign without value for the mind in the work of the writer, becomes in the painter a source of the keenest delight". The visual sign of the "silent arts" is thus paradoxically eloquent, a "speaking hieroglyph," while the printed word is mute, meaningless without the code by which it is interpreted.[47]

Delacroix does acknowledge that the materiality of painting subjects it

[44] "En littérature il faut absolument être clair. Sinon cette pensée qui s'est offerte à l'esprit du poète ne sort pas de ces caractères noirs qui nous restent sous les yeux comme des hiéroglyphes inexpressifs" (Unpublished note, Bibliothèque d'Art, Ms. 250, f. 31).

[45] "A travers les incorrections les plus grandes il ne se peut pas qu'une peinture ou une sculpture ne signifie de prime abord quelque chose" (ibid.).

[46] Cf. Leonardo (above, n. 12).

[47] On these distinctions, see Jirí Veltrusky, "Comparative Semiotics of Art."

to the caprices and hazards of time. The painted surface which strikes the senses and inspires thought may fade, darken, or otherwise degenerate with age: "All the genius in the world cannot prevent a varnish from yellowing, or a wash from evaporating. When the writer has painted blond Venus . . . all the centuries which have elapsed would not change at all the effect of his periods; but what eye will recognize the mother of love on a grimy canvas and covered over by yellow hues?"[48] But in the modern world, the problem affects literature just as much:

> On the fragility of painting and of all that our arts produce.—For paintings: the canvases, the oils, the varnishes, while the chemists exalt progress . . . Progress has, as [we] think, perfected paper, and not one of our books, our writings, the documents which serve to settle our business transactions, will exist a half century from now. (29 June 1854; II, 207)

> [Sur la fragilité de la peinture et de tout ce que produisent nos arts.— Sur les tableaux: les toiles, les huiles, les vernis, pendant que les chimistes exaltent le progrès . . . Le progrès a perfectionné, à ce qu'[on] croit, le papier, et pas un de nos livres, de nos écrits, des actes qui servent à régler nos rapports d'affaires, n'existeront *(sic)* dans un demi-siècle.]

More important, the modern conditions of production themselves—notably the world of ephemeral newspapers and *feuilletons*—condemn writing to a fragility perhaps even more serious. In a letter to Gautier which Delacroix copied into the diary, he praises Gautier's eulogy of Heine: "What then? your art which has so many resources that ours does not, is it nevertheless, in certain conditions, more ephemeral than fragile painting? what will become of four delightful pages written in a serial, between the catalogue of the virtuous actions of the 86 departments and the account of a vaudeville from the day before yesterday?" (25 February 1856; II, 432).

The materiality of painting is not valuable solely for the sensible, sensual pleasure it imparts, however, but as a vehicle for the most intangible sense, a "solid bridge" linking the mind of the viewer with that of the painter (18 July 1850; I, 391), and leading the imagination beyond the limits of matter to "the mysterious and profound sensation of which the forms are in a way the hieroglyph" (20 October 1853; II, 97). A

[48] "Prudhon," *O.L.* II, 137. The *Journal* complains repeatedly of the degradation of modern materials: "Tous ces tableaux périront prochainement" (13 September 1857; III, 126). Hence the importance of form: the notebook kept by his assistant, Louis de Planet, during the execution of the Palais Bourbon and Luxembourg libraries, is full of advice on ways to counteract the inevitable degradation of the paint, notably by using masses to mark the material form out clearly, as in ancient art.

"tangible reality . . . yet full of mystery" (23 September 1854; II, 277), painting provokes a double pleasure, for the mind and the eye, the senses and the imagination—observing a material object akin to the "real" one and perceiving its abstract sense: "You delight in the representation of these real objects as though you were actually seeing *them*, and at the same time the meaning that the images hold for the mind inflames and transports you."[49] This is true aesthetic experience in the Kantian tradition, the process by which thought is born of sensation.[50] Writing denatures the essence of experience, for in reading we "see" only with the mind. Painting is closer to the physical world, and thus incorporates within art the experience of reality itself:

> The art of the painter is all the closer to the human heart for seeming to be more material; for in it, as in external nature, a share is given openly to what is finite and to what is infinite, that is to say, to what the soul finds to move it inwardly in objects which strike the senses alone. (8 October 1822; I, 17–18)

> [L'art du peintre est d'autant plus intime au coeur de l'homme qu'il paraît plus matériel; car chez lui, comme dans la nature extérieure, la part est faite franchement à ce qui est fini et à ce qui est infini, c'est-à-dire à ce que l'âme trouve qui la remue intérieurement dans les objets qui ne frappent que les sens.]

The material of painting can have its effect independently of the subject, when the viewer is so far away as not to be able to make it out.[51] Delacroix copies out a long passage from Alphonse Karr on the effect of color, its "mysterious and poetic language," its power to communicate, though not state, the inexpressible: "Colors have such an influence on the mind that it is enough to look for a time at a color to feel oneself transported to a realm of ideas completely different from the one in which one found oneself formerly."[52]

[49] "Vous jouissez de la représentation de ces objets réels, comme si vous les voyiez véritablement, et en même temps le sens que renferment les images pour l'esprit vous échauffe et vous transporte" (20 October 1853; II, 97).

[50] Delacroix knew of Kant's theories through the writings of Madame de Stael. The passage in the *O.L.* I, 65f. comes, as Mras notes (*Eugène Delacroix's Theory of Art*, 31), from *De l'Allemagne*, 479f. (1869 ed.). In one of the Louvre notebooks Delacroix mentions a number of works on Kant (Louvre, 1745, f. 25 verso).

[51] *O.L.* I, 63. Delacroix calls this the "music" of the picture, the arrangement of color, light, and shadow. Baudelaire makes the same point about the "melody" of painting in the *Salon de 1846:* "La bonne manière de savoir si un tableau est mélodieux est de le regarder d'assez loin pour n'en comprendre le sujet ni les lignes" (*Oeuvres complètes* II, 425).

[52] Supplement (III, 391). Ironically, it was Karr who complained, in *Les Guêpes* of April 1840, of the rose-colored horse of the *Justice of Trajan*. See Baudelaire's response to this in his *Exposition Universelle de 1855* (*Oeuvres complètes* II, 592).

The definite forms of painting thus paradoxically convey mystery and "vague": "Painting is more vague than poetry, despite its fixed form to the eye. One of its greatest charms" (13 January 1857; III, 13–14). The physicality of painting leads beyond the physical object, its finite forms beyond the finite, its exteriority to inner thought, its definition to the "undefinable" and the "obscure sources of our most sublime emotions" (Supplement; III, 402): "The image presented to the eye not only satisfies the imagination, but fixes the object forever and goes beyond the conception" (27 January 1852; I, 446). Writing abstracts and abbreviates; the materiality of painting "fertilises" the idea (27 January 1847; I, 174), amplifies and augments it, and thus fulfills the primary criterion of art: "The arts are not at all an algebra, in which the abbreviation of the figures contributes to success in the problem; success in the arts is not at all a matter of abridging, but of amplifying, if possible, of prolonging the sensation, and by all available means" (20 October 1853; II, 98).[53]

In the practice of the two arts, too, Delacroix notes a similar paradox. Literature is more abstract and less manual, but more mechanical too, more an "affaire de métier" from which inspiration is absent: "It has always been my experience that, contrary to the received and accepted view, there was really more mechanism in the composition and execution of literature than in the composition and execution of painting" (Supplement; III, 447). In the old debate over whether painting is a mechanical ("vulgar") or liberal ("noble") art, Delacroix refutes the charge of mechanism, as Leonardo and Dolce had before him, and in fact reverses the terms.[54] It is writing which is mechanical, through the unavoidable requirements of rhetoric, the "thankless task of going over and over sentences and words, either to avoid an assonance or repetition, or else to adjust to the thought words which do not even give a precise idea of it" (Supplement; III, 447).

The point is not merely academic. In art or life, mechanism is deadly, removing the sole defense against the ever-present threat of *ennui:* the pleasure of work, the condition for interest and thought.[55] Delacroix's

[53] Hence the importance of drama, which appeals to several senses at once: "Qu'est-ce que le théâtre? Un des témoignages les plus certains de ce besoin de l'homme d'éprouver à la fois le plus d'émotions possible" (20 October 1853; II, 98).

[54] The debate reaches back to antiquity, with the tradition of the "mechanical" art dominating, particularly through the exclusion of painting from the medieval trivium and quadrivium. But for Aristotle (*Politics* VIII.iii.2), drawing is both a "useful" and a "liberal" art, leading one to appreciate beauty; cf. Leonardo, *Treatise on Painting*, 46; and Dolce, *Aretino*, 105, with Roskill's note, 244. See also Summers, *Michelangelo and the Language of Art*, 468 n. 22.

[55] Of writing the article on Charlet, he says: "Cet article . . . m'a donné de l'*ennui* à composer; écrire, c'est un métier particulier qu'il faut . . . pratiquer beaucoup. Je n'en ai

critique of contemporary socialist philosophy, unparalleled in the *Journal* for its vehemence and sarcasm, states clearly the degrading effects of mechanization:

Girardin still believes firmly in the coming of universal well-being, and one of the means of producing it, one which he comes back to by preference, is mechanized ploughing. . . . He thinks he is contributing greatly to the happiness of men by sparing them from working; he pretends to believe that all those unfortunate people who wrested their food from the earth—painfully, I admit, but with the feeling of their energy and of a perseverance well employed—will be moral people well satisfied with themselves when that terrain, which was at least their homeland, where their children were born and their parents buried, will no longer be anything but a factory for goods, exploited by the great arms of a machine and leaving the best part of its production in the impure and godless hands of speculators. . . .

O unworthy philanthropists! O philosophers without heart or imagination! You believe that man is a machine, like your machines; you strip him of his most sacred rights, on the pretext of saving him from labors that you prefer to regard as base, and which are the law of his being. (16 May 1853; II, 51–52.)[56]

[Girardin croit toujours fermement à l'avènement du bien-être universel, et l'un des moyens de le produire, sur lequel il revient avec prédilection, c'est le labourage à la mécanique. . . . Il croit grandement contribuer au bonheur des hommes, en les dispensant du travail; il fait semblant de croire que tous ces malheureux qui arrachaient leur nourriture à la terre, péniblement, j'en conviens, mais avec le sentiment de leur énergie et de leur persévérance bien employée, seront des gens moraux et bien satisfaits d'eux-mêmes quand ce terrain qui était au moins leur patrie, celle sur laquelle naissaient leurs enfants et dans laquelle ils enterraient leurs parents, ne sera plus qu'une manufacture de produits, exploitée par les grands bras d'une machine, et laissant la meilleure partie de son produit dans les mains impures et athées des agioteurs. . . .

O indignes philanthropes! O philosophes sans coeur et sans imagination! Vous croyez que l'homme est une machine, comme vos machines; vous le dépouillez de ses droits les plus sacrés, sous prétexte

eu que la fatigue sans le plaisir, ce que je ne puis dire de la peinture, qui est toujours mon passe-temps favori" (*Corr.* IV, 361).

[56] Cf. his similar tirade on 6 June 1856 (II, 453–5), which contains a cross reference to this passage.

de l'arracher à des travaux que vous affectez de regarder comme vils, et qui sont la loi de son être.]

The result is the ever-increasing burden of time, people "condemned to bear the burden of their days and . . . not know what to do with [their] time" (6 June 1856; II, 453). Painting involves no such mechanism, no formulaic or automatic filling in of gaps; "inspiration animates the slightest detail " (Supplement; III, 448). Indeed painterly execution, the most material, manual, and potentially "mechanical" aspect of that art, should partake ever of improvisation (27 January 1847; I, 174). Such a manner Delacroix saw in Corot: "He told me to let myself go a little, and to yield to what might come. . . . Corot goes deeply into an object: the ideas come to him, and he adds them as he works; that is the right way" (14 March 1847; I, 207). Execution is not mechanical but "ideal," on a par with the conception of the subject itself (25 January 1857; III, 54).

This view of writing certainly reflects Delacroix's own "difficulties" in that art, so frequently recorded in the *Journal*. Writing comes easily when it is done freely, in the "fraîcheur du premier jet," in the force of inspiring thought; he then feels as great a facility in it as in painting. The problems arise from the "tyrannical" needs of rhetoric, filling in the gaps, moving from one idea to another, forcing the writer to forgo some of the most expressive aspects of his style (17 July 1855; II, 359). The painterly equivalent is an Ingres-like "pedantry in execution," academic formulas, a perfection in "the art of boredom" (18 July 1850; I, 391).[57] Without these requirements writing could be easy—more so, even, than painting—for in this form it is an art exercised throughout one's life: "Unknown to ourselves, we spend our lives practicing the art of expressing our ideas by means of words. The man who turns over in his mind how he will go about obtaining a favor, putting off a tedious person, winning over a fair ingrate, works at literature without suspecting as much" (27 January 1853; II, 8).[58] Writing becomes less mechanical the closer it approaches to painting, abandoning the imperatives of length, extent, and progressive linear order. Delacroix notes the politician Dupin's recipe for effective speaking—to elide discursive expression altogether and concentrate on the "material" object of thought : "Do not think

[57] Practice and experience, however, can bring to writing a sense of pictorial composition, that is, an order which coincides with conception and execution: "Est-ce que je n'écris pas mieux et avec plus de facilité qu'autrefois? . . . ce que je trouvais autrefois une très grande difficulté, l'enchaînement, la mesure s'offrent à moi naturellement et dans le même temps où je conçois ce que j'ai à dire" (12 October 1852; I, 492).

[58] Once again, Delacroix inverts the standard scheme which makes painting the easier art, able to be undertaken by anyone. Cf. Dolce (Roskill, *Dolce's "Aretino" and Venetian Art Theory of the Cinquecento*, 99), who has Aretino refute the same point.

of the expressions when you are turning over the material in your head in advance, only of the thing itself, and imbue yourself with it thoroughly; the expression will come on its own when you come to speak" (27 November 1850; I, 421). In the same way, Delacroix can write in the traditional, rhetorical sense only by *erasing* the memory of painting from his mind, not thinking about it until he finishes his Poussin article, not daring to do so for fear of destroying the work already done: "I am coming to the conclusion that there is only one way of getting to the end of it . . . : that is, to keep my mind off painting until it is finished. . . . So I don't dare think about painting, for fear of sending the whole business to the devil" (8 May 1853; II, 39). It is perhaps significant in this context that his formal published articles do not deal with those artists he considered the most painterly, Rubens, Titian, and Veronese, as though the subject were too rebellious to the medium. They are written only in the freer, more "pictorial" writing of the *Journal*, a writing like Montaigne's, in which inspiration and expression more closely coincide.

On a loose sheet of notes, a small fragment records what may have been the title of a projected article on the relations between the arts: "Title/ On the boundaries of the different arts, and in particular the true power of painting."[59] The echo of another famous treatise on the subject is unmistakable. *Laokoon, ou sur les limites de la poésie et de la peinture:* indeed, the *Journal*'s reflections on writing and painting seem to carry out a rich and subtle dialogue with Lessing, grappling with the same issues. Yet Delacroix's addition to the title states the different purposes and radically divergent conclusions of his approach, validating the "true power of painting" in the face of Lessing's polemic on behalf of literature. The disparity divides not only two different arts but two different ages, and two conceptions of the world as well.

For Lessing the materiality of the visual arts impedes the realization of art's very purpose—creating the imaginary (rather than "real") presence of the object represented. As David Wellbery has shown, Lessing attributes to painting a "flagrancy," obtrusiveness, and self-assertion, an imposing presence which inhibits the imaginative perception of the idea; the material of poetry, language, is self-effacing, seeking to evoke an image so vivid that we cease to be aware of the means used to produce it.[60] The

[59] "Titre / des limites des arts entr'eux, et particulièrement de la vraie puissance de la peinture." See photograph in B.N. Est. R111228, and the catalogue of the 1885 Exhibition of Delacroix's works, no. 431. Cf. his extended discussion of the properties of each art at 20 October 1853, in which he concludes: "Thus one understands all that I said about the *power of painting*" (II, 98–99). As early as 1824, while reading Mme de Stael, he had noted the idea of writing "a kind of essay on painting where I could deal with the differences between the arts" [*des différences des arts entr'eux*] (26 January 1824; I, 49–50).

[60] Lessing, *Laokoon*, 122. See Wellbery, *Lessing's Laocoon: Semiotics and Aesthetics in the Age of Reason*, 118.

material forms of painting may be "hindrances" to expression:[61] robes on the sculpted Laocoon would hide his suffering, whereas in Virgil they strengthen the idea of his misfortune; the horns and diadem of a sculpted Bacchus would mask his physical beauty, while in poetry they have significance as characteristics of the god.[62] For Lessing, the abstraction of language negates material presence: "In poetry a garment is not a garment. It conceals nothing."[63] Language is spiritual, painting has the density, opacity, and heaviness of things, the corporeality which ties us to nature. Moreover, Lessing accepts a necessary relation between signs and the things they signify.[64] Through the temporality and abstraction of its signs, poetry can express action, emotion, and ideas, the supernatural and superhuman, invisibility and negation; painting is limited to the physical.[65] Its enduring presence is alien to the essence of the imagination, i.e., movement in time.[66] Painting "limits" the range of the imagination, "confines it,"[67] and circumscribes the theater of its operations, threatening it with stasis and mortification; our inner vision is bounded by the sphere of the bodily eye.[68]

Lessing's argument partakes of the suspicion of the material, and the privileging of the spiritual, that dominates the Western aesthetic tradition since Plato.[69] His famous theory of the "pregnant moment" is grounded in this very attitude: a painting is valued for the extent to which it suggests moments prior and subsequent to the one it actually represents.[70] A painting that represents the culmination of the action represents "too much," "binds the wings of fancy" and subjugates it to the senses.[71] Hence his preference, following the traditional distinction, for line over color, as Wellbery notes: drawing has the "freedom" of thought; color is limited and dense, like matter.[72] As Wellbery argues, Lessing's theory implies a

[61] *Laokoon*, 52, 75.

[62] Ibid., 52f., 74f.

[63] Ibid., 52.

[64] Ibid., 114.

[65] Ibid., 145, 156.

[66] Ibid., 54.

[67] Ibid., 22.

[68] Ibid., 110.

[69] On the "anti-platonism" of painting, see J. Lichtenstein, *La Couleur éloquente*, especially chapters 1 and 2.

[70] *Laokoon*, 130f. Cf. 139.

[71] Ibid., 23.

[72] Ibid., 99; *Laokoon*, ed. Blümner, 469. Cf. Wellbery, *Lessing's Laocoon*, 116; also J. Lichtenstein's remark that "l'idéal d'une peinture sans couleurs correspond . . . au rêve philosophique d'un corps privé de chair, ce fantasme d'un corps contrôlable et contrôlé qui serait enfin l'objet d'un 'bon' plaisir, uniquement soucieux de connaissance" (*La Couleur éloquente*, 73).

hierarchy and progress from matter to spirit, actuality to universality, the natural signs of painting to the arbitrary signs of language.[73] Bound to the senses and the visible, material world, painting is limited to the "lower," human order: pictorial representation carries out a degradation, reducing everything to human terms, lowering the divine to the level of common humanity, making the miraculous "sink" to the level of the ordinary.[74] Literature is allied to a "higher" realm,[75] closer to pure spirit, indeed to divine cognition itself: poetry marks the evolution of humanity to the status of a god, an escape from the tyranny of the senses.[76]

Delacroix, in contrast, insists on the importance of sense experience for the imagination. He is sarcastic about the contemporary taste for line, the preference for the abstract over the material:

> I know full well that this quality of being colorist is more unfortunate than commendable in the view of some modern schools that take refinement of drawing alone as a quality and sacrifice all else to it. It seems that the colorist is only concerned with the low, earthly parts of painting . . . and that color is only suited to distracting attention from more sublime qualities, which happily dispense with its prestige. (5 January 1857; III, 5–6)

> [Je sais bien que cette qualité de coloriste est plus fâcheuse que recommandable auprès des écoles modernes qui prennent la recherche seule du dessin pour une qualité et qui lui sacrifient tout le reste. Il semble que le coloriste n'est préoccupé que des parties basses et terrestres de la peinture . . . et que la couleur n'est propre qu'à distraire l'attention qui doit se porter vers des qualités plus sublimes qui se passent aisément de son prestige.]

Materiality is not alien to thought, as Lessing had argued, but a condition of it. It is the sensuous quality of a work of art which catches the attention, causes delight, and provokes the mind. Far from circumscribing the movement of the imagination, painting has a panoramic range; it is the temporal and successive logic of language, rather, that binds the imagination, keeping it on the single path of narrative causality and forbidding it to stray, indeed denying the reality of anything off the "route." To the obtrusiveness for which Lessing criticizes painting, Delacroix responds with the exhibitionism of narrative in its relentless progress toward its

[73] *Lessing's Laocoon*, 136f.
[74] *Laokoon*, 99, 101f.
[75] Ibid., 99.
[76] Wellbery, *Lessing's Laocoon*, 132.

end, and in the abusive demands it makes on the reader, who must follow its course from start to finish. Far from ordering the confusion of an instantaneous image, the competing claims of coexistent images on the viewer's attention,[77] language causes confusion in an image otherwise strong and clear: "It is a curious mystery, the impressions produced by the arts on sensitive natures: confused impressions, if one tries to describe them, full of strength and clarity if one experiences them again, even only in memory!" (20 October 1853; II, 97). In denying the traditional fixity of the image, Delacroix takes account of the temporal movement of the imagination which grounds Lessing's critique. But for him, such a temporality must be variable and reversible like that of the *Journal;* otherwise it elicits the same objections that Lessing makes against the image— exclusion, limitation, restriction, and stultification, what Delacroix calls *ennui.*

Yet the ideal form of poetry for Lessing is indeed narrative, which, through its causal action, gives positive unity to time. Narrative rectifies the deficiency of language—the "dismemberment" effected by the sequential order of words first analyzed by Leonardo[78]—by substituting for coexistence a causal progression, thus achieving the conception of the whole which is necessary for illusion.[79] The shield of Achilles is presented not in its parts when complete, but as a shield in the making, producing "the living picture of an action out of the tedious painting of an object."[80] Moreover, for Lessing narrative has its own special advantages. First, it surpasses the single moment of painting by representing what preceded and followed, offering "a whole gallery of paintings."[81] Second, while the continuous presence of painting leads naturally to the perception of the whole—"To the eye, the parts viewed remain continually present; it can run over them again and again. For the ear, however, the parts heard are lost if they do not remain in the memory"[82]—this presence might weary or disgust the viewer increasingly with each observation. In contrast, the abstraction and impermanence of language make even the most offensive verbal image tolerable, tempered as it is by narrative causality, the fact that "it was either anticipated by what . . . preceded or . . . softened and compensated for by what follows."[83] Third, narrative removes

[77] *Laokoon*, 59.

[78] Ibid., 126. Lessing's term is "Zergliederung." Cf. *Leonardo on Painting*, 37, and above, 25–26.

[79] *Laokoon*, 121.

[80] *Laokoon*, 134; cf. 116f.

[81] Ibid., 140, 107. See above, Introduction, n. 16.

[82] Ibid., 123.

[83] Ibid., 27.

the ambiguity which the fullness of an image inevitably entails—through the competition between its various parts, and the qualification of one part by another. The discursive order of language gives to the confusion of reality and the chaos of simultaneity an abstract purity and simplicity: "Poetry shows us bodies from one side only, in one position only, as regards only a single quality. . . . Painting cannot do this. In it, one part or one quality draws the others along with it".[84] A trait which is striking in a poem is, in a painting, "weakened or even contradicted" by the images which accompany it. In Lessing's example, a poem may concentrate exclusively on the power of Hercules over the lion. But a painting will have to suggest the opposite as well, the hero's potential defeat, for in it we see not only the power of the hero but that of the lion too—its claws, its teeth, all those features of a real lion which make it a formidable adversary: "The lion has jaws, it has claws with which it can strike, indeed which it must drive in, given the resistance it puts up to its conqueror. Hercules is invincible but not invulnerable. Thus *I see him simultaneously suffer when I should only see him triumph*."[85] Through its enduring presence, the continuous interaction of its parts, and its alliance with the material, "real" world, painting in Lessing's view cannot convey the singleness of meaning that literature can, where the writer exercises full control over the material.

Delacroix addresses all these points directly. In place of narrative extension, painting offers a powerful concentration of effect: "If it has only one moment, it concentrates the *effect* of that moment; . . . if [the painter's] power is not exerted on as many parts, he produces an effect perfectly unified and which can satisfy completely."[86] The gallery of pictures to which literature is so favorably compared may in fact tire the viewer/reader, who must pay attention even to the less interesting ones and thus may not appreciate the full beauty of those worthy of attention. The permanence which Lessing finds so problematic in painting—"To the eye, the parts viewed remain continually present; it can run over them again and again"—is for Delacroix the source of its complexity and interest, for it provokes a continual re-viewing and reinterpretation: like the rereading and revising carried out in the *Journal*, in painting nothing is said "once for all," but is reconsidered "again and again." And Lessing's critique of the fullness of the image states the very advantage of painting, in De-

[84] Ibid., 58; *Laokoon*, ed. Blümner, 371f.

[85] *Laokoon*, Blümner ed., 372 (my emphasis).

[86] 20 October 1853 (II, 99). "Si elle n'a qu'un moment, elle concentre l'*effet* de ce moment . . . ; si son pouvoir ne s'exerce pas sur autant de parties, il produit un effet parfaitement un et qui peut satisfaire complètement." Earlier editions wrongly print "souvenir" for "pouvoir."

lacroix's view. He certainly understood the objection, to which he alludes directly: "One should not show everything. It may seem difficult in painting, where the mind can only imagine what the eyes perceive. The poet has no trouble sacrificing or leaving out what is secondary" (13 January 1857; III, 22). But it may also reflect the complexity of a subject, and of perception and experience generally, thus accomplishing the purposes of art: breaking the viewer out of established patterns of thought, unsettling the imagination, leading it to conceive perhaps of the inconceivable, and challenging it to an activity that is pleasurable. In contrast, narrative, as Lessing defined it, is a self-fulfilling prophecy, its conclusion always a foregone conclusion, "anticipated by what preceded."[87] "We can foresee the outcome of this struggle":[88] for Delacroix, this orderly vision is not only false, but a dangerous and simplistic fantasy, soothing and comforting in the face of a complex and unpredictable experience.[89]

It is precisely this sense of absolute control which Delacroix so virulently rejects in his observations on politics, society, and history. Our sense of mastery over nature is a delusion, a mark rather of the limits of our knowledge and the narrowness of our own perspective. Human action may not be any different from the wayward and haphazard flight of a fly that he watches at his window.[90] Only those who see exclusively from their own point of view can believe in their power to control reality as an author does a narrative, when reality itself presents such compelling evidence to the contrary. This idea is affirmed repeatedly in both his writings and his paintings. History staggers between civilization and barbarism, flouting humanity's pretensions to progress; nature surprises at every turn, confounding the laws which we have formulated as "governing" it and which

[87] *Laokoon*, 27.

[88] Ibid., 24.

[89] Delacroix's critique extends to narrative the objections that Lessing himself had raised against description. Description lacks immediacy; each part presented in succession "erases" the preceding part, as Delacroix argues of writing. It is the kind of virtuoso performance by which Delacroix characterizes the novel, the talkative *sot* at the soirée—in Lessing's terms "a witty courtier who shines through everywhere and decks out his material with every sort of flattering allusion" (*Laokoon*, 137). Lessing's uneasiness with language as a medium is apparent in his notion of the wholeness and "unity" proper to painting, as against the succession of description extolled by Breitinger in his *Kritische Dichtkunst* of 1740. Breitinger employs the same example of the panoramic vista later used by Delacroix, but to different ends: as Wellbery notes, Breitinger's "broad vista" leaves only a confused impression on the observer, while description guides the reader through, drawing attention to each aspect according to its importance in the whole (Wellbery, *Lessing's Laocoon*, 204f.). For Lessing, however, description shatters the unity of representation, the impression of the whole, which narrative alone preserves (*Laokoon*, 124); it is the kind of "dismemberment" that Delacroix attributes to language in general, inadequate to the fullness of vision (*Laokoon*, 126).

[90] *O.L.* I, 121.

mark rather "the limitations of our feeble instinct";[91] the evolution from world-bound matter to divine spirit by which Lessing characterizes the history of art is contradicted by the all-too-material destruction that accompanies revolution, one of Delacroix's favorite themes;[92] in contrast to the Romantic image of the artist as a god, it becomes more and more evident to Delacroix that a rivalry with nature is ludicrous; far from mastering the world, we are constantly at its mercy. If for Lessing the abstraction of language gives full power to the imagination by freeing it from materiality and the real, for Delacroix this only encloses it the more within itself, and closes off the infinite source of pleasure and thought which is nature. Art, rather, may be a response to the difficulty of living "with ourselves," an attempt to wrest ourselves from "self-contemplation," to free the imagination from the limits of its own perspective (9 November 1857; III, 146).

For all the advantage which Delacroix accords to painting over literature in these discussions, however, he concedes that even it will fail, in the end, to create an impression of unity. For despite the high value placed on the instantaneity of the visual image, he understood the tremendous, indeed inescapable pressure of the human mind to resist stabilization and fixity, a pressure which rendered the static pictorial ideal ultimately an impossibility. The temporality of literature cannot be ignored, or banished through a concept of the fixed image, for the law of the imagination is mobility, instability, and change. In a series of quotations from another diarist, Maine de Biran, Delacroix notes this ineluctable mobility of our impressions:

> Thus this unhappy existence is only a sequence of heterogeneous moments which have no stability. They go floating on, fleeing rapidly without it ever being in our power to arrest them. Everything has an influence on us, and we change ceaselessly with whatever surrounds us. I often amuse myself watching the diverse states of my soul flow on; they are like the waters of a river, sometimes calm, sometimes agitated, but always succeeding one another with no permanence whatsoever. (29 March 1857; III, 86)

> [Ainsi cette malheureuse existence n'est qu'une suite de moments hétérogènes qui n'ont aucune stabilité. Ils vont flottant, fuyant rapidement sans qu'il soit jamais en notre pouvoir de les fixer. Tout

[91] Ibid.

[92] See 22 October 1849 (I, 326): "Je lis ce matin dans la *Description de Paris et de ses édifices* publiée en 1808 par Legrand et Landon, le détail effrayant des richesses, des monuments de tous genres qui ont disparu des églises pendant la Révolution. Il serait curieux de faire un travail sur cette matière pour édifier sur le résultat le plus clair des révolutions."

influe sur nous et nous changeons sans cesse avec ce qui nous envi-
ronne. Je m'amuse souvent à voir couler les diverses situations de
mon âme; elles sont comme les flots d'une rivière, tantôt calmes,
tantôt agités, mais toujours se succédant sans aucune permanence.]

The language of temporality dominates, even down to the metaphorical
river as the flow of time. The mobility of the imagination is noted fre-
quently in the *Journal:* "We are ourselves full of contradictions, fluc-
tuations, movements in different directions, which make pleasant or de-
testable the situation we are in and which does not change, whereas we do"
(19 July 1854; II, 213). A passage copied out from Captain Marryat in
1844 confirms this view: "There is no constancy in the mind of
man . . . the soul itself is variable and fragile . . . A person who was all
soul would be mobility by its very nature" (Supplement, 16 August 1844;
III, 421).[93] Despite its concentration and instantaneity, painting too is
affected, as Delacroix acknowledges:

The mind is so imperfect, so difficult to arrest, that the man most
sensitive to the arts feels, in the presence of a fine work, a kind of
disquiet, a difficulty in delighting in it completely, which the little
ways of producing an artificial unity, such as the repetition of motifs
in music, or the concentration of effect in painting, cannot over-
come. . . . A picture, which seems to satisfy this need for unity
more completely and more easily, since one seems to see it all at once,
does not succeed more than anything else if it is not well composed,
*and indeed I will add that, even should it offer to the highest degree a
great unity of effect, the soul will not, for all that, be completely satisfied.*
(26 March 1854; II, 155–56, my emphasis)

[L'esprit est si imparfait, si difficile à fixer, que l'homme le plus
sensible aux arts éprouve toujours, en présence d'un bel ouvrage,
une sorte d'inquiétude, de difficulté d'en jouir complètement, que ne
peuvent faire disparaître les petits moyens de produire une unité
factice, moyens comme la répétition des motifs dans la musique,
comme la concentration de l'effet dans la peinture. . . . Un tableau

[93] It is a common theme of Romanticism, of which Delacroix's admired *Obermann*
contains many examples: "Notre organisation n'est pas susceptible d'invariabilité" (I, 121,
first fragment); "Notre coeur change plus rapidement que les saisons annuelles . . . nos
jours, que rien ne renouvelle, n'ont pas deux heures qui puissent être semblables" (I,
159f., letter XLI); "J'avais mal observé la mobilité qui me caractérise . . . C'est constam-
ment une grande inconstance, bien plus dans les impressions que dans les opinions, ou
même dans les penchants. Elle ne tient pas au progrès des années . . . à quarante ans de
distance, je ne différerai pas plus que cent fois je n'ai différé d'un quart d'heure à l'autre"
(II, 232, letter XC).

qui semble devoir satisfaire plus complètement et plus facilement ce besoin d'unité, puisqu'il semble qu'on le voie tout d'une fois, ne le produit pas davantage s'il n'est bien composé, et j'ajoute même que, offrît-il au plus haut degré une grande unité dans son effet, l'âme ne sera pour cela complètement satisfaite.]

The impression of wholeness and instantaneity is never total to a mind which perceives in time. The constant movement of the imagination thus makes special demands upon the image: either the image is doomed to failure, or it must take account of this "imperfection" in the viewing subject, and incorporate a temporality by which its own properties—instantaneity, simultaneity, concentration of effect, assured *interest*—may be fully realized. The pictorial must be reconsidered, reconceived in terms of the natural instability, the "literary" temporality, of the imagination.

Hence the importance of memory, and the *Journal*. For Delacroix, memory infuses a temporal experience with the qualities of the image—its concentration of effect, its immediacy and instantaneity, its panoramic view. It operates in the way the pictorial imagination does, composing, idealizing, sorting out its perceptions and retaining the interesting ones: "There occurs within the mind, when it remembers the heart's emotions, the same thing that occurs when the creative faculty takes hold of it to animate the real world and draw from it imaginative pictures. It composes, that is to say, it idealizes and chooses."[94] Memory represents a temporality which yet accomplishes a "pictorial" selection and choice: "this involuntary activity of the soul which, remembering pleasant moments over and over again, discards and suppresses everything which lessened their charm at the time one was going through them. I compared this kind of idealization, for it is that, with the effect of fine works on the imagination" (28 April 1854; II, 174). It gives to the past the "renewable" quality of painting: "these simple objects, so familiar to my eyes and . . . to my heart, and yet so new each time I come back to them" (17 April 1854; II, 166).

Indeed those qualities proper to the image may be best perceived through the mind's existence in time: "When the work which has awakened feelings in [the soul] is absent, the soul must retreat into memory: then the memory of the work's unity will dominate, if indeed that quality be really there. It is then that the mind grasps the ensemble of the composition, or realizes the gaps and incongruities in it" (26 March 1854; II, 156). The "presence" of painting may have its fullest effect in activating the memory: "All sensitive people have the experience that in the presence of a beautiful painting, one feels the need to go far away from it to think

[94] *O.L.* I, 114f.

about the impression which it produced."[95] Memory, the matter of the *Journal*—its means, its subject, its purpose—is crucial to the perception of the image, and likewise to the enduring quality of the visual arts and the continuous pleasure they inspire: a painting's ability to provoke new sensations and new thoughts each time it is returned to. Confronting and interweaving past and present, the *Journal* embodies such a temporality, discontinuous, repetitive, and reversible, creating a "pictorial" writing which does not so much reflect, as reflect upon, Delacroix's literary and narrative painting.

[95] *O.L.* I, 74.

CHAPTER TWO

The Image in Time:
The Writing of
the *Journal*

AFTER A HIATUS of twenty-three years, the *Journal* resumes on 19 January 1847 with a long entry peculiarly revealing of Delacroix's autobiographical—and aesthetic—project:

> Natural history collection, open to the public Tuesdays and Fridays. Elephants, rhinoceroses, hippopotamuses. . . . I was gripped, upon entering this collection, by a feeling of happiness. As I advanced further, this feeling increased; it seemed to me that my being rose above the commonplaces, the petty ideas, the petty worries of the moment. What a prodigious variety of animals, and what a variety of species, of form, of destination. At each moment, what appears to us deformity alongside what seems to us gracefulness. Here, the herds of Neptune: the seals, the walruses, the whales, the immensity of fish with their vacant eyes, their mouths gaping senselessly; the crustaceans, the spider crabs, the turtles. Then the hideous family of serpents: the enormous body of the boa, with its little head; the elegance of its coils wound around the tree; the hideous dragon; the lizards, the crocodiles, the alligators, the monstrous gharial whose jaws suddenly taper and end at the nose with a weird projection. Then the animals close to our own nature: the innumerable deer, gazelles, elks, bucks, goats, sheep, cloven feet, horned heads, horns straight, twisted, coiled; the aurochs of the bovine family, the bison; the dromedaries and camels, the llamas, the vicuñas which are similar to them; finally, the giraffe, those of Levaillant, patched up and sewn together, but also the one from 1827 which, after having delighted the idlers and shone with an incomparable

(55)

sparkle, paid the mortal tribute in his turn, dying as obscure as his entry into the world had been brilliant. . . .

The tigers, the panthers, the jaguars, the lions, etc.

Whence comes the emotion that the sight of all that has produced in me? From the fact that I went out of my everyday ideas, which are my whole world, out of my street which is my universe. How necessary it is to shake yourself up from time to time, to stick your head out of doors, to try to read in nature, which has nothing in common with our cities and the works of men. Certainly, the sight of such things makes one better and calmer. As I left there, the trees themselves had their share of admiration, and they played their part in the feeling of pleasure that this day gave me. I came back by way of the far end of the garden, along the quay. . . . I write this by the fireside, delighted to have gone, before going home, to buy this diary, which I begin on a good day. May I often continue to take account of my impressions in this way. I will often see in doing that what one gains from noting one's impressions and examining them, while remembering them. (I, 161–63)

[Cabinet d'histoire naturelle, public les mardi et vendredi. Eléphants, rhinocéros, hippopotames. . . . J'ai été saisi, en entrant dans cette collection, d'un sentiment de bonheur. A mesure que j'avançais, ce sentiment s'augmentait; il me semblait que mon être s'élevait au-dessus des vulgarités ou des petites idées, ou des petites inquiétudes du moment. Quelle variété prodigieuse d'animaux, et quelle variété d'espèces, de forme, de destination. A chaque instant, ce qui nous paraît la difformité à côté de ce qui nous semble la grâce. Ici, les troupeaux de Neptune: les phoques, les morses, les baleines, l'immensité des poissons à l'oeil insensible, à la bouche stupidement ouverte; les crustacés, les araignées de mer, les tortues. Puis la famille hideuse des serpents: le corps énorme du boa, avec sa petite tête; l'élégance de ses anneaux roulés autour de l'arbre; le hideux dragon; les lézards, les crocodiles, les caïmans, le gavial monstrueux dont les mâchoires deviennent tout à coup effilées et terminées à l'endroit du nez par une saillie bizarre. Puis les animaux qui se rapprochent de notre nature: les innombrables cerfs, gazelles, élans, daims, chèvres, moutons, pieds fourchus, têtes cornues, cornes droites, tordues, en anneaux; l'auroch race bovine, le bison; les dromadaires et les chameaux, les lamas, les vigognes qui y touchent; enfin la giraffe, celles de Levaillant, recousues, rapiécées, mais celle de 1827 qui, après avoir fait le bonheur des badauds et brillé d'un éclat incomparable, a payé à son tour le funèbre tribut, mort aussi obscure que son entrée dans le monde avait été brillante. . . .

Les tigres, les panthères, les jaguars, les lions, etc.

D'où vient le mouvement que la vue de tout cela a produit chez

moi: de ce que je suis sorti de mes idées de tous les jours, qui sont tout mon monde, de ma rue qui est mon univers. Combien il est nécessaire de se secouer de temps en temps, de mettre la tête dehors, de chercher à lire dans la création, qui n'a rien de commun avec nos villes et avec les ouvrages des hommes. Certes, cette vue rend meilleur et plus tranquille. En sortant de là, les arbres eux-mêmes ont eu leur part d'admiration, et ils ont été pour quelque chose dans le sentiment de plaisir que cette journée m'a donné. Je suis revenu par l'extrémité du jardin sur le quai. . . . J'écris ceci au coin de mon feu, enchanté d'avoir été, avant de rentrer, acheter cet agenda que je commence un jour heureux. Puissé-je continuer souvent à me rendre compte ainsi de mes impressions. J'y verrai souvent ce qu'on gagne à noter ses impressions et à les creuser, en se les rappelant.]

The purchase of the agenda and the breaking of the long silence are motivated by his disconcerting, exhilarating visit to the Museum of Natural History, with its vertiginous variety of species and forms, its seemingly infinite collection of specimens of the misshapen, uncanny, monstrous, bizarre, and incongruous, and its rich testimony to worlds beyond his own. The conventional topoi about the self to which the early *Journal* bears witness—reunifying the "disintegrating" self, calming its turbulent movement, affirming its wholeness and individuality, constructing, fixing, defining, the quasi-religious activity of "se recueillir" (3 September 1822; I, 1)—here give way to a different conception of the self based on precisely the opposite qualities.

The early diary, begun on the eighth anniversary of his mother's death, follows the pattern of most, seeking to give shape and solidity to a self shattered through a traumatic experience:[1] "The day before yesterday was the anniversary of the death of my beloved mother. It is the day when I began my diary. May she be with me when I write, and may nothing make her ashamed of her son" (5 September 1822; I, 5). It is an effort at "resolve," "self-mastery," and "self-possession," an effort to keep hold of himself and arrest the terrifying mobility of his thoughts and emotions. After each interruption, the writing resumes specifically in order to stabilize a self dangerously out of control, to reintegrate its scattered parts, as when his friend Soulier returns from abroad to discover that Delacroix has been having an affair with his mistress:

I resume my enterprise after a long hiatus. I think that it is a way of calming the emotions which have been tormenting me for a long time. I seem to see that, since Soulier's return, I am more agitated, less master

[1] Michel Beaujour (*Miroirs d'encre*, 341) sees the self-portrait as the result of a "fall" into a formless space opened up by the loss of some garantor of unity.

of myself. I take fright like a child. All kinds of troubles add to it, that of my expenses as well as the way I spend my time. Today I made several good resolutions. May this paper, at least, in the absence of my memory, reproach me for forgetting them, a folly that would only serve to make me unhappy. (15 April 1823; I, 24)

[Je reprends mon entreprise après une grande lacune. Je crois que c'est un moyen de calmer les agitations qui me tourmentent depuis beaucoup de temps. Je crois voir que, depuis le retour de Soulier, je suis plus troublé, moins maître de moi. Je m'effarouche comme un enfant. Tous les désordres s'y joignent, celui de mes dépenses aussi bien que l'emploi de mon temps. J'ai pris aujourd'hui plusieurs bonnes résolutions. Que ce papier, au moins, à défaut de ma mémoire, me reproche de les oublier, folie qui n'eût servi qu'à me rendre malheureux.]

But as a form, a diary may work against this stability, creating a self through those very variations which the writing is meant to arrest or control; the stated ideal of psychological or moral order ever confronts the waywardness of the prose, its abandonment of narrative order, coherence, and organization. "But however hard we may try, we can never succeed in making our reason sovereign over all our desires. There will always be in our soul, as in our body, involuntary impulses" (May 1823; I, 33): already in 1823, this quotation from Voltaire, noted without comment, states the problem of the diary's project of self-representation.[2]

It is perhaps for this reason that the early diary, and the self it sought to define, falls rapidly into silence, and a profound silence at that. Indeed, in its second, highly innovative stage from 1847 onward, the *Journal* reverses these earlier values completely. The autobiographical rhetoric of consolidation, possession, and reintegration disappears; instead of an effort at self-definition, self-discovery, and self-affirmation the diary comes to celebrate, in both its theoretical reflections and its practice, the mobility and variety inherent in its writing. As with the early *Journal*, it is born of a "self-shattering" experience, but this now becomes a source of pleasure: getting out of himself, escaping the closed world of everyday habit, "shaking himself up." Like his visit to the Museum, it is an experience of amplification and expansion, freeing the self from constraint and limitation ("petites idées," "petites inquiétudes"), removing the blinders that made him mistake a street for a universe, and revealing worlds normally hidden from view. The result is happiness and enthusiastic creativity, pleasure, interest, and charm—like the breathtaking list of the Museum's species and forms, the Rabelaisian abundance and length of his descrip-

[2] *Traité de métaphysique*, chapter 7. It is telling that none of Delacroix's later self-portraits was ever finished, as Johnson has noted. See Johnson 64, M5, 230, and 237.

tion, the wealth of examples and the linguistic richness they evoke, over-running the rhetorical barriers of the traditional sentence, and even of the paragraph.[3] The "stable" self, in contrast, is linked to monotony and *ennui*, the artist's state before his visit; and to silence, the twenty-three years without a diary.

Self-possession now consists not in controlling his impressions but in reviewing them and fleshing them out, exploring the unknown regions of the mind, working what he calls its unploughed terrain: "In most people, intelligence is a field which lies fallow throughout nearly the whole of life. . . . Laziness is undoubtedly the greatest enemy of the development of our faculties" (9 June 1847; I, 230). Writing the diary is a way of breaking out of just such laziness (*paresse*), indolence, *ennui*, and providing a source of ongoing pleasure: "The pleasure that I find in rereading my earlier reflections in these diaries . . . should reform me of my laziness and make me write in them more often" (24 March 1855; II, 320). On the days when he does not write he languishes as though deprived of a source of energy: "Great interruption in these poor little notes from every day; I am very saddened by that" (11 March 1854; II, 147). Its mental meanderings and peregrinations afford the variety and self-renewal, indeed the "charm" of that equally "discontinuous" experience, that "vie décousue," travel (8 August 1850; I, 402): "This movement, this variety of situation and emotions, gives to all feelings more liveliness; by varying one's life, one better resists the fatal numbness of *ennui*" (14 October 1855; II, 407).[4] When, during a stay in Dieppe in 1855, he is kept indoors by a cold, the *Journal* becomes the space in which the fireside traveller's journey may continue: "I find it charming to have come to Dieppe, only not to be able to leave my room. Fortunately my imagination does not give up travelling: I go from my engravings to this little notebook" (9 October 1855; II, 401).

Delacroix's insistence, in that initial entry, on life and the living, on his own regeneration, and on the almost animistic quality of the world outside, the mobility and vivacity of his self-generating prose, the carnivalesque abundance of terms, the lively emotion provoked by the experience—all make one forget that this is a museum, a collection of stuffed animals, a house of the dead, a past fixed and frozen into stillness. No catacomb containing relics of the past, the Museum, like the *Journal*, is for him a source of new life, freeing him from real death—the mechanical movements, the deadened

[3] The experience was memorable, as the entry for 24 January 1849 attests: "Bonne journée. Elle m'a rappelé celle qui m'a vu commencer le journal que j'ai fait il y a juste deux ans" (I, 254).

[4] Cf. 2 March 1849 (I, 266–7): "Petetin . . . m'a dit que je surmonterais la cacochymie du corps et de l'esprit en faisant de temps en temps un voyage." In his letters, Delacroix refers to such movement as a "médecin" and a "moyen de tromper l'*ennui*" (*Corr.* IV, 122f.).

senses, and the sluggish mind of the enclosed self—and giving him the means to resist or postpone it: the purchase of the agenda, the keeping of the diary, noting and exploring his impressions while recalling them, *en se les rappelant*. Once again, the difference between the two stages of the work is crucial. While the early diary retains the conventional mnemonic functions of the genre—preserving the past, taming his rebellious memory "which lets everything evaporate," overcoming mortality by leaving this written "monument" to his existence, creating a "double life" (7 April 1824; I, 69–70)—the later one goes much further, reconceiving the past as part of a broad and shifting present. It is not the traditional storehouse, a drawer in which to preserve ideas for paintings; the early *Journal* records his frustration with this notion. Such a diary would be a treasury of corpses, coldly waiting their turn, lacking the original inspiration—"the death of genius" (11 April 1824; I, 73). The later *Journal* does not merely "preserve" the past in this sense, but establishes a temporal network in which past and present are brought continuously face to face, dissolving the chronological distinctions between them. In so doing it creates the means by which Delacroix, at all ages of his life, found inspiration for his works. After rereading his old notes on Rubens, he remarks: "When I wish . . . to put myself in a true mind for painting, I should reread these notes. I still have a very immediate memory of those admirable works" (6 March 1857; III, 71). In the *Journal*'s writing, the past takes on the present of painting. "What is necessary, then, for finding a subject, is to open a book capable of inspiring you" (11 April 1824; I, 74): the *Journal* is just such a book, serving not to fix ideas but to give birth to them.

It can only be so by rejecting that which, in writing, causes *ennui*—its discursive temporality—and appropriating the qualities of painting. Indeed the *Journal*'s conception of time and self reflects the critique of literary temporality made in his contrast between the two arts. The temporality of the later *Journal*, with which I will deal almost exclusively here, is extraordinarily complex, the entries beginning on one date and continuing, for lack of space, on earlier ones, wherever Delacroix found room to write. A single entry is thus fragmented and scattered haphazardly over the year, and sometimes over years, as he made free use of his earlier diaries.[5] The pages are everywhere punctuated by textual directions indicating where the sequel or preceding passage may be found: "suite à," "suite de," "renvoi de," crosses in the margin to mark an insertion, and so on.

Delacroix breaks the alleged subjection of the diarist to the order of the

[5] For example, the jottings at the back of the 1852 diary date from 1853; in 1848, having lost his diary in August of that year, he made some notes in his 1847 diary; entries dating from the beginning of a year are often written at the end of the preceding one, before Delacroix had had time to buy his new diary.

calendar, the "pact" of following the movement of the days.[6] The entries were often written well after the fact, thus calling into question the illusion of immediacy which the date conveys: "I regret very keenly not writing this until three weeks after the impression I had [of a Corregio]" (20 September 1855; II, 382); in an entry marked "Strasbourg, 29 September 1855," he acknowledges that he is actually writing it in Dieppe ten or twelve days afterward (II, 392). The diary's "present" often consists of a quotation from the past: on 15 March 1853 he copies out a long passage discovered on a scrap of paper from years before, and uses it to comment on his current state of mind (II, 9–10). Sometimes it alludes to a "future" which has already taken place: on 9 May 1857 he notes "day of the death of my poor friend Vieillard," which he learns about only the following day (III, 102); on 28 September 1852 he points ahead to an illness not yet acquired ("This, along with yesterday, is the last day that I worked before my illness," I, 489); on 10 August 1850 he signals the future vindication of a present decision ("I had every reason to congratulate myself, *as will be seen*, on my courage," I, 404). Time is fluid, indefinite, and uncertain, despite the regular indication of day and date: the entry for 31 August 1854 records a conversation with the painter Chenavard, but a parenthetical note on the thirtieth states that it may have taken place then.

Most important, Delacroix thwarts even the minimal progressive connotations of the calendrical order and its coincidence with the forward movement of reading: he continually rereads earlier entries and comments on them, and establishes over the course of the years an elaborate system of cross-references, thus displacing and reversing time, exercising a temporal freedom impossible in a narrative. Everywhere there are later corrections, revisions, insertions, underlinings, and crossings out in different ink or pencil. An interpolation from 1857 into an entry of 10 years previous alters his earlier opinion and reverts to an earlier one still:

> 5 *February 1847* . . . the *Memoirs* of Casanova . . . made an immense impression on me when I read them for the first time in the abridged edition in 1829. I have since had occasion to look through some passages from the more complete edition and I have had a different impression. . . .
>
> —I reread this in 1857. I am rereading the *Memoirs* of Casanova during my illness; I find them more enjoyable than ever, therefore they are good. (5 February 1847; I, 181–82)
>
> [les *Mémoires* de Casanova . . . m'ont fait un effet immense quand je les ai lus pour la première fois dans l'édition écourtée en 1829. J'ai

[6] Rousset, "Pour une poétique du journal intime," 1218; Blanchot, "Recherches sur le journal intime," 685.

eu occasion depuis d'en parcourir des passages de l'édition plus complète et j'ai éprouvé une impression différente. . . .

—Je relis ceci en 1857. Je relis les *Mémoires* de Casanova pendant ma maladie: je les trouve plus adorables que jamais; donc ils sont bons.]

Through cross-referencing, Delacroix skips from one note to another distant in time, and then beyond, creating a thematic coherence: the entry for 24 December 1853 refers back to a passage from 28 October ("transfer to here everything that is said earlier on the improbable nature of Walter Scott's plots," II, 139), and that one, in turn, to a passage from 12 October ("could be joined to the article on imitation, above", II, 107). The practice becomes more frequent as the years pass, some entries being followed by a whole string of cross-references, particularly when the diary becomes the *Dictionnaire des Beaux-Arts* (fig. 1). One entry from 1857 is constructed as follows (fig. 2):

Friday, 20 November 1857.
—I extract from one of my sketch-books this reflection which I noted at Champrosay on one of my walks. *[Here Delacroix copies out the passage, which dates from 6 May 1852.]* . . .
—I find in the same notebook from Champrosay the following, on the same subject. Monday, 9 May 1853. *[Here he copies this passage.]* For this see also Ag[enda] [18]53, 2[6] October.
—Look in a notebook containing drawings done at Ems and Dieppe, under the date 12 September 1852, for what I say on the sublime effect of the church of St Jacques of Dieppe seen in the moonlight.
—Also on the Sublime. Ag[enda] 1856, 10 June. That if geniuses who are incorrect and sublime at the same time are more subject to criticism, they are more often in general initiators, precursors, etc. Corneille, Shakespeare, Michelangelo. See Agenda [18]53, 20 October (III, 151–53)

For the linear order of chronology he substitutes a wayward route, zigzagging back and forth. In the entry for 17 September 1854, for example, he records Chenavard's view of the predominance of detail at the expense of the whole in Géricault's work, and adds, "I reread what concerns Géricault here, six months after, that is to say on 24 March 1855, during the state of weariness in which I find myself before the Exhibition; yesterday I saw some of Géricault's lithographs again . . . ; all that is cold, despite the superior way in which the details are treated; . . . there is never any sense of the whole in any of it" (II, 269). Nine months later, the entry of 11 December 1855

again discusses the absence of unity and the predominance of detail in Géricault; this note then continues, "I reread this in December of 1856. That reminds me that Chenavard told me, two years ago in Dieppe, that he did not regard Géricault as a master" (II, 415–16). This network is further complicated by the fact that the latter two notes (11 December 1855 and December 1856) are in fact written under 30 December 1853, with which entry they have another thematic link: the importance of the effect of the *ensemble* in painting, the simultaneity of the parts of a picture.[7] The December 1853 entry thus links five different moments: in addition to itself, it contains Delacroix's rereadings of 11 December 1855 and December 1856, which refer back to the entry of 17 September 1854, itself containing his rereading of 24 March 1855.

This jumbled temporality was frequently tidied up by the editors and the thematic web unravelled, to the detriment of the sense. For example, a letter to Madame de Forget of 25 August 1854, and printed under that date in the published *Journal*, on the importance of exercising mind and body to combat *ennui*, was actually written under 11 August in connection with the related entry there on different forms of *ennui*: "Addition from 25th August. Letter to Madame de Forget which I recopy and which has a relation to the preceding." Elsewhere, an entry on the tomb of Maréchal de Saxe from 25 September 1855, and published under that date, is in fact written under *23 March* as an example of the problem there discussed, i.e., keeping too closely to the model (fig. 3):

> *23 March 1855*. I notice this morning, on examining some sketches that I did after the figures in the Apollo gallery (sculptures on the cornices, etc.), . . . the incorrigible coldness of those pieces. I can only attribute it, despite the breadth of the execution, to that excessive timidity which never permits the artist to depart from the live model. . . .
>
> *Baden-Baden, on my arrival, 25 September.* Yesterday I saw . . . at the church of St. Thomas the tomb of Maréchal de Saxe: it is the best example of the drawback that I'm pointing out.[8] The execution of the figures is wonderful, but they almost frighten you, so closely do they imitate the live model. (II, 319; II, 386)
>
> [Je remarque ce matin, en examinant des croquis que j'ai faits

[7] This has only recently come to light. Joubin, following the editors of the first edition, places the 11 December 1855 and December 1856 entries under 11 December 1855, but is puzzled that they are not in the original manuscript (II, 415–16). In fact, Delacroix wrote them under December 1853, a year for which the original manuscript is missing. The proper place was noted by Robaut in his manuscript copy of the original.

[8] As it is published, the "drawback that I'm pointing out" refers to nothing at all.

d'après des figures de la galerie d'Apollon (sculptures sur les corniches, etc.),. . . . l'incorrigible froideur de ces morceaux. Je ne peux l'attribuer malgré la largeur de l'exécution qu'à l'excessive timidité qui ne permet jamais à l'artiste de s'écarter du modèle. . . .

Baden, en arrivant, 25 septembre. J'ai vu hier . . . à l'église Saint-Thomas le tombeau du Maréchal de Saxe: c'est le meilleur exemple de l'inconvénient que je signale. L'exécution des figures est merveilleuse, mais ils *[sic]* vous font presque peur, tant ils sont imités d'après le modèle vivant.]

Moreover, when composing his entry on "Execution" for the *Dictionnaire des Beaux-Arts* in 1857 (23 January; III, 29), he refers to the passage written in Baden by the date under which it appears (23 March), not by its date of composition.[9]

A final example from 23 February 1858 illustrates this temporal interconnectedness and complexity:

23 February 1858. [Long discussion of the perfection of ancient sculpture, and the relative "imperfection" of painting from the Renaissance onward]

28 February 1860. I reread that. Relate it to what I wrote at the beginning of this year in the 1860 notebook on the same subject, but with a different conclusion: not that I do not still find the the antique as perfect as before; but in comparing it with the moderns . . . I find in the latter a particular charm which I do not dare say is due to their imperfection, but to a kind of indefinable piquancy which one does not find in the antique. . . . What I write here joins up naturally with what I said on the following page *[i.e. his note of 26 February 1858, on the almost necessarily weak parts of certain works of genius, due to the superiority of the main idea]*[10]

[Entry of 28 February 1860 continues here, on the boldness of certain geniuses who opened the way to the future] Same subject, 1853, 23 October *[i.e. entry of 26 October 1853, which for lack of space continues on the page for the 23rd]* Look for the notebook containing my tirade on primitive geniuses, initiators *[i.e. entry of 10 June 1856]*

Inspired by his rereadings here, Delacroix goes on to discuss the

[9] Joubin's reference to II, 319 (23 March) thus makes no sense, since he prints the passage under its September date. There are many more such examples.

[10] The published edition places this note from 28 February 1860 under 27 February 1858, but Delacroix places it squarely under 23 February, where it belongs thematically.

changes in one's opinion over time, and the varying reputation of artists as a result]

I find, in some old notes, my opinion on Titian from four years ago. . . . Here is what I said four years ago. *[i.e. his note of 5 January 1857; III, 4–7]*
[Entry continues and ends] (III, 172–77)

These practices, completely absent from the early *Journal*, confound and disrupt the linear progression that Delacroix attributed to writing. Each autonomous "pensée détachée" is mobile and variable, a discrete unit like an image, grasped in one sitting, as instantaneous as writing permits —a "shortness" corresponding specifically, in his view, to the pictorial quality of presenting only what is essential (29 October 1857; III, 142). Through its going and coming, its comparing and contrasting of notes far apart in time, it creates a "literary" simultaneity. Confined to its place within a linear order, the past of narrative is not free to realign itself, to evoke sensations and ideas outside the place assigned to it, to "say something new." In contrast, in the *Journal* each entry is part of a network of relations like the parts of a picture, and takes on new meaning at each rereading, as a painting does whenever it is returned to. Open-ended and inconclusive, the diary is not, like narrative, dependent on the end, a situation which would in any circumstances impede pleasure: "Can one be truly happy in a situation which must come to an end? That apprehension of the upcoming departure, in the end, spoils all pleasure" (7 June 1853; II, 69).

The *Journal* reflects the essayistic style of models mentioned and quoted repeatedly within its pages—Addison's *Spectator*, Senancour's *Obermann*, Voltaire's *Dictionnaire philosophique*, the *Pensées* of Pascal, the *Meditations* of Marcus Aurelius, and especially the *Essais* of Montaigne. It responds to Delacroix's dream of a writing which would come as easily to him as painting, a text composed of autonomous thoughts "stitched together" (21 July 1850; I, 393), but with the seams apparent, as it were: "Must one absolutely write a book following all the rules? Montaigne writes in fits and starts. Those are the most interesting works" (7 May 1850; I, 363)— a note which he recalls and repeats several years later in theorizing the form of the *Dictionnaire des Beaux-Arts* (13 January 1857; III, 28). Like the *Essais*, the *Journal*'s entries are individual *tableaux* with no necessary connection between them; they satisfy what is for Delacroix the only reasonable requirement of consistency, that of the page. This is a writing which provokes a particular kind of reading, as a clipping from the *Moniteur universel*, inserted into the diary, suggests: "[Montaigne] opens one book, then another, runs his eyes over a page and dreams, listens to his

own thoughts through the thoughts of others, and peruses himself more than he peruses his volume."[11] It opens up the space of contradiction, allowing a posing and counterposing, the multiple and mobile perspective which writing theoretically denies. The *Journal* fulfills Delacroix's ideal of a writing that has the "panoramic" fullness of painting, presenting the "for and against" as a case is pleaded in court:

> It seems then that an impartial man should only write as two people, so to speak, just as there are two lawyers for a single case. Each of those lawyers sees so clearly the arguments that militate in favor of an adversary, that often he anticipates those arguments; and when he refutes the grounds on which one objects, it is on grounds that are just as good and which at least are plausible. . . .
>
> Whence I conclude that a man of good faith should only write a book as one examines a case in court: that is, having set out one theme, you should have almost another person inside who would play the role of the opposing lawyer charged with contradicting you. (23 February 1858; III, 177)

> [Il semble donc qu'un homme impartial ne devrait écrire qu'en deux personnes pour ainsi dire; de même qu'il y a deux avocats pour une seule cause. Chacun de ses avocats voit tellement les moyens qui militent en faveur d'un adversaire, que souvent il va au-devant de ces moyens; et quand il rétorque les raisons qu'on lui objecte, c'est par des raisons tout aussi bonnes et qui au moins sont spécieuses. . . .
>
> D'où je conclus qu'il faudrait presque qu'un homme de bonne foi n'écrivît un ouvrage que comme on instruit une cause: c'est-à-dire, un thème étant posé, avoir comme un autre personnage en soi qui fasse le rôle d'un avocat adverse chargé de contredire.]

Such a perspective is the only one faithful to the multifaceted experience of the human mind, and is a sign of spiritual and moral "health," as he maintains repeatedly:

> It is remarkable how the for and against can be found in a single brain! One is astonished at the diversity of opinion among different people; but a man of healthy mind conceives of all possibilities, he can put himself, or does so without knowing it, into all points of view. That explains the reversals of opinion in the same man, and these should surprise no one but those who are not capable of forming opinions of things for themselves. (23 February 1858; III, 176)

[11] From Montaigne's "library" essay, III, iii: "Là, je feuillette à cette heure un livre, à cette heure un autre, sans ordre et sans dessein, à pièces décousues; tantost je resve, tantost j'enregistre et dicte, en me promenant, mes songes que voicy."

[Combien le pour et le contre se trouvent dans la même cervelle! On est étonné de la diversité des opinions entre hommes différents: mais un homme d'un esprit sain conçoit toutes les possibilités, sait se mettre ou se met à son insu à tous les points de vue. Cela explique les revirements d'opinion chez le même homme, et ils ne doivent surprendre que ceux qui ne sont pas capables de se faire à eux-mêmes des opinions des choses.]

And elsewhere: "subtle minds . . . see easily all the different sides of things" (23 September 1854; II, 275).

This was certainly a feature of Delacroix himself, his all-embracing, variable and "capricious" intelligence, noted by his closest contemporaries.[12] As George Sand put it: "Delacroix delights equally in the different aspects of beauty by the multiple facets of his intelligence."[13] The *Journal* acknowledges this ceaseless change that derives from the mind's existence in time, the protean, contradictory, unpredictable, and complex nature of thought, permitting the artist to compare his recent views on Titian, in the example above, with those, completely different, of four years earlier. Moreover, the process is ongoing and non-progressive; a later entry has no priority over an earlier one it refutes. Nor, by the same token, should the earlier form be considered inalterable: Delacroix notes that Voltaire and Pascal jotted down their ideas, but reworked these later as they wished (8 March 1860; III, 277). This give-and-take, this multiple perspective is the sole means of approaching truth, which can never be equal to one or another side alone: "Truth in any question cannot be absolute" (23 February 1858; III, 177). Hence his criticism of the single-mindedness of Ingres: "His is a mind completely skewed; he only sees one point" (24 March 1854; II, 153). The repetitions in the *Journal*, its recurring issues, its frequent resumptions of an argument, are testimony to what is never completely said, never said "once for all": "It is probably only God, or a god, who can say about things only what should be said about them" (23 August 1850; I, 414). Even the concession to the absolutism of God, added later here in pencil as if to prove the never-ending process of reinterpretation it asserts, contains a comical and telling relativ-

[12] T. Silvestre, *Histoire des artistes vivants*, 70: "Au reste, son intelligence, capricieuse comme la gourmandise, passe du Dante à l'Arioste aussi facilement que de Shakespeare à Racine; il vous dit une fois: 'je suis pour le dix-septième siècle'; une autre fois: 'je suis tout au dix-huitième' . . . 'Je causais, il y a longtemps, avec M. Delacroix, me disait un de mes amis; il trouvait Balzac tracassier, puéril, irritant . . . il exaltait, au contraire, la large manière d'un de nos romanciers célèbres. Deux ou trois ans plus tard, reprenant le même sujet:—Ah! sans doute, disait-il, Balzac, voilà un écrivain; l'autre n'est qu'un orateur!'"

[13] Ibid., 48.

ism ("or a god"). The point is reaffirmed elsewhere: "One never knows a master sufficiently to speak about him in absolute and definitive terms" (1 November 1852; I, 496).[14]

Delacroix's *oeuvre* is marked by this phenomenon of repetition, this fascination with the variations in his reactions to a single object, experience, or thought:

> I see the drawings from Morocco again, and my impressions are those of someone else. . . . How could our thoughts of today be those of formerly? My body is renewed, without a doubt. There is not a piece of my hair which was on my head twenty years ago; how then could the thoughts born in my brain . . . be the same?[15]

> [Je revois les dessins du Maroc, et mes impressions sont celles d'un autre. . . . Comment nos pensées d'aujourd'hui seraient-elles celles d'autrefois? Mon corps est renouvelé sans contredit. Il n'y a pas un morceau de mes cheveux qui fût sur ma tête il y a vingt ans; comment les pensées qui naissent dans le cerveau . . . seraient-elles les mêmes?]

He regularly returned to the same subjects in his paintings and treated them anew: two versions of the *Women of Algiers*, of *Tasso in the Hospital of Saint Anna*; three of *Ruggiero Rescues Angelica*, *Ovid among the Scythians*, *The Death of Ophelia*, *Perseus and Andromeda*, *The Sultan of Morocco and his Entourage*; four of *The Bride of Abydos*, of *Medea about to Kill her Children*, four *Lion Hunts*; six of *Christ on the Sea of Galilee*; seven of the *Lamentation* and of *Hamlet and Horatio*—the list goes on. This reinterpretation corresponds to his practice in the *Journal* of rereading and recommenting on the entries, or taking up their content afresh: "The man who rereads and who has in hand a pen to correct himself is more or less another man than the one who wrote the first draft" (8 March 1860; III, 277).

For all its abundance, the *Journal* has the discretion and reserve attributed to painting. It does not say everything or "talk too much"; on the contrary, the reader is conscious of being left out, of not knowing what the spaces between entries may have contained. The diarist himself complains of this at an early stage, as though the gaps tease him with secrets he no longer knows, mocking the "mastery" which he claims to have acquired over himself and over time: "I have just reread hurriedly all the preced-

[14] This would account as well for Delacroix's intense dislike of extremism of any sort: "Il n'y a plus en France, et je dirai ailleurs, d'état intermédiaire: ou jésuites ou septembriseurs; il faut subir l'un ou l'autre régime" (5 May 1854; II, 180).

[15] *O.L.* I, 119.

ing: I deplore the gaps. It seems to me that I am still master of the days which I have set down, although they have passed. But those that this paper does not mention, they are as though they never even happened" (7 April 1824; I, 69–70). On 28 February 1849, he writes: "I have not written since the 16th, and I am annoyed about it: I could have noted down various interesting things" (I, 266). Sometimes he calls attention to leaving things out deliberately: "The memory of it [a letter from his brother] annoys me to such a degree that I do not want to recall what I felt, nor set out here what he told me" (8 October 1822; I, 16). A useful analogy might be his idea of the teller of stories and anecdotes, or the collector, who, in the best of cases, chooses individual anecdotes or objects with care:

> An anecdote must come into a conversation like anything else; but to focus the interest on that alone is to imitate the collectors of curiosities, another group that I cannot stand, who cause you to feel disgust at beautiful objects to dazzle you with their abundance and confusion, instead of bringing out a small number by choosing them and putting them in a light that suits them. (2 May 1853; II, 35)

> [Il faut qu'une anecdote arrive comme autre chose dans la conversation; mais ne mettre d'intérêt qu'à cela, c'est imiter les collectionneurs de choses curieuses, autre groupe que je ne puis souffrir, qui vous dégoûtent des beaux objets pour vous en crever les yeux par leur abondance et leur confusion, au lieu d'en faire ressortir un petit nombre en les choisissant et en les mettant dans le jour qui leur convient.]

The *Journal* may be considered a collection of this sort, selecting some thoughts and experiences, and passing over the rest; returning to some repeatedly as the years go by, thus putting them into "a new light." Moreover, the "self-expansion" which the diary makes possible is not the "literary" exhibitionism that Delacroix deplored, but more often than not a confrontation with others, letting them speak, and frequently for themselves: pages of direct quotation, paraphrase, and allusion make the diary the kind of instructive and substantive conversation which he associated with painting.[16] Such is, indeed, the self of Delacroix's diary, its presence often not stated but implied, constructed by analogy with a multitude of others, or through direct engagement with them. It belongs among those "papers which speak" that remove the burden of time:

[16] "On n'a qu'à gagner . . . en écoutant. Ce que vous vouliez dire à votre interlocuteur, vous le savez . . . ; ce qu'il a à vous dire, vous l'ignorez sans doute: ou il vous apprendra quelque chose de nouveau pour vous, ou il vous rappellera quelque chose que vous aviez oublié" (23 September 1854; II, 275–6).

To feel oneself buried in papers which speak, I mean drawings, sketches, memories . . ., that is a happiness which . . . seems superior to all others. At that moment you delight completely in yourself; nothing hurries you, nothing impels you . . . but aspiring to what is great by inner contemplation or by the sight of the masterpieces of the ages, I feel myself neither crushed by the weight of time, nor frightened at its rapidity. It is a pleasure of the mind, a delicious mingling of calm and ardor, which the passions cannot give. (5 October 1854; II, 285)

[Se sentir enseveli dans les papiers qui parlent, je veux dire les dessins, les ébauches, les souvenirs . . ., voilà un bonheur qui . . . paraît supérieur à tous les autres. On jouit alors complètement de soi; rien ne vous presse, rien ne vous sollicite . . . mais aspirant . . . à ce qu'il y a de plus grand par la contemplation intérieure ou par la vue des chefs d'oeuvre de tous les temps, je ne me sens ni accablé du poids des heures, ni effrayé de leur rapidité. C'est une volupté de l'esprit, un mélange délicieux de calme et d'ardeur que les passions ne peuvent donner.]

The improvisatory quality of the *Journal* preserves the freshness and immediacy which Delacroix associates with painting, and which the temporal unfolding of literature usually prevents: the vitality of the impressions conveyed by Montaigne, "all the interest of naturalness, and all the liveliness of impressions rendered and expressed as soon as they are felt" (Supplement; III, 447). Hence the attraction of Byron, whose language, in Delacroix's view, conforms so happily to his fancy, and whose "ode-like" rather than "narrative" poetry preserves the quality of improvisation, corresponding to the painter's ability to retain "the freshness of the first draft": "One should be able, like Lord Byron, to recover one's inspiration on command . . . Lord Byron says that when he writes, he does not know what is going to come next, and he does not worry about it much at all . . . [his kind of poetry] is more akin to the ode than to narrative; he can thus abandon himself to his whim" (21 July 1850; I, 392–93).[17] Such writing can be grasped all at once, like a painting: "An ode, a fable will present the virtues of a picture which one takes in all at once" (23 September 1854; II, 277). Likewise, the *Journal*'s prose permits the lack

[17] As a cross reference here indicates, Delacroix is referring to some extracts from Thomas Medwin's *Journal of the Conversations of Lord Byron* (1824), which he had copied into the diary a few days previously: "Quand il écrivait, il ne savait point ce qui allait venir après et ne s'en inquiétait guère. C'est là la véritable inspiration poétique. . . . Il peut toujours reprendre son sujet où il en est resté et le continuer comme s'il n'avait pas été interrompu. Il a le talent d'un *improvisatore*" (15 July 1850; I, 389).

of finish in detail that painting does, the literary equivalent of painting's *indication* or *croquis*, with their inherent expressiveness, and their capacity to concentrate interest on selected objects.

This lack of finish reflects an ongoing painterly concern of Delacroix's, one which preoccupied him throughout his career. While he firmly believed in the importance of finish and argued strongly in its favor, the *Journal* records alongside an ongoing and nuanced ambivalence, debating the question more and more. Here both sides of the issue are explored, and the unfinished given a prominent—in fact, the more prominent—place, thus qualifying some of his more definite pronouncements, and suggesting the importance of the unfinished for his aesthetic and his practice. As he argues, a highly finished work may be the greatest achievement of the artist, a beauty *in itself* rather than one produced through a contrast with inferior parts of the work: "Mozart is superior to everyone by his finished form. These beauties, like those of Racine, do not shine simply by their proximity to tasteless features or failed effects" (21 April 1853; II, 25). But Delacroix finds himself defending the *ouvrage fini* in curiously unpersuasive ways, and is compelled to acknowledge repeatedly the extraordinary power of the unfinished. If a trio by his adored Mozart fails to move him at a concert, he attributes the fault to himself rather than to the work: contemporary ears have become accustomed to the forms, rhythms, and harmonies that were original with Mozart, having been copied and imitated endlessly since. One forgives—and forgets—the flaws and "négligences" of Rubens because of the stunning sublimity of the rest (21 April 1853; II, 25). He quotes Byron on the problem of too much finish in poetry and painting: "[The poet Campbell] spoiled his finest works in trying to finish them too much. All the brilliance of the first draft is lost. It is in poems as in paintings; they must not be too finished" (15 July 1850; I, 388). The unity of Rubens's tapestries on the *Life of Achilles*, which so impressed Delacroix when he saw them in 1852, is a function of the artist's not finishing too much; it results from their "élan," their "liberté," the verve that comes from "incorrection" (26 January 1852; I, 443).

Indeed finish can give to painting the wearisome continuity, the false consistency which Delacroix so disliked in literature:

> One always has to spoil a picture a little to finish it. The final touches intended to bring about harmony among the parts take away some of the freshness. One has to appear before the public having cut out all the happy negligences which are the passion of the artist. I compare these murderous retouchings to those banal flourishes which end all arias, and to those meaningless spaces which the composer is forced

to place between the interesting parts of his work, to lead from one motif to another or to set them off. (13 April 1853; II, 17)

[Il faut toujours gâter un peu un tableau pour le finir. Les dernières touches destinées à mettre de l'accord entre les parties ôtent de la fraîcheur. Il faut paraître devant le public en retranchant toutes les heureuses négligences qui sont la passion de l'artiste. Je compare ces retouches assassines à ces ritournelles banales qui terminent tous les airs et à ces espaces insignifiants que le musicien est forcé de placer entre les parties intéressantes de son ouvrage, pour conduire d'un motif à l'autre ou les faire valoir.]

A spirited defense of the finished, which directly contradicts this entry, consists curiously of reasons why the *unfinished* moves us more:

No, one does not spoil the picture in finishing it. Perhaps there is less scope for the imagination in a finished work than in a sketch. One feels different impressions before a building which is going up and in which the details are not yet indicated, and before the same building when it has received its remainder of ornamentation and finish. It is the same with a ruin which acquires a more striking aspect by the parts which it lacks. The details are effaced or mutilated, just as in the building going up one does not yet see more than the rudiments and the vague indication of the moldings and ornamented parts. The finished building encloses the imagination within a circle and forbids it to go beyond. Perhaps the sketch of a work only pleases as much as it does because everyone finishes it to his liking. (20 April 1853; II, 22–23)

[Non, on ne gâte pas le tableau en le finissant! Peut-être y a-t-il moins de carrière pour l'imagination dans un ouvrage fini que dans un ouvrage ébauché. On éprouve des impressions différentes devant un édifice qui s'élève et dont les détails ne sont pas encore indiqués, et devant le même édifice quand il a reçu son complément d'ornements et de fini. Il en est de même d'une ruine qui acquiert quelque chose de plus frappant par les parties qui manquent. Les détails en sont effacés ou mutilés, de même que dans le bâtiment qui s'élève on ne voit encore que les rudiments et l'indication vague des moulures et des parties ornées. L'édifice achevé enferme l'imagination dans un cercle et lui défend d'aller au delà. Peut-être que l'ébauche d'un ouvrage ne plaît tant que parce que chacun l'achève à son gré.]

Giving fuller scope to the imagination, not being overrun with detail, inspiring each viewer to finish the work in his or her own way, the unfinished work has the virtues of painting and the image; the finished work, in contrast, has the self-enclosing, limiting, and despotic quality of writing, tyrannizing the mind, leaving it no freedom to respond, imprisoning it in a manner dangerously suggestive of the most stultifying *ennui*, including the self-enclosure which the experience of the Museum of Natural History, and the writing of the *Journal*, so dramatically broke open. The sketch and the unfinished monument respond to the imagination's need for expansion and activity: "It is once again the story of the finished work compared to the sketch—about which I already spoke—of the monument which shows only its broad, main lines, before the finishing and the coordinating of all the parts have given it something more definite, and consequently circumscribed its effect on the imagination, which delights in vagueness and and embraces vast objects on the basis of summary indications" (26 October 1853; 102–103).[18]

Thus even when he defends finish, Delacroix seems to justify a manner in which he does not wholly believe and to which he does not fully respond. The unfinished work is more suggestive, and consequently inspires. It is "imperfect" artists like Shakespeare who will best lend themselves to translation into another medium, for example, and thus provoke innovation in the other arts: "Our authors are too perfect for us. . . . The more perfect the work which gives the idea to the picture, the less chance a neighboring art which is inspired by it will have of creating an equal effect on the imagination" (30 January 1860; III, 257).[19] In an astonishing move, Delacroix closes his defense of finish by arguing that even the finished painting is always *unfinished* to the trained or accomplished eye, which will view it according to how it might have been *otherwise*. In bringing out the artist's individual talent, finish suggests equally the real limitations of this, moving the artistic eye and vivid imagination of the viewer to complete it at will, to his or her liking, *à son gré:*

Artists gifted with a very definite sensibility, when contemplating, and even admiring, a fine work, criticize it not only for the flaws

[18] But contrast Diderot, who maintains that literature is always unfinished relative to the precision of painting, thus allowing the painter freedom to render it at will (*Pensées détachées sur la peinture*, 838f.).

[19] As Johnson remarks (*Delacroix*, 51), Racine inspired no completed picture, while Shakespeare inspired many.

which are really in it, but also with respect to the difference it presents vis-à-vis their own feeling. When Correggio said his famous *Anch'io son' pittore*, he meant: "There is a fine work, but I would have put into it something that is not there." Thus the artist does not spoil the picture in finishing it; rather, by closing the door to interpretation, by renouncing the vagueness of the sketch, he shows himself more in his own personality, thus revealing the whole extent, but also the limits, of his talent. (20 April 1853; II, 23).

[Les artistes doués d'un sentiment très marqué, en regardant et en admirant même un bel ouvrage, le critiquent non seulement dans les défauts qui s'y trouvent réellement, mais par rapport à la différence qu'il présente avec leur propre sentiment. Quand le Corrège dit le fameux: *Anch'io son' pittore*, il voulait dire: "Voilà un bel ouvrage, mais j'y aurais mis quelque chose qui n'y est pas." L'artiste ne gâte donc pas le tableau en le finissant; seulement, en fermant la porte à l'interprétation, en renonçant au vague de l'esquisse, il se montre davantage dans sa personnalité, en dévoilant ainsi toute la portée, mais aussi les bornes de son talent.]

L'artiste ne gâte donc pas: the assertion falls weakly, having been so qualified and redefined as to suggest almost the opposite. Finish has become a virtue as a lack of finish, defining the artist's scope and thus the limitations beyond which others may go.

The *Journal* is itself perhaps the best testimony of Delacroix's irresistible attraction to the unfinished. The irregularity of its entries seems to exemplify the "uneven leaps," the "sudden falls" alongside sublime transports that he criticizes in Corneille and Pindar (26 October 1853; II, 104), its rough form far removed from the polish of Mozart, Racine, Virgil, and Ariosto. A long entry on the special qualities of painting which approaches a theory of the art is followed by a two-line note that he went to Mme Villot's only after dinner; a terse mention of the imminent change-over from the constituent to the legislative assembly in 1849 is followed by a comment on Meyerbeer's big feet! His defense of its special kind of writing, like his defense of the unfinished picture—their freshness and variety, their complexity and fullness, their mobility, freedom, and life—thus becomes particularly important; these notes on the unfinished from 1853 recur, or are formally referred to, in 1857 and again in 1859.

Similarly, the fragmentary form of the *Journal's pensées détachées* suggests Delacroix's evolving conception of unity, pictorial composition, and the *ensemble*, consistent with his observation of nature: "It is only man who produces things which lack unity. Nature finds the secret of putting unity even into the detached parts of a whole. The branch detached from a tree is a whole little tree" (22 March 1857; III, 83). The same language

had earlier been used of the ever-fragmentary effect of literary discourse: "It is only nature which produces whole things" (Supplement; III, 433). Unity consists in the most disparate forms of nature, in the most fragmented and detached parts of some larger—and yet no "more" unified—whole. It is significant that, of all the passages on unity in the *Journal*, he chose this one on the wholeness of Nature's *parties détachées*, emphasizing fragmentation and seeming discontinuity, for the definition of unity to be used in the *Dictionnaire des Beaux-Arts* (25 January 1857; III, 38). The idea recurs in an extraordinary network of passages going and coming between diaries and notebooks from 1849 to 1860.

> I have often said that the branches of a tree were themselves whole little trees: fragments of rocks are similar to masses of rocks, particles of earth to heaps of earth. I am convinced that one could find great numbers of these analogies. A feather is composed of a million feathers. (21 November 1857; III, 156–57)[20]

> [J'ai dit souvent que les branches de l'arbre étaient elles-mêmes de petits arbres complets: des fragments de rochers sont semblables à des masses de rochers, des particules de terre à des amas énormes de terre. Je suis persuadé qu'on trouverait en quantité de ces analogies. Une plume est composée d'un million de plumes.]

An individual is a whole, with a system of laws or an organization consistent with the larger whole of which it is part: ". . . even a part of an object is a kind of complete unity; thus a branch detached from a tree presents the conditions of the whole tree. It is in this way that a single man presents, in the course of his development, the different phases presented by the history of the art he practices" (5 August 1854; II, 226–27).[21] Comparing his 1826 portrait of Count Palatiano with his recent work, he finds the same evolution from "timidity and dryness" to "breadth and neglect of detail" that he sees in the history of European painting. "Nature is singularly consistent with itself" (5 August 1854; II, 226–27):[22] drawn in a certain way, a fragment of a boulder on the beach resembles an immense cliff; a chip of stone a huge boulder; a molehill a vast expanse of rugged terrain; an ant-hill a country with slopes, gorges, and mountain

[20] In addition to the two passages already cited (25 January 1857 and 22 March 1857), cf. 5 August 1854 (II, 227–28), where the same passage is developed at greater length.

[21] Delacroix refers to the Swedenborgian theory of nature, mentioned in an article on Napoleon by the American writer Emerson in the *Revue britannique* of 1850, in which parts are microcosms of the whole (21 November 1857; III, 156–7).

[22] Same phrase in a notebook of 1849 (*O.L.* I, 112–13), another notebook of 1855 (cited in M. Tourneux, *Eugène Delacroix devant ses contemporains*, 38), and at 12 April 1860 (III, 289).

passes traversed by hordes of little people; boulders uncovered by the tide resemble the gulfs, inlets, peaks, and valleys of the surrounding landscape. Similarly, he finds in the variety of nature a correspondence or "repetition" of forms among very different objects: patterns formed on the sand washed by the sea resemble the striped skin of a tiger (5 August 1854; II, 226–27); a slug encountered in a walk at Augerville has the same markings as a panther (15 October 1856; II, 472); water dripped onto a dusty road becomes the image of criss-crossing branches of certain trees (6 May 1852; I, 469); young girls playing on the riverbank remind him of butterflies or grasshoppers (12 April 1860; III, 289); the boulders at Augerville suggest a whole menagerie of real and fantastic creatures— boars, elephants, centaurs, and bulls (13 July 1855; II, 353). Individual forms are part of a diverse but unified system: "Certain forms which seem to inattentive eyes the product of chance . . . are not only geometrically composed, but recall, through a perfect imitation, the forms of objects of a completely different species."[23]

Fragmentation may thus project a unity for the imagination, and the model for this is, significantly, a literary one, Delacroix's favorite example of the "imperfect" and "unfinished" writer: Shakespeare. Shakespeare's "accumulation of details" is like nature's, creating the same unity of impression and the same simplicity of expression:

> There is a secret logic, an unperceived order in that accumulation of detail, which you would think would be a shapeless mountain, but in which one finds distinct parts, planned respites, and always the sequel and the result.
>
> *Baden-Baden, on my arrival, 25 September.* I notice here in this very place, from my window, the great similarity that Shakespeare has to external nature in this respect, for example, the natural scene that I have before me; I mean from the perspective of this heap of details which, taken together, nevertheless seem to create a whole for the mind. The mountains that I went through to get here, seen from a distance, form the simplest and most majestic lines; seen close to, they are no longer even mountains, they are parts of boulders, meadows, trees in groups or separate; works of human hands, houses, roads, all occupy one's attention by turns. This unity, which the genius of Shakespeare establishes for the mind through his irregularities, is still a quality proper to him. (25 March 1855; II, 324 and 387–88)[24]
>
> [Il y a une logique secrète, un ordre inaperçu dans cet entassement

[23] *O.L.* I, 113; cf. *Journal*, 6 May 1852 (I, 469).

[24] This passage written in Baden six months later was placed by Delacroix directly after the discussion of Shakespeare at 25 March, as a continuation of that argument; it was

de détails, qui semblerait devoir être une montagne informe et où l'on trouve des parties distinctes, des repos ménagés, et toujours la suite et la conséquence.

Baden, en arrivant, 25 septembre. Je remarque ici même, à ma fenêtre, la grande similitude que Shakespeare a en cela avec la nature extérieure, celle par exemple que j'ai sous les yeux; j'entends sous le rapport de cet entassement de détails dont il semble cependant que l'ensemble fasse un tout pour l'esprit. Les montagnes que j'ai parcourues pour venir ici, vues à distance, forment les lignes les plus simples et les plus majestueuses; vues de près, elles ne sont plus même des montagnes: ce sont des parties de rochers, des prairies, des arbres en groupes ou séparés; des ouvrages des hommes, des maisons, des chemins, occupent l'attention tour à tour.

Cette unité que le génie de Shakespeare établit pour l'esprit à travers ses irrégularités est encore une qualité qui est propre à lui.]

The metaphorical rejoins the real, as the "shapeless mountain" of parts becomes like the mountains around Baden—fragmented and discontinuous viewed from nearby, unified, harmonious, and beautiful from a distance: "Beautiful mountains, from afar almost mingling with the horizon" (25 September 1855). The view accordingly inspired an image, in watercolor.

Similarly, his observations on the human and animal forms of the boulders at Augerville in 1855 (13 July; II, 353) are entwined with reflections on the unity of Rossini and Shakespeare, despite their "négligences" and "irrégularités" (16 July; II, 357)—a connection he makes explicitly, and by referring to the same notes, in 1860:

I find the following in a notebook kept at Augerville during my stay in July 1855 . . . "I saw a little while ago those young ladies—all blue, green, and yellow—who were playing on the grass along the river. At the sight of these butterflies which are not butterflies, although their bodies present the analogy, whose wings unfold a little like those of grasshoppers, and who are not grasshoppers, I thought about that inexhaustible variety of nature, always consistent with itself, but always diverse . . . The idea of old Shakespeare came at once to my mind, who creates with everything he finds to hand. Each personage, placed in a given circumstance, presents itself to him all of a piece with its character and physiognomy. With the same human

separated off by earlier editors, but as the "in this respect" demonstrates, should be restored to its proper place.

data he adds or subtracts, modifies his material and produces for you men of his own invention who are nevertheless true. That is one of the surest traits of genius. Molière is like that; Cervantes is like that; Rossini, with his alloyed element, is like that." (12 April 1860; III, 289)

[Je trouve dans un calepin écrit à Augerville pendant mon séjour en juillet 1855 . . . "Je voyais tout à l'heure ces demoiselles bleues, vertes, jaunes, qui se jouaient sur les herbes le long de la rivière. A l'aspect de ces papillons qui ne sont pas des papillons, bien que leurs corps présentent de l'analogie, dont les ailes se déploient un peu comme celles des sauterelles, et qui ne sont pas des sauterelles, j'ai pensé à cette inépuisable variété de la nature, toujours conséquente à elle-même, mais toujours diverse . . . L'idée du vieux Shakespeare s'est offerte aussitôt à mon esprit, qui crée avec tout ce qu'il trouve sous sa main. Chaque personnage placé dans telle circonstance se présente à lui tout d'une pièce avec son caractère et sa physionomie. Avec la même donnée humaine il ajoute ou il ôte, il modifie sa matière et vous fait des hommes de son invention qui pourtant sont vrais. C'est là un des plus sûrs caractères du génie. Molière est ainsi; Cervantès est ainsi; Rossini avec son alliage est ainsi."]

The diary's principle of the *partie détachée* is at the basis of the relation developed here, between discontinuity and *ensemble*, detail and whole, individuality and truth, Shakespeare's "unity . . . through his irregularities," bridging the gap between "literary" detail and "pictorial" *ensemble*.

Within the same network of passages Delacroix debates an issue closely related to those of finish and unity, disproportion. As in the case of finish, his assertions of the importance of proportion are matched by his admission of the expressive power of disproportion, confirmed by his own experience of nature. Like the sketch or the unfinished work, disproportion is moving to the soul, which is actively engaged and "adds" to the object (9 May 1853; II, 41).[25] The oft-visited Antin oak in the forest of Champrosay is now large, now unrecognizably small, its proportions a function of the viewer's perspective:

In the presence of this fine tree which is so well proportioned, I find a new confirmation of these ideas.—At the distance necessary to embrace all its parts, it appears of an ordinary size; if I place myself under its branches, the impression changes completely. Perceiving only the trunk which I am almost touching, and the beginning of its

[25] He specifically refers to his earlier discussion of the unfinished at 20 and 21 April 1853 (II, 22–25). The 9 May note is from a notebook, recopied into 20 November 1857.

thick branches which spread out above my head like the immense arms of this giant of the forest, I am astonished at the grandeur of these details; in a word, I find it grand, and even terrifying in its grandeur.

—Could disproportion be a condition of admiration? If, on the one hand, Mozart, Cimarosa, and Racine cause less surprise, because of the admirable proportion in their works, do not Shakespeare, Michelangelo, and Beethoven owe a part of their effect to an opposite cause? For my part I think so. (9 May 1853; II, 42)

[En présence de ce bel arbre si bien proportionné, je trouve une nouvelle confirmation de ces idées. —A la distance nécessaire pour en embrasser toutes les parties, il paraît d'une grandeur ordinaire; si je me place au-dessous de ses branches, l'impression change complètement: n'apercevant que le tronc auquel je touche presque et la naissance de ses grosses branches, qui s'étendent sur ma tête comme d'immenses bras de ce géant de la forêt, je suis étonné de la grandeur de ces détails; en un mot, je le trouve grand et même effrayant de grandeur.

—La disproportion serait-elle une condition pour l'admiration? Si, d'une part, Mozart, Cimarosa, Racine étonnent moins, à cause de l'admirable proportion de leurs ouvrages, Shakespeare, Michel-Ange, Beethoven, ne devront-ils pas une partie de leur effet à une cause opposée? Je le crois pour mon compte.]

The same ideas dominate his two essays on the beautiful, "Questions sur le beau" (1854) and "Des Variations du beau" (1857): beauty should not be limited to regularity and symmetry, which from the "canon" of ancient sculpture have passed into facile recipes and formulas, but is found as much, although differently, in the "imperfection" of Beethoven, the "bizarreries" of Michelangelo, the improvisatory verve of Rubens.[26]

All these passages belong to what is surely one of the most prominent and complex concerns of the *Journal*, the relative value of perfection and the sublime. Delacroix, following tradition, defines the sublime in terms of disproportion, perfection in terms of finish: "On the sublime and on perfection . . . Sublime means all that is most elevated; perfect, that which is most complete, most finished. *Perficere*, to finish completely, to put the crowning touch. *Sublimis*, that which is highest, that which touches the sky" (26 June 1857; III, 107).[27] Proportion can detract from

[26] *O.L.* I, 24f., 29, 28, 31.

[27] Cf. 5 June 1857 (III, 106) where the sublime is "dû le plus souvent à un contraste tranché ou à une disproportion."

the effect of the work: "A too perfect proportion hinders the impression of the sublime" (13 January 1857; III, 14). He specifically cites his earlier remarks on the Antin oak in this context: "I say in a diary (9 May 1853) that the Antin oak seen from a distance appears mediocre. Its form is regular; the mass of leaves is proportionate to the trunk and to the spread of the branches. Once arrived under the branches themselves, and only perceiving parts without relating them to the whole, I experience the sensation of the sublime" (25 January 1857; III, 37) He goes back and forth between the two, arguing the "for and against" of each. The church of Saint Jacques at Dieppe, like the oak tree, seems common and undistinguished until enlarged to monstrous dimensions by the evening shadows; the cliffs are striking through their disproportion with our own smallness and that of the objects which surround them (28 June 1853; I, 485–86).[28] He is critical of the "tasteless and interminable" conversations in Shakespeare, the "monstrosities" of Pindar, the "abominations" of Corneille (10 June 1856; II, 455–56), in contrast to the perfection of Virgil, Racine, Mozart, and Ariosto. But the former are repeatedly characterized as the "initiators" and "precursors," the "shepherds of the flock," "formless" monuments, perhaps, but eternal ones.[29] If the sublime is obtained at the price of "shocking disparities" (9 May 1853; II, 43), the sustained excellence of a "perfect" artist like Racine and the "continuous joy" it inspires (26 October 1853; II, 103) are sometimes so subtle as not to be felt, or to be felt only if one perseveres: "I said to Cousin that I thought the defect in Racine was his very perfection; one did not not find him so beautiful because he is in fact too beautiful" (7 September 1854; II, 257); ". . . one sees, in Corneille, when he is sublime. Racine is often so, and just as often; but the progression of his work is so sustained that the truly sublime passages are joined to the rest by insensible transitions. . . . The sustained warmth of his diction and the appropriateness of the feelings seem simple, and do not appear prodigious until one goes deeply into such a profound art" (26 June 1857; III, 108). The quotation from La Rochefoucauld a few days later makes the point less ambiguously: "There are beautiful things which have more brilliance when they remain imperfect than when they are too finished" (29 June 1857; III, 108–109).

Indeed, in this context Delacroix is led to abandon some of the tastes he usually holds most dear. Citing a disagreement between Racine and Molière, in which Molière maintains that perfection must often be sacrificed for the purposes of expression, Delacroix remarks: "For my part I am

[28] This passage on the sublime, written in a notebook on 12 September 1852, and published in part under that date by previous editors, was in fact written into the diary by Delacroix under the entry of 28 June 1853.

[29] 10 June 1856 (II, 456); 20 November 1857 (III, 153)

delighted with this example: here Molière is evidently a greater artist than
Racine, who shows himself to be only a craftsman" (17 July 1855; II,
359).[30] He even rejects his cherished Voltaire, who criticized the tasteless-
ness of Shakespeare, and supports the decisive and (for Delacroix)
irresistible position of Cardinal de Bernis: "Here is the response of the
cardinal, who shows himself, in my opinion, to be more a man of true
taste than Voltaire . . . 'One must . . . acknowledge that these tragedies
[Shakespeare's and Calderon's], extravagant or coarse though they may
be, *do not bore one*'" (9 April 1858, my emphasis; III, 184). Exposed to
the sublime of Homer and Shakespeare, the lifelong admirer of Racine
and Voltaire becomes their harsh critic, with even a touch of sarcasm:

> It must be confessed that our moderns (I am speaking of the Racines,
> the Voltaires) have not known this kind of sublime, these astonishing
> naivetés which poeticize common details and make of them paintings
> for the imagination to delight in. It seems that our men think them-
> selves far too high and mighty to speak to us like men, about our
> sweat, the simple impulses of our nature, etc. (3 September 1858;
> III, 212–13)

> [Il faut avouer que nos modernes (je parle des Racine, des Voltaire)
> n'ont pas connu ce genre de sublime, ces naïvetés étonnantes qui
> poétisent les détails vulgaires et en font des peintures pour l'imagina-
> tion et qui la ravissent. Il semble que nos hommes se croient trop
> grands seigneurs pour nous parler comme à des hommes, de notre
> sueur, des mouvements naïfs de notre nature, etc.]

These instances validate the *Journal*'s own "détails vulgaires"; from this
"heap" emerges the indefinable unity which he perceives in Shakespeare
and the mountains around Baden, the "self" of the diary. The same con-
clusion is reached at precisely the same time through a parallel, and
highly significant, experience—reading the *memoirs* of Saint-Simon:
"Under his pen all those everyday adventures take on an incredible inter-
est" (3 September 1858; III, 212–13).
"I have said that in those great men whose element is the sublime, art
appears to play a secondary role. They would need, which is impossible,
inspiration at every moment: they would need, every time they spread
their wings, to find a favorable wind" (30 November 1857; III, 164). But
this impossibility is precisely the goal—and achievement—of the writing
of Montaigne, which has "all the liveliness of impressions rendered and
expressed as soon as they are felt" (Supplement; III, 447), the improvisa-

[30] This sentence, and the long passage it introduces, is Delacroix's comment, not, as
the Joubin edition prints it, part of the quotation.

tions of Byron, which can "recover inspiration on command" (21 July 1850; I, 392), and the essayistic entries of the *Journal*, which preserve the "freshness of the first draft." Indeed, Delacroix considers it a quality of the very greatest minds to enjoy the liveliness of impression which characterizes youth, while gaining the sureness of expression and the intelligence which come with age, contrary to the law of nature. Noting the calming of his own sensibility over the years, and his corresponding growth in understanding, he remarks: "Perhaps the very great men, and I believe this absolutely, are those who have preserved, at the age when the intelligence has all its strength, a portion of that impetuosity of impression which is the characteristic of youth" (9 October 1849; I, 314).

Many of these same issues arise in Delacroix's reflections on a subject which he considered directly pertinent, the new art of photography. His critique of photography presents the same ambiguities as his critique of writing, allowing him to refine and revise his conception of the pictorial (notably perspective and composition) as he does, through the *Journal*, his conception of writing. Like the diary, photography had an unquestionable effect on his understanding of nature and the work of art. If, like literature, photography is in his view inferior, perhaps even *because* it is so, it is nevertheless the locus of experimentation, the space of reflection for his ideas about art.

Like writing, photography was a form which Delacroix consistently rejected and practiced at the same time. He sat for numerous photographs from 1842 onward and was fascinated by the new photo-mechanical techniques. As others have pointed out, he marvelled at the results of photography and was enthusiastic about the possibilities it offered to the artist.[31] As he wrote to his friend, the artist and photographer Constant Dutilleux, in 1854:

> How I regret that such an admirable invention comes so late. . . . The possibility of doing studies after such results as it gives would have had on me an influence which I can imagine only by how useful they still are to me, even with the little time I can devote to doing thorough studies: it is the palpable demonstration of the true design of nature, of which we otherwise have only very imperfect ideas.[32]

In 1853 he notes that, had the daguerreotype been invented thirty years

[31] Aaron Scharf, *Art and Photography*, chap. 4; Van Deren Coke, *The Painter and the Photograph: From Delacroix to Warhol*, 9; F. Trapp, "The Art of Delacroix and the Camera's Eye"; Jean Sagne, *Delacroix et la photographie*.

[32] *Corr.* III, 196 (7 March 1854).

previously, it would have had a tremendous effect on his career (15 October; II, 89). Delacroix was a founding member of the Société hélio-graphique in 1851, the first association of photographers, and was actively engaged in procuring photographs from which to work as early as 1850.[33] In 1854 he collaborated with the photographer Eugène Durieu to produce an album of photographs from which he could subsequently study and draw. Delacroix arranged the models in a variety of poses and Durieu did the photography; for the following three years he took them with him on his holidays and did over eighty drawings from them, both as studies of the human form and as the inspiration for specific pictures. He frequently had his own works photographed.[34]

But for Delacroix photography had the same indiscriminating inclusiveness, the same indiscreet exactitude as the realist novel. Like the novel, it suffers from an excess of detail which "drowns" the whole, paralyzes the eye, and abandons the mind to *ennui:* "If the eye had the perfection of a magnifying glass, photography would be unbearable: one would see every leaf on a tree, every tile on a roof, and on these tiles moss, insects, etc." (1 September 1859; III, 232). It lacks the composition of painting, leaving the eye and mind of the viewer no rest in which to reflect on a few selected and meaningful objects.[35] The edge is as interesting and as visually important as the center; the accessory occupies as important a place as the main image and often obscures it altogether. A photograph is, like the painter's model, a "dictionary," not a composition.[36]

Moreover, the exactitude of the photographic image, its "despairing perfection,"[37] makes it a monstrosity, falsifying the operation of the eye, which does not "see" everything within the field of vision, but selects and chooses according to the state of mind, the memory, and the immediate circumstances of the viewer:

> In front of nature, it is our imagination which makes the picture: we see neither the blades of grass in a landscape, nor the blemishes in the skin of a pretty face. Our eye, in its happy inability to perceive

[33] An unpublished note in the *Journal* for 4 February 1850 says: "Demander à Boissard des daguerréotypes sur papier."

[34] See, for example, *Journal,* 14 November 1853 (II, 111–2): "[Riesener] me conseille de publier mes croquis au moyen de la photographie; j'avais eu cette pensée qui serait féconde." In 1860, he gives two studies to Charles Nègre to be photographed (6 July 1860; III, 295). Photographs were also taken of the Saint-Sulpice murals, though seemingly without success (*Corr.* IV, 267; 23 August 1861).

[35] The notion of "repose" for the eye is traditional. See De Piles, for whom it is necessary to composition for concentrating the effect (Puttfarken, *Roger de Piles' Theory of Art,* 93).

[36] "De l'enseignement du dessin," *O.L.* I, 17, 58.

[37] Ibid., 17.

these infinitesimal details, only communicates to our mind what it should perceive; the latter itself performs a further operation, unknown to us; it does not take account of all the eye presents to it; it connects the impressions it feels to other, prior ones, and its pleasure depends on its present disposition. (1 September 1859; III, 232)

[Devant la nature elle-même, c'est notre imagination qui fait le tableau: nous ne voyons ni les brins d'herbe dans un paysage, ni les accidents de la peau dans un joli visage. Notre oeil, dans l'heureuse impuissance d'apercevoir ces infinis détails, ne fait parvenir à notre esprit que ce qu'il faut qu'il perçoive; ce dernier fait encore, à notre insu, un travail particulier; il ne tient pas compte de tout ce que l'oeil lui présente; il rattache à d'autres impressions antérieures celles qu'il éprouve et sa jouissance dépend de sa disposition présente.]

Photography betrays the conceptual experience of vision, in which the brain receives a "tableau," a pictorial selection of reality, rather than the overwhelming "heap of materials" that characterizes photography and writing: "You see only what is interesting, whereas the instrument will have registered everything" (12 October 1853; II, 86). In so doing, it betrays the purposes of art itself—"il faut intéresser avant tout"[38]— keeping the mind from languishing, as with a novel, "amidst that monotony and that emptiness" (1 September 1859; III, 233).

Despite its alleged realism, photography is, for Delacroix, abstract in its means, like the printed word, lacking the materiality which is the basis of aesthetic emotion; the representation is not itself a source of sensual— and consequently, spiritual and intellectual—delight. Painted images, or even engraved and etched ones, carry the mark of their material creation: the tangible quality of paint or brushstroke, thickness of line, marks of hatching. Photography, like writing, partakes of death, for it is a surface without depth and without corporeality, freezing, likewise, the mind of the viewer. It makes no concessions to the mobility of the imagination either through the materiality of touch, texture, and tone, or through the choice and highlighting of objects. Indeed, for Delacroix, the best photographs are those in which the imperfections of the process do not allow everything to be rendered absolutely, but instead leave gaps allowing the eye to reflect on certain objects. The calotype, to which he refers, was usually considered inferior because less precise and detailed than the daguerreotype.[39] But it corresponded to his concern for less detail and also for a certain materiality: the paper negative produced a less precise

[38] O.L. I, 60
[39] Sagne, *Delacroix et la photographie*, 25f.

print than the metal one, preserving the texture of the paper and rendering masses of light and shade.

Yet if showing what the eye does not see is in one sense a fault of photography, it is also the source of its value and its ongoing attraction for Delacroix, as the *Journal* repeatedly attests: "I look passionately, and without wearying of them, at these photographs of male nudes, this admirable poem, this human body on which I am learning to read, and the sight of which tells me more about it than all the inventions of scribblers " (5 October 1855; II, 399). A photograph may not be a poem, but it nevertheless brings out the poetry of reality and teaches the viewer to read nature anew. Comparing some of Durieu's photographs, even the least successful ones, with the engravings of Marcantonio after Raphael, Delacroix is led to see the falsity of these latter images, and the manner of seeing they presuppose:

> After examining those photographs of nude models, some of which were of a poor sort, and with some exaggerated parts and hardly pleasing in their effect, I brought out the engravings of Marcantonio. We experienced a feeling of repulsion, and almost of disgust, at the incorrectness, the mannerism, the lack of naturalness, despite the quality of style, the only one there was to admire, but which we no longer admired at that moment. In truth, if a man of genius makes use of the daguerreotype as it should be used, he will rise to heights that we do not know. . . . Up to now, this art by means of a machine has only done us a detestable service: it spoils masterpieces for us, without satisfying us completely. (21 May 1853; II, 58–59)

> [Après avoir examiné ces photographies qui reproduisaient des modèles nus, dont quelques-unes étaient d'une nature pauvre et avec des parties outrées et d'un effet peu agréable, je leur ai mis sous les yeux les gravures de Marc-Antoine. Nous avons éprouvé un sentiment de répulsion et presque de dégoût, pour l'incorrection, la manière, le peu de naturel, malgré la qualité de style, la seule qu'on puisse admirer, mais que nous n'admirions plus dans ce moment. En vérité, qu'un homme de génie se serve du daguerréotype comme il faut s'en servir, et il s'élèvera à une hauteur que nous ne connaissons pas. . . . Jusqu'ici, cet art à la machine ne nous a rendu qu'un détestable service: il nous gâte les chefs-d'oeuvre, sans nous satisfaire complètement.]

This experience is confirmed repeatedly: a photograph of Rubens's *Raising of the Cross* shows up all the painting's imperfections of drawing, which Delacroix had not noticed through the color and execution of the real

thing (24 November 1853; II, 119); photographs of Marcantonio's engravings after Raphael make all the clearer the "incoherences" and "weaknesses" of the conception (19 November 1853; II, 114). If, in the view of some of his contemporaries, photography risked dehumanizing the artist,[40] it could on the contrary reinvest the artist, as a viewer, with humanity, counteracting the dehumanizing effect of tradition and restoring the individual's *own eyes*. It is photography which makes Delacroix exclaim: "We accept all that tradition offers us as something consecrated, we see with the eyes of others; artists are the first to be taken in, and are more duped by this than the public. . . . What would you say of these pious imbeciles who stupidly copy those inadvertencies of the painter of Urbino and offer them up as sublime beauties?" (19 November 1853; II, 116).

The last time Delacroix's eyes had been made to see as they had never done before, and to cease "seeing with the eyes of others," was an experience universally agreed to be of immeasurable importance for his life and work, his voyage to Morocco in 1832, which transformed his conception of light, color, and form, and convinced him of the falsity of the neoclassical conception of the antique, specifically that of David. The experience of photography likewise leads him to rethink his notion of the image, and provokes extensive discussion of issues such as pictorial unity, hierarchy and subordination, compositional arrangement and choice. It participates in the same network of issues—and passages—around writing and painting, and develops the same aesthetic. The disproportion in a photograph is not so very different from Delacroix's experience of the Antin oak recorded at about the same time: details take on enormous proportions, as in a photograph, or an entry of the *Journal*. His criticism of the photograph as a fragment, a part cut from some greater whole, is counterbalanced by his own observations of the "microcosmic" forms of nature discussed above—each branch resembling the whole tree, a feather made up of a million feathers, and so on. His analogy of the photograph and the dictionary should be seen in the context of his own choice of the dictionary form for his treatise on the fine arts—a form discontinuous, repetitive, and contradictory like the *Journal*, having the freedom and variety that stimulate the imagination. Photography's defect of presenting everything to the eye, and all at once, may be a virtue, showing what the eye does not see, freeing it from the structures and habits by which it

[40] Baudelaire's tirade in the *Salon de 1859*, the year of photography's entry into the official exhibition, is the most famous example, but a rhetoric of dehumanization pervades the discourse on photography in the period overall. See Scharf, *Art and Photography*, esp. chaps. 5 and 6; Robert Sobieszek, "Photography and the Theory of Realism in the Second Empire: A Reexamination of a Relationship," 149f.

organizes reality, and realizing the plurality of perspectives, the "other view," which he regarded as a pictorial, and literary, ideal. Moreover, the "natural truth" of photography is the same quality which leads him to the "blasphemous" judgment that Rembrandt may be a far greater painter than Raphael: "I find in myself, the further I go on in life, that truth is what is most beautiful and most rare" (6 June 1851; I, 439).[41]

The aesthetic of the *Journal* is consistent with some of the most characteristic features of Delacroix's style, notably his use of color; line imposes the exclusion, irreversibility, and single-mindedness of writing. As we have seen, the analogy is traditional in the history of art theory and was current in Delacroix's time.[42] Accordingly, for Thoré, linguistic description is appropriate for Ingres or monochrome bas-reliefs, whereas colorist works must be seen.[43] As J. Lichtenstein argues, it is color which constitutes the autonomy of painting, allowing it to "escape the hold of discourse";[44] it is color that fulfills the theoretical requirements of the *Journal*. For the determinate forms, the "clarity," "appropriateness," and "correctness," the stable, finite meaning of line, color substitutes forms fluid and shifting, spreading beyond the lines that should contain them. Dependent on light, color is necessarily variable and unstable;[45] it floats, wanders, blurs the boundaries between objects, merges them, unifying the painting by keeping the figures from isolation and total separateness.[46] As Johnson has noted, the freedom and unevenness of Delacroix's contours make the colors shade into the ones around them.[47] Line separates and demarcates, producing an effect of "discontinuity," "gaps," "a lack of unity";[48] color creates a system of correspondences and allusions, a complex pattern of relations, which defines Delacroix's notion of pictorial unity, or "liaison" (25 January 1857; III, 41).[49] For all its brilliance and directness, it has the discretion which he prizes in the image over the noisy and pestering persistence of writing: "In contrast to common opinion, I would

[41] Cf. his later quotation of Boileau: "Rien n'est beau que le vrai" (III, 196).

[42] See above, Introduction, 14–15.

[43] *Le Temps*, 9 August 1861 (quoted in Sérullaz, *Peintures murales*, 166).

[44] *La Couleur éloquente*, 13f.

[45] Puttfarken, *Roger de Piles' Theory of art*, 66.

[46] It is precisely the separation of Poussin's figures that allows them to be read as a narrative, a causal and temporal sequence (Puttfarken, *Roger de Piles' Theory of Art*, 15). Delacroix deplored this "cut out" quality of Poussin's figures and admired the more colorist unity of Lesueur: "Cette prétendue conscience donne aux tableaux du Poussin une sécheresse extrême. Il semble que toutes ses figures sont sans lien les unes avec les autres et semblent découpées; de là ces lacunes et cette absence d'unité, de fondu, d'effet, qui se trouvent dans Lesueur et dans tous les coloristes" (6 June 1851; I, 439).

[47] Johnson, *Delacroix*, 80.

[48] 6 June 1851 (I, 439). The terms are applied to Poussin and Raphael.

[49] Cf. Johnson, *Delacroix*, 78f.

say that color has a force more mysterious and even more powerful; it acts, so to speak, without our being aware of it" (6 June 1851; I, 437).

The repetition of tones associates disparate objects in the picture and qualifies them in terms of one another, thus representing the combinatory, associative unity of the *Journal*. Different combinations of pigments multiply these connections through a kind of tonal modulation:

> When I find that linen has a violet shadow and a green reflection, have I said that it presents only these two colors? Isn't orange necessarily in it too, since in green you have yellow, and in violet you have red?[50]

Similarly, a red flag has violet shadow and orange transparency, but green is present too, because the yellow in the orange, and the blue in the violet, combine to form green.[51]

Delacroix's use of reflections—specks or "spots" of color referring to one another back and forth across the surface of the canvas—is consistent with this notion of unity.[52] As he describes them, such reflections "form a unity from objects very disparate by their color" (13 January 1857; III,14). He relies on optical mixtures, the impression of a single tone caused by the juxtaposition of different ones, and on the law of complementary color, the mutual enhancement of complementary tones because each is tinged with the other—red with green, yellow with violet, blue with orange.[53] An unpublished note dated 5 September 1861, just after the completion of the Saint-Sulpice murals, describes this play of contrasts: the green wallpaper makes his white bed curtains appear green in their deep folds and rose in the outer folds closest to him; in fair-skinned people violet dominates the color of the skin and is contrasted by yellow highlights.[54] Shadows on the sand bathed in sunlight are violet, making

[50] "Quand je trouve que le linge a l'ombre violette et le reflet vert, ai-je dit qu'il présentait seulement ces deux tons? L'orangé n'y est-il pas forcément, puisque dans le vert se trouve le jaune et que dans le violet se trouve le rouge?" (*O.L.* I, 72). René Piot remarks, on the basis of Andrieu's observations, that Delacroix mixed his combined colors only lightly with the palette knife, "de façon à laisser jouer dans le mélange les deux ou trois couleurs pures qui le composaient" (*Les Palettes de Delacroix*, 66).

[51] *O.L.* I, 72.

[52] See L. de Planet, *Souvenirs de travaux de peinture avec M. Eugène Delacroix*, 30: "Le reflet emprunte toujours le ton de l'objet qui le détermine"; Johnson, *Delacroix*, 78f., and his discussion of Saint-Sulpice (V, 174); Jack Spector, *The Murals of Eugène Delacroix at Saint-Sulpice*, 146ff. On the unifying effects of reflections, see Diderot, *Essais sur la peinture*, 689.

[53] Cf. the note on this in his Chantilly notebook, taken from Mérimée's *De la peinture à l'huile* (1830). Delacroix adds, "La tête des deux petits paysans. Celui qui était jaune avait des ombres violettes. Celui qui était plus sanguin et plus rouge, des ombres vertes" (Guiffrey, *Le Voyage d'Eugène Delacroix au Maroc*, 154).

[54] Bibliothèque d'Art, ms. 250, f. 93.

the sand itself a purer yellow.[55] These concerns recur throughout the *Journal* in extensive color notes for his paintings.

Color harmony is thus based on fragmentation, like the *Journal*, a unity composed of disparate and shifting parts, like the unity of nature itself. A color contains the reflections from surrounding objects; shiny or polished objects have no color "of their own," but are almost mirrors, reflecting surrounding tones (13 January 1857; III, 13). He observes with interest the prismatic effect of his gray jacket in the sunlight: "All the colors of the rainbow were shining in it as in crystal or a diamond. Each of these shiny fibers reflected the most brilliant colors, which changed with each movement that I made" (4 November 1857; III, 143). This is the shimmering, flickering, metamorphosing image by which Baudelaire represents color in his 1846 *Salon*, the correspondences by which "red sings the praises of green," the unified tone of a multicolored spinning top, the reciprocal exchange, reflection, modulation, and shading that take place with the continuous changing of the light, the symphony of color produced through a variety of individual tones.[56] And for Baudelaire, significantly, such a unity defies the restrictive linearity of the prose which would describe it.[57]

Like the *Journal*'s writing, Delacroix's paintings have a mobility, animation, and restlessness,[58] created not only through the play of tones and reflections, but also through an agitated, irregular, and broken brushstroke, variation in touch, and use of impasto and hatching.[59] The importance of making the brushwork evident, and of not so finishing the work as to hide it, is stated clearly in the *Journal*: touch is a means of expression, a way of rendering thought, so many "indications de la pensée" (13 January 1857; III, 17). As Johnson shows, in defining his figures he also relied on uneven, irregular contours, thus producing a sense of continuous movement, varying the edge as though the object were not wholly fixed in space; the line moves from thick to thin, and frequently breaks altogether, letting the color spill over or the underpainting show through.[60]

The relative spontaneity of the *Journal*'s writing, the improvisatory

[55] *O.L.* I, 73.

[56] *Oeuvres complètes* II, 422ff. Cf. de Piles' notion of pictorial harmony as a concert (*Cours de peinture par principes*, 111f., quoted in Mras, *Eugène Delacroix's Theory of Art*, 38 n. 103; also Puttfarken, *Roger de Piles' Theory of Art*, 78), and Diderot's "multitude innombrable de prêts et d'emprunts" (*Pensées détachées sur la peinture*, 809).

[57] *Salon de 1846, Oeuvres complètes* II, 437 ff.

[58] Cf. Elizabeth Abel, who signals the movement in Delacroix's paintings as a way of incorporating "some of literature's temporal movement into what he felt was painting's superior simultaneity" ("Redefining the Sister Arts: Baudelaire's Response to the Art of Delacroix," 375).

[59] Johnson, *Delacroix*, 78.

[60] Ibid., 79f.

quality of its composition, is consistent with Delacroix's working methods too. From the many notes, drawing, sketches, and studies which preceded a finished picture, it is clear that he altered his original conception considerably as he went along.[61] Even in his large decorative schemes, he did not carry out a fixed plan, but evolved the idea as he worked, as Anita Hopmans has shown.[62] In the effect of his paintings, he was concerned to preserve an element of spontaneity within the formal work, the quality of the "premier jet," the original inspiration, a mark of personal passion within an ordered and organized expression.[63] In his note on touch for the *Dictionnaire des Beaux-Arts*, he implies that paintings must have an "unfinished" effect when viewed from close to, in order to seem unified from a distance, precisely the point made about the Antin oak, Shakespeare, and the mountains around Baden, in the context of disproportion, lack of finish, and the sublime: "At a certain distance the touch blends into the whole, but it gives to the painting an accent which the blend of tones cannot produce. In contrast, on seeing the most finished work from close to, one will still discover traces of touches" (13 January 1857; III, 17).[64] This is the "improvisational" method theorized in the *Journal* and confirmed later, as we have seen, by his conversation with Corot: "Execution in painting must always partake of improvisation" (27 January 1847; I, 174).[65] It preserves within the temporal, successive, "literary" process of execution a painterly immediacy, the freshness of an ongoing inspiration: "He [Corot] maintains, like some others who perhaps are not wrong, that despite my desire to systematize, instinct will always win out with me" (14 March 1847; I, 206). Significantly, improvisation and composition are

[61] Spector, *The Death of Sardanapalus*, 46.

[62] "Delacroix's Decorations in the Palais Bourbon Library: A Classic Example of an Unacademic Approach." The subjects of the hemicycles at each end of the library, so crucial to the theme of the whole—*Orpheus Civilizes the Greeks*, and *Attila and his Barbarian Hordes Overrun Italy and the Arts*—were not decided definitively until early 1843, after the cupolas were well underway. They emerged in the doing, crystallizing around a rough idea through the catalyst of chance: two sentences encountered in the *Revue des deux mondes*. (The Orpheus subject, however, had been considered early on, as the B.N. ms. proves. See below, 149 n.55.) One of Delacroix's complaints against fresco was the necessity of conceiving all the effects of the whole beforehand (25 January 1857; III, 31).

[63] Johnson finds this especially in the late work (*Delacroix*, 102).

[64] Delacroix was repeatedly accused of carelessness, weak execution, and a lack of finish by contemporary critics, of leaving the image unresolved, undefined, not clearly legible, confused and confusing. Baudelaire notes that "les critiques n'ont pas manqué, comme à l'ordinaire, pour lui reprocher de ne savoir peindre que des esquisses" (*Salon de 1859*, *Oeuvres complètes* II, 635); Gustave Planche remarks that Delacroix frequently takes a study for a finished painting (*Revue des deux-mondes*, 15 November 1851). See below, chapter 6, 193–95, as well.

[65] See above, chapter 1, 44.

not incompatible: "The predominance of inspiration does not involve the absence of all genius for combining things . . . Alexander proceeded, according to the expression of Bossuet, in great and impetuous spurts" (Supplement; III, 429).

Relative to other autobiographical forms, a diary disrupts most explicitly the hierarchy of value by which importance is ascribed to events. In Delacroix's, trivial incidents are often privileged over seemingly more important ones: a quarrel with the gardener or a recipe for making coffee receives ample space while tumultuous public events may go unmentioned; the world is openly organized according to the idiosyncratic view of the subject within it, without the pretension to reproduce and parallel history which marks memoirs and narrative autobiography. His frequent comments on the importance of the pictorial *ensemble* would seem to contradict the *Journal*'s flouting of this, and yet his paintings too may be seen to disrupt realistic hierarchies. Proportion, exactitude, and conformity to the real are rejected in favor of effect. "It is exactitude for the imagination that I require" (10 October 1855; II, 403): Delacroix seeks a conformity only to the artist's conception of the subject, involving a disruption of hierarchy akin to the *Journal*'s representation of experience.[66]

On the level of sense, the aesthetic of the *Journal* can be related to the extraordinary complexity of Delacroix's narrative paintings. It accounts for the striking phenomenon, in his choice of subjects, of what we might call transitional moments, moments of uncertainty, tension, and indecision, however "final" the titles or the subject may seem: the scene poses the struggle, the conflict, the precariousness, rather than the resolution—the moment when the action could go either way. This is clearly related to his concern for dramatic interest, his conception of the action of history painting. Yet it is also significant for his idea of history and of the story the painting tells. The ceiling of the Apollo gallery shows not the triumph, but the combat, of Apollo, at a moment when the difference between victory and defeat lies, as he says explicitly, in a few remaining arrows. Liberty leads the people on barricades built up from the fallen corpses of revolutionaries—an image consistent with Delacroix's life-long ambivalence about revolution.[67] Peace bringing back abundance to the earth in the Salon de la Paix of the Hôtel de Ville represents still the suffering of Earth, with a figure having the pathos of Eve supplicating God in vain after the Fall (in the Palais Bourbon library), or of Greece on the ruins of

[66] The criticism of the mare in the foreground of *Ovid among the Scythians* (1859)—large enough to be the "mare of the Trojan horse"—is only one example: the figures should have been "better subordinated one to the other," according to a "more ordered hierarchy" (quoted in Johnson 334).

[67] See above, chapter 1, 50–51.

Missolonghi.[68] In these "narrative" paintings, Delacroix breaks the strict rules of narrative, pointing up the uncertainty of the outcome, and the alternatives to it; in so doing he points up as well the fragility and precariousness of that outcome, its ongoing susceptibility and vulnerability to the influence of fortune, or of time.

Similarly, his narrative cycles do not follow a fixed sequence, but explore the subject loosely in its diverse aspects, moving the viewer back and forth through formal, iconographical, and coloristic connections, and deepening, qualifying, and enriching the sense accordingly. A work will not be "read" in a single, linear manner any more than the *Journal* should be read as a narrative autobiography; rather, through the multiple connections among its parts, it will translate the variety and complexity of the subject that he considered one of painting's chief benefits.[69] From the Palais Bourbon and the Luxembourg libraries to the chapel at Saint-Sulpice, Delacroix poses the questions—of the value and limits of culture, or the relation of human and divine—questions ruminated in the *Journal* as well, debated and considered at different times from different points of view. In these works, he emphasizes the give and take which alone can convey the complexity of a subject in time, accommodating the "literary" temporality of the imagination with the "pictorial" many-sidedness of truth, the "for and against," the multiple perspective, the "panoramic view" of different possible routes which is for him the truth of painting, and of human experience too.

[68] Johnson V, 138.

[69] For Louis Marin, such a multiplicity of possible choices, far from shattering the unity of the painting, constitutes the unity proper to painting. Although there are constraints on the viewer's freedom, imposed by the painting's "rhetoric," its representational premises, and so on, the "circuit" always includes the possibility of choice: "La relative liberté de parcours en impliquant hésitations, retours, différences, n'engage jamais le regard dans un mouvement linéaire irréversible . . . Ainsi la somme ouverte des parcours possibles réalisés ou virtuels forme système." The unity of painting consists precisely in the relation of possible readings within the *ensemble*. See *Etudes sémiologiques: Ecritures, peintures*, 21.

1. Delacroix. Pages from the *Journal*, 28–29 January 1857. Notes for the *Dictionnaire des Beaux-Arts* with extensive cross-referencing. Paris, Bibliothèque d'Art et d'Archéologie, Fondation Jacques Doucet.

2. Delacroix. Pages from the *Journal*. Note of 20 November 1857 (continuing on the 16th and 17th), showing Delacroix's practice of recopying, quotation, autocitation, and cross-referencing. Paris, Bibliothèque d'Art et d'Archéologie, Fondation Jacques Doucet.

3. Delacroix. Pages from the *Journal*. Note of 23 March 1855 (continuing on the 22nd), with insertion dealing with the same theme from 25 September, marked by an "X". Paris, Bibliothèque d'Art et d'Archéologie, Fondation Jacques Doucet.

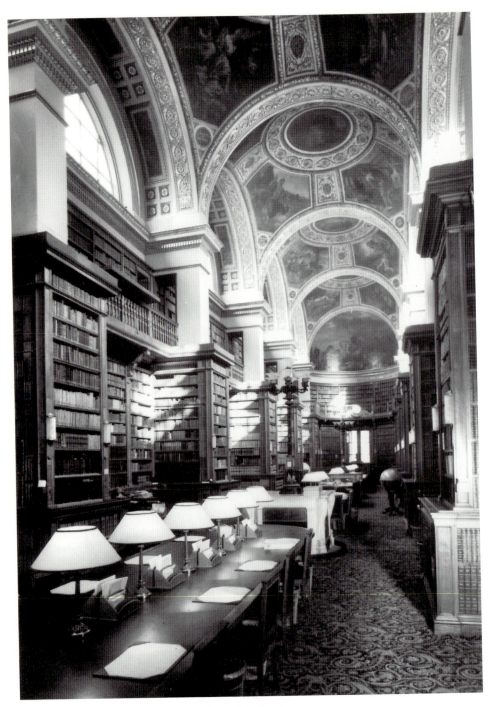

4. Deputies' Library, general view. Paris, Palais Bourbon.

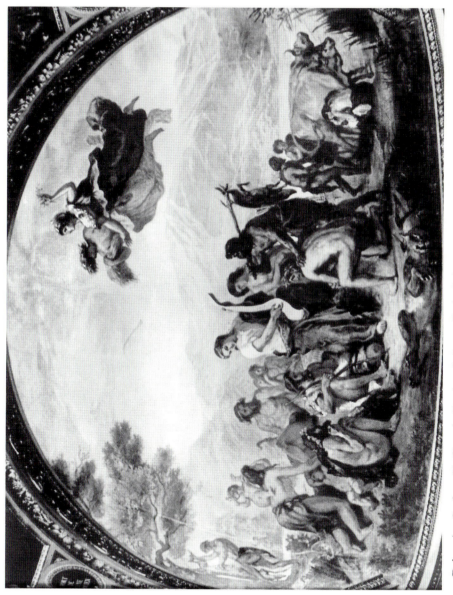

5. Delacroix. *Orpheus Civilizes the Greeks*, 1838–47. Paris, Palais Bourbon.

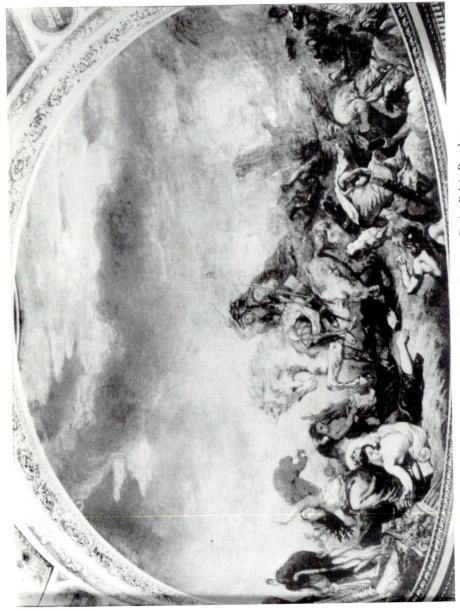

6. Delacroix. *Attila and his Hordes Overrun Italy and the Arts*, 1838–47. Paris, Palais Bourbon.

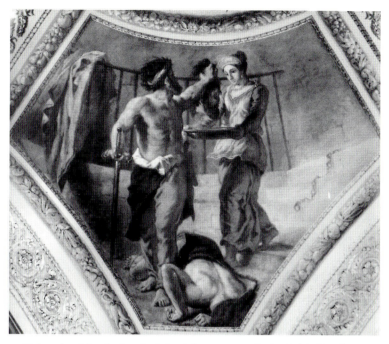

7. Delacroix. *John the Baptist Beheaded*, 1838–47. Paris, Palais Bourbon.

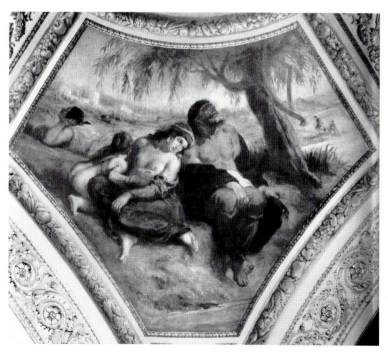

8. Delacroix. *The Babylonian Captivity*, 1838–47. Paris, Palais Bourbon.

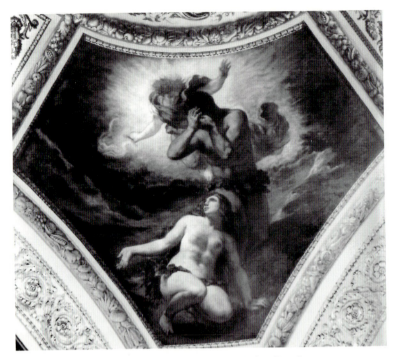

9. Delacroix. *Adam and Eve*, 1838–47. Paris, Palais Bourbon.

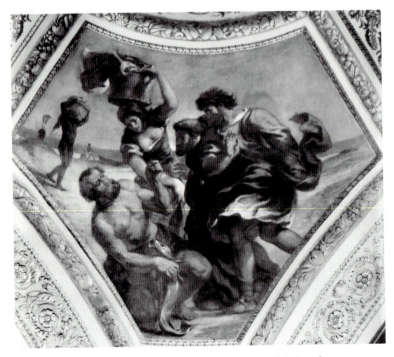

10. Delacroix. *The Tribute Money*, 1838–47. Paris, Palais Bourbon.

13. James Barry. *Elysium*, 1784. RSA, London.

14. James Barry, *Elysium*, detail: Tartarus. RSA, London.

11. Henri Lehmann. *Theology*, 1852. Sketch for the Hôtel de Ville. Paris, Musée Carnavalet.

12. James Barry. *A Harvest Home, or Thanksgiving to Ceres and Bacchus*, 1784. RSA, London.

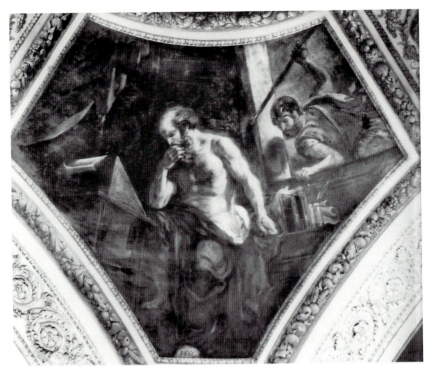

15. Delacroix. *Archimedes Killed by the Soldier*, 1838–47. Paris, Palais Bourbon.

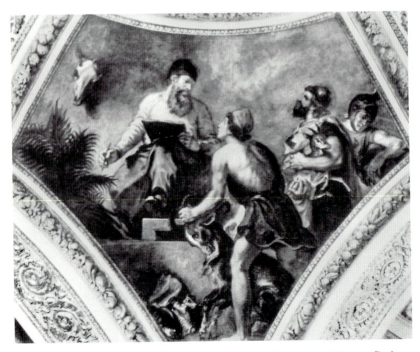

16. Delacroix. *Aristotle Describes the Animals Sent by Alexander*, 1838–47. Paris, Palais Bourbon.

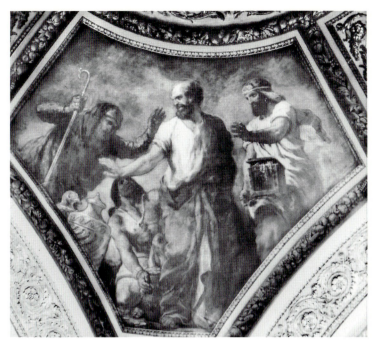

17. Delacroix. *Hippocrates Refuses the Gifts of the Persian King*, 1838–47. Paris, Palais Bourbon.

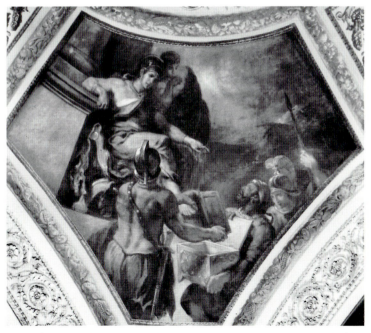

18. Delacroix. *Alexander and the Poems of Homer*, 1838–47. Paris, Palais Bourbon.

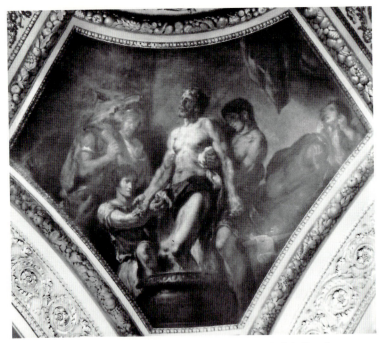

19. Delacroix. *The Death of Seneca*, 1838–47. Paris, Palais Bourbon.

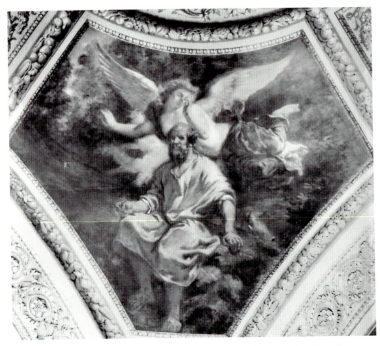

20. Delacroix. *Socrates and his Genius*, 1838–47. Paris, Palais Bourbon.

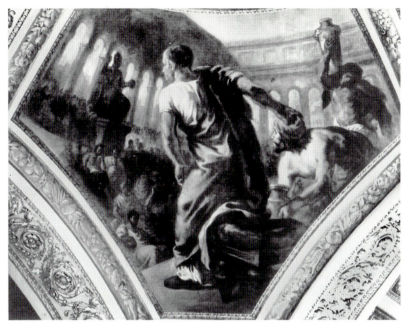

21. Delacroix. *Cicero Accuses Verres*, 1838–47. Paris, Palais Bourbon.

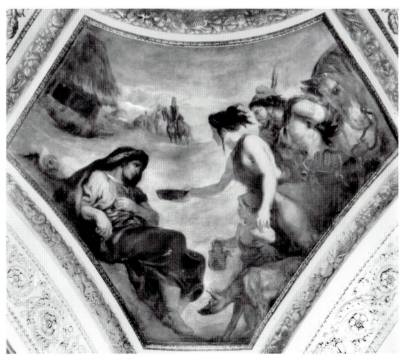

22. Delacroix. *Ovid among the Scythians*, 1838–47. Paris, Palais Bourbon.

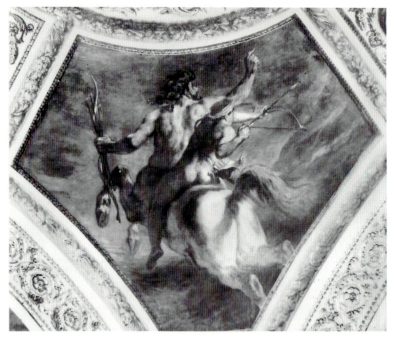

23. Delacroix. *The Education of Achilles*, 1838–47. Paris, Palais Bourbon.

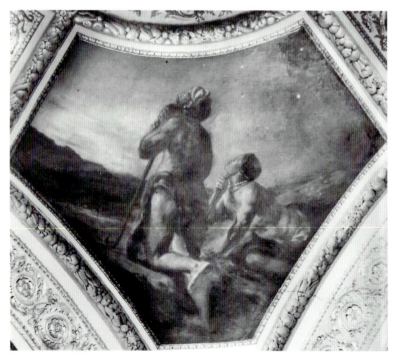

24. Delacroix. *The Chaldean Shepherds, Inventors of Astronomy*, 1838–47.
Paris, Palais Bourbon.

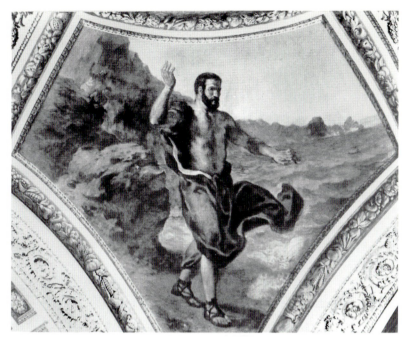

25. Delacroix. *Demosthenes Declaiming by the Seashore*, 1838–47. Paris, Palais Bourbon.

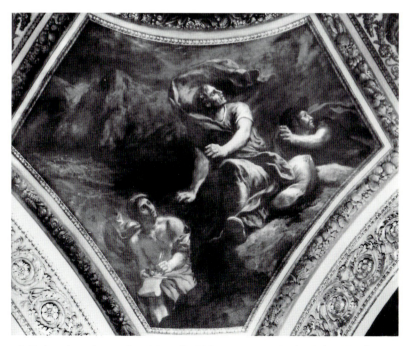

26. Delacroix. *The Death of Pliny the Elder*, 1838–47. Paris, Palais Bourbon.

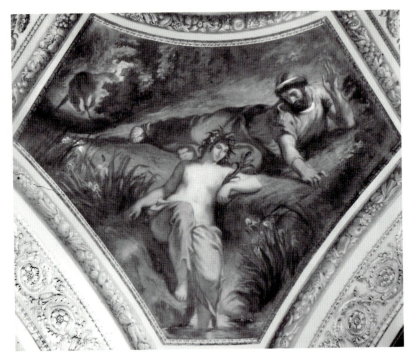

27. Delacroix. *Numa and Egeria*, 1838–47. Paris, Palais Bourbon.

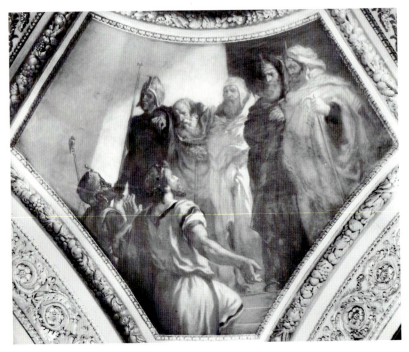

28. Delacroix. *Herodotus Consults the Magi*, 1838–47. Paris, Palais Bourbon.

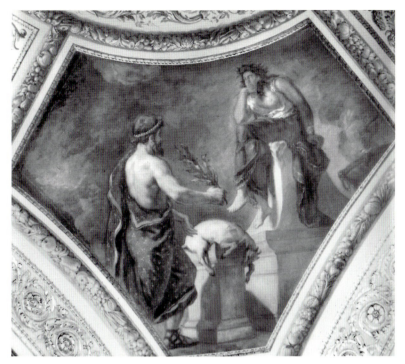

29. Delacroix. *Lycurgus Consults the Pythia*, 1838–47. Paris, Palais Bourbon.

30. Delacroix. *Hesiod and the Muse*, 1838–47. Paris, Palais Bourbon.

31. Delacroix. *Dante and the Spirits of the Great*, 1841–46. Paris, Palais du Luxembourg.

32. Delacroix. *Alexander Preserves the Poems of Homer*, 1841–46. Paris, Palais du Luxembourg.

33. Delacroix. *Alexander Preserves the Poems of Homer*, detail: dead warrior. Paris, Palais du Luxembourg.

34. Delacroix. *Alexander Preserves the Poems of Homer*, detail: captive Persians. Paris, Palais du Luxembourg.

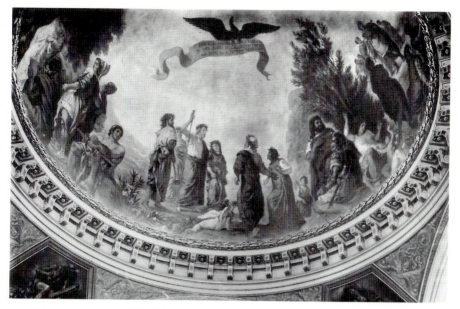

35. Delacroix. *Dante and the Spirits of the Great*, detail: the Homer group. Paris, Palais du Luxembourg.

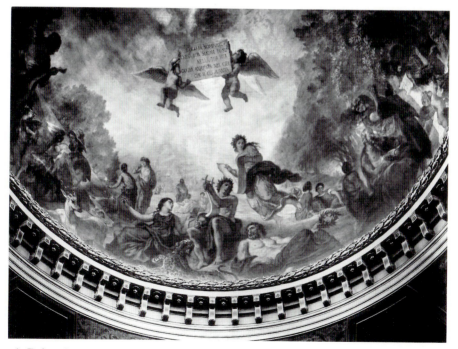

36. Delacroix. *Dante and the Spirits of the Great*, detail: the Orpheus group. Paris, Palais du Luxembourg.

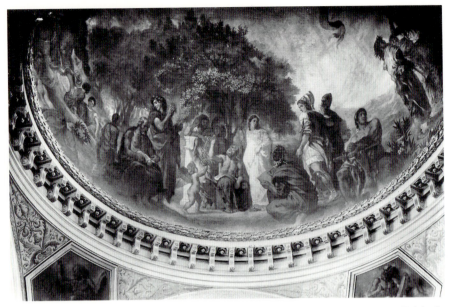

37. Delacroix. *Dante and the Spirits of the Great*, detail: the Greek group. Paris, Palais du Luxembourg.

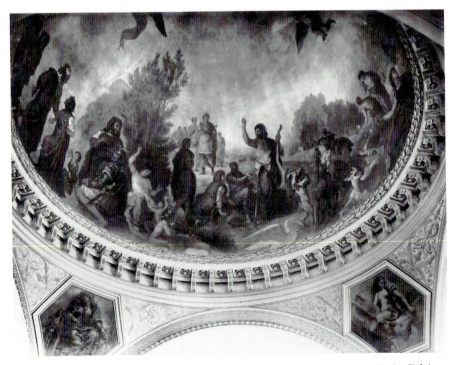

38. Delacroix. *Dante and the Spirits of the Great*, detail: the Roman group. Paris, Palais du Luxembourg.

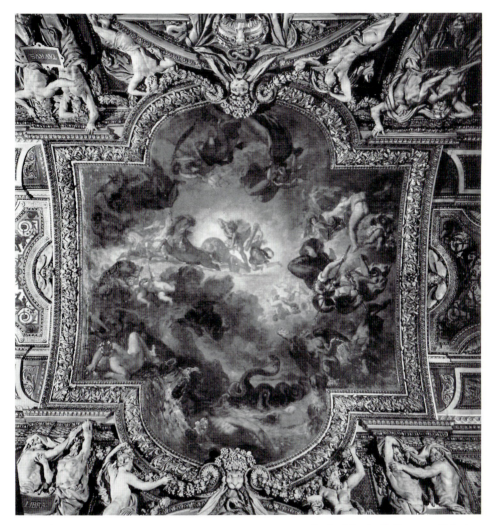

39. Delacroix. *Apollo Slayer of the Serpent Python*, 1850–51. Paris, Musée du Louvre, Galerie d'Apollon.

40. A. Renard de Saint-André, after Le Brun. *Apotheosis of Louis XIV*, engraving from *La Petite Galerie du Louvre*, Paris, 1695.

41. Ingres. *Apotheosis of Napoleon*, 1853. Sketch for the Hôtel de Ville. Paris, Musée du Petit Palais.

42. E. Baudet, after Le Brun. Escalier des Ambassadeurs, Versailles, detail of vault: Apollo and Python. Engraving from L.C. Le Fevre, *Grand Escalier du château de Versailles, dit Escalier des Ambassadeurs*, Paris, 1725.

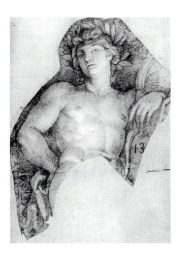

43. Le Brun. *Apollo*. Cartoon for the ceiling of the Escalier des Ambassadeurs, Versailles. Paris, Musée du Louvre, Département des Arts Graphiques.

44. Le Brun. *Monster*. Cartoon for the ceiling of the Escalier des Ambassadeurs, Versailles. Paris, Musée du Louvre, Département des Arts Graphiques.

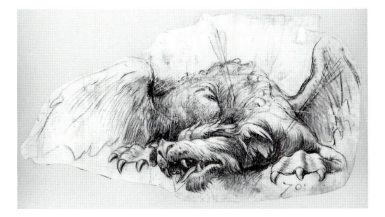

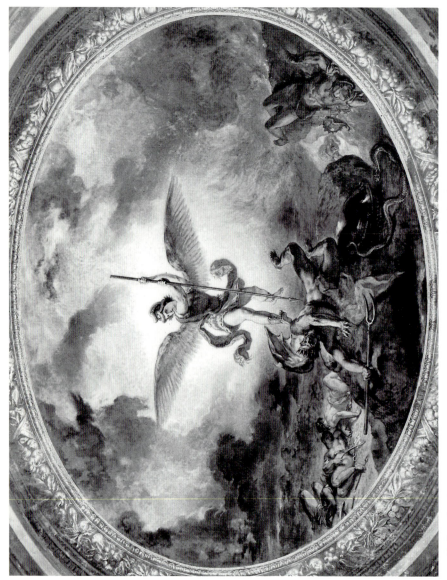

45. Delacroix. *Saint Michael Defeating the Devil*, 1849–61. Paris, Church of Saint-Sulpice.

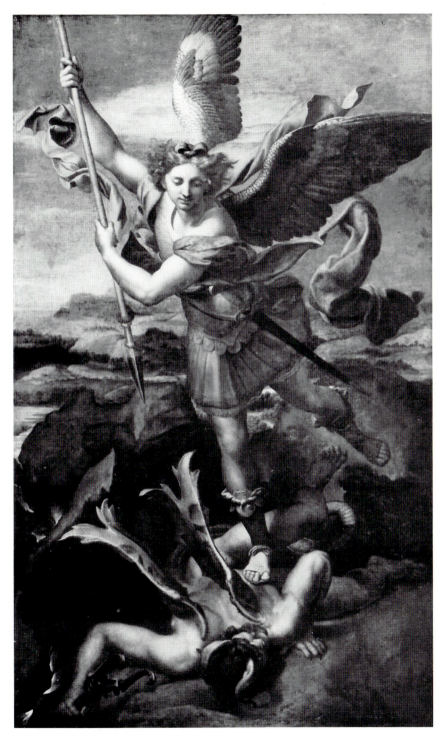

46. Raphael. *Saint Michael*, 1518. Paris, Musée du Louvre.

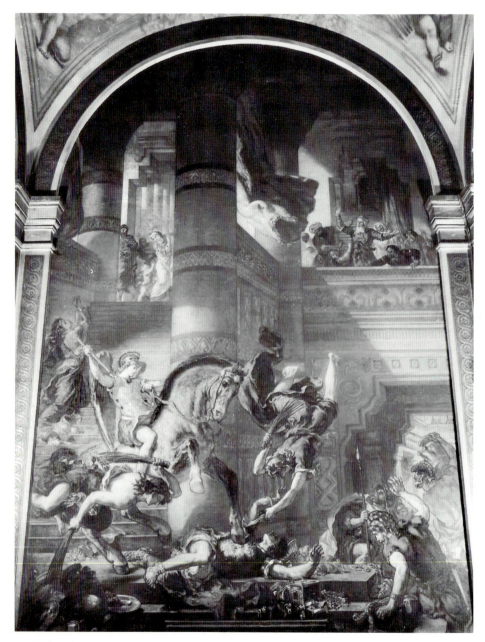

47. Delacroix. *Heliodorus Driven from the Temple*, 1849–61. Paris, Church of Saint-Sulpice.

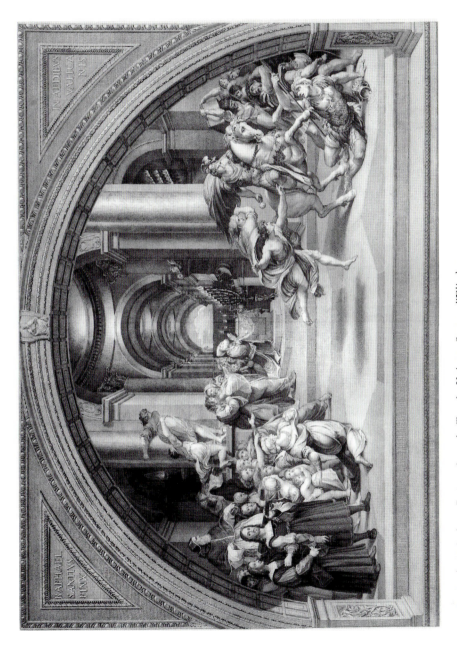

48. Raphael. *Heliodorus Driven from the Temple*. Vatican, Stanza d'Eliodoro.

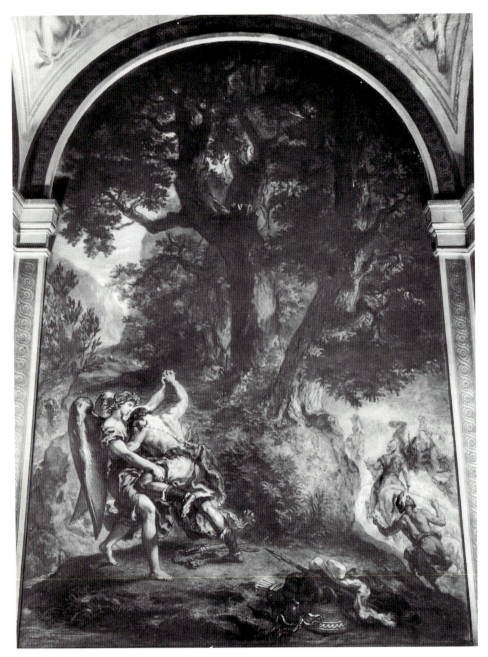

49. Delacroix. *Jacob Wrestling with the Angel*, 1849–61. Paris, Church of Saint-Sulpice.

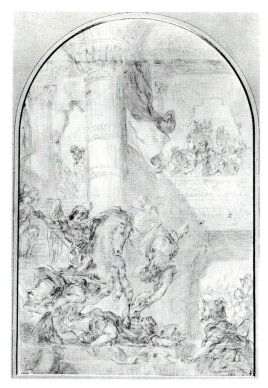

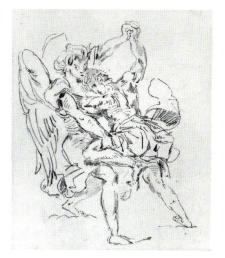

51. Delacroix. Sketch for *Jacob Wrestling with the Angel*. Musée de Grenoble.

50. Delacroix. Sketch for *Heliodorus Driven from the Temple*. Chantilly, Musée Condé.

52. Delacroix. Sketch for *Heliodorus Driven from the Temple*. Paris, Musée du Louvre, Département des Arts Graphiques.

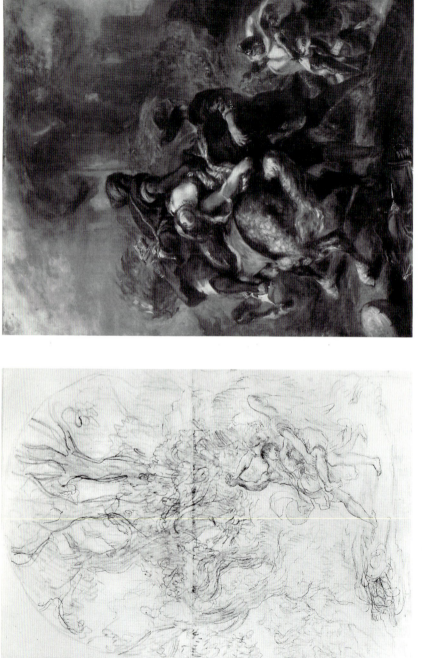

53. Delacroix. Sketch for *Jacob Wrestling with the Angel*. Cambridge, Mass., The Fogg Art Museum, Harvard University Art Museums, Gift of Philip Hofer.

54. Delacroix. *The Abduction of Rebecca*, 1846. New York, Metropolitan Museum of Art.

A Language for Painting
The *Dictionnaire des Beaux-Arts*

IN HIS 1863 ESSAY on Delacroix, Baudelaire defined the peculiar contradiction between the classicism, prudence, and "moderation" of this painter's style of writing, and the suddenness, turbulence, and violence of his art—a distinction noted frequently at the time, and which has persisted to this day.[1] Baudelaire's examples included the various articles which Delacroix had published over the course of his career, from early essays on Lawrence, Raphael, and Michelangelo (1829–30) to the late one on Charlet (1862).[2] But concurrently with these, Delacroix conceived of a more ambitious and innovative critical project, a treatise on the fine arts, which he never completed but which he drafted substantially in the later *Journal*, especially from 1857 onward.[3] This, the *Dictionnaire des Beaux-Arts*, represented a highly experimental and original kind of writ-

[1] *L'Oeuvre et la vie d'Eugène Delacroix, Oeuvres complètes* II, 753f. Vapereau's *Dictionnaire des contemporains* (1858) notes the contrast between the elegance and "mesure" of Delacroix's articles and the "fougue" and "hardiesse" of his painting. E. Véron opposes Delacroix's innovative paintings to his Academic writings, but makes an exception for his notebooks (*Les Artistes célèbres: Eugène Delacroix*, 6ff., 82); cf. Silvestre, *Histoire des artistes vivants*, 70; Phoebe Pool, *Delacroix*, 19f.

[2] Delacroix's published art criticism included the following articles: "Des critiques en matière d'arts" (*Revue de Paris* 2, 1829); "Thomas Lawrence: Portrait de Pie VII" (ibid. 4, 1829);"Raphael" (ibid. 11, 1830); "Michel-Ange" (ibid. 15, 1830); "Sur le *Jugement dernier*" (*Revue des deux mondes* 11, 1 August 1837); "Puget" (*Plutarque français*, 1845); "Prudhon" (*Revue des deux mondes* 16, 1 November 1846); "Gros" (ibid. 23, 1 September 1848); "De l'enseignement du dessin" (ibid., new per., 1st ser., 7, 15 September 1850); "Le Poussin" (*Moniteur universel*, 26, 29, 30 June 1853); "Questions sur le beau" (*Revue des deux mondes*, new per. 2nd ser., 7, 15 July 1854); "Des Variations du beau" (ibid., 2nd per., 9, 15 June 1857); "Charlet" (ibid. 37, 1 January 1862). The latter two are incorrectly dated as July 1857 and July 1862, respectively, in most of the Delacroix literature.

[3] See Christine Sieber-Meier, *Untersuchungen zum "Oeuvre littéraire" von Eugène Delacroix*.

ing about art, a criticism reflecting the concerns and techniques which, as I have argued, inform both the diary and the conception of painting related to it.[4] The conventional art-critical problem of verbalizing the visual, accounting for the workings and effects of one medium through another and, in Delacroix's view, radically different one,[5] is treated in a way unique in the history of nineteenth-century art writing. Delacroix was well suited to the task: not since Joshua Reynolds had a painter of such stature produced such a serious body of writings on art, and not until much later would painters like Matisse, Signac, Denis and others begin to write publicly; in the French tradition, there was no comparable precedent at all. As with the *Journal*, Delacroix theorizes and puts into practice a writing which incorporates the benefits of the image within the domain of time—a writing *about* the image, not based on the superiority of writing *over* the image which discursive criticism implies,[6] but rather proper to painting itself.

In this, his most extensive literary project, Delacroix might have used as a half-serious, half-comical epigraph the line quoted and underlined (without comment) from *David Copperfield* in July 1857: "I never thought, when I used to read books, what work it was to write them" (24 July; III, 111). Indeed, in the myriad reflections on the composition of the *Dictionnaire* which fill the pages of the *Journal*, one encounters all the major issues of the painting-writing debate as Delacroix conceived of it. He specifically sought a form which would avoid the progression, singleness, and false consistency of narrative, its successive "chain" or thread (13 January 1857; III, 26), and would instead approach the essayistic freedom, flexibility, and looseness, the "fits and starts" of his model, Montaigne.

> After the work that the author put in to follow the thread of the idea, incubate it, develop it in all its parts, there is also the work of the reader who, having opened a book to relax, finds himself unwittingly caught up, almost as a matter of honor, in deciphering, understanding, and retaining what he would be only too happy to forget,

[4] See Anne Larue, "Fragments ou pensées détachées? Etude de quelques romantiques," 246f., and Guillerm, *Couleurs du noir*, 43–49.

[5] The bibliography on this problem is immense. For some theoretical points of departure, see J.-P. Bouillon, "Mise au point théorique et méthodologique," 880–900; *Romantisme* 71 (1991), issue on "Critique et art," especially the articles by Dario Gamboni ("Pour une étude de la critique d'art au XIXè siècle," 9–17), and Jean-Pierre Leduc-Adine ("Des règles d'un genre: la critique d'art," 93–100); A.-M. Christin, *L'Espace et la lettre*; D. Scott, *Pictorialist Poetics*; M. Baxandall, *Patterns of Intention: On the Historical Explanation of Pictures*; Salim Kemal and Ivan Gaskell, eds., *The Language of Art History*. For the example of Baudelaire, see Timothy Raser, *A Poetics of Art Criticism: The Case of Baudelaire*, chapter 2.

[6] Cf. J. Lichtenstein, *La Couleur éloquente*, 163.

so that at the end of his enterprise he might have followed with profit all the routes that it pleased the author to make him follow. (7 May 1850; I, 363)[7]

[Après le travail qu'il a fallu à l'auteur pour suivre le fil de son idée, la couver, la développer dans toutes ses parties, il y a bien aussi le travail du lecteur qui, ayant ouvert un livre pour se délasser, se trouve insensiblement engagé, presque d'honneur, à déchiffrer, à comprendre, à retenir ce qu'il ne demanderait pas mieux d'oublier, afin qu'au bout de son entreprise, il ait passé avec fruit par tous les chemins qu'il a plu à l'auteur de lui faire parcourir.]

Accordingly, he considered using the title *Essais* (11 January 1857; III, 9). Such a work would proceed without transitions, hierarchy, or semantic order, an approach motivated specifically, as he suggests, by the *painterly* vision of the author:

One sees a picture all at once, at least in its ensemble and its principal parts. For a painter accustomed to this kind of impression, so favorable to the comprehension of a work, a book is like an edifice . . . in which, once inside, he must give equal attention in succession to the different rooms of which the monument he is visiting is composed, without forgetting those he left behind, and not without seeking in advance, in what he already knows, what his impression will be at the end of the tour. (13 January 1857; III, 26)

[On voit un tableau tout d'un coup, au moins dans son ensemble et ses principales parties: pour un peintre habitué à cette impression favorable à la compréhension d'un ouvrage, le livre est comme un édifice . . . dans lequel, une fois introduit, il lui faut donner successivement une attention égale aux différentes salles dont se compose le monument qu'il visite, sans oublier celles qu'il a laissées derrière lui, et non sans chercher à l'avance dans ce qu'il connaît déjà, quelle sera son impression à la fin du voyage.]

A conventional treatise—methodical, systematizing, and categorical—is for him both false and useless, unfaithful to the changing point of view and the varying opinions of any single intelligence:

To write treatises on the arts as an expert, to divide up, treat methodically, summarize, make systems to instruct categorically: all that is a mistake, wasted time, an idea false and useless. The most capable man can only do for others what he does for himself, that is, to note

[7] As noted earlier, Delacroix cross-references and partially recopies this passage in 1857 when he begins to draft the Preface to the *Dictionnaire* (13 January; III, 28).

and observe as nature offers him objects of interest. With such a man, the points of view change at each moment; his opinions are necessarily modified; one never knows a master sufficiently to speak of him in absolute and definitive terms. (1 November 1852; I, 496)

[Faire des traités sur les arts *ex professo*, diviser, traiter méthodique-ment, résumer, faire des systèmes pour instruire catégoriquement: erreur, temps perdu, idée fausse et inutile. L'homme le plus habile ne peut faire pour les autres que ce qu'il fait pour lui-même, c'est-à-dire noter, observer, à mesure que la nature lui offre des objets intéressants. Chez un tel homme, les points de vue changent à chaque instant. Les opinions se modifient nécessairement; on ne connaît jamais suffisamment un maître pour en parler absolument et définitivement.]

Delacroix aims, rather, for a more spontaneous, if less orderly, writing, tentative and profuse, rich in suggestion, containing multiple and even contradictory perspectives: "Let a talented man, who wishes to set down his thoughts on the arts, pour them out as they come to him; let him not be afraid of contradicting himself; there will be more fruit to be had amid the profusion of his ideas, even if contradictory, than in the thread— combed, tightened, and cut—of a work in which the form will have preoccupied him" (1 November 1852; I, 496).[8]

For this purpose, he considers writing a dialogue or a correspondence, to allow for maximum variety, contrast, and contradiction, "the two sides of life": "Dialogues would allow great freedom, language in the first per-son, easy transitions, contradictions, etc." (25 January 1857; III, 43). Elsewhere he conceived of some dialogues on painting in similar terms: "This form, although old, is perhaps the best to avoid monotony and give piquancy. Also permits suspensions, reflections of all kinds, descriptions, allusions to the most varied things; it can also serve by the contrast of the characters of the interlocutors" (Supplement; III, 430).[9] A series of let-ters would do likewise, permitting a more disrupted progression of topics, and a freedom approaching idiosyncracy in the treatment of them: "The form of letters would be the best. One passes from one subject to another without transition; one is not forced into developments. A letter can be as short and as long as one likes" (9 December 1853; II, 129).[10] He notes specifically the epistolary form of Senancour's *Obermann*, one of his favorite readings, cited extensively in 1857: "The manner of *Ober-*

[8] Once again, Delacroix later cross-references this and the preceding quotation for the Preface to the *Dictionnaire* (13 January 1857; III, 15).

[9] Undated note, probably from the early 1850s.

[10] In 1857 he returns to this idea of writing a dialogue or a correspondence, as a *complement* to the *Dictionnaire* (25 January 1857; III, 43).

mann. —Letters on all kinds of subjects" (25 January 1857; III, 43).
Indeed Senancour insists in his Preface on the non-narrative, irregular
character of his work: "These letters are not a *novel*. There is no dramatic
movement, no plot prepared and carried through, no dénouement."[11]
The protagonist himself reaffirms the importance of what he calls an
"epistolary freedom" within the novel: "If you absolutely wish that I come
back to my first point by a transition within the rules, you will put me in
great difficulty."[12] Like Delacroix, Senancour defends the repetitions oc-
casioned by the epistolary form ("but if the things are good, why carefully
avoid coming back to them?"),[13] as well as its contradictions: "But why
would one be shocked to see, in matters of uncertainty, the for and against
said by the same man . . . The sincere man says to you: 'I felt like this, I
felt like that.'"[14] *Obermann* places itself in the lineage of Montaigne, as
being not a belabored, well-wrought work, but rather "the free and incor-
rect sensations, opinions, and dreams of a man often isolated, who writes
in private, and not for his bookseller."[15] This ideal of a small fragment of
thought drawn from his mind at will dominates in all Delacroix's reflec-
tions on writing about art, for which Addison's *Spectator* provided yet
another model: "All I do is dream about a work in the manner of the
Spectator: a short article of three or four pages, and fewer still, on the first
subject that comes along" (8 May 1853; II, 39).

Perhaps the decisive justification for the *Dictionnaire*'s form, however,
came from this remark of Montesquieu's, noted and underlined in 1855:
"A man who writes well does not write as *one* writes, but as *he* writes, that
is, as he thinks" (17 July 1855; II, 359). Indeed the *Journal* itself, De-
lacroix's own *pensées détachées*, would provide the model for his writing on
art. Through the separateness and discontinuity of its articles, the dictio-
nary approximates most closely the form of the diary, and allows for the
variety, freedom, and mobility of the mind in its relation to objects of
thought: "Do a *Dictionary of the arts and of painting:* convenient theme.
Separate effort for each article" (10 October 1853; II, 83). In contrast to
a "real" book, which "links together, deduces the principles, develops,
sums up," a dictionary consists of distinct entries joined by no narrative

[11] Etienne Pivert de Senancour, *Obermann*, ii. It is noteworthy that it was precisely this
Preface which, many years earlier, had motivated Delacroix's critique of George Sand's far
more "rhetorical" and "literary" Introduction to the 1844 edition of *Obermann*, and the
limitations of such writing as hers in contrast to painting. Perhaps Senancour's Preface
provided a first suggestion of an alternative kind of writing.

[12] Ibid., II, 32, letter L.

[13] Ibid., iii.

[14] Ibid., iii–iv.

[15] Ibid., v.

chain and no transition from one to the next;[16] like the diary, "it does not oblige the panting reader to follow it in its course and its developments" (16 January 1860; III, 251–52). The medium most "opposed to rhetoric," it follows a purely conventional order, that of the alphabet, as the diary follows, for convenience, the calendar, unlike the hierarchical "monument" or "edifice" that is a conventional treatise.[17] It constitutes a tissue of interconnected and cross-referenced themes and ideas;[18] it allows for the full complexity of the subject and does not attempt to suppress whatever repetition or contradiction may arise from this. Its entries may be compared and contrasted at will, reordered and reshuffled like a deck of cards, for as many points of view.[19] It has the liveliness of immediate impressions, the concentration of effect characteristic of the visual image. It releases the author from the necessity of consistency and removes the taboo of contradiction, allowing instead the variation proper to the imagination. The repetition it occasions is a form of creation, the subject provoking new thoughts and new sensations at each recurrence, as a painting inspires new ideas and pleasures each time one returns to it: "This form must bring about repetitions, etc. So much the better! the same things said over again in another way often have . . . etc." (13 January 1857; III, 28). It is meant not to fix meanings, but to explore them, thus providing the endless source of thought that was for Delacroix the purpose of art itself: "One picks it up or puts it down; one opens it at random, and it is not impossible to find in it, through reading just a few fragments, the occasion for a long and fruitful meditation" (16 January 1860; III, 252).

But this is not the encyclopedic ideal dictionary of the nineteenth century, encompassing the whole of human knowledge within its covers. On the contrary, for Delacroix, the ideal of completeness is impossible; the dictionary as he conceives it carries everywhere the mark of contingency, subjectivity, and suppression (16 January 1860; III, 251–52), its material determined almost haphazardly, even lackadaisically, "at the inclination of the author's disposition, sometimes of his laziness" (13 January 1857; III, 26). He acknowledges the incongruity between the totalizing connotations of the title, and the incompleteness and relativism of the work: "This title would really be appropriate only to a book as complete as possible Would it be possible for one man alone to be endowed with the learning indispensable to such a task? Undoubtedly not" (13 January

[16] *O.L.* I, 88: "point de transitions nécessaires."

[17] 13 January 1857 (III, 26–27); 16 January 1860 (III, 251).

[18] For example, the article "touche" has cross references to "finir," "contour," "raccourcis," and "fresque" (13 January 1857; III, 17ff.).

[19] Cf. his metaphor of a card game (12 May 1853; II, 45).

1857; III, 25). The notes and drafts for the Preface emphasize this sub-
jectivity and limitation:

> The title of "dictionary" is very ambitious for a work sprung from
> the head of a single person and including only as much knowledge as
> it is possible for one man to encompass. If one adds to that the fact
> that his knowledge is far from being complete and is even very
> insufficient . . .
>
> The drawback to such a work done by a single person is in the
> necessary limitations of the mind and knowledge of that person; it is
> in that drawback that a work like this one would deviate from the
> true principle of a dictionary, which is to give all the information it
> is possible to have on a given matter, at the moment the work is
> published. Certainly, no man can embrace the whole of art; it is thus
> possible, indeed it is almost certain, that his ideas do not maintain,
> in matters of this kind, a stability which is not a feature of the intel-
> ligence of a single person.[20]

> [Le titre de dictionnaire est bien ambitieux pour un ouvrage sorti
> de la tête d'une seule personne et n'embrassant que ce qu'il est pos-
> sible à un homme d'embrasser de connaissances. Si l'on ajoute à cela
> que ses connaissances sont loin d'être complètes et sont même très
> insuffisantes . . .
>
> L'inconvénient d'un ouvrage semblable fait par une seule personne
> est dans les bornes nécessaires de l'esprit et des connaissances de cette
> personne; c'est par cet inconvénient qu'un ouvrage comme celui-ci
> s'écarterait du vrai principe d'un dictionnaire, qui est de donner toutes
> les informations qu'il est possible d'avoir sur une matière, au moment
> où l'ouvrage est publié. Certes, chaque homme ne peut embrasser l'art
> tout entier; il est possible, même il est presque certain que ses idées ne
> conservent pas, sur des matières de ce genre, une fixité qui n'appartient
> pas à l'intelligence d'un seul homme.]

Thus he everywhere insists on the dictionary as a personal account, the
product of a single mind, and of the restricted knowledge and experience
of an individual:

> Therefore one can contest the title of "dictionary" . . . One will
> call it . . . the collection of ideas that one man alone could have on
> an art, or on the arts in general, during a fairly long career. . . .
>
> This little collection is the work of one person alone, who has

[20] *O. L.* I, 84ff. Similar ideas are stated in the *Journal*, 1 November 1852 (I, 496) and
13 January 1857 (III, 15).

spent his whole life involved with painting. He can therefore only claim to shed on each object the little bit of light that he has been able to acquire, and still he will only be giving information that is wholly personal to him. . . . The most universal man is still very limited, if not in ability, at least in knowledge.[21]

[On pourra donc contester le titre de dictionnaire . . . On l'appellera . . . le recueil des idées qu'un seul homme a pu avoir sur un art, ou sur les arts en général, pendant une carrière assez longue. . . .

Ce petit recueil est l'ouvrage d'une seule personne, qui a passé toute sa vie à s'occuper de peinture. Il ne peut donc prétendre qu'à donner sur chaque objet le peu de lumière qu'il a pu acquérir, et encore ne donnera-t-il que des informations toutes personnelles. . . . L'homme le plus universel est encore très borné, sinon en capacité, au moins en connaissance.]

But if such a dictionary does not fulfill the requirements of a "true" one, it also avoids the flaws of this, notably its tendency to become a compilation of mediocrities, banalities, and commonplaces, "a collection of the theories and practices in circulation," a summary of "everybody's ideas on the subject,"[22] a Flaubertian *Dictionnaire des idées reçues,* "*avant la lettre,*" lacking the spontaneity and freshness which have the power to interest and persuade.[23] The evolution of the encyclopedic dictionary from the firm ideological stances taken by Diderot's and d'Alembert's, to the pretension to impartiality claimed by nineteenth-century examples, confirms Delacroix's point. For him, originality is the fruit of a single intelligence, "having ideas of its own."[24] Only a collection of separate, competing dictionaries, in disagreement with one another, unharmonized and unhomogenized, could begin to approach the scope of the ideal of this genre:

Men of genius doing a dictionary would not agree among themselves: on the other hand, if you had from each of them a collection of their particular observations, what a dictionary one could compose with such material. (13 January 1857; III, 28)

[Des hommes de génie faisant un dictionnaire ne s'entendraient pas: en revanche, si vous aviez de chacun d'eux un recueil de leurs observations particulières, quel dictionnaire ne composerait-on pas avec de semblables matériaux.]

A dictionary of this kind . . . would be the best possible if it were the work of several men of talent, but on condition that each of them

[21] *O.L.* I, 86, 87, 90.
[22] Ibid., 86.
[23] Ibid., 89.
[24] Ibid., 86.

dealt with his subject without the participation of his colleagues. Done in common, it would fall into banality . . . Each article, amended by each of the collaborators, would lose its originality, to take on . . . a banal unity. (16 January 1860; III, 249)

[Un dictionnaire de ce genre . . . serait le meilleur possible, s'il était l'ouvrage de plusieurs hommes de talent, mais à la condition que chacun d'eux traitât son sujet sans la participation de ses confrères. Fait en commun, il retomberait dans la banalité . . . Chaque article amendé par chacun des collaborateurs perdrait son originalité pour prendre . . . une unité banale.]

To a certain extent, the model for such a critical project as Delacroix envisaged came from the past. In considering the idea of a dialogue, he notes the antiquity of the form, of which the history of art criticism indeed contains numerous illustrious examples.[25] He read Dolce's *Aretino*, for example, and quotes it in the *Journal*,[26] notably its discussion of Titian and its affirmation of the superior power of painting to attract interest. This dialogue in fact provides a notable example of the possibilities of the genre that Delacroix mentions, for it is less exclusively expository than it may at first seem: despite the apparent dominance of Aretino, the contrasting views of his interlocutor, Fabrini, are stated repeatedly; and even when Fabrini's position is refuted, Aretino's does not take priority, despite his claim that it will "conclusively" do so, but a balance is reached instead. For instance, Aretino argues throughout for the superiority of Titian over Raphael and Fabrini's favorite, Michelangelo; but the conclusion is that "three obtain pride of place—namely, Michelangelo, Raphael, and Titian."[27] Perhaps more important, the dialogue affirms its incompleteness and provisionality by occasionally raising issues which are not discussed, thus indicating the gaps and holes in its own argument. In a discussion of the care that painters of antiquity took with color, Aretino tells the famous story of Protogenes, who, frustrated at his inability to represent the foam at the mouth of a panting horse, throws at his picture the sponge on which he had wiped his brushes, and inadvertently

[25] Supplement (III, 430). Roskill (*Dolce's "Aretino" and Venetian Art Theory of the Cinquecento*) discusses the prevalence of the dialogue form in the sixteenth century, citing Paolo Pino, *Dialogo della pittura* (1548) and the lost dialogues of Vasari on Michelangelo from mid-century (9f., 61 n. 22). See also the many examples in Baxandall, *Giotto and the Orators*, esp. part 2.

[26] 15 August 1850 (I, 414–15); 5 January 1857 (III, 5).

[27] Roskill, *Dolce's "Aretino" and Venetian Art Theory of the Cinquecento*, 195. Delacroix quotes this passage in the *Journal* (5 January 1857; III, 5). The dialogue also makes clear its difference from an expository treatise by pointing to the artificiality of the situation it presents as real, or at least as verisimilar: "There is no one listening in on us, in any event," declares Fabrini, as the reader does precisely that (Roskill, 99).

creates the effect perfectly. Fabrini justifiably remarks, however, that it is chance, rather than the painter's skill or care, which deserves praise. But Aretino passes over this potentially damaging point without comment.[28] The dialogue thus reveals what his theory does not take into account.

The precedents from Delacroix's cherished eighteenth century were even more important. Diderot's *Pensées détachées sur la peinture* of 1776–77 have the same fragmentary character that Delacroix sought for his own work, including maxim-like extracts and bits of dialogue.[29] (Delacroix frequently alluded to his critical ideal as "pensées détachées.")[30] Moreover the stupendous prominence of the encyclopedic dictionary—a veritable mania, as the Preface to the *Encyclopédie* itself laments—provided Delacroix with numerous examples of a critical, formal, and epistemological approach in keeping with his own aims. He mentions specifically the *Dictionnaire historique* of Pierre Bayle (1697), consisting of commentary and philosophical digression in addition to the text "proper": "He would be an ill-inspired man who saw in the dictionary of Bayle, for example, nothing more than compilations. It relieves the mind which has so much trouble engaging itself in long developments, following them with suitable attention or classifying and dividing up the material" (16 January 1860; III, 252).[31] Like Delacroix, Bayle notes explicitly the unpolished style of his work, and his conception of it as a collection of useful materials to which others can give form, in which each reader may find something of *particular* interest.[32] Delacroix's emphasis on the advantages of discontinuity and the suggestive potential of the dictionary is also echoed in Voltaire's *Dictionnaire philosophique*, which he cites repeatedly. As Voltaire states in the Preface:

> This book does not require a sustained reading; rather, at whatever place it is opened, one finds matter for reflection. The most useful books are those whose readers themselves do half the work; they extend the thoughts which are presented to them in bud; they correct

[28] Ibid., 153.

[29] On Delacroix's familiarity with Diderot's art criticism, see Mras, *Eugène Delacroix's Theory of Art*, 15 and n. 14.

[30] E. g., 7 May 1850 (I, 363); 12 May 1853 (II, 44).

[31] See Bayle's Preface to the first edition: "J'ai divisé ma composition en deux parties: l'une est purement historique, un narré succinct des faits: l'autre est un grand commentaire, un mélange de preuves et de discussions, où je fais entrer la censure de plusieurs fautes et quelquefois même une tirade de réflexions philosophiques; en un mot, assez de variété pour pouvoir croire que par un endroit ou par un autre chaque espèce de lecteur trouvera ce qui l'accommode" (*Dictionnaire historique* XVI, 2).

[32] Ibid., 5f.: "Rien de ce que je dis de mon chef ne sent un auteur qui retouche son travail, et qui châtie la licence de ses premières pensées et du premier arrangement de ses paroles"; and 10: "J'eusse voulu que d'autres prissent la peine de donner la forme aux matériaux, d'y ajouter et d'y retrancher."

what seems to them faulty, they strengthen by their reflections whatever appears weak.[33]

This ideal is inherent in the dictionary as a form, a result of the non-narrative, and specifically alphabetical, order; even the *Encyclopédie* bears witness to it. Indeed, into the grand conceptual design of the genealogical "tree" inspired by Bacon, which established the relative place of each art or science and traced its derivation from the main branches of history, philosophy, and poetry, the alphabetical arrangement of articles injected a radically destabilizing element.[34] Adopted ostensibly for the convenience and ease of the reader, and to avoid repetition,[35] it in fact disrupted the systematic, organic order of the conception. This problem was acknowledged by Diderot himself: "If one objects to us that the alphabetical order will destroy the unity of our system of human knowledge, we will respond that, this unity consisting less in the arrangement of the material than in the relations within the material, nothing can annihilate it."[36] Indeed, as Sylvain Auroux has argued, the alphabetical arrangement of articles exploded the unity of the more traditional thematic classification, broke the alleged relationship between the hierarchized organization of the world and the organization of knowledge.[37] Diderot's uneasiness with the very concept of an encyclopedic system has been studied by Jacques Proust.[38] In both the *Prospectus* and the article "Encyclopédie" written five years later, Diderot emphasized the arbitrary and incomplete nature of the "system," and insisted on its necessary openness: "One will find us always disposed to acknowledge our inadequacy, and to take advantage of the enlightenment which is offered us. We will receive it with gratitude . . . ; so convinced are we that the final perfecting of an encyclopedia is the work of centuries."[39]

[33] Voltaire, Preface to the *Dictionnaire philosophique*, xxxii: "Ce livre n'exige pas une lecture suivie; mais, à quelque endroit qu'on l'ouvre, on trouve de quoi réfléchir. Les livres les plus utiles sont ceux dont les lecteurs font eux-mêmes la moitié; ils étendent les pensées dont on leur présente le germe; ils corrigent ce qui leur semble défectueux, ils fortifient par leurs réflexions ce qui leur paraît faible."

[34] The metaphor of the "arbre généalogique" dominates Diderot's *Prospectus* of 1750, which became, with some alterations, the *Discours préliminaire* of the *Encyclopédie* as a whole. The main branches—history, philosophy, and poetry—corresponded to the three faculties of memory, reason, and imagination; the common "trunk" was human understanding. See Diderot, *Oeuvres complètes* V, 90.

[35] Diderot, *Oeuvres complètes* V, 93n.

[36] Ibid., 118.

[37] *La Sémiotique des encyclopédistes. Essai d'épistémologie historique des sciences du langage*, 319.

[38] "Diderot et le système des connaissances humaines."

[39] *Prospectus, Oeuvres complètes* V, 103.

Even in putting forward the notion of the "tree of knowledge," he had called attention to its arbitrariness:

> This tree of human knowledge could be formed in several ways . . . But the difficulty was all the greater in that there was more of the arbitrary. And how should there not be? Nature only offers us particular things, infinite and with no fixed or determined division . . . And on this sea of objects which surrounds us, if there appear some which, like tips of rocks, seem to pierce the surface and dominate the others, they owe this advantage only to particular systems, to vague conventions, and to certain events foreign both to the physical arrangement of beings and to the true institutions of philosophy.[40]

In fact, only the alphabetical order—non-hierarchical and non-signifying—could take account of Diderot's increasing epistemological doubt about the whole enterprise, as Proust has traced it: a sense of the impossibility of ordering knowledge in a fixed way, notably a linguistic one.[41] Diderot became convinced of the interdependence and interrelatedness of things, and thus of the necessity of a more flexible system in which they hold varying "places" and are considered from different perspectives. In the article "Encyclopédie," he wrote explicitly that the work's form corresponded to a new conception of knowledge, one which considered the world through an infinity of points of view and recognized equally the infinite number of systems by which it might be approached.[42] The cross references were meant to affirm an encyclopedic cohesion among the different articles, which the alphabetical order had ostensibly shattered;[43] but such a cohesion was multiform, rather than the hierarchical order of a thematic arrangement. Indeed, in the article "Encyclopédie", the *renvois* acquire a more disruptive role of opposition, contrast, and confrontation, exposing the falsity of another idea: "They will attack, shake, overturn secretly some

[40] Ibid., 90f.: "Cet arbre de la connaissance humaine pouvait être formé de plusieurs manières . . . Mais l'embarras était d'autant plus grand, qu'il y avait plus d'arbitraire. Et combien ne devait-il pas y en avoir? La nature ne nous offre que des choses particulières, infinies et sans aucune division fixe et déterminée . . . Et sur cette mer d'objets qui nous environne, s'il en paraît quelques-uns, comme des pointes de rochers, qui semblent percer la surface et dominer les autres, ils ne doivent cet avantage qu'à des systèmes particuliers, qu'à des conventions vagues, et qu'à certains événements étrangers à l'arrangement physique des êtres et aux vraies institutions de la philosophie." Cf. article "Encyclopédie," *Oeuvres complètes* VII, 210f.

[41] "Diderot et le système des connaissances humaines," 122.

[42] "L'univers soit réel soit intelligible a une infinité de points de vue sous lesquels il peut être représenté, et le nombre des systèmes possibles de la connaissance humaine est aussi grand que celui de ces points de vue" (*Oeuvres complètes* VII, 211).

[43] Preface to the *Encyclopédie*, xviii.

ridiculous opinions which one would not dare to insult openly . . . they will always have the dual function of confirming and refuting, unsettling and conciliating."[44] They can even have a creative dimension, making connections which "would lead to new speculative truths, or to the perfecting of the known arts, or to the invention of new arts, or to the restoration of lost ancient arts."[45]

The connection between Diderot's more flexible system and the famous "Promenade Vernet" section of the *Salon de 1767*, analyzed by Jacques Proust, is of capital importance: like Delacroix's *Dictionnaire*, Diderot's conception of the encyclopedia is related to a particular kind of pictorial art, and to a way of viewing that art. The ideal "system" (if one may call it such) follows the model of a Vernet landscape painting which, as his conceit of visiting the depicted site implies, is approached from within and from various directions, traversed to and fro, and observed from different angles. (Similarly, the cross references of the *Encyclopédie* had been described as "itineraries."[46]) This reflects his conception of pictorial unity: the eye "proceeds, goes deeply in, retraces its steps. Everything is connected, everything holds together."[47] An object of knowledge becomes, as Proust puts it, an intricate "web of relations, within a complex and changing network from which even the observer is not separate,"[48] a complex built up through encyclopedic cross-referencing and, in Delacroix's case, an emphasis on the possible contradictions and inconsistencies that may result. The kind of pictorial narrative which the *Salon* introduces, and the interpretative approach which that narrative demands, reflect the multiple network of the *Encyclopédie*'s cross-references and interrelations in ways very similar to the connection between Delacroix's pictorial narrative and the *Dictionnaire des Beaux-Arts*. Both imply the conception of a more varied and multiple understanding, be it epistemological or hermeneutic, and a greater sense of the role of the subject in the changing nature of the object itself.

In justifying the unorthodox form of the work, Delacroix takes refuge in a Reynoldsian division of expertise, the painter being "more skilful at handling the tools of his own art than the pen," and thus less practiced in

[44] Diderot, *Oeuvres complètes* VII, 221. The political implications of this are of course profound. Diderot continues: "Toutes les fois, par exemple, qu'un préjugé national mériterait du respect, il faudrait à son article particulier l'exposer respectueusement . . . ; mais renverser l'édifice de fange . . . en renvoyant aux articles où des principes solides servent de base aux vérités opposées" (ibid., 222).

[45] Ibid., 223.

[46] Ibid., 216.

[47] *Essais sur la peinture*, 687.

[48] "Diderot et le système des connaissances humaines," 126.

creating a unified narrative of different parts, "having a beginning and an end."[49] But his recourse to painting in fact has a more important purpose, that of relating the dictionary's form to a specifically *pictorial* vision. In its separateness and autonomy, each entry "stands out," engaging the viewer with the force, concentration, and suggestiveness that characterize the visual image:

> Each separate article stands out better and leaves more of a trace in the imagination. . . .
> In a work like this one . . . one will perhaps find it more interesting to fix one's attention only on separate objects, each article forming a kind of separate chapter more suited to impress the mind, and without the imaginative expense necessary to join the detached point to the one which precedes or the one which follows. Artists . . . will find more quickly matter for reflection in this arrangement.[50]

> [Chaque article séparé ressort mieux et laisse plus de trace dans l'esprit. . . .
> Dans un ouvrage comme celui-ci . . . on trouvera peut-être plus d'intérêt à ne fixer l'attention que sur des objets séparés, chaque article formant comme un chapitre à part plus propre à saisir l'esprit, et sans les frais d'imagination nécessaires[51] pour rattacher ce point détaché à celui qui précède ou à celui qui suit. Les artistes . . . trouveront plus vite matière à réflexion dans cette division.]

If books can be considered "parts of paintings in motion, one succeeding another, without the possibility of taking them in all at once" (13 January 1857; III, 26), then the dictionary is a book which somewhat overcomes the problem, a book which is not one,[52] allowing the reader to go and come among the parts, to create shifting and changing configurations of "tableaux" according to the interest or need of the moment. Such a method of reading is "pictorial," responding specifically to a painterly approach to the world, one used to seeing and understanding a thing "all at once, at

[49] *O.L.* I, 88. Cf. Joshua Reynolds, 15th discourse: "To develop the latent excellencies, and draw out the interior principles, of our art, requires more skill and practice in writing, than is likely to be possessed by a man perpetually occupied in the use of the pencil and the pallet" (*Discourses on Art*, 267). Baudelaire quotes Delacroix on this in his 1863 essay on the painter (*L'Oeuvre et la vie d'Eugène Delacroix*, in *Oeuvres complètes* II, 754): "'La plume,' disait-il souvent, 'n'est pas mon *outil*; je sens que je pense juste, mais le besoin de l'ordre, auquel je suis contraint d'obéir, m'effraye.'"

[50] *O.L.* I, 88f.

[51] The printed text has "accessoires," an easy misreading for "nécessaires", which makes more sense.

[52] "Il lui a semblé [to the author] qu'un dictionnaire n'était pas un livre, même quand il était tout entier de la même main" (*O.L.* I, 88). Cf. 13 January 1857.

least in its ensemble and its principal parts." Delacroix implies, more-over, that it corresponds more faithfully to the practice of reading itself:

> There are few [books] . . . that one reads completely and all in se-quence. One reads fragments of them; the reader, when the work is worth it, ends up redoing it for his own use, just as in a picture gallery, one stops in preference before certain canvases while ignor-ing other ones.[53]

> [Il en est bien peu [de livres] . . . qu'on lise de suite et complète-ment. On en lit des fragments; le lecteur, quand l'ouvrage en vaut la peine, finit par le refaire à son usage, de même que, dans une galerie de tableaux, on s'arrêtera de préférence devant certaines toiles en négligeant d'autres.]

The dictionary so conceived solicits the participation of the reader, who chooses, makes connections, weighs up the contradictions, and takes the written entry as the point of departure for sustained thought. Baudelaire's remark about Delacroix's reserve in his accounts of his own paintings was not wide of the mark: "The reader will be obliged to guess a lot, to collaborate, so to speak, with the writer of the note."[54] The concentration and concision of these short descriptions were indeed for Baudelaire *picto-rial*, a means of "making a picture," reproducing "the rapid movements of thought."[55]

If these ideas take form explicitly only in the *Dictionnaire*, one can already see their traces in a very different, and apparently very conven-tional, example of Delacroix's criticism. His day-to-day account, in the 1853 *Journal*, of the progress of his article on Poussin shows the early signs of a writing trying to break free of its rhetorical bonds. If the diary can be believed, the conventional form of the finished article was achieved only at great cost: Delacroix's frustration with writing a "proper" article is evident at every stage. The same arguments which come to constitute the theory of the dictionary four years later are stated here as mere yearnings, unfulfillable fantasies to be reluctantly repressed, and replaced by a more acceptable form. Delacroix's resistance is evinced in the extraordinary dif-ficulty he had in writing the "damnable article" (12 May 1853; II, 44), fitting it into the mold of a genre the limitations of which he was con-stantly aware, making it conform when he was beginning to conceive of a different kind of critical writing altogether. For a period of four weeks, from 8 May to 7 June, he isolated himself at his house in Champrosay,

[53] Ibid., 88.
[54] *L'Oeuvre et la vie d'Eugène Delacroix, Oeuvres complètes* II, 756.
[55] *Oeuvres complètes* II, 473ff., 755.

alternating work on the article with glorious long walks in the country, reflecting on matters ranging from the scent of the rain-soaked landscape to Ouija boards, from friendship to photography, from the wobbly gait of swallows to the plodding manners of contemporary society. Significantly, he noted in one entry the importance of one's physical situation for inspiring thought: "For Mozart, Rossini, Voltaire, ideas came to them in bed; for Rousseau, I think, as he walked in the countryside" (12 May 1853; II, 45).

From the start, work on the article was exasperating and vexatious in the most personal way, prey to the slightest movement of chance and marked by wild swings of mood: "In the mornings, I struggle with Poussin. Sometimes I want to send it all packing, other times I throw myself into it with a kind of fury" (10 May 1853; II, 43); "I tried working on the article, and after having written a few lines . . . a bad mood took hold of me, and I did nothing but read and even sleep until the middle of the day" (13 May 1853; II, 45); "There are days when I apply myself to this work with a lot of spirit, others where it puts me off horribly;"[56] "Sometimes I want to throw Poussin out the window, sometimes I take it up again reasonably or with fury" (29 May 1853; II, 62). The grim frustration comes from the need to give the necessary order to the "jumble", create a credible unity of diverse and abundant material—a unity which will inevitably be false: "I lack a sure method of coordinating the parts, putting them in their order, and especially, after taking so many notes ahead of time, of remembering all that I resolved to put into my prose" (8 May 1853; II, 39).

It is precisely at this time that, contemplating his "dismembered" article,[57] its limbs strewn helter-skelter across his work table, he begins to "dream of a work in the manner of the *Spectator*" and to credit the "pensée détachée" method of Pascal.

> Worked out as best I could, in pencil, all I had to say, on large sheets of paper. I am inclined to think that the method of Pascal—writing each separate thought on a little piece of paper—is not too bad . . . One would have all the categories and subcategories in front of one like a game of cards, and one would be struck more easily by the order to give them. (12 May 1853; II, 44–45)

[Débrouillé comme j'ai pu, au crayon, tout ce que j'ai à dire, sur de

[56] "Il y a des jours où je me livre à ce travail avec beaucoup d'entrain; d'autres où il me répugne horriblement" (14 May 1853; II, 47).

[57] *Corr.* III, 156: "Le terrible article dont je vois les membres épars sur ma table. Je sue sang et eau pour coudre tout cela ensemble et je crois que c'est l'obligation de le faire qui me rend la besogne pénible."

grandes feuilles de papier. Je serais tenté de croire que la méthode de Pascal—d'écrire chaque pensée détachée sur un petit morceau de papier—n'est pas trop mauvaise . . . On aurait toutes ses divisions et subdivisions sous les yeux comme un jeu de cartes, et l'on serait frappé plus facilement de l'ordre à y mettre.]

His ideal, stated repeatedly in these weeks, is of a collection of miscellaneous articles, on anything which takes his fancy, as short or long as the author may like or the subject may inspire, grouped in no particular order. He even contemplates a publication of this kind—free, natural, casual and particular, discontinuous and without rhetoric, reveries of a Rousseauian solitary walker, as his botanical metaphor suggests:

Fould advises me to publish my reflections, thoughts, and observations as they are, and I find this idea better than authoritative articles. For this, they would have to be written separately, each on a separate sheet, and put in a box as I went along. In that way I could, in my idle moments, touch up one or two of them, and after a while I would have made a bundle of all of it, like a botanist who goes around collecting in the same box the herbs and flowers that he has gathered in a hundred different places, and each with a particular emotion attached to it. (20 May 1853; II, 57)[58]

[Fould me conseille d'imprimer, comme elles sont, mes réflexions, pensées, observations, et je trouve que cela me va mieux que des articles *ex professo*. Il faudrait pour cela les écrire à part, chacune sur une feuille séparée, et les mettre au fur et à mesure dans un carton. Je pourrais ainsi, dans les moments perdus, en mettre au net une ou deux, et au bout de quelque temps, j'aurais fait un fagot de tout cela, comme fait un botaniste, qui va, mettant dans la même boîte les herbes et les fleurs qu'il a cueillies dans cent endroits, et chacune avec une émotion particulière.]

But as always with Delacroix, these were not merely formal questions. Indeed, interwoven with these reflections, as though part of the same intellectual fabric, are aesthetic issues which correspond closely to them. The first, and most recurrent, is the discussion of the relative merits of the finished versus the unfinished work (sketches and studies), and of proportion versus disproportion, which we have seen in Chapter 2—a discussion which forms the basis of his entry on the sublime for the *Dictionnaire* four

[58] Cf. Rousseau's metaphor of the botanist who collects samples of plants for his *herbier* which, when opened, carries him back with renewed charm to the site where they were gathered (*Les Rêveries du promeneur solitaire*, seventh promenade).

years later.[59] Ever drawn to the values of finish, completeness, and proportion of his beloved Mozart and Racine, he here acknowledges and analyzes the incomparable effect of the *ébauche*, disproportion, and lack of finish in artists such as Michelangelo, Shakespeare, and Beethoven. Like the diary and the *Dictionnaire*, such works are perceived in their parts, rather than as an *ensemble*, and solicit the participation of the viewer (or listener, or reader), whose soul is invoked to supplement the "incomplete" impression that they communicate (9 May 1853; II, 40–43). As we have seen earlier, Delacroix comes increasingly to attribute this to all acts of perception and interpretation, however "finished" or "perfect" the object.

The same question arises again a few days later in connection with his own work:

> Riesener resumed his criticism of the search for a certain finish in my small pictures, which seems to him to make them lose a lot, compared with the sketch or things done in a more expeditious manner and at the first attempt. Perhaps he is right, and perhaps he is wrong. (21 May 1853; II, 57–58)

> [Riesener a repris sa critique de la recherche d'un certain fini dans mes petits tableaux, qui lui semble leur faire perdre beaucoup, en comparaison de ce que donne l'ébauche ou une manière plus expéditive et de premier jet. Il a peut-être raison et peut-être qu'il a tort.]

When his other friend, Pierret, argues that the painter's conception matters most, Delacroix intervenes with an ambiguous view, noting the value of both approaches:

> I answered him with this observation, which I set out in this notebook a few days ago, on the unfailing effect of the sketch as compared to the finished picture, which is always a bit spoiled as to touch, but in which the harmony and depth of the expression become a compensation.
>
> At the Prieur oak, I showed them how much more striking the separate parts appear, etc., in a word the old story of Racine compared with Shakespeare. (21 May 1853; II, 58)

> [Je lui ai répondu par cette observation, que j'ai mise dans ce livre il y a quelques jours, sur l'effet immanquable de l'ébauche comparée au tableau fini, qui est toujours un peu gâté quant à la touche, mais

[59] The notes which he took on 9 May 1853, and transcribed into the diary entry for the same day, are recopied into the 1857 diary under 20 November as material for the article "Sublime" (III, 152f.).

dans lequel l'harmonie et la profondeur des expressions deviennent une compensation.

Au chêne Prieur, je leur ai montré combien des parties isolées paraissent plus frappantes, etc., en un mot, l'histoire de Racine comparé à Shakespeare.]

It is at this time, as well, that he theorizes the similar effects of photography. Like the unfinished work, photographs sacrifice the ensemble to an emphasis on detail, showing only a "part cut out from a whole" (1 September 1859; III, 232); but in their "exaggerated parts, of a hardly pleasing effect" (21 May 1853; II, 58), they point up the falsity of style and manner of finished works. As we have seen, it is photography which, privileging detail over the *ensemble*, will make Delacroix's eye see what it had never seen before, and teach him to read a new *ensemble*, the "admirable poem" of the human body (5 October 1855; II, 399); just as seeing the great Antin oak from close to, from under its hyperbolic branches, will reveal the extraordinary, complicated, and magnificent form of the whole tree, which otherwise appears unrecognizably small, just "ordinary."[60] These discussions are imbued with the same issues which Delacroix raises about writing, and suggest the critical importance of his reflections on writing for his aesthetic thought. A "disproportionate" vision, seeing parts rather than the whole; an "unfinished," moving and suggestive work: these are the values evoked à propos of the *Dictionnaire*'s *pensées détachées*, which seize and focus the attention of the reader, and provoke a wide-ranging aesthetic reflection.[61]

The critical purposes of the *Dictionnaire* were one with its form. Delacroix insists throughout his notes on the personal nature of its content and the instructive function this fulfills: "It is the fruit of experience that one should find in a work of this kind. Now, experience is always fruitful in men endowed with originality; in common artists, it is only a rather long apprenticeship in the recipes that one finds everywhere" (16 January 1860; III, 249). By this, however, he does not mean merely technical information, but rather the whole range of artistic reflection, the "philosophy" of art, in which technical expertise plays a crucial role: he expresses an intention to deal more with philosophical than with technical matters (13 January 1857; III, 27), and considers entitling the work, in an echo of Voltaire, a "Petit Dictionnaire philosophique des Beaux-Arts" or "Extraits d'un dictionnaire philosophique des Beaux-Arts" (11 January 1857; III, 9). He openly seeks to improve upon those mediocre artists who mistake technique for art itself, and those mediocre estheticians who have

[60] 9 May 1853 (II, 40–41). See above, chapter 2.
[61] *O.L.* I, 88f.

disdained it as too trivial a matter for "high" theoretical speculation (13 January 1857; III, 27–28). Ultimately the aim of such a personal instruction is itself personal to each reader, teaching one to read anew: "I would like to help teach people to read fine works better" (4 February 1857; III, 60).

This objective was compelling. Delacroix sought a criticism suggestive and thought-provoking, "fruitful," to use his own term, interesting in his sense. In one of the rare instances where he discusses a particular art critic, he judges Gautier harshly for producing a creation of his own rather than a true critique, self-indulgently substituting a replica for a suggestive analysis, enclosing the reader within the bounds of the article rather than opening up the boundaries of the work itself:

> He takes a picture, describes it in his own way, himself makes a picture that is charming, but he has not done the work of true criticism; provided he finds the means of making the macaronic expressions glitter and shimmer (expressions he finds with a pleasure that sometimes wins you over), or that he cites Spain and Turkey, the Alhambra and the Atmeidan of Constantinople, he is happy, he has achieved his purpose as an inquisitive writer, and I think he does not see beyond that. . . . There will be neither instruction nor philosophy in such criticism. (17 June 1855; II, 341)

> [Il prend un tableau, le décrit à sa manière, fait lui-même un tableau qui est charmant, mais il n'a pas fait un acte de véritable critique; pourvu qu'il trouve à faire chatoyer, miroiter les expressions macaroniques qu'il trouve avec un plaisir qui vous gagne quelquefois, qu'il cite l'Espagne et la Turquie, l'Alhambra et l'Atmeïdan de Constantinople, il est content, il a atteint son but d'écrivain curieux, et je crois qu'il ne voit pas au-delà. . . . Il n'y aura ni enseignement ni philosophie dans une pareille critique.]

Delacroix instead proposes provocative configurations, juxtaposing, for example, the English school with those members of the French who would seem to have "analogous qualities"—Hunt and Millais with Ingres, Delaroche, Janmot and Flandrin—to bring out their respective characteristics. Such a comparison indeed leads him to a long, thoughtful evaluation of Janmot, whose "barbarous" execution nevertheless betrays, in his view, a "natural talent" and an evocative manner which inspires Delacroix to a very Baudelairean comparison with Dante:

> There is in Janmot a remarkable Dantesque flavor. I think, in seeing him, of those angels in the Purgatory of the famous Florentine; I love those robes green as the grass of meadows in May, those heads,

the result of inspiration or dream, which are like the reminiscences of another world.[62]

It is significant, for his view of criticism, that he accepted Baudelaire's weird and daring comparison of himself, Delacroix, to Poe, which led Delacroix to consider the similarities and differences between them, the changes in his own manner, and the value of an effect of mystery:

Back at home, continued my reading of Edgar Poe. This reading reawakens in me that sense of the mysterious which preoccupied me more in my painting in the past, and which was, I think, diverted by my work on site, allegorical subjects, etc., etc. Baudelaire says in his preface that I recall in painting this feeling of the ideal, which is so singular and takes pleasure in the terrible. He is right: but the kind of disjointedness and the incomprehensibility which mingle with his [Poe's] conceptions do not suit my character. (30 May 1856; II, 450–51)[63]

[En rentrant, continué ma lecture d'Edgar Poe. Cette lecture réveille en moi ce sens du mystérieux qui me préoccupait davantage autrefois dans ma peinture, et qui a été, je crois, détourné par mes travaux sur place, sujets allégoriques, etc. Baudelaire dit dans sa

[62] "Il y a chez Janmot un parfum dantesque remarquable. Je pense, en le voyant, à ces anges du purgatoire du fameux Florentin; j'aime ces robes vertes comme l'herbe des prés au mois de mai, ces têtes inspirées ou rêvées qui sont comme des réminiscences d'un autre monde" (17 June 1855; II, 341–42). The examples from Baudelaire's own reviews of Delacroix's work are numerous, such as his account in the *Salon de 1846* of the ceiling of the Luxembourg library: "Il est impossible d'exprimer avec de la prose tout le calme bienheureux qu'elle respire, et la profonde harmonie qui nage dans cette atmosphère. Cela fait penser aux pages les plus verdoyantes du *Télémaque*, et rend tous les souvenirs que l'esprit a emporté des récits élyséens" (*Oeuvres complètes* II, 438).

[63] In the Preface to his translation of Poe's *Histoires extraordinaires* in 1856 (*Edgar Poe, sa vie et ses oeuvres*), Baudelaire wrote: "Au sein de cette littérature où l'air est raréfié, l'esprit peut éprouver cette vague angoisse, cette peur prompte aux larmes et ce malaise de coeur qui habitent les lieux immenses et singuliers. . . . Solitude de la nature ou agitation des villes, tout y est décrit nerveusement et fantastiquement. Comme notre Eugène Delacroix, qui a élevé son art à la hauteur de la grande poésie, Edgar Poe aime à agiter ses figures sur des fonds violâtres et verdâtres où se révèlent la phosphorescence de la pourriture et la senteur de l'orage. La Nature dite inanimée participe de la nature des êtres vivants, et, comme eux, frissonne d'un frisson surnaturel et galvanique. L'espace est approfondi par l'opium; l'opium y donne un sens magique à toutes les teintes, et fait vibrer tous les bruits avec une plus significative sonorité. Quelquefois des échappées magnifiques, gorgées de lumière et de couleur, s'ouvrent soudainement dans ses paysages, et l'on voit apparaître au fond de leurs horizons des villes orientales et des architectures, vaporisées par la distance, où le soleil jette des pluies d'or" (*Oeuvres complètes* II, 317f.). He probably sent a copy of the book to Delacroix, as was his custom. It appeared on 12 March (Baudelaire, *Correspondance* I, 341), and Delacroix mentions having one already on the 27th.

préface que je rappelle en peinture ce sentiment d'idéal si singulier et se plaisant dans le terrible. Il a raison: mais l'espèce de décousu et l'incompréhensible qui se mêle à ses conceptions ne va pas à mon esprit.]

Despite the widely held opinion that Delacroix did not appreciate the connection (or Baudelaire's criticism in general),[64] this is the only place in the entire diary in which he reflects at any length upon a critic's view of himself. In fact, what Delacroix disliked in Poe was very specific: his moments of unintelligibility, and that usual literary problem, in his view, the monotonous *longueurs*. But the mystery, *surnaturalisme*, and *terrible* that Baudelaire brings out in his comparison are never, for Delacroix, in question:

> His [Poe's] metaphysics and his research into the soul, into life after death, are most singular and give one much to think about. His Vankirk speaking about the soul, during his mesmeric trance, is a bizarre and profound piece which makes one ponder. There is monotony in the plot of all his stories; it is only, in truth, that phantasmagorical gleam by which he illuminates those confused and terrifying figures, which constitutes the charm of this singular and very original poet and philosopher. (30 May 1856; II, 450–51)

Baudelaire's unusual association accomplished what Delacroix demanded of criticism generally: bringing together "analogous" artists to stimulate the reader's own critical imagination, provoking a consideration of the *specific* talent of each.

By "philosophy" Delacroix thus means the kind of essayistic reflection rendered in the *Journal* itself. Significantly, it is another, less reflective set of memoirs which sets him thinking about the importance of such a "philosophical" approach, the *Mémoires d'un bourgeois de Paris* of Eugène Véron: "Véron's book was on the table . . . No philosophy (big article on this word apropos of the arts in general: without this philosophy that I mean, no duration for the book or the picture, or rather no existence at all)" (17 October 1853; II, 92–93). The "instruction" is not prescriptive, not an "apprenticeship in the recipes that one finds everywhere" but a kind of invitation to informed thought. Hence the exemplarity of the great masters can work negatively, pointing up their shortcomings—"What is there that is more instructive than their mistakes themselves?" (16 January 1860; III, 249)—which Delacroix occasionally puts across with spectacu-

[64] Claude Pichois, *Lettres à Charles Baudelaire*, 112; Jacques Crépet, *L'Art romantique* in *Oeuvres complètes* (1925), 444; cf. Armand Moss, *Baudelaire et Delacroix*, 143; C. Roger-Marx, *Le Figaro littéraire* 12 January 1963, 16.

lar effect: "When Poussin said, in a witticism, that Raphael was an ass, . . . he knew what he was saying."[65] The *Dictionnaire* is meant to inspire, and to provide the materials for, critical reflection and judgment, much as the "dictionary of nature" furnishes the artist with ideas and forms for a picture.[66] Such instruction is literally "eye-opening":

> For the admiration which these privileged men inspire . . . must not be a blind admiration; to adore them in all their aspects would be . . . the most dangerous of things; . . . entire schools have been founded on badly interpreted aspects of the masters, and deplorable errors have been the result of that thoughtless zeal to take inspiration from the bad sides of remarkable men. (16 January 1860, III, 251)[67]

Delacroix's own approach is to consider an individual style, its relation to technique, and its place within the history of the art. His notes on Titian provide a fine example of this, integrating Titian's particular style into the formal and technical interests of the sixteenth century. Titian's place as a great colorist is analyzed in the context of the relative status, at the time, of fresco and oil, the new effects which advances in the oil medium permitted, and the aesthetic value of color versus line. For Delacroix, the change in materials favored a different style: a "breadth" in the rendering of figures and drapery, in contrast to the "dryness" of Titian's predecessors; a perfection in the rendering suited to expressing "the nuances and preciousness of objects," in contrast to the architectural "broad lines" of fresco; richness and variety of expression rather than simplicity of impression, but with no less naturalness (5 January 1857; III, 4–7). Titian's colorism goes, above all, with the expression of a true feeling or thought: "He obeys a true emotion at each moment. . . . He disdains . . . all that does not lead him to a livelier expression of his thought." If it lacks the elegance of Raphael, it never becomes mere "manner," mere painterly "habit," but rather has the "largeur" and naturalness of the antique.

[65] 1 November 1852 (I, 496). Delacroix goes on to qualify the remark, of course, as applying to Raphael's drawing; but his point that no artist excels at everything at every moment is made repeatedly in the *Journal*.

[66] *O.L.* I, 58.

[67] This is a recurrent concern of Delacroix's, directed against those who imitate even the weaknesses of the great masters. As we have seen in chapter 2, it is through that other experience of disproportion and incompletion, so similar to the *Journal* and the *Dictionnaire*— photography—that the rightness of Poussin's remark is appreciated. Comparing photographs of the nude with engravings after Raphael's nudes, he says: "C'est en voyant surtout ces gravures, qui passent pour les chefs-d'oeuvre de l'école italienne, qui ont lassé l'admiration de tous les peintres, que l'on ressent la justesse du mot de Poussin, que 'Raphaël est un âne, comparativement aux anciens'" (21 May 1853; II, 59).

"The antique is that way" (5 January 1857; III, 5): true to Delacroix's essayistic manner, this simple mention in passing becomes the subject of another note altogether—"On the antique and the Dutch school/ Titian." It draws together Titian, Veronese, and the Dutch school as artists who do not imitate the antique, but are the modern representatives of its spirit: truth to nature, but not servile imitation; masterful execution whose virtuosity is put in the service of simplicity, taste, and truth, rather than affectation and display; tranquillity, calm, selfpossession, "that lively sang-froid," "truth united with the ideal" (25 January 1857; III, 59–60). Delacroix acknowledges the unorthodox yoking of such seemingly distinct examples, as though to call attention to the personal nature of his account. The mention of Rossini as a counter-example of the "modern" spirit brings the discussion—and the issue—abruptly into the present.

This is indeed a significant feature of the *Dictionnaire*'s "personal" criticism: the contemporary urgency of the matter under discussion. Interwoven throughout the article are the clear threads of Delacroix's dialogue with his own era, and his view of Titian's importance for the nineteenth century. If "this quality of being colorist is more unfortunate than it is commendable with those modern schools that take refinement of drawing alone as a quality and sacrifice all else to it" (5 January 1857; III, 5–6), Delacroix points out the inappropriateness of trying to imitate the early masters or ancient frescoes in the modern medium of oil. To the archaizing, "epic" ideal of the Academy, he holds up the "verve combined with power" of Titian and Veronese, the "strength," "breadth," and "fullness" of Rubens (5 January 1857; III, 7). Thus he creates a place for their modern followers, who, despite the achievement of these predecessors, make an original contribution to the history of painting:

> It seems in fact that those sixteenth-century men left little to do; they were the first to venture, etc., and seem to have reached the limit in all genres; and yet in each of those genres one has seen talents showing some innovation. These talents, arriving in eras less and less favorable to great endeavors, to boldness, to innovation, to naiveté, have encountered good fortune, if you like, and have not failed to please their own century, itself less advantaged, but equally avid for delight. (1 January 1857; III, 1–2)

> [Il semble effectivement que ces hommes du seizième siècle ont laissé peu de chose à faire: ils ont parcouru les premiers, etc., et semblent avoir touché la borne dans tous les genres; et pourtant dans chacun de ces genres on a vu des talents montrant quelque nouveauté. Ces talents, venus dans des époques de moins en moins favorables aux grandes tentatives, à la hardiesse, à la nouveauté, à la

naïveté, ont rencontré des bonnes fortunes, si l'on veut, qui n'ont pas laissé de plaire à leur siècle moins favorisé, mais avide également de jouissances.]

The allusion to himself is transparent.[68] Delacroix seeks to justify his own colorism as conducive to originality, developing his own style according to his conception of nature and rendering it according to the means at his disposal, rather than "transferring" the style of the masters.[69] Archaism is criticized frequently as a "pernicious taste," "inexcusable,"[70] inappropriate to the ever-changing ideal of art: the critic Frédéric de Mercey "demonstrates all that is false about that resurrectionist art, by proving that each change in the evolution of human history must be translated by a transformation in art."[71] A later note on the "beau moderne" states the importance of using contemporary means of expression:

You must avail yourself of the means which are familiar to the time in which you live; without that you are not understood and you will not live. That technique from another era that you employ to speak to men of your time will always be an artificial one, and the people who come after you, comparing this borrowed manner with the works of the era in which that manner was the only one known and understood, and therefore executed in a superior way, will condemn you to inferiority.[72]

[Il faut se servir des moyens qui sont familiers aux temps où vous vivez; sans cela vous n'êtes pas compris et vous ne vivrez pas. Ce moyen d'un autre âge que vous allez employer pour parler à des hommes de votre temps, sera toujours un moyen factice, et les gens qui viendront après vous, en comparant cette manière d'emprunt aux ouvrages de l'époque où cette manière était la seule connue et comprise, et par conséquent supérieurement mise en oeuvre, vous condamneront à l'infériorité.]

[68] A cross-reference to an earlier diary entry makes the connection explicit; for there, in a letter thanking the art critic Louis Peisse for his favorable article, Delacroix berates the proponents of line who criticize him, and finds justification in being placed by Peisse in the lineage of Rubens and Correggio (15 July 1849; I, 299).

[69] See articles "Imitation" and "Imitateurs" (1 March 1859; III, 222–23).

[70] *O.L.* I, 62.

[71] Page attached to 10 April 1856. Cf. 9 April 1856: "From that derives the ridiculousness of trying to go back in time and archaize." Parts of the latter note were used for "Des Variations du beau" (*O.L.* I, 51).

[72] 16 March 1857 (III, 77–78). Cf. *O.L.* I, 62: "Le goût de l'archaïsme est pernicieux; c'est lui qui persuade à mille artistes qu'on peut reproduire une forme épuisée ou sans rapports à nos moeurs du moment."

This personal, idiosyncratic nature of Delacroix's project is evident in all the *Dictionnaire*'s categories for which there exists sufficient material to judge. The difference between this and a conventional dictionary of the fine arts can be appreciated by comparing it to the contemporary *Dictionnaire de l'Académie des Beaux-Arts*, which began to appear in 1858 and to which Delacroix, elected to the Institute in 1857, was later meant to contribute.[73] In contrast to the "philosophical," original character of his *Dictionnaire*, yoking together artists of different schools and eras, going and coming between past and present, the Academy's is precise, objective, and impersonal, emphasizing the vocabulary and terminology of the arts—technical and aesthetic terms, genres of art-work, gods, goddesses, figures and customs from antiquity, monuments, academies, and museums. The most obvious category for the expression of personal views—particular artists—is omitted altogether. Delacroix's dictionary may not have been written specifically against that of his colleagues at the Institute, but the coincidence is striking; it certainly contradicted theirs in material, purpose, approach, and, of course, judgment.

A subject treated in both—fresco—provides a case in point. The Academy's entry gives a long description of the procedure, discusses the paints appropriate to it, and traces its history from antiquity to the present. In keeping with the academic reverence for fresco, which Delacroix repeatedly contested, it affirms fresco's superior aptitude for harmony and unity, due to the uniform composition of its paints; its incomparable capacity for personal expression; its suitability to the ideal; and, through its sheer difficulty and the impossibility of retouching, the uncompromising challenge it poses to the artist:

> Of all the genres of painting, this one, because of its very requirements, is the most favorable to the development of high-level talent, . . . the most capable, in a word, of giving the exact measure of the resources which an artist has at his disposal, and which he owes to the strength of his training as well as to the privileges of his temperament. . . . It imposes on him the duty of giving himself unreservedly, under threat of betraying his mandate or demonstrating his impotence, because in such a case there could be no place for timorous minds or for uncertain talents.[74]

> [De tous les genres de peinture, celui-ci, en raison des exigences

[73] The *Dictionnaire* ceased publication after the sixth volume (with the entry "gypse") around 1900. The second volume appeared in 1865, after Delacroix's death. A note in the *Journal* of 8 August 1859 refers to "l'article sur la situation des artistes chez les anciens et les modernes.—A faire pour le Dictionnaire de l'Académie" (III, 223).

[74] *Dictionnaire de l'Académie des Beaux-Arts* VI, 72f.

mêmes, est le plus favorable au développement des talents de haute race, . . . le plus capable, en un mot, de donner la mesure exacte des ressources dont un artiste dispose et qu'il doit à la force de ses études aussi bien qu'aux privilèges de son organisation. . . . Elle lui impose le devoir de se livrer sans réserve, sous peine de trahir son mandat ou de démontrer son impuissance, parce qu'en pareil cas il ne saurait y avoir de place pour les intelligences timorées ni pour les talents incertains.]

Delacroix challenges all these points, implying that the alleged superiority of fresco is measured only according to the lowered standard of the viewer's, and even the painter's, expectations—fresco's restricted palette and its necessary simplicity of form: "One would be wrong to suppose that that genre is more difficult than oil painting because it demands to be done at the first go. The fresco painter demands less of himself, materially speaking: he knows that the viewer will not ask of him any of the nuances which are obtained in the other genre only by complicated efforts" (25 January 1857; III, 31). The supposed *tout d'un coup* quality of fresco painting is for Delacroix a myth: he insists on the preparatory role of the drawing and the cartoon, in which the composition and even the coloring are marked out in advance, and also cites the widespread evidence of retouching in even the most famous frescoes. Indeed he rejects rapidity of execution as a criterion of value altogether: "And what does it matter, after all, whether a work is done easily or not? What matters is that it produce the whole effect that one has the right to expect." In response to the translucence and limpidity of fresco, he asserts from experience that it fades and becomes dull with time, acquiring a whitish-grayish film; its supposed advantage of using only earth tones, and thus ensuring harmony to its coloring, for him produces instead an unevenness, as the differing quantities of lime cause correspondingly different levels of fading, falsifying the relative values of the tones. The much vaunted durability of fresco is belied by its tendency to detach itself from the wall—not only in damp climates, as was universally recognized, but, for Delacroix, in dry ones too, in which making the prepared (wet) ground adhere to the wall presents major difficulties. The Academy's article does what Delacroix ascribes to ordinary dictionaries, that is, it reports what "is thought" on the subject; his, on the other hand, calls this into question and considers fresco from a different point of view, taking at the same time a position on modern art, against the archaizing ideals and methods of some of the Parisian art establishment. As another note on fresco states, "to return to the austerity of fresco after Rubens and Titian is infantile."[75]

[75] *O.L.* I, 63.

In the context of what another dictionary writer, Pierre Larousse, in 1865 called the "century of dictionaries,"[76] Delacroix's choice of genre makes a clear statement about the cultural discourse of his own time. The blatantly personal and ostensibly limited nature of his dictionary clashes spectacularly with the all-inclusive ideal, the extravagant ambition, the universalizing pretensions of its contemporary counterparts, and the nineteenth-century public for which they were intended. The culmination of this latter movement was Larousse's own dazzling and monstrous achievement, the *Grand Dictionnaire universel du dix-neuvième siècle* of 1865, whose grandiose mission and humanitarian purposes, expressed in a relentless, breathtaking rhetoric, could not have been more distant—even taking into account the different type of dictionary each represented—from the essayistic style and the personal, limited aims of Delacroix's:

> We live in an era when the feverish activity of minds, turned violently away from political speculation, seems to have folded back upon itself for a moment, to launch subsequently, with an irresistible urge, onto a course where the sciences and arts open up limitless horizons to it. Never has the thirst for learning, knowing, judging, taken hold of minds so imperiously; never has thought, in a state of constant over-excitement because of new discoveries, taken on a more extensive body of bold questions and problems, although with fertile solutions; never has reason felt itself more liberated from the old ways of past centuries . . . Our scholars produce excellent works every day, and those who can procure them, and who have the time to read them, thus find themselves able to satisfy all those immense appetites of the mind; but the collection of these works forms a veritable library, and it is not given to everyone to buy an entire library, nor, especially, will everyone have the time needed to read it all. It is a unique book, containing everything, that alone could put all knowledge within reach of the multitude . . . The *Grand Dictionnaire universel* thus comes at the right time and fulfills its destiny; it comes . . . to offer the whole inventory of modern science; it comes to satisfy . . . legitimate hunger for knowledge; it brings to the scholar, the writer, the historian, the philosopher, the industrialist, the shopkeeper, the artist, the worker, to all who imagine and to all who execute, an inexhaustible supply, a formidable arsenal, in which are collected, classified, and labelled, all the means, all the resources, all the forces, all the arms which genius, patience, research, science, and the meditations of great men have placed in the service of human intelligence. Never . . . never, had so vast a col-

[76] Preface to the *Grand Dictionnaire universel du dix-neuvième siècle*, v.

lection of valuable materials, of useful or indispensable information, been accumulated in so universal an encyclopedia. . . . Ah! it is a formidable task which we undertook, when we resolved to erect this monument to the genius of mankind; heavy is the burden we have carried for twenty years, following up every discovery, noting every advance, analyzing every idea, evaluating every system, spying out, so to speak, each moment in which a new bud was going to open out to the world of thought. Today when our research has arrived at its end, when our materials are complete, we are going to get down to the job and hasten the work so that the edifice may soon be finished.[77]

At issue here are fundamentally different conceptions of knowledge and its uses. Larousse's, pieces of the "monument," materials for the "edifice," able to be collected, assembled, inventoried; so many books in a library coextensive with the world; a "panorama"[78] bounded by the horizon, its infinitude nevertheless manageable to the high aspirations of "nineteenth-

[77] Ibid., lxivf.: "Nous vivons à une époque où la fiévreuse activité des intelligences, détournée violemment des spéculations politiques, semble s'être repliée un instant sur elle-même, pour se lancer ensuite, avec un élan irrésistible, dans la carrière où les sciences et les arts lui ouvrent un horizon sans bornes. Jamais la soif d'apprendre, de savoir, de juger, ne s'était emparée plus impérieusement des esprits; jamais la pensée, surexcitée sans cesse par de nouvelles découvertes, n'avait abordé un ensemble plus étendu de questions et de problèmes hardis, mais d'une solution féconde; jamais la raison ne s'était sentie plus affranchie des errements des siècles passés . . . Nos savants produisent tous les jours d'excellents ouvrages, et ceux qui peuvent se les procurer et qui ont le temps de les lire, se trouvent ainsi en mesure de satisfaire à tous ces immenses appétits de l'esprit; mais l'ensemble de ces ouvrages forme une véritable bibliothèque, et il n'est pas donné à tout le monde d'acheter une bibliothèque entière, tout le monde surtout n'aura pas le temps qu'il faudrait pour la lire. C'est un livre unique, contenant toutes choses, qui pourrait seul mettre toutes les connaissances à la portée du grand nombre . . . Le *Grand Dictionnaire universel* vient donc à son jour, à son heure; il vient . . . offrir l'inventaire de la science moderne; il vient satisfaire des . . . avidités de savoir légitimes; il apporte au savant, au littérateur, à l'historien, au philosophe, à l'industriel, au commerçant, à l'artiste, à l'ouvrier, à tout ce qui imagine, à tout ce qui exécute, un inépuisable approvisionnement, un arsenal formidable, où sont rassemblés, classés, étiquetés, tous les moyens, toutes les ressources, toutes les forces, toutes les armes que le génie, la patience, les recherches, la science, les méditations des grands hommes, ont mis au service de l'intelligence. Jamais . . . jamais un si vaste amas de matériaux précieux, de renseignements utiles ou indispensables, n'avait été accumulé dans un répertoire aussi universel. . . . Ah! c'est une redoutable tâche que nous avons entreprise, lorsque nous avons résolu d'élever ce monument au génie de l'homme; c'est un lourd fardeau que celui que nous portons depuis vingt ans, suivant chaque découverte, notant chaque progrès, analysant chaque idée, appréciant chaque système, épiant, pour ainsi dire, chaque moment où un germe nouveau allait éclore au monde de la pensée. Aujourd'hui que nos recherches sont arrivées à leur terme, que nos matériaux sont complets, nous mettons la main à l'oeuvre, et nous allons presser les travaux pour que l'édifice soit bientôt achevé."

[78] Ibid., lxxii.

century man," and within reach of a society that takes the universe as its domain: it is not surprising that Larousse's impassioned encomium ends with a rousing homage to the socialist Proudhon, "the boldest and most profound thinker of the nineteenth century."[79] Delacroix's, *pensées détachées*, notes and jottings, one man's personal thoughts on the limited range of topics with which his time on earth has made him acquainted, individual objects to capture the interest of the reader, a "little" collection shedding on the subject the "little quantity of light" that a single person has managed to acquire:[80] his is almost a posture of conversation, the kind of personal contact with another artist which in his view no amount of training or individual practice could provide. "There is no artist who has not felt in his career how much a few words by an experienced master could be rays of light and sources of interest very different from what his own particular effort or his common training, etc. . . ."[81] The note trails off but the sense is clear. Delacroix speaks from experience, as one who has benefited from such contact on his own account—whose conversation with Corot taught him how to render the trees and landscape at which he came to excel; whose encounter with Rubens's *Raising of the Cross* taught him the essence of the *grand style*, the force of impression produced by greater freedom, which he could apply to his own work on the ceiling of the Apollo Gallery;[82] whose viewing of Dürer in 1849 showed him the importance of a knowledge of nature and led him to remark, "He is an *instructive* painter; everything, in him, is to be consulted" (10 March 1849; I, 274, my emphasis).

The ever increasing publication of art criticism in the nineteenth century, fueled by the dramatic expansion of the press, and the growing influence of critics over public taste makes the *Dictionnaire*'s understated, diminutive posture—the critic's withdrawal into the personal and even the private—all the more striking.[83] Delacroix was interested early on in the

[79] Ibid., lxxvi.

[80] *O.L.* I, 87.

[81] Ibid.

[82] 14 March 1847 (I, 207) and 10 August 1850 (I, 409).

[83] The three bibliographies of nineteenth-century Salon criticism record the growth of Salon reviews alone: from thirty-nine in 1822 to 137 in 1870, the numbers fluctuating in the interim but showing overall a clear increase (see Neil McWilliam et al., *A Bibliography of Salon Criticism in Paris from the Ancien Régime to the Restoration 1699–1827*; Neil McWilliam, *A Bibliography of Salon Criticism in Paris from the July Monarchy to the Second Republic, 1831–51*; and Christopher Parsons and Martha Ward, *A Bibliography of Salon Criticism in Second Empire Paris*). The bibliography by Gustave Lebel shows an even more remarkable growth in art periodicals generally, from six in 1822 to sixty-five in 1885 ("Bibliographie des revues et périodiques d'art parus en France de 1746 à 1914"). See also McWilliam, "Opinions professionnelles: critique d'art et économie de la culture sous la

role of critics in the reception of works of art, as his wry article of 1829, "Des critiques en matière d'arts," attests. Intermediaries between artists and the public, controlling the one while directing the other how to react, guards at the door of the seraglio keeping the two apart, critics wield enormous power, tempered, nevertheless, by the publicity which they provide.[84] Similarly, a later note attacks the power of the pen in the contemporary art world: "The pen has dethroned all powers, politics itself is submitted to it, and the author of novels . . . will criticize, enjoying himself and in order to amuse himself, a herd of painters and musicians who await from his books permission to live."[85]

These opinions, delivered in such an ironic, bantering tone, became ever more widespread and earnest among Delacroix's contemporaries, as the business of art criticism spread increasingly from literati (Sainte-Beuve, Barbey d'Aurevilly, Gautier, Janin, Baudelaire) and professionals drawn from the realm of official institutions (Peisse, Vitet, Blanc, Chennevières), into the hands of journalists and *chroniqueurs*, for whom it was often a one-time affair.[86] The currency of such views may be measured by Baudelaire's terse, ironic summary of them in the famous first section of the *Salon de 1846*, with its flamboyant title, "A quoi bon la critique?": "The artist first reproaches criticism for not being able to teach anything to the bourgeois, who wants neither to paint nor to write—nor to teach anything to art itself, since it is from art that criticism was born."[87] The evident literary emphasis of such criticism—describing or narrating the painting's subject, or comparing the artist to a literary figure, for example—made it particularly vulnerable to the scorn of artists.[88] Neil McWilliam

Monarchie de Juillet"; Antoinette Ehrard's introduction to the decade 1850–60 in J. P. Bouillon et al., eds., *La Promenade du critique influent*, 11f.; Harrison White and Cynthia White, *Canvases and Careers: Institutional Change in the French Painting World*, 94ff.; Joseph C. Sloane, *French Painting Between the Past and the Present: Artists, Critics, and Traditions from 1848 to 1870.*

[84] "Des critiques en matière d'arts," *O.L.* I, 7.

[85] *O.L.* I, 94.

[86] McWilliam, Introduction to *A Bibliography of Salon Criticism in Paris from the July Monarchy to the Second Republic, 1831–51*, xi.

[87] Baudelaire, *Oeuvres complètes* II, 417.

[88] See Ehrard, in Bouillon et al., *La Promenade du critique influent*, 14f. The confidence of the literary critic of painting was boundless. As she notes, Silvestre, writing on the "philosophical" art of Chenavard, asserts that painting and writing are different, but he does not question his own ability to discuss painting through the medium of writing. Gautier stated that literature contained the sphere of art in its "immense orb" (quoted in A. Ubersfeld, *Théophile Gautier*, 36). For a critique of this by a critic, however, see Mathilde Stevens's "Impressions d'une femme au Salon de 1859" (ibid., 91), which accuses her fellow critics of emphasizing the intellectual over the material, and treating the painting or statue as a book. Baudelaire's greatest homage to Delacroix was perhaps to

has surveyed this broad field of hostility toward critics, directed against their alleged ignorance, power, partisanship, and manipulative practices.[89] From his work and that of Sloane, it is clear that with the exception of learned accounts such as those appearing in the *Revue des deux mondes*, the *Journal des débats*, *L'Artiste*, and the *Gazette des Beaux-Arts*, art criticism during the July Monarchy and the Second Empire generally served as a guide through the Salon, providing information and assessments to a public for whom the event was a major date on the social calendar, a kind of festival, to use Sloane's term.[90] This public was projected as avid consumers of a packaged knowledge which they were too busy to discover for themselves, a knowledge previously reserved for only a privileged few and now available to all, medicinal and reviving like a healthy tonic for the intellectually malnourished social body—an image brilliantly caricatured in the address to the bourgeois which opens Baudelaire's *Salon de 1846*.[91] The universally low reputation which critics had among artists—the well-known malaise before the democratization and commercialization of culture—derived from the very real economic fact that they could make or break a career in both the marketplace and the world of official commissions.

Delacroix had little to fear in this regard, despite his oft-expressed sense of isolation and his bitterness toward the Second Empire: a significant portion of the corps of critics in the decade from 1850 to 1860 considered him an undisputed master, a point of reference for everyone else.[92] Nevertheless, he shared many of these concerns about critics, notably their lack of qualifications and their unabashed partisanship. He invokes Voltaire's scathing attack, in the *Questions encyclopédiques*, on the ignorance and presumption of professional critics, likened to toads— which absorb the earth's poison and pass it on to others—and to

suggest his own limitations in translating Delacroix's art through words, in contrast to Delacroix's achievement in doing the reverse. At the start of his 1863 essay (*L'Oeuvre et la vie d'Eugène Delacroix*), he wrote: "Je crois . . . que l'important ici est simplement . . . de montrer, enfin, autant que la parole écrite le permet, l'art magique grâce auquel il a pu traduire la parole par des images plastiques . . . " (*Oeuvres complètes* II, 743).

[89] McWilliam, "Opinions professionnelles: critique d'art et économie de la culture sous la Monarchie de Juillet," 23f.

[90] *French Painting Between the Past and the Present*, 34.

[91] *Oeuvres complètes* II, 415f.

[92] See Ehrard, Introduction to Bouillon et al., *La Promenade du critique influent* (13), and the numerous examples in the articles reproduced for that decade. Delacroix was variously championed by Edmond About, Ernest Chesneau, Paul Mantz, Alexandre Dumas, Edouard Duranty, Zacharie Astruc, and Paul de Saint-Victor, not to mention Baudelaire, Gautier, Thoré, and Silvestre.

"langueyeurs de porc," who judge no sample good.[93] Modern conditions of publication require the critic to know everything, but, as Delacroix exclaims, "Who can know everything?" (16 March 1857; III, 75). Criticism is like an "ordinary" dictionary, reporting and repeating the current view: "It drags along with what has been said, and does not get out of the rut" (15 July 1849; I, 299). Instead, the explicit emphasis on personal experience, with all its limitations, by this increasingly celebrated and decorated master betrays one of the *Dictionnaire*'s main purposes—to affirm his deep and long-held belief in the importance of material, practical experience for the "spiritual" sense of the plastic arts: "Most books on the arts are written by people who are not artists: that is the reason for so many false notions and so many judgments made at the whim of caprice and prejudice" (5 January 1857; III, 8). In terms of journalistic criticism, this is supported by the facts: in the period from 1848 to 1870, according to the list compiled by Sloane, very few critics could be considered artists in any real sense, and for most of these painting was not the primary profession.[94] Reversing the standard order, in which anyone with a liberal education can write on the visual arts,[95] he says, "I firmly believe that any man who has received a liberal education can speak pertinently of a book, but not of a work of painting or sculpture." The *Dictionnaire*, the writings of a painter on his own art, is meant to fill this gap, making clear the extent to which the technical aspects of the arts are one with their particular aesthetic, both historically (the relation between the

[93] Voltaire, *Oeuvres complètes* XVIII, 289f. In the same article Voltaire states: "Un excellent critique serait un artiste qui aurait beaucoup de science et de goût, sans préjugés et sans envie" (289). Delacroix complains of the literary bias of art critics in a letter to Thoré in 1847: "On nous juge toujours avec des idées de littérateurs, et ce sont celles qu'on a la sottise de nous demander" (*Corr.* II, 310; 8 April 1847). The complaint is rampant: Seznec and Adhémar record the same discontent among eighteenth-century artists (Diderot, *Salons* I, 14f.). See also Whistler's spirited attack in the "Ten O'Clock Lecture" (17), where critics are described as middlemen separating the public and the painter, treating the work as a hieroglyph for a story, and holding "mere execution" in disdain; in 1899 Gauguin feared that art criticism's literary emphasis might make painters lose sight of what really concerned them (quoted in Donald Kuspit, *The Critic is Artist: The Intentionality of Art,* 82).

[94] Fourteen percent, according to Harrison White and Cynthia White (*Canvases and Careers: Institutional Change in the French Painting World,* 95f.), although some of those counted produced very little criticism, and others had practiced art for only a brief period. Sloane identifies the following artists who wrote on art: Amaury-Duval, Astruc, Louis Auvray, Jules Breton, Couture, Delaborde, De La Rochenoire, Delécluze, De Mercey, Galimard, Gigoux, Gill, Lecoq de Boisbaudran, Lavergne, Perrin, Félix Régamey (*French Painting Between the Past and the Present,* 217–26).

[95] See Harrison White and Cynthia White, *Canvases and Careers: Institutional Change in the French Painting World,* 10.

(125)

technical state of the arts at a particular moment, and the ideal in that art at that moment), and in the abstract too—the aesthetic proper to painting by virtue of its differences from the other arts: "What art is there in which execution does not so closely follow invention? In painting, in poetry, the form is inseparable from the conception" (13 January 1857; III, 28). In this way, the *Dictionnaire* represents the culmination of the long years of debate in the *Journal* on the difference between the arts, especially painting and literature.

Delacroix is aware of the uniqueness of his position both as a painter writing ("Artists, in general, write little"),[96] and as a painter writing on aesthetics.[97] The *Dictionnaire* is the product of this awareness: in conception, the result of a pictorial way of seeing, discreet rather than *bavard* and "intemperate" like writing;[98] limited to selected items of the author's experience and expertise, rather than detailing everything, as the writer, through the fluidity and facility of the medium, is wont to do; suggestive, not exhaustive; done in his "idle hours" and "free time," in contrast to the ethic of rapidity driving journalistic criticism; personal notes confided to a public of individuals, each person finding in them material for his or her particular interests or needs, rather than the ideal "mass" audience of journalistic criticism, forming ever larger numbers of readers according to its image.

Moreover, one sees in this conception of his critical enterprise the reflection of his pictorial enterprise too. Delacroix's most public art is very much a personal statement, made in public and to the public, to be sure, but nonetheless highly individual in the choice and treatment of the subject, as was well recognized at the time. "Personal," however, does not mean unintelligible or hieratically private; Delacroix was everywhere concerned with the communicability of his art, its ability to speak. It implies, rather, the "personal" nature of the *Dictionnaire*'s reflections: one man's particular, and highly original, conception of a subject, the issues it suggests to him and its importance for his own time, like the treatment of Titian in the *Dictionnaire*, or the ideas on civilization rendered in the Luxembourg and Palais Bourbon libraries. "Beauty is everywhere, and . . . each man not only sees, but absolutely must render, it in his own way" (1

[96] *O.L.* I, 91.

[97] "Quoique l'auteur soit du métier et en connaisse ce qu'une longue pratique, aidée de beaucoup de réflexions particulières, puisse en apprendre, il ne s'appesantira pas autant qu'on pourrait le penser sur cette partie de l'art . . . Il paraîtra ainsi empiéter sur le domaine des critiques en matière d'esthétique qui croient sans doute que la pratique n'est pas nécessaire pour s'élever aux considérations spéculatives sur les arts" (13 January 1857; III, 27).

[98] *O.L.* I, 93.

October 1855; II, 395). Delacroix's public murals are the fruit of such personal reflection, engaging the viewer as he wishes the *Dictionnaire* to do: the same personal choice of subject, and the same personal treatment of it, rendered according to his "disposition" (13 January 1857; III, 26), and so often in contrast to the "accepted" view; the same space of reflection, of going and coming among the different parts and moving the viewer likewise to thought; bringing out the ambiguities of a subject, the "for and against"—"nothing too absolute"—as in the much ruminated appeal of both *ébauche* and *fini*, perfection and disproportion, in the *Dictionnaire*, or the complicated, ambiguous struggles of the Saint-Sulpice murals and the Apollo ceiling. Like the *Dictionnaire*, Delacroix's painting provides those "flashes of light" worth more than perhaps a year of training, and speaks to each viewer individually.[99] Both are selective and consequently rich in interest, that single most important element, in his view, of any work of art;[100] instructive even in their errors, they inspire not blind admiration but understanding (16 January 1860; III, 250). Alike, they represent that "voracious imagination" which, from within its deepest solitude, "had the incessant need to break out of himself [and] to address himself to the imagination of others" (16 January 1860, III, 253), like that of the other *peintre/littérateur* to whom Delacroix in fact applied these words—Michelangelo.

[99] Ibid., 87. (See above, 122.)

[100] "Mettre de l'intérêt dans un ouvrage, tel est le but principal que doit se proposer l'artiste" (25 January 1857; III, 47).

A Painter in the House
of Letters

THE DECORATIONS for the Palais Bourbon and Luxembourg libraries, which occupied Delacroix from 1838 to 1847, represent particularly compelling cases of the relations between word and image in his work. For this impassioned and thoughtful reader, this painter of literary subjects, this writer on painting and literature, library decoration would have posed an especially stimulating challenge, providing another, different context in which to explore this interest so central to his thought and practice: a painter in the house of letters, producing a pictorial commentary on the literary; "mute books" like the "mute poetry" of the Simonidean, *ut pictura poesis* tradition, alongside the "speaking" ones lining the walls; images to recount and interpret the significance of letters in the history of civilization, in a way that only images could do.[1]

The status of the library as the repository of civilization had motivated most library decoration since antiquity, particularly in the form of statues, busts, and medallions of civilization's most illustrious representatives; decoration served frequently as a means of cataloguing, identifying the author or subject of the books in its vicinity.[2] The ongoing debates of the 1830s and 1840s concerning the future of Parisian libraries, particularly the Bibliothè-

[1] The confrontation of visual and verbal is a theme in treatises on library decoration from at least the seventeenth century. See Claude Clément, *Musei sive bibliothecae*, 1635: "mute books which are born of the chisel, the stylus, the brush" (119). Clément alludes to the famous passage in Plutarch attributing to Simonides the dictum that painting is "silent poetry" and poetry a "speaking picture" (*Moralia* 346F; see also 17F and 58B).

[2] See, for example, Seneca, *De Tranquillitate Animi*, ch. ix, quoted in J.W. Clark, *The Care of Books*, 21f.: "these productions of men whose genius we revere . . . with their portraits ranged in line above them." For the prevalence of such decoration, see André Masson, *Le Décor des bibliothèques du moyen âge à la Révolution* and *The Pictorial Catalogue: Mural Decorations in Libraries*. For the design of ancient libraries in particular, see Clark, chapter 1.

que Royale, reveal the continued dominance of the motif of great figures of the past, as in Léon de Laborde's remark of 1845: "Where will one pay a rightful tribute to great men, if not amid the masterpieces of their genius?"[3] More allegorical figures of civilization from the traditional iconographic stock were common too. From ancient philosophers and church fathers to the seven liberal arts, from Apollo and his lyre to Athena, goddess of libraries, from the Muses to the Virtues, decoration celebrated and commemorated the status of the library as the seat of culture, learning, and the arts—the "temple of the Muses," the reunion of the knowledge of the ages.[4]

"Subjects . . . which pay tribute to letters or civilization": as his working notes attest, the theme of civilization motivated both of Delacroix's schemes as well.[5] In the Palais Bourbon, twenty episodes in the history of ancient civilization unfold between the birth and death of antiquity at either end; in the Luxembourg, Dante's meeting with the poets in Canto IV of the *Inferno* sets in motion a parade of illustrious personages from the Greco-Roman past, founders of, and models for, the European cultural tradition.

[3] *De l'organisation des bibliothèques dans Paris*, no. 8, 41. De Laborde allows for statues and busts, having earlier complained of an over-insistence on sumptuous decoration, notably in the most important library projects of the time, the Luxembourg and Palais Bourbon: "La bibliothèque de la chambre des pairs avec ses magnifiques boiseries, et celle de la chambre des députés avec les peintures de M. Eugène Delacroix, sont autant de dépendances d'un grand bâtiment, pour lesquelles l'architecte semble avoir abdiqué devant le décorateur" (ibid., 29f.). On the history of the Parisian library projects, see Dominique Varry, ed., *Histoire des bibliothèques françaises*, vol. 3: *Les Bibliothèques de la Révolution et du XIXè siècle*.

[4] See the prescriptions of Clément in his *Musei sive bibliothecae*, discussed in Masson, *Le Décor des bibliothèques*, 88ff. Examples are numerous, and only a small sample can be given here. Both Sixtus IV's library in the Vatican (1484) and the Escorial library (1584) represent philosophers and church fathers; the latter also depicts the liberal arts (see Anthony Grafton, ed., *Rome Reborn: The Vatican Library and Renaissance Culture*, 34; Masson, *Le Décor des bibliothèques*, 72ff.). Veronese's ceiling of the Libreria Vecchia of the Marciana (1556) in Venice features allegories of music, arithmetic and geometry, and Honor. The staircase of the Marciana has an Apollo playing the lyre (ibid., and J. W. Clark, *The Care of Books*, 214f.); Raphael's *Parnassus* has been explained in terms of the original plan of the Vatican's Stanza della Segnatura as Julian II's private library (see John Shearman, "The Vatican Stanze: Function and Decoration," 380f.). Representations of Minerva occur in the Doges' Palace in Venice (Masson, *Le Décor des bibliothèques*, 119), and in Girodet's ceiling in the library of the château of Compiègne of 1818. Major examples of the Muses are Altomonte's Vienna Hofbibliothek (1730), his library at the Admont Monastery (1776), and Boucher's painting in the Cabinet des Médailles of the Bibliothèque Nationale (ibid., 129, 169). For more examples, see Masson, *Pictorial Catalogue*. For a useful list of library iconography, see Margarete Baur-Heinhold, *Schöne alte Bibliotheken. Ein Buch vom Zauber ihrer Räume*, 285–89.

[5] Note on a sheet of plans for the Luxembourg library (B.N. ms. N.a.f. 25069, f. 145). Similarly, on one for the Palais Bourbon, he wrote "des traits à l'honneur des lettres ou de la philosophie" (Bibliothèque d'art ms. 250, f. 112; a copy is quoted by Sérullaz, *Peintures murales*, 50).

Yet these subjects do not merely celebrate the great figures of antiquity and their achievements—the contents of the library, as it were. Rather, they explore the nature of civilization itself: its fragility, certainly—an idea appropriate to the place housing its few remains—but also its contingency, weakness, and even potential for perversion. Such was the special value of the image among so many words: to convey the complexity of this essentially human phenomenon, its nuances and contradictions. Indeed, these illustrious figures and momentous events proclaim how tenuous was, and is, the line by which they survive, how haphazard and irregular their appearance, how dangerous the forces which threaten, not only from without, but at every moment from within. The one subject common to both programs (despite much shifting back and forth of subjects in his notes) indicates the centrality of this idea to Delacroix's approach: Alexander preserving the poems of Homer, saving the precious manuscript in the casket found among the spoils of the defeated Persians—a fable of the fortuitous preservation of culture and ancient tradition, the origin of that other receptacle for books, the library itself.[6] The motif had been used before, most notably by Raphael in the Stanza della Segnatura of the Vatican, originally intended as a library.[7] But Delacroix emphasizes what Raphael, in an era which he considered more hospitable to the arts,[8] had relegated to a visual footnote—the single, timely act by which so much else endured: an enlightened ruler conserving the great national epic threatened otherwise with disappearance and oblivion. For Delacroix, the stakes in the nineteenth century were higher, and survival could not be taken for granted: "At the moment we do not have a devotion to the saints any more than a devotion to the beautiful."[9]

[6] Delacroix was drawn to this subject and intent on using it. It is one of the most recurrent ideas in the sheets of notes for both schemes (Getty ms. 864470; Bibliothèque d'Art ms. 250, f. 117; sheet of notes in *Mémorial*, no. 370; Palais Bourbon ms., quoted in Sérullaz, *Peintures murales*, 52).

[7] As Sara Lichtenstein noted (*Delacroix and Raphael*, 204f.), the Alexander subject occupies a grisaille under the *Parnassus* mural, and is matched on the other side by *Augustus Saving the Aeneid from the Flames*. Delacroix considered this latter subject for the Palais Bourbon as well, as two sheets of notes attest: "Virgile mort. Auguste empêche qu'on brûle l'*Enéide*" (Getty ms. 864470); "Virgile voulant faire brûler l'Enéide" (transcript by Robaut in B.N. Est. R111070). Many years later he recalled the Augustus subject as especially suitable to a library (18 April 1857; III, 92). See below, 159, and S. Lichtenstein, 206. Another example of the Alexander subject is the ceiling of the Palazzo Reale, Turin, by Laurent Pécheux (1778–83), where it is paired with a subject later considered by Delacroix for another library: Tarquin paying five gold talents for the Sibylline books (see below 159, and Masson, *Pictorial Catalogue*, 57f.). The Tarquin subject is also found in the Sixtus V library in the Vatican (see Grafton, *Rome Reborn: The Vatican Library and Renaissance Culture*, plate 30).

[8] "Raphael," *O.L.* II, 14: "à cette époque . . . l'impulsion fut générale vers le beau"; ibid., 17: "le sentiment du grand et du simple était partout."

[9] Ibid., 5.

Such a notion of the insecurity and precariousness of civilization was surely evoked by the phenomenon of the library itself, as the vestiges of past achievement and knowledge. As Léon de Laborde wrote in his own proposal for a library in 1845: "Amid the products of so many generations now disappeared, [visitors] will feel in themselves something like a warning about human fragility, something like a voice which proclaims that thought . . . is the only durable trace of man on earth."[10] But Delacroix questions this very durability while evoking it, showing the vulnerability of culture, exposed not only to occasional barbarian invaders, but to a more persistent and pernicious enemy, the barbarism within civilization itself.

THE DEPUTIES' LIBRARY, PALAIS BOURBON

Orpheus brings to the Greeks, dispersed and abandoned to a primitive life, the benefits of the arts and civilization. He is surrounded by hunters covered with the skins of lions and bears. These simple men stop in wonder; their wives approach with their children. Oxen, joined by the yoke, trace furrows in this ancient soil, on the shore of lakes and on mountainsides still covered in mysterious shade. Withdrawn under crude shelters, old men, younger men, more fierce or more timid, gaze from afar at the divine foreigner. The centaurs stop at the sight of him and prepare to return to the depths of the forests. The naiads, the river gods wonder from amid their reeds, while the two divinities of the arts and of peace, fecund Ceres loaded with husks, Pallas Athena holding in her hand an olive branch, traverse the blue of the sky, and descend to earth upon hearing the voice of the enchanter.

Attila followed by his barbarian hordes tramples under his horse's hooves Italy overturned on ruins. Eloquence, in tears, and the Arts flee before the wild steed of the king of the Huns. Fire and murder mark the passage of these savage warriors, who come down from the mountains like a torrent. At their approach, the timid inhabitants abandon the countryside and the towns, or, stopped in their flight by the arrow and the lance, water with their blood the earth which nourished them.[11]

[10] *De l'organisation des bibliothèques dans Paris*, no. 8, 48.

[11] Delacroix's descriptions of the hemicycles, *Le Constitutionnel*, 31 January 1848 (quoted in Johnson V, 58 and 60): "Orphée apporte aux Grecs, dispersés et livrés à la vie sauvage, les bienfaits des arts et de la civilisation. Il est entouré de chasseurs couverts de la dépouille des lions et des ours. Ces hommes simples s'arrêtent avec étonnement; leurs femmes s'approchent avec leurs enfants. Des boeufs, réunis sous le joug, tracent des sillons dans cette terre antique, au bord des lacs et sur le flanc des montagnes couvertes encore de mystérieux ombrages. Retirés sous des abris grossiers, des vieillards, des hommes, plus

Delacroix's description of the half-domes at either end of the Deputies' Library in the Palais Bourbon left little doubt as to the general theme underlying the long space and the twenty-two paintings of the scheme overall: the birth of civilization and its destruction—the dawn of antiquity, appropriately, at the southern end of the room, and its brutal extinction at the hands of barbarian invaders to the north (figs. 4–6). In between, five cupolas, divided into four pendentives each, represent scenes from philosophy, history, science, legislation, eloquence, literature, poetry, and theology, grouped flexibly according to theme.[12] The subjects are as follows, beginning at the southern (Orpheus) end and reading each cupola clockwise from the southeast quadrant:

FIRST CUPOLA	SECOND CUPOLA	THIRD CUPOLA	FOURTH CUPOLA	FIFTH CUPOLA
[science][13]	[history and philosophy]	[legislation and eloquence]	[theology]	[poetry]
Death of Pliny the Elder	Herodotus consults the magi	Numa and Egeria	The tribute money	Alexander and poems of Homer
Aristotle describes the animals sent by Alexander	The Chaldean shepherds, inventors of astronomy	Lycurgus consults the Pythia	John the Baptist beheaded	Ovid among the Scythians
Archimedes killed by the soldier	Socrates and his genius	Demosthenes declaiming by the seashore	The Babylonian captivity	Hesiod and the Muse
Hippocrates refuses the gifts of the Persian king	Death of Seneca	Cicero accuses Verres	Adam and Eve	Education of Achilles

If the half-domes presented a clear historical evolution, however, the place of the intervening images was less evident. Most critics of the time understood that Delacroix's purpose in them was not chronological and

farouches ou plus timides, contemplent de loin le divin étranger. Les centaures s'arrêtent à sa vue, et vont rentrer dans le sein des forêts. Les Naïades, les Fleuves s'étonnent au milieu de leurs roseaux, pendant que les deux divinités des arts et de la paix, la féconde Cérès chargée d'épis, Pallas tenant dans sa main un rameau d'olivier, traversent l'azur du ciel, et descendent sur la terre à la voix de l'enchanteur."

"Attila suivi de ses hordes barbares foule aux pieds de son cheval l'Italie renversée sur des ruines. L'Eloquence éplorée, les Arts s'enfuient devant le farouche coursier du roi des Huns. L'incendie et le meurtre marquent le passage de ces sauvages guerriers, qui descendent des montagnes comme un torrent. Les timides habitants abandonnent, à leur approche, les campagnes et les cités, ou atteints dans leur fuite par la flèche et par la lance, arrosent de leur sang la terre qui les nourrissait."

[12] On the flexible arrangement, see Anita Hopmans, "Delacroix's Decorations in the Palais Bourbon Library: A Classic Example of an Unacademic Approach."

[13] Delacroix gave no titles to the cupolas. These are Johnson's (V, 34 and n. 4).

not narrative, resulting in a lack of coherence which Clément de Ris, for one, regretted:

> We think that it would have been more appropriate to make the pendentives serve as a historical link between the half-domes, and to choose the subjects so as to lead the mind of the spectator by means of a sequence of great historical facts from Orpheus, one of the founders of Greek civilization, to Attila, who destroyed that same civilization; this approach, explaining the two end-subjects by means of one another, would have made one grasp the immediate correlation between them, and would have given to them, placed together, a unity which in our opinion they lack.[14]

Those more willing to accept the episodic character of the pendentives interpreted them as exemplary figures or stories from each category. Prosper Haussard, for example, wrote:

> The two vast hemicycles and the five small cupolas of the library display the whole history of the genius of ancient civilization. The two hemicycles, the opposite, circular extremities of the gallery, are like the two poles of this history, and represent the Greek era which begins, the Roman era which ends . . . Under the five painted cupolas . . . it is not the ages, nor the chronological sequence, but the broad planes, the high spheres of this history which are ranged one after the other and are resplendent: the Sciences, Philosophy, Legislation, Theology, Poetry . . . They consist of four pendentives in which is dramatically summarized each special genius, in its most sublime representatives or works.[15]

With a rhetorical question, Charles Blanc likewise observed the difference between the thematic, non-narrative groupings of the cupolas and the overarching narrative of the half-domes: "[It has] for its subject, the intellectual history of the ancient world, from the dawn of civilization to the darkness of barbarism . . . However, how can one recount this history of antiquity . . . ? Should one follow the events in their order of sequence and duration?"[16]

[14] L'Artiste, 9 January 1848 (quoted in Sérullaz, Peintures murales, 69).

[15] Le National, 17, 18, 19, 20 October 1850 (quoted in Sérullaz, Peintures murales, 71). This was echoed later by Paul de Saint-Victor in his obituary of Delacroix: "[Les peintures du Palais Bourbon] déroulent, entre Orphée et Attila, entre l'aurore et le crépuscule du monde antique, toute l'histoire de sa civilisation et de son génie. Cette histoire ne suit pas l'ordre chronologique . . . L'artiste divise l'antiquité en cinq zones: les Sciences, la Philosophie, la Législation, la Théologie, la Poésie. Chacune de ces zones remplit une coupole, et y développe en quatre tableaux ses types les plus élévés et ses oeuvres les plus sublimes" (La Presse, 22 September 1863, quoted in ibid., 74).

[16] Les Artistes de mon temps (1876), 56, 59.

This discrepancy is instructive: the movement from civilization to barbarism traced by the hemicycles is not a linear development, a progressive decline, but, as others have suggested, an alternation between the two,[17] an example of "those eternal alternatives of grandeur and misery" (21 September 1854; II, 274) which for Delacroix defined human history. But this does not mean simply an oscillation over the longer course of time; the composition of Delacroix's scheme implies the coming and going between civilization and barbarism *within civilization itself.* The history of culture presented by the cupolas is an ongoing, relentless struggle against forces within as destructive as those of Attila without. Indeed the exemplarity of the twenty images is dubious at best, dominated by what Pierre Angrand called a "dramatic pessimism":[18] four scenes of death and murder, three of exile, two of thwarted bribery and corruption. The point is crucial, going beyond a mere Romantic taste for drama and action: between the defeat of barbarism in the *Orpheus* and the return to barbarism in the *Attila*, the pendentives catalogue the testimonials of a civilization permeated by barbarism in the form of conquest, tyranny, betrayal, greed, and even that original force which civilization was formed to counteract, nature—threats to those worthy achievements by which a high culture seeks to leave its mark on a resistant and even hostile world. Delacroix's sketches and notes for the library contain many more such examples: Galileo in chains describing the movements of the planets; history and philosophy surrounded by the ruins of the centuries; Socrates before his judges, and so on.[19]

The contrast between this and other cycles on the history of culture is striking. Of the twenty-eight main pendentives in Henri Lehmann's Galerie des Fêtes in the Hôtel de Ville (1853), for example, only two suggested even remotely an ambivalence akin to Delacroix's: predictably, the War pendentive, showing figures with torch and sword flying through the air above a woman cringing in fear; and Philosophy, aging and withered over her books and manuscripts, as the book of truth remains resolutely

[17] Pierre Angrand, "Genèse des travaux d'Eugène Delacroix à la Bibliothèque de la Chambre," 328; Sérullaz, *Peintures murales*, 76; Johnson, *Delacroix*, 91.

[18] Angrand, "Genèse des travaux d'Eugène Delacroix à la Bibliothèque de la Chambre," 326. J. Ribner calls attention to the pessimism of the *Attila* in particular, in relation to certain statements in the *Journal* (*Broken Tablets: The Cult of the Law in French Art from David to Delacroix*, 132).

[19] For the first two, see Bibliothèque d'Art ms. 250, f. 116; for the Socrates, see Robaut's transcription in B.N. Est. R111070, and cf. Louvre 270. Cf. also Delacroix's plans for the Palais Bourbon's Salle des Conférences, part of his original proposal, showing the members of the Roman Senate immobile on their ivory seats as the Gauls take possession of the city; and Lycurgus, alone, facing a revolt of the Lacedemonian people (A.N. F21 752, quoted in Sérullaz, *Peintures murales*, 50).

closed. Otherwise, Lehmann's vision of history celebrates humanity's mastery of the land, animals, and elements, and achievements in commerce, industry, finance, medicine, the arts and sciences, theology, justice and charity. It began with an allegory of origin, a woman crowned with flowers and husks offering her breast to putti, and ended with allegories of Abundance and Glory.[20] Vitet called it "this epic with man as its hero";[21] Delaborde described it as the entire history of human labor from the struggle with the beasts to the conquests of the mind, from the rude laborer to the poet, astronomer, and judge;[22] for Jules Lecomte it was an "encyclopedic history of the world, from Adam and Eve to the most refined civilization." The single, progressive order of this work was never in doubt:

> Thus through multiple, successive allegories, we see mankind parade in all its struggles, its efforts and its conquests. . . . It is all of humanity illustrated and progressing from brutal action to fecund meditation . . . from the most rude labors of the body to the most sublime conceptions of genius. . . . It is a complete journey through humanity, having two phases: barbarism–civilization.[23]

The theology subject provides a good example of the difference between Lehmann's unproblematic allegories and Delacroix's ambiguous dramas. To the latter's predominant images of violence and suffering—*John the Baptist Beheaded, The Babylonian Captivity, Adam and Eve* driven from Paradise, offset only by the divine beneficence of *The Tribute Money* (figs. 7–10)—corresponds Lehmann's image of the apotheosis of the true faith: "Theology. Her right hand on the Gospel, her left raised toward the cross and the chalice, carried by two angels, her foot on Error with its eyes blindfolded, she proclaims the true doctrine and the true faith." (fig. 11).[24]

In James Barry's cycle on "The Progress of Human Culture" for the Royal Society of Arts in London (1784)—the description of which led Delacroix in 1843 to adopt the Orpheus subject for his own, as Hopmans has shown[25]—the initial Orpheus picture is followed by representations of human accomplishment: *A Harvest Home, or Thanksgiving to Ceres and Bacchus* (fig. 12); *The Victors at Olympia; Navigation, or The Triumph of the Thames; The Distribution of Premiums in the Society of Arts;* and *Elysium*

[20] See Marius Vachon, *L'Ancien Hôtel de Ville de Paris,* 62ff.; and Marie-Madeleine Aubrun, *Henri Lehmann 1814–1882. Catalogue raisonné de l'oeuvre.*

[21] *Revue des deux mondes,* 1 December 1853.

[22] Ibid., 1 May 1869.

[23] *L'Artiste* 49(1853), 29f., quoted in Aubrun, *Henri Lehmann 1814–1882. Catalogue raisonné de l'oeuvre,* 197.

[24] Vachon, *L'Ancien Hôtel de Ville de Paris,* 65.

[25] "Delacroix's Decorations in the Palais Bourbon Library: A Classic Example of an Unacademic Approach," 245f.

and Tartarus, or the State of Final Retribution (fig. 13).[26] The barbarism
of the first picture is converted, unlike that of Delacroix's *Orpheus*, into
the apotheosis of the "cultivators and benefactors of mankind"; only a
corner of *Elysium and Tartarus* represents the punishment of vice (fig.
14).[27] Perhaps only Chenavard's never completed plans for the Panthéon
(1848–51) reflected some of Delacroix's ambivalence, bringing together,
for example, the death of Socrates and the age of Augustus, Luther de-
stroying the papal bulls and the golden age of Louis XIV. But Che-
navard's subjects followed a historical order—from Genesis to the French
Revolution—and recounted an "inverse" narrative of cyclical decadence,
as we shall see in the next chapter.[28]

Delacroix's cycle is neither a history as such, nor a series of representa-
tive episodes, but a reflection on the insecurity of the civilization it cele-
brates, threatened from within itself, its values so often maintained only
by a solitary figure, in distant exile or heroic death. The pictorial narra-
tive makes plain the complexities of a history—the stakes and the price—
that writing, the context and sometime subject of the narrative, might
itself conceal. The inclusiveness of the individual image and the relations
between different images produce a scheme faithful to Delacroix's views
on culture.[29] The massive images at either end posit the terms which
define and debate the space between: Delacroix's civilization testifies to
that barbarism over which it never fully triumphs, which survives in
force, and leaves it prey to the apocalyptic devastation of an Attila—an
Attila, unlike Raphael's, that is not repulsed, not stopped by divine inter-
vention, but ubiquitous within civilization itself.

The library ceiling represents the conflict in all its complexity, counter-
ing control of nature with destruction by nature, piety with treachery,
preservation of the arts with their extinction. The hemicycles establish the
bold oppositions to which the pendentives refer in a more nuanced way,

[26] See Barry's description in *An Account of a Series of Pictures in the Great Room of the Society of Arts, Manufactures, and Commerce at the Adelphi*, 40f. Also William Pressly, *The Life and Art of James Barry*, chap. 4.

[27] Barry, *An Account of a Series of Pictures*, 116. Interestingly, Barry's description is far more problematic. He lashes out at those responsible for the sorry state of contemporary affairs, particularly the lot of the artist—unrecognized, uncompensated, unhoused. These outbursts are counterbalanced by other statements of almost utopian progress: "The foun-dation of the royal academy . . . was happily and providentially reserved for our age, when previous enquiry, knowledge, and liberal sentiment had sufficiently enabled us to emerge from the barbarism and fanatical blindness of our bigoted ancestors" (ibid., 98f.).

[28] See Joseph C. Sloane, *Paul Marc Joseph Chenavard*; also Gustave Planche's review of Chenavard's cartoons in the *Revue des deux mondes*, 15 January 1852.

[29] Bryson (*Tradition and Desire*) discusses the interrelation of images, but not in the empirical context of Delacroix's views, either of culture or of pictorial narrative itself.

mixing, combining, and even reversing the terms. To the civilization of the *Orpheus* and the barbarism of the *Attila* correspond peace and war, rich landscape and scorched earth, luxuriant tree and blasted trunk, calm and furious agitation, light and smoke, dominant blue and dominant red, horizontal mountain range and Huns descending, as Delacroix wrote, like a torrent down a mountainside; humanizing the beast and bestializing man, cultivating the land and laying it waste, drawing sustenance from the earth and watering it with human blood; the formation of society in the group uniting around Orpheus and its splintering and scattering as the figures flee from Attila. Stationed at the "ideal" vantage point which Delacroix posits, as Johnson remarks, midway between the two,[30] the viewer experiences the full force of this dual perspective, is made constantly aware of the presence of both within the space of civilization between. This testimony to the achievements of culture is also, as Bryson argues, a "desublimating" analysis of it,[31] but not, in this sense, to reveal the hidden violence at its origin; rather, Delacroix depicts the ongoing, sometimes overwhelming barbarism against which civilization defines itself, and with which it must contend at every point. Indeed, for every noble or virtuous achievement, he presents either the hard struggle by which it was accomplished, or a starkly contrasting example, infusing the space of civilization with manifestations of the barbarism at its boundaries, and testifying to the often tragic dominance of the latter within the supposed preserve of the former.

This issue fascinated Delacroix: "Barbarians are not found only among the savages: how many savages there are in France, in England, in this Europe which is so proud of its enlightenment" (21 November 1857; III, 158). The presence, or threat, of barbarism within civilized society is a recurrent topic in his diary and his notes: "Recent eras, of redoubtable memory, have shown that the barbarian and even the savage were still living in civilized man" (3 March 1860; III, 275). This is the case not only in times of social and political unrest, but in society generally: "The savage always returns. The most advanced civilization cannot banish from our cities the atrocious crimes which seem the lot of people blinded by barbarism" (I, 248). "The crimes which one sees a host of contemptible people perpetrate within society are more awful than those which savages commit": a "savage" may kill for reasons of survival—to clothe and feed himself—but "those perfidious plots, long premeditated, which are hidden under all sorts of veils—friendship, tenderness, little attentions—are only seen in civilized men" (17 November 1852; I, 498).

[30] V, 33.
[31] *Tradition and Desire*, 194.

The theme of *homo homini lupus* is revived from year to year, as in an (undated) note from years earlier recopied into 1853:

> How does such a beautiful world as this contain so many horrors! I see the moon look peacefully down on dwellings apparently immersed in silence and calm. The stars seem to hover in the sky over these peaceful abodes. But the passions which inhabit them, the vices and crimes, are only dormant, or lie in wait in the shadows and prepare their arms. Instead of uniting against the horrible ills of mortal life in a common, fraternal peace, men are tigers and wolves roused one against the other to destroy each other. . . . All these faces are masks, these hands rushing to shake your hand are steely claws ready to plunge into your heart. From within this horde of hideous creatures there appear noble and generous natures. These rare mortals, who seem left on earth for the sole purpose of testifying to the fabled golden age, are the privileged victims of that multitude of traitors and scoundrels who surround and press them. (15 March 1853; II, 10)

> [Comment ce monde si beau renferme-t-il tant d'horreurs! Je vois la lune planer paisiblement sur des habitations plongées en apparence dans le silence et dans le calme. Les astres semblent se pencher dans le ciel sur ces demeures paisibles. Mais les passions qui les habitent, les vices et les crimes ne sont qu'endormis ou veillent dans l'ombre et préparent des armes. Au lieu de s'unir contre les horribles maux de la vie mortelle dans une paix commune et fraternelle, les hommes sont des loups et des tigres animés les uns contre les autres pour s'entre-détruire. . . . Tous ces visages sont des masques, ces mains empressées qui serrent votre main sont des griffes acérées prêtes à s'enfoncer dans votre coeur. A travers cette horde de créatures hideuses apparaissent des natures nobles et généreuses. Ces rares mortels, qui ne semblent laissés à la terre que pour témoigner du fabuleux âge d'or, sont les victimes privilégiées de cette multitude de traîtres et de scélérats qui les entourent et les pressent.]

The note employs the rhetoric of the library's subjects: the hordes of morally hideous people preparing their assault are Attila's attacking "hordes barbares," the tigers and wolves with their deadly claws concealed behind the mask of civilized behavior are as savage as the untamed, pre-Orphic beasts arranged around the base of that picture; the golden age is the sunny, mythical landscape of the *Orpheus*, of which the occasional noble soul celebrated in the different pendentives is the rare representative in an otherwise barbaric milieu. The fantasized communal society "united against the ills of mortal life" is the group around Orpheus, a civilization constantly shattered by the

mutual enmity of man against man. It survives only in exceptional individuals, isolated among the predominant Attila-like scoundrels of contemporary society and victimized at every point by them.

This is indeed the barbarism of many of the pendentives, which rehearse the final disaster, depicting civilization threatened or destroyed by a force akin to Attila himself. Archimedes is killed by the "barbaric" Roman soldier, as Delacroix calls him in some notes for the picture.[32] Lost in thought, the great mathematician is oblivious to the brutality that will overwhelm him (fig. 15). His books and scrolls repeat the prominent scroll of Orpheus and the blue of his drapery the coloring of that hemicycle;[33] the soldier's red tunic prefigures the blaze of the *Attila*, in which the blue-clad figure of Italy and the putto holding the scrolls are trampled underfoot. The image of the doomed thinker contrasts sharply with the image of tranquil learning in *Aristotle Describes the Animals* alongside (fig. 16). In the same cupola, Hippocrates refuses the gifts through which the king of Persia seeks to tempt him to betray his own people by curing the enemy of the plague (fig. 17): in Delacroix's terms, "vases filled with coins, and precious caskets." The kind of "coffre précieux" used to preserve the poems of Homer in the *Alexander* painting in the poetry cupola (fig. 18) is here used to inspire that covetousness which Delacroix repeatedly identified as one of the worst forms of barbarism. The exemplary figure of Hippocrates resists, but cannot defeat, the barbarism which surrounds him.

The other cupolas contain equally striking examples. To the piety of Alexander sending to his teacher, Aristotle, animals collected from the furthest regions of his conquest, correspond the infamy and treachery of Nero, who condemns his teacher, Seneca, to death; here the emblem of civilization, the scroll on the right, is a death warrant (fig. 19). The Stoic philosopher taking his own life is a Christ-like figure, a martyr put to death by a barbaric society. In this, the painting qualifies even the exalted and seemingly unambiguous subject of *Socrates and his Genius* alongside, reminding us, despite the serenity of the image, of the most famous example of a virtuous philosopher executed by society (fig. 20);[34] in fact, Delacroix at one point considered the subject of "Socrates before his judges."[35] The meditative solitude and *recueillement* which Delacroix honors as the true source of

[32] Bibliothèque d'Art ms. 250, f. 116: "Archimède tout occupé de la solution de son problème ne voit pas le barbare qui s'apprête à le tuer."

[33] The question of Orpheus's scroll (raised by Hopmans, "Delacroix's Decorations in the Palais Bourbon Library," 247f.; and Bryson, *Tradition and Desire*, 177f.) can be resolved in terms of the space decorated, the library itself: Delacroix's interest in emphasizing *letters* as the mark and measure of civilization. In Barry's *Orpheus* a scroll lies by Orpheus's side.

[34] This connection is noted by Bryson also (*Tradition and Desire*, 188).

[35] See Robaut's transcription of a page of notes, B.N. Est. R111071.

inspiration in the Socrates picture[36] cannot help but be qualified by the surrounding images of isolation and persecuted, solitary genius that run through the cycle. In the central cupola, devoted to legislation and eloquence, Cicero exposes the corruption of Verres, the governor of Sicily, guilty of plundering works of art of the people under his protection (fig. 21)—a lesser version, within civilization, of the action of Attila overrunning Italy and the arts at the end, and in direct contrast to Alexander *preserving* the poems of Homer, and thus guaranteeing civilization, in the poetry cupola (fig. 18). John the Baptist is put to death through the spite of a woman and the lust of a king, in Delacroix's grim image with its shocking foreshortened torso (fig. 7).[37] *The Babylonian Captivity* shows the chosen people destitute and reduced to "mean labors" (fig. 8). And the civilization of *Adam and Eve* (fig. 9) is perhaps the most barbarous of all, the hostile, "savage" world of illness and suffering into which they are cast, exiled like the Babylonians, condemned to the same harsh labor. The salutary grace of Providence which, in the accompanying picture, makes the tribute money turn up miraculously in the fish, is here tempered by the pitilessness depicted in Delacroix's image of the Fall, Eve's pathetic plea for mercy having no effect on the harsh fury of the avenging angel.[38]

Even that most civilizing art, poetry, is menaced by barbarism, as a transformation of the *Orpheus* picture brings out: in *Ovid among the Scythians,* the poet is exiled from his native land and finds succour, as Delacroix describes it, only in a "barbarian land" (fig. 22). This is an Orpheus (he has a scroll too) banished by his own people and honored by the "barbarians" who offer him sustenance. In his description of Delacroix's later painting on this same subject (1859), Baudelaire brings out the paradox by quoting the passage from Chateaubriand's *Martyrs,* where Eudore comes upon the tomb of Ovid overgrown with weeds:

[36] See his commentary: "On voit voler derrière lui et se pencher à son oreille, son génie ou démon familier, qui n'était peut-être que la solitude elle-même et le recueillement dans lequel les vrais sages ont toujours retrempé leur âme et puisé des inspirations profondes" (quoted in Johnson V, 69). Reading Medwin's *Conversations with Lord Byron* in 1850, Delacroix copied out a passage expressing the same idea by means of another subject used in the ceiling: "Chérissant sa solitude, cette première de toutes les inspirations, et qui n'est autre que cette Egérie à qui le législateur des Romains allait demander le génie et la sagesse" (15 July 1850; I, 390).

[37] Delacroix at one time considered a variant of this subject, "Cicero and Fulvia": having been sent the head of Cicero by her husband Antony, Fulvia heaps insults upon it and pierces the tongue with a needle (Getty ms. 864470; and see Angrand, "Genèse des travaux d'Eugène Delacroix à la Bibliothèque de la Chambre," 315 and n. 35). Bryson sees in the Baptist image a suggestion of the future of Orpheus (*Tradition and Desire,* 200).

[38] See an early note on this subject (Louvre 1758, inside cover): "Adam et Eve nuds et ayant péché . . . La maladie, les maux, le péché etc. les suivent. On voit la porte du paradis. Archange sur la porte."

Ah! less ungrateful than the peoples of Ausonia, the savage inhabitants of the banks of the Ister still remember the Orpheus who appeared in their forests! They come to dance around his ashes; they have even retained something of his language, so sweet to them is the memory of that Roman who accused himself of being the barbarian, because he was not understood by the Sarmatian![39]

Barbarus hic ego sum: Ovid makes the point about himself, but to the Romantic mind the barbarism lay in Augustus's Rome, which, in Chateaubriand's words, "watched with a dry eye the tears of Ovid flow for twenty years."[40] The tears of the *Tristia* and the *Epistulae ex Ponto:* the poetry so crucial to the civilization of the *Orpheus* is here spurned and ignored; the scroll at the center of the hemicycle, the focal point of the newly formed society, lies here on the ground, apart and untouched. The image provides a counterweight to the Alexander one adjacent to it (fig. 18): Augustus's insult versus Alexander's tribute, the banishment of Ovid versus the preservation of Homer.

For Delacroix, barbarism can in fact emerge from a surfeit of civilization itself, whose benefits may weaken moral character or physical health, as in the excessive materialism and commercialism of contemporary society:

> So it is that after a century and a half almost of a more refined civilization which recalls the great age of antiquity—I mean the century of Louis XIV and a bit beyond—the human species, and I understand by that the small number of nations which currently carry the flame, declines again into the shadows of a wholly new barbarism. Mercantilism, the love of pleasure, in this state of mind, are the most energetic motives of the human soul. (21 November 1857; III, 158)

> [Voilà qu'après un siècle et demi à peu près d'une civilisation plus raffinée qui rappelle les beaux temps de l'antiquité—je parle du siècle de Louis XIV et un peu au-delà—le genre humain, et j'entends par là le petit nombre des nations qui portent actuellement le flambeau, redescend dans les ténèbres d'une barbarie toute nouvelle. Le

[39] "Moins ingrats que les peuples d'Ausonie, les sauvages habitants des bords de l'Ister se souviennent encore de l'Orphée qui parut dans leurs forêts! Ils viennent danser autour de ses cendres; ils ont même retenu quelque chose de son langage: tant leur est douce la mémoire de ce Romain qui s'accusait d'être le barbare, parce qu'il n'était pas entendu du Sarmate!" *Oeuvres complètes* II, 635. For Delacroix's description of the picture, see Johnson V, 75.

[40] *Les Martyrs*, Book VII. Delacroix read this work at least in part, as a notebook attests (B.N. ms. N.a.f. 13296).

mercantilisme, l'amour des jouissances, sont, dans cet état des esprits, les mobiles de l'âme humaine les plus énergiques.]

The end-result of so-called progress is a return to the "état sauvage," society brought to the edge of the abyss "into which it can very well fall to make way for a total barbarism."[41] At its most "advanced" stage, civilization sits atop the volcano that destroyed Pliny: "This new world . . . which seeks to emerge from our ruins is like a volcano under our feet" (3 September 1857; III, 124). The rhetoric of decadence so pervasive in post-revolutionary France returns frequently in the *Journal*:

I do not need to point out how much certain so-called advances have harmed morality, or even well-being. One invention, by suppressing or diminishing work and effort, has diminished the dose of patience for enduring ills and the dose of energy for surmounting them. . . . Some other improvement, by increasing luxury and a seeming well-being, has exerted a fatal influence on the health of generations, on their physical valor, and has brought about equally a moral decadence. Man borrows from nature poisons such as tobacco and opium so as to make of them the instruments of vulgar pleasures. He is punished by the loss of his energy and by debasement. (21 September 1854; II, 273–74)

[Je n'ai pas besoin de faire remarquer combien certains perfectionnements prétendus ont nui ou à la moralité, ou même au bien-être. Telle invention, en supprimant ou en diminuant le travail et l'effort, a diminué la dose de patience à endurer les maux et d'énergie à les surmonter. . . . Tel autre perfectionnement, en augmentant le luxe et un bien-être apparent, a exercé une influence funeste sur la santé des générations, sur leur valeur physique et a entraîné également une décadence morale. L'homme emprunte à la nature des poisons, tel que le tabac et l'opium, pour s'en faire des instruments de grossiers plaisirs. Il en est puni par la perte de son énergie et par l'abrutissement.]

The increasing mastery of material existence—the great technological advances of the time—may only increase the covetousness and materialistic desires they were meant to satisfy. Thus the acquisition of knowledge,

[41] 23 April 1849 (I, 289–90). With these remarks cf. the passage copied from Chateaubriand in 1834 on the future of society: "Vraisemblablement l'espèce humaine s'agrandira, mais il est à craindre que l'homme ne diminue, que quelques facultés éminentes du génie ne se perdent, que l'imagination, la poésie, les arts ne meurent dans les trous d'une société-ruche où chaque individu ne sera plus qu'une abeille, une roue dans une machine . . . Si la religion chrétienne s'éteignait, on arriverait par la liberté à la pétrification sociale où la Chine est arrivée par l'esclavage" (Supplement; III, 386).

itself a *mark* of civilization, is converted into a new kind of barbarism, the counterweight to a pre-Orphic ignorance:

> There is in any civilization only one precise point where it is given to human intelligence to show all its force: it seems that during these rapid moments, comparable to a bright flash in the middle of a dark sky, there is almost no interval at all between the dawn of this brilliant light and the final term of its splendor. . . . There would have to be a renaissance of morals in order to have one in the arts: that point which finds its place between two barbarisms, one whose cause is ignorance, the other, more irremediable yet, which comes from the excess and abuse of knowledge. (13 January 1857; III, 21)

> [Il n'y a dans toute civilisation qu'un point précis où il soit donné à l'intelligence humaine de montrer toute sa force: il semble que pendant ces moments rapides, comparables à un éclair au milieu d'un ciel obscur, il n'y ait presque point d'intervalle entre l'aurore de cette brillante lumière et le dernier terme de sa splendeur . . . Il faudrait une renaissance des moeurs pour en avoir une dans les arts: ce point qui se trouve placé entre deux barbaries, l'une dont la cause est l'ignorance, l'autre plus irrémédiable encore, qui vient de l'excès et de l'abus des connaissances.]

The arts themselves share this duality, "destined to refine morals and to corrupt them all over again" (21 September 1854; II, 274). Indeed civilization may itself occasion the worst barbarism, from which the savage is exempt, *ennui*: "*Ennui* is the great enemy of civilized man, surrounded by the pleasure of the arts and the refinements of an easy, opulent life. The savage beset by need . . . does not experience this lassitude, nor this emptiness which we seek constantly to fill."[42] Similarly, "it is civilization . . . which created the arts of all kinds destined to console man or to delight him, and by an inexplicable contrast, it is civilization which delivers him to *ennui* and sadness."[43] With such a state of affairs, the invasion of an Attila is not far away: "Having arrived at a certain degree of civilization, nations see the notions of virtue and valor especially weaken. The general loss of vigor, which is probably the product of the advance of pleasures, brings about a rapid decline . . . It is in such a situation that it

[42] "L'*ennui* est le grand ennemi de l'homme civilisé, entouré du plaisir des arts et des raffinements d'une vie facile et opulente. Le sauvage pressé par le besoin . . . n'éprouve ni cette lassitude, ni ce vide que nous cherchons sans cesse à combler" (Bibliothèque d'Art ms. 250, f. 104).

[43] "C'est la civilisation . . . qui a créé les arts de toutes sortes destinées à consoler l'homme ou à le réjouir, et par un contraste inexplicable, c'est elle qui le livre à l'*ennui* et à la tristesse" (ibid., f. 103).

is difficult to resist conquest" (21 September 1854; II, 274). His reading notes on Custine's *Lettres sur la Russie*, taken sometime after 1843, make the point in the extreme:

> When the so-called most civilized nations on earth have weakened themselves through political debauchery, . . . the floodgates of the north will once again be opened upon us; then we will undergo a last invasion, no longer by ignorant barbarians, but by masters tricky and enlightened, more enlightened than ourselves, for they will have learned, from our own excesses, how one can and should govern us. (Supplement; III, 403)

> [Lorsque les nations, soi-disant les plus civilisées de la terre, auront achevé de s'énerver dans leurs débauches politiques, . . . les écluses du nord se lèveront de nouveau sur nous; alors nous subirons une dernière invasion, non plus de barbares ignorants, mais de maîtres rusés, éclairés, plus éclairés que nous, car ils auront appris de nos propres excès, comment l'on peut et l'on doit nous gouverner.]

Thus squeezed between two barbarisms—ignorance and the abuse of knowledge, "natural" bestiality and "civilized" *abrutissement*—civilization struggles to maintain itself against the presence of these forces within. Product of human intelligence, the barbarism of civilization—malice, deception, intrigue, and self-interest (21 November 1857; III, 158)—can paradoxically abandon mankind to a life worse than that of the beasts. These "floods" of bad tendencies, "rivers" of evil passions breaking their banks, cupidity, base envy, and calumny against which no dike can hold firm are as barbarous as the "torrent" of Attila's warriors overrunning Italy and the arts.[44] Against this background the great figures of civilization stand out, but with little of the hero's glory: "Not only is it the case that the greatest in talent, boldness, and constancy, is ordinarily the most persecuted, but he is himself wearied and tormented by that burden of talent and imagination . . . Almost all great men have had a life more beset, more wretched than that of other men" (1 May 1850; I, 361).[45]

[44] "Qui élèvera une digue aux mauvais penchants? Quelle main fera rentrer dans leur lit le débordement des passions viles; où est le peuple qui élèvera une digue contre la cupidité, contre la basse envie, contre la calomnie qui flétrit les honnêtes gens dans le silence et dans l'impuissance des lois?" (6 June 1856; II, 455). Cf. Delacroix's description of the warriors who "descendent des montagnes comme un torrent" (above, 131).

[45] "Non seulement le plus grand par le talent, par l'audace, par la constance, est ordinairement le plus persécuté, mais il est lui-même fatigué et tourmenté de ce fardeau du talent et de l'imagination [. . .] Presque tous les grands hommes ont eu une vie plus traversée, plus misérable que celle des autres hommes." Same text with slight variants in *O.L.* I, 118.

The civilizing art of Orpheus charms and tames the animals: the oxen with their yoke in the group tilling the soil in the right middleground, the hunter skinning the boar on the left, Ceres goddess of agriculture hovering overhead, all reflect the traditional relationship between civilization and the control of nature, harnessing the prodigious and terrible forces of nature for mankind's benefit and use (fig. 5). This idea is repeated in *Aristotle Describes the Animals* (fig. 16), *The Education of Achilles* in the art of hunting (fig. 23), *The Chaldean Shepherds Inventors of Astronomy* (fig. 24), and in a figurative sense, *Demosthenes Declaiming by the Seashore* (fig. 25), training his voice to project above the roar of the waves in preparation for the noise of the Athenian assembly. But for Delacroix, the mastery of nature by which civilization defines itself is never complete; *The Death of Pliny the Elder* represents the destruction of civilization *by* nature, as Pliny attempts to describe the eruption of Vesuvius moments before he is buried in the burning flow (fig. 26). Indeed, nature may even become all the greater an enemy the more civilized mankind becomes: "As soon as man sharpens his intelligence, increases his ideas and the means of expressing them, acquires needs, nature thwarts him everywhere . . . If he suspends for a moment the labor which he has imposed upon himself, she reasserts her rights, she invades, she undermines, she destroys or disfigures his work; . . . What do they matter to the progress of the seasons, to the course of the stars, rivers, and winds, the Parthenon, Saint Peter's, and so many marvels of art? An earthquake, *the lava of a volcano* will have their way" (1 May 1850; I, 360, my emphasis).[46] The barbarism of humanity is a kind of "joining forces" with nature's own, the hordes of warriors trampling Italy like the volcano that buried Pliny: "But man himself, when he abandons himself to the savage instinct which is the basis of his nature, does he not conspire with the elements to destroy fine works?"

Delacroix not only shows the presence of barbarism within civilization, but queries the sense of the terms themselves. The barbarism in the *Ovid* lies not in the uncultured "barbares," the Scythians, so similar to the uncultured Greeks of the *Orpheus*, but in the supposedly civilized Romans who banished the poet. Other pendentives do likewise, particularly by inverting the *Orpheus* model. In the cupola devoted to legislation and eloquence, for example, Numa learns the "arts of peace" from the nymph

[46] "Sitôt que l'homme aiguise son intelligence, augmente ses idées et les manières de les exprimer, acquiert des besoins, la nature le contrarie partout. [. . .] S'il suspend un moment le travail qu'il s'est imposé, elle reprend ses droits, elle envahit, elle mine, elle détruit ou défigure son ouvrage. . . . Qu'importent à la marche des saisons, au cours des astres, des fleuves et des vents, le Parthénon, Saint-Pierre de Rome, et tant de miracles de l'art? Un tremblement de terre, *la lave d'un volcan* vont en faire justice." Same text with slight variants in *O.L.* I, 117.

Egeria, the source of his wisdom and inspiration (fig. 27).[47] Delacroix's verbal echo of the "arts of peace" taught by Orpheus[48] reinforces the formal connections between the two pictures: the nymph among the reeds on the right of the half-dome, contemplating the poet in wonder, comes to center stage here, as Numa listens to her in equal wonder. Similarly, the centaur on the left of the *Orpheus*, preparing to return, with the arrival of civilization, to the depths of the forest, as Delacroix describes it, becomes a bringer of civilization in the poetry cupola: the centaur Chiron teaching Achilles the arts that Orpheus teaches the Greeks.[49] *Adam and Eve* presents an alternative myth of the origin of civilization, where civilization is itself a kind of barbarism, and the "savage life" of the *Orpheus*'s Greeks the mythical paradise; where tilling the soil is not a "benefit" but a punishment, and thorns and thistles the fruits of human labor; where the wrathful angel with fiery sword *prevents* the peace and abundance which the voice of the poet summons to earth in the figures of Pallas Athena and Ceres.

Other pendentives follow a similar pattern of reversal, placing the "civilized" figure in the position of the *Orpheus*'s Greeks—a seeker, rather than a bringer, of knowledge. Thus Herodotus consulting the magi for his histories and learning from them the traditions of the past (fig. 28) occupies the intellectual position of the untaught Greeks.[50] Delacroix brings out the ambiguity of this relation by making the Egyptian priests "examine with curiosity this Greek come from afar," as the Greeks themselves do Orpheus. Lycurgus consults the Pythia for the laws of Sparta (fig. 29), the Chaldean shepherds gaze in wonder at the heavens (fig. 24), Hesiod hears the muse's divine song (fig. 30). The original story of the *Orpheus* is repeated over and over within civilization, but with the enlightened and civilized overcoming ignorance in the manner of the barbarian Greeks: by seeking after knowledge from without, from contact with the "barbaric," the foreign, strange, and unknown. A note in the 1854 diary is pertinent here: "Hippocrates found right away all that was positive knowledge in medicine. I am mistaken: he visited Egypt, and perhaps a few other sources of primitive knowledge, and brought these principles back from there" (27 May 1854; II, 195). The line separating knowledge from ignorance, or civilization from barbarism, is indistinct:

[47] Ovid, *Metamorphoses* XV, 482–84; cf. Plutarch, *Numa* IV.2.

[48] Angrand draws attention to this ("Genèse des travaux d'Eugène Delacroix à la Bibliothèque de la Chambre," 329 n. 12).

[49] Johnson remarks the centaur as a thematic link (V, 36). The other art which Chiron taught Achilles was, of course, a quintessentially Orphic one: playing the lyre.

[50] An early plan had a variant of this subject, "Pythagoras Consulting the Egyptian Priests" (sheet of notes transcribed by Robaut, B.N. Est. R111070).

the knowledge that defines civilization may perhaps be gained only by putting oneself in the position of the uncivilized Greeks, listening for the "enchanting voice" which the traditional din of civilization would otherwise drown out.

The barbarism of Attila erupts in full force when the tension within civilization gives way: the weakness of the civilized and the strength of the savage combine to bring about the catastrophe. For Delacroix the causes themselves do not change—the fury of Attila encompasses the numerous forms of barbarism depicted in the cupolas—but the resistance put up to them does. Yet if, as his remark quoted earlier implies, ancient civilization is, within the immense duration of time, almost no space at all, almost a single point, a momentary flash surrounded and traversed by darkness, the dazzling display of its tenuous successes nevertheless fills the long extent of this room like the books lining its walls, reminding the viewer of not only the difficulty of the struggle but the value of it too, the "fine works," in the broad and narrow sense, which it is the purpose of civilization to create and to preserve. "India, Egypt, Nineveh and Babylon, Greece and Rome, . . . all that has perished, leaving almost no trace; but that little bit which has remained is yet our whole heritage; we owe to those ancient civilizations our arts, . . . the few correct ideas that we have about everything; the small number of certain principles that govern us still in the sciences, the art of medicine, the art of governing, of building, even of thinking" (22 March 1850; I, 352–3). Indeed this admission seems, in the end, to bear out the testimony of the ceiling, and to pose the question, too: the question, troubling for Delacroix, of the survival of civilization in the face of that new barbarism with which the entry in fact deals—the contemporary doctrine of progress.

THE PEERS' LIBRARY, PALAIS DU LUXEMBOURG

Compared to the drama and energy of the Deputies' Library on which Delacroix was working at the same time, the Luxembourg decorations seem a moment of almost mythical repose: in the dome, tranquil groupings of illustrious personages—philosophers, poets, orators, soldiers, and statesmen, discoursing amid the limpid streams and verdant meadows of Dante's Elysian fields, suffused with the shimmering, rosy light of an eternal springtime (fig. 31); in the hemicycle, Alexander preserving the poems of Homer, a gesture of enlightened largesse amid the violence and destruction of war (fig. 32). "I have found for the Luxembourg a subject which departs a bit from the banality of Apollo and the Muses, etc. It is made for a library: it is the moment when Dante . . . is presented by Virgil

to Homer and to a few great poets who are in a sort of Elysium . . .
In short, one sees there all the great men you could want, walking about
and sitting down to vary their pleasure."[51] As Delacroix indicates, the
theme of the cupola is the great figures of antiquity, which unfold from
the famous episode in *Inferno* IV of Dante's encounter with the poets in
limbo. The Homer motif unifies the two pictures and relates them to the
library context, tracing the meeting of Dante and Homer, as it were, to
the farsighted action of Alexander represented on the wall. As in the Dep-
uties' Library, the scheme celebrates the preservation of the high ideals
and accomplishments of the tradition of European civilization, reflecting
the status and role of the library as an institution. Here, in particular, the
"historical" figures—the Greek and Roman groups—display the breadth
of culture and talent to which Delacroix attributed the extraordinary
achievement of antiquity: the union of soldiery and philosophy, poetry and
rule, statecraft and the liberal arts, an ideal befitting the library of a
legislative body such as this one. As he writes later:

> At Rome, as at Athens, the same man was lawyer, warrior, pontiff,
> aedile, inspector of public games, senator, magistrate. He had given
> himself the education which responds to each of these states. It was
> difficult for such a man to be a mediocre connoisseur in whatever
> branch of knowledge, such as it then was.[52]
>
> [A Rome, comme à Athènes, le même homme était avocat, guerrier,
> pontife, édile, inspecteur des jeux publics, sénateur, magistrat. Il
> s'était donné l'éducation qui répond à chacun de ces états. Il était
> difficile qu'un tel homme fût un médiocre appréciateur, dans quelque
> branche que ce soit, des connaissances telles qu'elles étaient alors.]

But if the fury of Attila is absent from these images, the fragility of
civilization which it represents is not.[53] Here, too, civilized values are
never completely secure, never free of the threat of destruction, from war,
envy, tyranny, or intrigue. Delacroix's decorations make the unorthodox
point that the liberal arts they celebrate will not guarantee, in themselves,

[51] *Corr.* II, 120, August 1842.

[52] 4 February 1857 (III, 60–61). These are notes for his 1857 article, "Des Variations
du beau" (*O.L.* I, 42).

[53] Critics in Delacroix's time always linked the Luxembourg decorations to the *Orpheus*
half-dome of the Palais Bourbon, never to the rest of that cycle. See, for example, Clément
de Ris ("La Bibliothèque et le Salon de la Paix à la Chambre des Députés," *L'Artiste*, 9
January 1848, quoted in Sérullaz, *Peintures murales*, 69), who sees in the serenity of the
Orpheus "une seconde édition revue, corrigée et considérablement augmentée" of the Lux-
embourg dome. (There is, incidentally, no need for the "sic" regularly added to the title of
this article; it deals with Horace Vernet's decorations in the Salon de la Paix, or Salle des
Pas-Perdus, of the Palais Bourbon, along with Delacroix's library.)

the unbroken endurance or continuity of civilization. The values and actions of the illustrious do not prevent the annihilation of their cultures: Carthage and Nineveh have disappeared, and barrenness now afflicts the once-fecund Italy of Dante.[54] (As we have seen, Delacroix elsewhere describes a barbarism deriving from an excess and abuse of knowledge.) Yet unlike the Palais Bourbon, the Luxembourg scheme emphasizes the revival of culture after its collapse, the sudden and unexpected regeneration after perhaps centuries of devastation, through the agency of individual enlightenment, invention, originality, "genius."[55]

These ideas make themselves felt whether one begins with the ostensibly "historical" point of departure, seen immediately upon entering the room—the *Alexander* hemicycle over the window (fig. 32)—or, as Delacroix does in his description, with the thematic one, Dante and Virgil meeting Statius, Horace, Ovid, and Homer, which dominates the immense and visually compelling dome (fig. 35). In fact, while the dome, impressive in its dimensions, its variety of figures, and its dazzling landscape, has received the more attention, one is struck by the tight spatial relation between them, making the hemicycle a kind of pendant to it and a presence impossible to ignore. The *Alexander* thus provides an abiding reminder of the destruction of one civilization which permitted the preservation of another: it is among the spoils of the defeated Persians that the magnificent casket is found, into which the poems of Homer are placed. Delacroix does not neglect this crucial part of the story, so rich in dramatic and decorative possibilities:[56] the broken chariot on the left, spilling out its dead warrior in an almost grotesque position, his head crushed and bleeding against the ground, his legs in the air; one horse rearing behind, another staggering, convulsed, to the ground, its red-orange harness floating like ribbons of blood; the smoky, blue-gray remains of the battle in the background—all keep the violence of the battle present (fig.

[54] 21 September 1854 (II, 273); "Des Variations du beau," *O.L.* I, 53.

[55] The theme of civilization motivated Delacroix's thoughts for this library, and not only the Deputies' one, from the start. A neglected sheet of notes for it, made on an invitation from December 1840, records his search for "subjects . . . which pay tribute to letters or civilization," and specifically mentions the subject which will only later become so important to the Palais Bourbon: "Orpheus civilizing men" (B.N. ms. N.a.f. 25069, f. 145). Other subjects listed are repeated in a sheet of early notes in the Bibliothèque d'Art (ms. 250, f. 111), notably "Thetis and the Arms of Achilles," and "Ceres Bringing Agriculture"; the latter, also an image of civilization, was likewise transferred to the Palais Bourbon.

[56] His description of the *Alexander* pendentive in the Palais Bourbon specifies "the precious casket found among the spoils of Darius" (Sérullaz, *Peintures murales*, 67). His notes for the subject add "That can enrich the composition" (ms. Palais Bourbon, quoted in ibid., 52).

33). (He specifies in his description that the action takes place on the battlefield itself.)[57] Nor does Delacroix abstract the human dimension of this conquest: on the other side of the picture, the defeated Persians taken in captivity, bejewelled and richly attired, bow in supplication in the shade of slender, arching palms (fig. 34). Women lovely like the *Women of Algiers*, the little nude prince who wonders at the event in a gesture of childlike innocence, the old woman clasping her hands in despair—all reflect the pathos of conquest and war. Framed by these two images, the act of preservation emerges from loss and destruction. This happens not through some cyclical inevitability, however, but through the particular, individual wisdom of Alexander, which the dome in turn explains: his humanist culture, instilled by his teacher Aristotle through the poetry of the *Iliad* (it was, the story holds, Aristotle's copy of Homer that Alexander ordered for safekeeping).

Across the interval of centuries, and the wide sky of the cupola ceiling, the tradition survives and Homer indeed "lives" again, now as an inspiration to the "bella scuola" of Latin poets through which, for Dante certainly (who did not know Homer), he was "preserved." Thus begins the narrative of the dome, moving clockwise in a circle, as Delacroix prescribed, from Dante and Homer, to the Greeks, to Orpheus, to the Romans and back again. The circularity of the ceiling permits the dual position of Canto IV both as the point of departure for the unfolding of the historical and mythical past of great figures, and as the chronological culmination of this: Florence as the successor to Greece and Rome, Dante joining the company of the Latin poets and Homer. But the narrative is motivated neither by chronology nor by fidelity to the literary source: the Orpheus group breaks into the historical evolution from Greece to Rome to medieval Florence, and figures within the groups mingle anachronistically. Delacroix does not follow Canto IV, but introduces figures as he pleases, for visual and semantic variety.

Perhaps more important, the seemingly clear delineation of groups is blurred from the start, as figures thematically more appropriate to the Greek and Roman groups are moved to flank the Dante one: Achilles on the left, Pyrrhus and Hannibal on the right (fig. 35). Delacroix's description of the picture brings this out explicitly: "On one side and in the foreground, Achilles seated near his shield and close to the group dominated by the author of the *Iliad*; on the other, Pyrrhus wearing his arms, and Hannibal: the latter, standing, his eyes turned toward the part of the picture where one sees the Romans."[58] Connected to two groups, these

[57] "Après la bataille d'Arbelles et sur le champ de bataille même" (Johnson V, 113).
[58] Quoted in Johnson, V, 112.

figures complicate the narrative progression: Hannibal looks back at the Romans, of whom he was the sworn enemy, thus moving the eye, as Johnson notes, in a counter-clockwise direction, at least momentarily;[59] and Achilles' more pronounced separation from the Dante group is countered by a backward look toward it, and by Delacroix's substitution of Statius, author of the *Achilleid*, for the Lucan of Dante's original. Contiguous with Achilles, Statius holds the trumpet by which he will sing the hero's fame, as Johnson remarks.[60]

The dual position of these figures affects the picture in important ways. As in the *Alexander* hemicycle, the central episode is now flanked by images of war and potential destruction: that the Achilles figure is modelled on the Ludovisi Mars,[61] was noted in the first reviews, and Pyrrhus wears the armor of battle. The statement of cultural tradition conveyed by the meeting of poets carries with it a reminder of the potential disruption of tradition: threats to the "illustrious" civilization of Rome on the right; on the left, a suggestion of the war which is the very subject of the poem.

Poetry is the repository of civilization like the library itself, preserving and spreading the values and traditions of a culture, and the fame of those who represented them: on the other side of the dome, Orpheus receives the Muse's song (fig. 36). As the bringer of civilization, he exemplifies the union of poetry and law which dominates the cycle.[62] From him, Hesiod learns the mythological traditions of Greece which become the *Theogony*, and Sappho creates her divine hymns. In between the two "poetry" groups, the civilized values which poetry instills manifest themselves in history: Alexander, soldier, student of philosophy, and lover of the arts, poised between his teacher Aristotle and the painter Apelles; Socrates, soldier and philosopher, surrounded by a representative of each—Alcibiades and Plato—and by Aspasia, preceptress to himself and to the great general, statesman, and orator, Pericles; Xenophon, Socrates'

[59] V, 91.

[60] V, 91. Statius appears with Dante and Virgil in Raphael's *Parnassus* (see L. Dussler, *Raphael. A Critical Catalogue of his Pictures, Wall-Paintings, and Tapestries*, 74). Robaut transcribes a note for the Palais Bourbon which mentions the *Pharsalia*: "Le jeune Pompée consulte la Pythonisse dans la Pharsale—(guerre de César et de Pompée)" (B.N. Est. R111071). In 1849 Delacroix mentions the *Pharsalia* as a possible source of subjects (7 March 1849; I, 272).

[61] Paul Mantz, *L' Artiste*, 7 February 1847 (quoted in Sérullaz, *Peintures murales*, 104).

[62] The tradition of Orpheus as lawgiver is ancient. See Aristophanes' *Frogs* 1032. Cf. Clément de Ris, who calls the Orpheus of the Palais Bourbon "ce poétique législateur" ("La Bibliothèque et le Salon de la Paix à la Chambre des Députés", *L'Artiste*, 9 January 1848, quoted in Sérullaz, *Peintures murales*, 69). Ribner cites Horace and Boileau, and gives other iconographical examples (*Broken Tablets*, 109ff.).

biographer and another example of the soldier-scholar, conversing with the orator and statesman Demosthenes (fig. 37). The Greeks represent that conjunction of the liberal arts and public life which for Delacroix marks a high civilization, in which customs and institutions are infused with learning and the arts, and these in turn inspire the high ideals of virtuous action:

> Poetry is born of itself in those fortunate lands where men have few needs and consequently much leisure, especially when customs and institutions favor the effect of the beautiful. Such was Greece, where, through a unique convergence, all the conditions seem to have come together at a certain moment to develop the feeling and the cult of beauty.[63]

Similarly, he writes: "There are without a doubt privileged eras where everything seems to be offered at the same time, where the intelligence of the judges matches the new endeavors of artists."[64]

In contrast, the group of Romans strikes a more somber note, dominated in the center by Stoic resignation and heroic suicide (fig. 38): Cato of Utica reading the *Phaedo* before taking his own life, having refused to surrender in the face of Caesar's onslaught, or to appeal for clemency to a man he had long accused of tyranny and corruption; here Caesar approaches menacingly from behind. On the left, Cato's daughter Portia hears her father's words; later, as the wife of Brutus, she will follow his noble example, and swallow the burning coals which now glow forebodingly in the foreground. That other exemplar of Stoicism, Marcus Aurelius, listens and gestures toward him. Neither the charming image of Cincinnatus with his spade, on the right, nor the lovely nymphs and child on the left, can assuage the troubling message of this central group, the last bastion of truth and virtue in a society succumbing to tyranny. From the group around Socrates to that of Cato (both figures make the same gesture), the distance in Delacroix's image is immense: the values affirmed in the assembly of Greeks here sustain a few individual Romans against the threat of their own people and the decline of their own civilization into infamy. The painter of *The Death of Marcus Aurelius* in 1844, and the avid reader of the *Meditations*, understood exceedingly well the value of Stoicism as a final manifestation of heroic vir-

[63] "Des Variations du beau," *O.L.* I, 41f: "La poésie naît d'elle-même dans les contrées heureuses où les hommes ont peu de besoins et par conséquent beaucoup de loisir, surtout lorsque les moeurs, les institutions y favorisent l'effet du beau. Telle a été la Grèce, où, par un accord unique, toutes les conditions semblent s'être rencontrées dans un certain moment, pour en développer le sentiment et le culte."

[64] Ibid., 52.

tue before the disastrous course of the empire set in, the vestiges of a "true" philosophy transcending the partisan and fugitive concerns of particular political regimes:[65] "The reign of informers and scoundrels could not be that of the beautiful, and even less that of the true. If these inestimable treasures show themselves somewhere, it will be in the virtuous protests of a Seneca or a Tacitus. Light graces, soft descriptions, will have given way to indignation or Stoic resignation."[66] The humility and simplicity of Cincinnatus, who, recalled from his fields to save Rome, subdued the enemy and immediately relinquished his power to return to his rustic life, contrast sharply with the thirst for power of a Caesar, here carrying his orb; Cato's firmness of character stands out against the vacillations and indecision of Cicero, once an ally of Pompey against Caesar, as was Cato, but who accepted the victor in spite of his personal opposition, and received his favor, while Cato went to his death.[67] The great orator-statesmen who represent eloquence in the central cupola of the Palais Bourbon, their statues flanking the entrance to that library, here suggest Plutarch's famous contrast between Demosthenes' integrity and Cicero's appeasement.[68]

In relative terms, the Romans already mark a decline: "That taste perished among the ancients, along with institutions and customs, when it was necessary to please barbarian conquerers, as were, for example, the Romans with respect to the Greeks."[69] Indeed the presence of Caesar and Cicero makes the Roman group all the more troubling, for they undermine the

[65] "Les moralistes, les philosophes, j'entends les véritables, tels que Marc-Aurèle, le Christ . . . n'ont jamais parlé politique. . . . Ils n'ont recommandé aux hommes que la résignation à la destinée, non pas à cet obscur *fatum* des anciens, mais à cette nécessité éternelle que personne ne peut nier, et contre laquelle les philanthropes ne prévaudront point, de se soumettre aux arrêts de la sévère nature. Ils n'ont demandé au sage autre chose que de s'y conformer et de jouer son rôle à la place qui lui a été assignée au milieu de l'harmonie générale. La maladie, la mort, la pauvreté, les peines de l'âme, sont éternelles et tourmenteront l'humanité sous tous les régimes; la forme, démocratique ou monarchique, n'y fait rien" (20 February 1847; I, 188–9).

[66] 4 February 1857 (III, 61–62), notes for "Des Variations du beau" (*O.L.* I, 43). The subject of the death of Marcus Aurelius had once been considered for the Bourbon library. (See "Marc-Aurèle mourant" on a sheet of drawings and subjects in the Palais Bourbon, quoted in Sérullaz, *Peintures murales*, 52). On *The Death of Marcus Aurelius* as conveying the theme of the fragility of civilization, see Johnson 281. The death of Seneca, so close to the Cato image here—taking his own life in the face of Nero's plan to murder him, his wife attempting to follow him as Portia does here—is depicted in the Deputies' library.

[67] Cf. the note in Bibliothèque d'Art ms. 250, f. 130: "Cicéron pouvait avoir un caractère sincère. Mais son habitude de philosopher sur tout amoindrit ses résolutions et ses actes."

[68] *Comparison of Demosthenes and Cicero*, esp. IV. Demosthenes and Cicero are of course standard representatives of oratory in libraries (Masson, *Pictorial Catalogue* 9, 68).

[69] 4 February 1857 (III, 61). Cf. "Des Variations du beau," *O.L.* I, 42.

very tradition that the ceiling otherwise celebrates: these figures, here evoked as examples of tyranny and moral expediency, respectively, in direct contrast to the Cato group which they threaten, are also great examples of the "cultured statesmen" honored in the Greeks opposite and in Alexander who oversees the whole. Cicero, orator-soldier-philosopher, and Caesar, general-writer-legislator, were standard, commonplace members of the corps of illustrious Romans. Their union of statecraft and liberal arts was a traditional attribute, and widely represented: in the Palais Bourbon Delacroix himself depicts Cicero's denunciation of the corruption of the Sicilian governor Verres, and in an early plan lists him as an example of eloquence and statesmanship; in a notebook he mentions Caesar as one of the "great men" possessing a multiplicity of talents, and on a sheet of subjects for the Palais Bourbon lists "Caesar writing his commentaries."[70] But here they seem one step on the way to the "alliance of art and infamy" that for Delacroix defined the decadence of a culture.[71] Indeed, he suggests the inadequacy of the liberal arts to guarantee civilized values:

> Would there be a necessary connection between the good and the beautiful? Can a decadent society find pleasure in elevated things in whatever genre possible? Probably not; thus in our societies as they are, with our narrow customs, our cheap little pleasures, the beautiful can only be an accident, and this accident does not hold a large enough place . . . to bring the majority of minds back to the beautiful. Afterward, there is night and barbarism. (4 February 1857; III, 62)

> [Y aurait-il une connexion nécessaire entre le bon et le beau? Une société dégradée peut-elle se plaire aux choses élévées dans quelque genre que ce soit? Il est probable que non; aussi, dans nos sociétés comme elles sont, avec nos moeurs étroites, nos petits plaisirs mesquins, le beau ne peut être qu'un accident, et cet accident ne tient pas assez de place pour . . . ramener au beau la généralité des esprits. Après, vient la nuit et la barbarie.]

Education and moral example do not suffice: "People who say that man learns everything through education are imbeciles, including the great philosophers who have defended this thesis" (11 September 1855; II,

[70] Johnson 552; Louvre 262; Louvre 1758, f. IV (printed with some misreadings in *Journal*, III, 366f.); Louvre BCb4 L10a. In the *Aretino*, Dolce mentions Caesar (along with Demosthenes, Marcus Aurelius, and Dante) as men of learning who were painters, combining, like Alexander, the arts and statecraft. See Roskill, *Dolce's "Aretino" and Venetian Art Theory of the Cinquecento*, 104ff.

[71] "quand les arts se font plus volontiers les complaisants de l'infamie" (4 February 1857; III, 61). Cf. "Des Variations du beau," *O.L.* I, 43.

374). As we have seen, *The Death of Seneca* represented in the Palais Bourbon provides a different perspective on the philosophical education of princes from the Aristotle/Alexander relationship depicted here. The point is important: even from within the great cultural flowering of the Dante group, we are led, through the presence of Rome's enemies and the backward look of Hannibal, to the Romans, to reminders of the threats to civilization from without and from within. Ultimately, only the gesture of Alexander ensures the line from Homer to Virgil to Dante, tenuous and uneven though it is; otherwise, the "lord of song" is silenced, and the values he represents—those that inspired Alexander himself, instructed through a reading of the *Iliad*—are lost.

The importance of illustrious personages for Delacroix lay to a great extent in this, in their role of renewing a culture from within its decline, or in the face of its destruction. The circularity of the ceiling does not disguise the gaps between the groups. As his writings confirm, the course of cultural tradition is not continuous but irregular, an order defined by "vicissitudes," the law of "caprice" and chance, unpredictable and unforeseen, perhaps unintelligible in the moment, but fertile and momentous:

> What is the whim which makes a Dante or a Shakespeare appear, the latter among the Anglo-Saxons who were still barbarians, like a spring gushing forth in the midst of the desert, the former in mercantile Florence, two hundred years before that elite of fine minds of which he will be the beacon?
>
> Each of these men arises suddenly and owes nothing to what preceded him, nor to what surrounds him: he is similar to that god of India who engendered himself . . . Dante and Shakespeare are two Homers, . . . arriving with a whole world which is their own, in which they move freely and without precedents.
>
> Who can regret that instead of imitating, they invented, or that they were themselves, instead of beginning Homer and Aeschylus again?[72]

> [Quel est le caprice qui fait apparaître un Dante, un Shakespeare, celui-ci chez les Anglo-Saxons encore barbares, pareils à une source jaillissante au milieu d'un désert, celui-là dans la mercantile Florence, deux cents ans avant cette élite de beaux esprits dont il sera le flambeau?
>
> Chacun de ces hommes se montre tout à coup et ne doit rien à ce qui l'a précédé, ni à ce qui l'entoure: il est semblable à ce dieu de l'Inde qui s'est engendré lui-même . . . Dante et Shakespeare sont deux

[72] *O.L.* I, 53.

Homère, . . . arrivés avec tout un monde qui est le leur, dans lequel ils se meuvent librement et sans précédents.

Qui peut regretter qu'au lieu d'imiter, ils aient inventé? qu'ils aient été eux-mêmes, au lieu de recommencer Homère et Eschyle?]

For Delacroix, a renaissance occurs not because of a general culture, but through the vision of a particular individual, without precedent and unprovoked by any immediate "cause": "A source which springs up unexpectedly in an arid place and soon becomes a great river which spreads abundance where sterility reigned."[73] On a drawing for the Salon du Roi, he noted, "How much chance influences the appearance of great men and the development of the arts."[74] Such figures are "beacons" and "torches,"[75] flashes in a dark night, finding the last smouldering spark of the fire of inspiration; coming at different eras, separate and distinct, but holding hands across the centuries,[76] as the figures assemble and discourse together here; unique in themselves and proper to their age, but equivalent—Dante as a new Homer but not an imitator of Homer.

In the interim are perhaps centuries of darkness and barbarism, when the fruits of knowledge and culture are all but lost: from the heroic age of Orpheus on one side of the dome, to the Greece of Homer on the other, from Athens to Rome, from Rome to Florence, Delacroix's groups mark simultaneously the historical rupture and the symbolic connection. His writings clearly state the irrevocable loss caused by the wayward cycles of history: "It is far from being the case that man receives intact the stock of knowledge that the centuries see accumulate: if he perfects certain inventions, for others he remains well behind the inventors; a great number of these inventions are lost. What he gains on the one hand he loses on the other."[77] And although devastation may actually clear the air and carry with it the seeds of regeneration, the time is long: .

It is a storm which purifies the air after having stirred it up; new seeds seem to be scattered by that hurricane in that worn-out soil; a new civilization will perhaps emerge from it; but it will take centuries to see flourish there again the peaceful arts destined to refine customs and corrupt them once again, to bring those eternal alternatives of grandeur and misery in which appears no less the weakness of man than the

[73] "Une source qui jaillit à l'improviste dans un lieu aride et devient aussitôt un grand fleuve qui répand l'abondance où régnait la stérilité" (B.N. ms. N.a.f. 25069, f. 150, notes for "Des Variations du beau").

[74] Johnson V, 15, fig. 10.

[75] "Des Variations du beau," *O.L.* I, 52, 53.

[76] Ibid., 43f.

[77] 21 September 1854 (II, 273). Cf. *O.L.* I, 115.

singular power of his genius. (21 September 1854; II, 274)

[C'est un orage qui purifie l'air après l'avoir troublé; de nouveaux germes semblent apportés par cet ouragan dans ce sol épuisé: une nouvelle civilisation va peut-être en sortir: mais il faudra des siècles pour y voir refleurir les arts paisibles destinés à adoucir les moeurs et à les corrompre de nouveau, pour ramener ces éternelles alternatives de grandeur et de misère dans lesquelles n'apparaît pas moins la faiblesse de l'homme aussi bien que la singulière puissance de son génie.]

Even so, within the most hostile of climates, the inspiring "source" is never completely dry;[78] individuals capable of redirecting and instilling new life in the tradition continue to present themselves. These are the great "inventors" and "initiators"—Homer, Dante, Shakespeare, Titian—"original talents,"[79] leaving their mark on memory and history, earning the fame that places them in the realm of the illustrious: "their great renown has won them such a precious distinction."[80] No single era, no single people has an exclusive claim to beauty or virtue: "Human genius is inexhaustible."[81]

Perhaps the source of inspiration, here in this magnificent landscape under this splendid, luminous sky, is ultimately not tradition or learning, but nature:

Simple tradition cannot produce a work which makes one cry out: "How beautiful it is!" A genius sprung from the earth, a man unknown and privileged will overturn that structure of doctrines used by everybody and which produce nothing. . . . Guided by a naive inspiration, drawing from surrounding nature and from a profound feeling the inspiration that erudition cannot mimic, they excite around them the people and cultured men, they express the sentiments which were in every soul.[82]

[La simple tradition ne saurait produire un ouvrage qui fasse qu'on s'écrie: "Que c'est beau!" Un génie sorti de terre, un homme inconnu et privilégié va renverser cet échafaudage de doctrines à l'usage de tout le monde et qui ne produisent rien. . . . Guidés par une naïve inspiration, puisant, dans la nature qui les entoure et dans un sentiment profond, l'inspiration que l'érudition ne saurait

[78] O.L. I, 52.

[79] Ibid., 53; B.N. ms. N.a.f. 25069, f. 148.

[80] "Leur grande renommée leur a valu une distinction si précieuse": Delacroix's translation, provided in his description of the painting, of the quotation from Canto IV in the eagle's banderole in the sky of the dome (Johnson V, 111).

[81] "Des Variations du beau," O.L. I, 39.

[82] "Questions sur le beau," O.L. I, 26.

contrefaire, ils passionnent autour d'eux le peuple et les hommes cultivés, ils expriment des sentiments qui étaient dans toutes les âmes.]

The divine source of which the great have drunk, here offered to Dante in his turn by the putto, bubbles up from the earth, this Hippocrene the spirit of that same Muse that hovers over Orpheus, Sappho, and Hesiod. Nature may forever rejuvenate itself on our ruins, as Delacroix wrote[83] but therein provides a never ending source of inspiration. Indeed, for him, nature is fundamental to creation, reflecting itself in that mirror which gives back an image moving to the soul: the imagination.[84]

DELACROIX'S DECORATIONS burst onto the drab scene of Parisian library decoration with all the force of their dazzling color on somber walls. In a publication on the restorations and extensions for the Palais Bourbon in 1840, the architect Jules de Joly decried the lack of full-scale decoration in Parisian libraries, quoting Quatremère de Quincy on the subject; only the former Sainte-Geneviève library from the 1720s boasted extensive decoration.[85] (Ironically, this would soon become a dormitory for the Collège Henri IV, and the decorations removed or covered over, with the building of the new library by Labrouste.[86]) No other libraries contemporary with Delacroix's two would be animated by such intelligent and provocative commentaries on the nature of the civilization preserved within their walls. For the Luxembourg itself, the senators had envisaged a rather different decorative scheme, proposed by one of their own august company: the history of the book from the papyrus to the printing press,[87] rather like the Vatican library of Sixtus V (1585–90), which depicts the inventors of the alphabet and the founding of the great libraries of the world.[88] Labrouste's Sainte-Geneviève library (1838–50) had paintings of trees by the follower of Ingres, Desgoffe, in the vestibule, and on the landing of the stairwell a copy of Raphael's *School of Athens* by the Balze brothers; no paintings adorned the reading room at all.[89] His reading

[83] *O.L.* I, 123.

[84] "The imagination . . . is only in us a kind of mirror, where nature such as it is comes to be reflected, to give us, through a kind of powerful reminder, the spectacle of things in which the soul alone takes pleasure (25 January 1857; III, 48).

[85] Jules de Joly, *Plans, coupes*, 11.

[86] J.W. Clark, *The Care of Books*, 289; Masson, *Le Décor des bibliothèques*, 143f. The dome carried a painting of Saint Augustine by Restout.

[87] A. Hustin, "Les Peintures d'Eugène Delacroix au Sénat," 1.

[88] Grafton, *Rome Reborn: The Vatican Library and Renaissance Culture*, 44.

[89] On the Sainte-Geneviève decorative program, see Neil Levine, "The Book and the Building: Hugo's Theory of Architecture and Labrouste's Bibliothèque Sainte Geneviève."

room for the Bibliothèque Impériale (1859–64) had only classical land-scapes, again by Desgoffe, on the walls. Pastiche and prettification, the easy accessibility of universal knowledge and a conception of the library as a peaceful garden within the rush and bustle of the modern city (La-brouste's design was the first to make decorative use of iron construction): these came to replace the intellectually complex, stimulating, and perhaps unsettling schemes in which Delacroix reflected on the meaning of the space he was decorating—on the importance, and limitations, of culture.

Delacroix did not cease to reflect on the painting of libraries. Long afterward, he cut out of the *Moniteur* of 7 April 1857 a review by Edouard Thierry of a French translation of Richard de Bury's *Phi-lobiblon*.[90] In it, he marked three passages: (1) Racine's letter to his eldest son, urging him to maintain some water in his library so that the mice would not ruin his books; (2) Montaigne's ambivalence, expressed in his "library" *essai* (III, iii), about the "mixed" charms and pleasures of read-ing, which yet involve a certain pain: "in it the soul is exercised but the body . . . remains, however, inactive, is brought down, and grows sad. I know no excess more damaging for myself, nor one more to be avoided in my declining years";[91] and (3) Tarquin hesitating to buy the volumes containing the future of Rome. On the bottom of the page, Delacroix scribbled the latter two,[92] clearly as subjects for paintings, reflecting two of his favorite concerns: in the Montaigne passage, the ambiguity of let-ters which, as we have seen, can "civilize" humankind but abandon it likewise to sorrow; in the Tarquin story, the destruction of tradition which the library should preserve, a reminder less of what endures than of what has been lost.

Indeed, in the published *Journal* a few days later, under 18 April, one finds this note: "Subjects for a library: Augustus opposes the destruction of the *Aeneid;* crowning of Petrarch or Tasso; the Sibyl proposing her vol-umes to Tarquin and having them burned as he refuses them" (III, 92). With the recurring image of Tarquin, Delacroix's fears for the future of civilization and his belief in its vulnerability reach their peak.[93] Raphael's *Augustus Preserving the Aeneid* in the Stanza della Segnatura is counter-balanced there by *Alexander Preserving the Poems of Homer.* Delacroix's *Augustus* here is instead offset by Tarquin, arrogantly refusing the oracular books offered by the Cumaean Sibyl because of their high price, and ending up the loser: at his first refusal, she burns three of the nine, at his

[90] The clipping was omitted from the published *Journal.* Also included in it was a review of Baudelaire's *Nouvelles Histoires extraordinaires.*

[91] Montaigne, *Essais,* II, 250.

[92] "Montaigne et sa bibliothèque; Tarquin et la Sibylle."

[93] On the Tarquin subject, see above n. 7.

second she burns three more, and when only three are left he must pay the cost originally set for all. The story states the all-too-easy destruction of an entire tradition, through the fault of those, unlike Attila, most responsible for ensuring its continuation; its meager, fragmentary survival must be *blamed* on this ruler. Tarquin now rivals Augustus and Augustus's equivalent, the Alexander of the Palais Bourbon and the Luxembourg: "barbaric" shortsightedness versus "civilized" enlightenment, folly versus wisdom, culture delivered to the flames or saved from them, loss and preservation, both equally random and equally likely.

It is intriguing to imagine what library would have carried this daring image of explicit destruction within civilization, had Delacroix realized his plan. On the same day, he noted his visit to the Delaroche exhibit at the Ecole des Beaux-Arts: "The Emperor was visiting the Ecole that day, and finished up with said exhibit" (18 April 1857; III, 92). Napoleon III's tour of the Ecole had one significant consequence: the decision was taken to expand its buildings onto the Quai Malaquais, and to finish the work to the library built by Félix Duban so many years before (1834–39).[94] Perhaps in drafting his subjects Delacroix had this project in mind. If so, they would have extended his reflection on painting and literature even further: images of the preservation and destruction of books to adorn the library of the academy of images. In the end, Duban's library had no specific pictorial decoration at all.[95] As though proof of the very tenuousness they represent, Delacroix's late ideas were never realized, and came close to the fate of so many other "beaux ouvrages": saved from the flames only as terse jottings on a page from the diary and a loose cutting from the *Moniteur*, rescued from the fire by the housekeeper Jenny and hidden, as the story goes, in the woodpile of his house in the Place Furstenberg.[96]

[94] Archives Nationales AJ[52] (10), Ecole des Beaux-Arts, Procès-Verbaux de la Commission: "Un projet d'agrandissement de l'Ecole . . . a été mis sous les yeux de l'Empereur; Sa Majesté s'est informée des besoins de l'Ecole et a écouté avec bienveillance les explications qui lui ont été fournies par M. le Président [of the Commission of the Ecole des Beaux-Arts] et par M. Duban, architecte de l'Ecole . . . Le Président . . . a ajouté qu'il serait désirable que [le terrain] qui borde le quai . . . fût consacré en totalité au service de cette école, qui manque de salles d'exposition, de salles d'exercice pour ses concours, de salle de bibliothèque." The immediate response, as early as the following day, was favorable (A.N. F[21] 779). Plans for the library had been discussed at the Ecole as early as September 1856 (ibid.). See also Varry, *Les Bibliothèques de la Révolution et du XIXè siècle*, 199; and C. Marmoz, "The Building of the Ecole des Beaux-Arts," 132.

[95] There are pictures from the old Académie Royale de Peinture et de Sculpture hung above the bookcases; the ceiling is coffered.

[96] See Dutilleux's note on the *Journal* manuscripts, given to him by Delacroix's housekeeper Jenny Le Guillou on 23 June 1864 (transcription by Robaut in B.N. Est. R111388): "les notes écrites du maître sauvées par elle du feu où Delacroix voulait les jeter quelques jours avant sa mort . . . "; also Silvestre's account in Bruyas, *La Galerie Bruyas*, 381.

The Ambiguities of History:
The Apollo Gallery

THE RESTORATION of the Apollo Gallery in the Louvre, voted in December 1848, was one of the most significant public projects of the republican government. It was meant to provide the last link in what would be a spectacular national museum, unrivalled in grandeur and beauty, spanning the whole distance between the two royal palaces. In his report to the National Assembly, Ferdinand de Lasteyrie emphasized the Gallery's role in joining the diverse sections of the museum, and remarked: "What other monument devoted to the arts could present a development comparable to this uninterrupted line, which will extend from the Pavilion of the Tuileries to the colonnade of the Louvre? The only gap existing today would be bridged by the restoration of the Apollo Gallery."[1] On its completion in 1851, Philippe de Chennevières noted the special importance of its position as the point of access to the museum overall: "It is by way of this monument of the most glorious age of France that visitors, come from around the world to this pantheon which is the Louvre, and henceforth devoted to genius, will be led into the sanctuary of our most valuable national riches."[2] The scheme conceived for the Gallery under the July Monarchy—a series of paintings representing the history of the Louvre[3]—was abandoned in favor of restoring the Gallery according to the original plans, sumptuous and grandiose, of Le Brun. The project was thus a national imperative, and the finished work a statement of national pride, a testimony to the universal preeminence of French culture.

The main image, indeed the focal point of the Gallery—Delacroix's

[1] Quoted in Philippe de Chennevières, *Notice historique et descriptive de la Galerie d'Apollon au Louvre*, 66.

[2] Ibid., 7.

[3] On this phase of the Gallery's history, see Marie-Claude Chaudonneret, "Historicism and 'Heritage' in the Louvre, 1820–40: From the Musée Charles X to the Galerie d'Apollon."

Apollo Slayer of the Serpent Python (fig. 39), the great central panel of the ceiling, completed in October of 1851—has accordingly been interpreted ever since in terms of the social, political, and philosophical issues of the mid-nineteenth century. The victory of the sun god over the grotesque creature of the slime has been variously seen as the triumph of enlightened thought over prejudice and ignorance, science over superstition, social progress over reaction, and more recently, the bourgeoisie over socialism and the people, political order over civil strife, and, in the language of the Palais Bourbon murals, civilization over barbarism.[4] The iconography of the Gallery as a whole, conceived by Le Brun in 1661 to glorify the absolutism of the Sun King, would not (indeed did not) fail to have topical significance in a country still recovering from the turmoil of 1848. As Matsche has shown, the story of Apollo's victory over Python, used by Le Brun in the Escalier des Ambassadeurs at Versailles, was clearly recognized as an allegory of the victory of the Sun King over enemies both at home and abroad, modern enlightenment and progress over ignorance and stagnation, order over chaos.[5] The description in the *Mercure galant* interprets the subject in terms of civil war:

> His Majesty . . . has put an end to civil wars and prevented the secret rebellions to which certain enemies wished to give birth in France. These rebellions are figured by the serpent Python . . . because he only finds his origins in the gross impurities of the earth, and because he was pierced almost at birth by the arrows of Apollo, who represents the person of the king in this subject.[6]

Other accounts support this assertion:

> The frightful serpent Python formed from the grossest impurities of the earth, and destroyed by Apollo, signifies that His Majesty had

[4] See below for contemporary reaction. T. J. Clark interprets the image in terms of the impending *coup d'état* of Louis-Napoléon (*The Absolute Bourgeois: Artists and Politics in France 1848–51*, 140). F. Matsche ("Delacroix als Deckenmaler: 'Apollon vainqueur du serpent Python,'" 474) discusses the more general relevance of the allegory's connotations for Delacroix's time. But contrast M. Hesse ("Eugène Delacroix 1798–1863. Deckenbild in der Galerie d'Apollon des Louvre: Realitätsstruktur und Bildaussage," 96f.), who argues that the mythological subject would not have been considered directly applicable to contemporary politics, not only because the monarchy had fallen, but also because mythology had ceased to be taken as a serious means of topical expression, having been caricatured in work such as Daumier's and Offenbach's; the image would have been taken as a historical and historicizing one.

[5] "Delacroix als Deckenmaler: 'Apollon vainqueur du serpent Python,'" 473f. On Le Brun's painting, see below, 167.

[6] *Mercure galant*, September 1680, 2, 309–11 (quoted in Matsche, "Delacroix als Deckenmaler: 'Apollon vainqueur du serpent Python,'" 473).

fortunately ended the civil wars which had troubled the first years of his reign, and that he had stifled the secret rebellions that enemies had wished to incite in France; it can also very well signify the abolition of duels, and that salutary severity of the King who purged France of such a dangerous monster.[7]

Of the general connotations which the figures held for Delacroix there can be little doubt: on a sheet of drawings, he associated the Python with "ignorance, barbarism—blind furor";[8] his explanation of the painting calls Apollo "the god of warmth and life," and describes the struggle as the "victory of light over darkness and the revolt of the waters."[9] His painting might thus seem to reflect the values of an increasingly powerful middle class, which would culminate later in the Second Empire of Napoleon III.

Such an interpretation, however, is adequate only if the work is taken as the kind of exclusive, "literary" narrative which Delacroix consistently rejected, and which painting, in his view, inherently denied. Instead, he compresses into a single image the ambiguities of a historical moment, the "two sides" proper to painting: the pictorial narrative is at once inclusive and inconclusive. Despite its title, *Apollo Slayer of the Serpent Python* shows not the triumph, but the combat, of Apollo, at a moment when the difference between victory and defeat lies in a few remaining arrows. The battle is far from over, its outcome far from certain, and the Python is still very much alive, raising its enormous head and breathing fire. In this gallery devoted to the glory of the nation, *Apollo Slayer of the Serpent Python* calls attention, just as much, to the vulnerability of the seemingly highest civilization, the precariousness of the most apparently secure political and social order, the non-finality of the most allegedly decisive of the god's triumphs. Far from merely reflecting the ideals of Louis-Napoléon's regime and its middle-class constituency, the painting called these into question and challenged their power to endure, offering an image of the uncertain, unpredictable, and reversible movement of history.

Delacroix's painting operates within Le Brun's plan for the gallery as a whole, meant to celebrate the reign of the Sun King Louis XIV: the progress of the sun across the sky in the course of a day and, more generally, the cyclical movement of time. The central panel, intended to depict Apollo in his chariot at the height of his power—the sun at its zenith—fell within a series representing, at the top of the ceiling, the times of day,

[7] Le Fèvre, *Grand Escalier du Château de Versailles, dit escalier des Ambassadeurs* (quoted in Musée de Versailles, *Charles Le Brun: Le Décor de l'Escalier des Ambassadeurs à Versailles*, cat. 32). Le Fèvre specifically describes the image as the "true symbol of royal authority triumphing over domestic conflicts."

[8] Louvre, 385.

[9] Reprinted in Johnson V, 117.

leading from dawn, to morning, to noon, to evening, to night; it was surrounded on a lower level by the four seasons and the signs of the zodiac, representing the twelve months; at the south end figured the Triumph of Neptune and Amphitrite, or the awakening of the waters, and at the north end the Triumph of Earth, both under the fecund influence of the sun's warmth and light.

Delacroix chose a subject in which the water and earth are in full revolt. The story comes from Ovid's *Metamorphoses* (I, 241–444), the sending of the great flood by Jove to destroy the human race in punishment for its impiety. As the waters subsided, the moist earth heated by the sun produced "creatures new and strange," including the huge snake Python, which Apollo destroyed in a fierce and close battle, "crushing him with countless darts, well-nigh emptying his quiver, till the creature's poisonous blood flowed from the black wounds."[10] In Delacroix's image, the sun chariot charges furiously outward from deep within the painting, suffused in light. A ferocious Apollo, his eyes intent on the enemy, his hair and drapery blowing wildly about, aims his final arrow downward toward the slime and darkness of the lower regions, the domain of the Python, peopled by monsters, wild beasts, and human corpses floating in the flood waters. On the right, as Delacroix describes it in his commentary on the painting, Minerva, Mercury, and Hercules attack the grotesque monsters; on the left Vulcan chases away the impure vapors. Above, Victory prepares to crown Apollo and Iris unfolds her scarf—in Delacroix's words, "symbol of the triumph of light over the darkness and the revolt of the waters."

Despite the certain tone of this *projected* outcome to the battle, however, the painting represents a moment of dramatic uncertainty and suspense. The reassuring figure of Victory is countered by the central, and far more prominent, figure of Apollo, who as yet shows little sign of winning;[11] on the contrary, as Delacroix specifies (following the Ovidian model), he has used up most of his arrows. These have pierced the Python but not in the least subdued it, as its rearing head and powerfully coiled body suggest. The blood flowing from its wounds is countered by other, more threatening reds, which lead the viewer to manifestations of the monster's still-terrifying force—the fire of rage it spews forth, its furious red eye, and the inside of its massive mouth. The image thus calls attention less to the victory of Apollo, than to the real possibility of defeat, to the uncertainty

[10] *Metamorphoses* I, 443f.

[11] Some contemporary reviewers agreed. *The Builder* notes that "some art critics think that Victory is more darkly kept than might have been required" (quoted in Johnson V, 124).

of the god's triumph over an enemy who may be "powerless," as Delacroix says, and yet still unconquered. The formal parallels between Apollo and the Python make them fitting, equivalent adversaries: the four horses charging forward and outward are matched on a parallel plane by the four coils of the monster's body leading backward and inward; the two confront one another, Python leaning backward and up, Apollo forward and down. The god is not an image of classical order and serenity, but has the fury associated with the flood. The pictorial interest of the work lies as much in the creatures of the slime as in the god of light. Delacroix himself considered the best part of the painting the corpses floating in the waters of the flood around the serpent:

> The execution of the dead bodies in the Python picture, that is my true execution, the one which is most according to my inclination. I would not have that doing it from nature, and the freedom that I employ then gets over the difficulty of the absence of the model. Remember this characteristic difference between that part of my picture and the others. (14 June 1851; I, 440)

> [L'exécution des corps morts dans le tableau de Python, voilà ma vraie exécution, celle qui est le plus selon ma pente. Je n'aurais pas celle-là d'après nature, et la liberté que je déploie alors fait passer sur l'absence du modèle. Se rappeler cette différence caractéristique entre cette partie de mon tableau et les autres.]

Nor are the other monsters subdued, as Hercules is bitten savagely in the lower right of the picture.

Moreover, the image contains constant reminders of the subordination of the victory to time. In the central panel of this gallery dedicated to the sun god and the Sun King, and arranged, according to Le Brun's plan, around the motif of the sun's progress across the sky in the course of a day, Delacroix represents not the apotheosis of Apollo, but the struggle of Apollo with the darkness.[12] This high noon encompasses both day and night, light and dark: the image thus reminds the viewer that the sun at its zenith is also, inevitably, a setting sun, and that the high civilization it represents (be it that of Louis XIV or the contemporary Louis-Napoléon) is a tenuous one, won by a single arrow and subject to the decline or destruction brought about by time.

Within the picture itself, the horses of the sun rehearse the movement of the day from sunrise to sunset which the gallery repeats on a larger

[12] Cf. Giulia Ballas ("La Signification des Saisons dans l'oeuvre de Delacroix," 17): "Dans cette lutte il n'y a ni vainqueur ni vaincu, seule est importante la lutte elle-même."

scale: the position of their heads reflects that of the sun at each stage of the day. This "microcosm of the entire programme set at its heart," as Johnson calls it,[13] qualifies the victory and introduces into it the notion of inevitable and eventual defeat. Delacroix thus adds to the uncertainty of the victory a suggestion of its fragility too, and the precariousness of the order that the victory presumably establishes. Even in the strongest affirmation of the god's triumph, the picture preserves the notion of a return to darkness, chaos, and night. The third horse, representing the sun at high noon, is the color of the light surrounding Apollo and, placed alongside the horse of the setting sun, implies the possible demise of the god's reign too. And if, as Johnson points out, the last horse has the same color of coat, but qualified by a dark mane,[14] this is not only a symbol, but also a reminder of the sun's decline from within an image of high noon, and the decline of the values and institutions it may represent, as well.

While the theme of the passage of time was inscribed in Le Brun's original conception, which Delacroix was commissioned to follow and complete, a comparison of the *Apollo* with Le Brun's plans brings out Delacroix's particular insistence on the tenuousness of the victory and the destabilizing action of time. Le Brun left no specific plans for the central panel;[15] but written accounts of his project and his other treatments of the theme suggest an unequivocally triumphant Apollo, majestic in calm repose, and a Python crushed and powerless. According to Le Brun's biographer Claude Nivelon, the central panel was to contain not a combat at all, but merely Apollo on a golden chariot drawn by four horses, "who during his daily course scatters his light onto the four corners of the world represented by nations in four large groups of sculpture placed in the four angles of that gallery."[16] Chennevières proposes a possible sketch of this subject, representing Apollo seated on the summit of Mount Parnassus, leaning against a sleeping lion, his left hand touching his lyre, and flanked on the right by the horn of abundance and on the left by five Muses.[17] In an album of engravings of the original gallery by Le Brun's pupil, A. Renard de Saint-André, which Delacroix consulted and

[13] V, 117.

[14] Ibid.

[15] See Chennevières, *Notice historique et descriptive de la Galerie d'Apollon au Louvre*, 48; cf. Johnson V, 115; Sérullaz, *Peintures murales*, 127.

[16] Claude Nivelon, *Vie de Charles Le Brun et description détaillée de ses ouvrages*, B.N. ms. 12987, f. 154, quoted in Chennevières, *Notice historique et descriptive de la Galerie d'Apollon au Louvre*, 47.

[17] *Notice historique et descriptive de la Galerie d'Apollon au Louvre*, 48. This was perhaps a plan for the Salon du Dôme, or Apollo Rotunda, the circular room at the north end of the gallery, which was supposed to feature "l'histoire d'Apollon considéré comme conducteur des Muses et dieu des Beaux-Arts" (ibid., 26).

copied,[18] the central panel is left blank. But the frontispiece reproduces Le Brun's *Apotheosis of Louis XIV* (fig. 40), the ceiling of the Petit Cabinet du Roi in the Louvre, a work clearly distinct from Delacroix's conception, and closer, in fact, to Ingres' *Apotheosis of Napoleon* of 1853 (fig. 41). As Chennevières describes it: "Victory guides his chargers, Renown sounds his praise, Abundance pours out his benefits, and Minerva, flying behind his chariot, supports his crown."[19]

Le Brun did represent the triumph of Apollo over the Python in the Escalier des Ambassadeurs at Versailles. Although the staircase was destroyed in 1752, Nivelon's account, contemporary engravings, and Le Brun's own drawings give a clear idea of the character of this painting. Nivelon describes it as "Apollo leaning against a large golden tripod on which is placed a similar crown, and the serpent Python crushed at the base of this tripod to indicate that His Majesty, like a second Apollo, by his virtue and valor has surmounted his rebellions and civil wars depicted by that animal, which had been born, according to the poets, from the terrible slime."[20] An engraving by E. Baudet in 1725 shows an Apollo noble and majestic, crowned with laurel and holding the bow with which he has slain the Python, lying defeated at his feet. (fig. 42). In a cartoon by Le Brun in the Louvre, the expression of the face is serene, the attitude of the body calm, with none of the tense fury and wild energy of Delacroix's (fig. 43). Similarly, a cartoon of the Python shows a creature crushed and flattened on the ground, his body pierced with arrows, his head fallen lifeless between two massive paws, his tongue lolling lifeless out of now powerless jaws (fig. 44), in contrast to the rearing, defiant adversary of Delacroix's work.

The harmony—or incongruity—of Delacroix's image relative to Le Brun's conception was vigorously debated at the time. Although some, like Gustave Planche, saw the work as fitting perfectly into the scheme ("M. Delacroix has submitted in a docile way to the advice of his predecessor"),[21] others considered it far too tempestuous, and indeed too "human" an image, a struggle unsuited to the superiority of the god. The implication was that such a representation called into question the power of Apollo, who must expend so much effort to defeat the enemy. Even

[18] See *Journal*, 15 April 1850 (I, 355).

[19] *Notice historique et descriptive de la Galerie d'Apollon au Louvre*, 28. Cf. A. Renard de Saint-André, *La Petite Galerie du Louvre du dessein de feu M. Le Brun*. See also Jennifer Montagu, "The Early Ceiling Decorations of Charles Le Brun," 401.

[20] *Vie de Charles Le Brun*, f. 294.

[21] *Revue des deux mondes*, 15 November 1851 (quoted in Sérullaz, *Peintures murales*, 121). Cf. Louis Peisse, *Le Constitutionnel*, 18 October 1851 (quoted in Johnson V, 122); Charles Tillot, *Le Siècle*, 30 October 1851.

Planche questioned this: "Apollo is not an ordinary hunter, and we can hardly allow that he does not on the first thrust mortally wound the adversary he has chosen."[22] He also conceded that "one would have the right to ask him [Delacroix] why he has not given more nobility, more elegance to the god of the day."[23] Ernest Vinet challenged the appropriateness of the work in more strident terms:

> M. Delacroix, although the contrary has been said, has overturned the program planned by Le Brun. The premier painter of Louis XIV had proposed to represent . . . the son of Latona on his chariot, surrounded by the Seasons. The painter of the Battle of Taillebourg has shown us in preference the struggle of Apollo and the monster born of the earth and the waters.[24]

Delacroix is specifically criticized for depicting an Apollo overcome by "anxious rage," precisely the quality he attributes, in his own commentary, to the Python. Instead, Vinet counters, "With what majestic indifference, on the contrary, the antique Apollo sends his mortal arrow!"[25] This alleged victory is exceedingly, even excessively hard-won: "The instinct of M. Delacroix leads him to sow peril everywhere on his path, to show us incessantly sorrow and misery, pain and effort. He does not free even the gods from it."[26] Vinet complains that Delacroix has privileged the nether regions, giving them a "savage grandeur," and has "neglected the gods in favor of monsters."[27] Planche reports the objection that the opposition between light and dark is not sufficiently pronounced for a painting which is supposed to portray the victory of the former over the latter.[28] In 1886 A. Genevay points out the inconsistency between the *fougue* of Delacroix's image and the calm of Le Brun's surrounding scheme, and between his insistence on struggle and Le Brun's serenity.[29] In raising a similar objection, H. Jouin suggests the extent to which Delacroix emphasizes the temporality of the theme: where Le Brun's painting would have concen-

[22] *Revue des deux mondes*, 15 November 1851, 745.

[23] Ibid. (quoted in Sérullaz, *Peintures murales*, 122).

[24] *Revue contemporaine*, 15 September 1853 (quoted in Sérullaz, *Peintures murales*, 124).

[25] Ibid., 125.

[26] Ibid, 125.

[27] Quoted in Johnson, V, 124.

[28] *Revue des deux mondes*, 15 November 1851, 747.

[29] *Le Style Louis XIV: Charles Le Brun, décorateur. Ses oeuvres, son influence, ses collaborateurs et son temps*, 60. Genevay emphasizes more specifically the "logic" of Le Brun's work, and the virtues of such compositional, narrative order in painting generally. In his view, Delacroix's image breaks with this ideal, refusing to provide a proper point of departure from which the rest of the gallery's narrative evolves (ibid., 57ff.).

trated on the timeless, unchanging aspect of Apollo—a tripod surrounded by the attributes of the sun—Delacroix's is "episodic," part of a temporal scheme as the god and the sun are too.[30]

Delacroix had reason for making it so: "Does barbarism not come almost periodically, and similar to the Fury who awaits Sisyphus rolling his stone to the top of the mountain, to overturn and confound, to bring night after too brilliant a light?" (1 May 1850; I, 360). The ambiguity of the *Apollo* is consistent with this view of history; the painting includes such a reminder of darkness within an image of the "too brilliant light." The *Journal* for 1849–50, precisely the time Delacroix was working on the picture, is preoccupied with this conception of history, to which he opposes the contemporary, narrative "dogma" of progress and human perfectibility. This was a time of intense concern over what he considered the dangerous course of political events, and the speciousness and unjustifiability of contemporary confidence in progress:

> After the experiences that have been staring us in the face for a year, I believe one can affirm that every progress must bring not a greater progress yet, but in the end the negation of progress, a return to the point at which one began. The history of the human species is there to prove it. . . . Is it not evident that progress, that is the progressive march of things for better or worse, has at the present time brought society to the edge of the abyss into which it can very well fall, to give way to a total barbarism? (23 April 1849; I, 289–90)

> [Je crois d'après les expériences[31] qui nous crèvent les yeux depuis un an qu'on peut affirmer que tout progrès doit amener nécessairement non pas un progrès plus grand encore, mais à la fin négation du progrès, retour au point dont on est parti. L'histoire du genre humain est là pour le prouver. . . . N'est-il pas évident que le progrès, c'est-à-dire la marche progressive des choses en bien comme en mal a amené à l'heure qu'il est la société sur le bord de l'abîme où elle peut très bien tomber pour faire place à une barbarie complète.]

A day after deciding on the subject of the combat of Apollo and Python, he wrote: "How do the modern philosophers who have written so many fine things on the gradual development of humanity reconcile in their systems that decadence of works of the mind with the progress of political institutions? . . . That alleged modern progress in the political order is thus only a development, an accident, of this precise moment" (22 March

[30] *Charles Le Brun et les arts sous Louis XIV*, 270.
[31] Wrongly printed as "renseignements" in the published editions.

1850; I, 351–2). History, rather, is non-progressive and non-narrative, subject to reversal or annihilation at every point: "Contrary to those fanciful ideas that Saint-Simon and others have made fashionable, humanity proceeds by chance . . . Perfection is in one place when barbarism is in another. . . . India, Egypt, Nineveh and Babylon, Greece and Rome, all that existed under the sun, carried the fruits of civilization to a point which the imagination of the moderns can hardly conceive, and all that has perished, leaving almost no trace" (22 March 1850; I, 352). During this period he conceived the ironic project of "letters from a Roman from the century of Augustus or the emperors, demonstrating, by means of all the reasons we would find at present, that the civilization of the ancient world cannot perish" (22 April 1849; I, 289). History is not cumulative, but moves forward and backward in fits and starts: "We can tomorrow embrace despotism with the fury that we have used to free ourselves of any chain" (22 March 1850; I, 352). The triumph of light, warmth, and life over darkness, the victory of the divine order over the unruly elements that Delacroix describes in his invitation for the Gallery, is thus not only hard-won but also short-lived, subject to the inevitable but unpredictable disruptions of time.[32] "Darkness is reborn from the multiplicity of light," he had earlier quoted from Custine, "being dazzled is a momentary blindness" (Supplement; III, 404).

Presenting the triumph of Apollo as simply one stage in the cycle of the sun from rising to setting conformed to a view of history which, in the nineteenth century, ran directly counter to the doctrine of "linear" progress and perfectibility inherited from Condorcet and developed, with variations, by Saint-Simon, Lamarck, and Comte. Saint-Simon's "march of civilization," for example, followed the causal order of narrative succession:

One opens the great book of the past, one observes with scrupulous attention the course followed to this day by the progress of civilization.

When one observes with a sufficiently philosophical mind the course followed by the progress of civilization, the picture of that progress becomes a genealogical one in which each epoch engenders

[32] Even the cyclical notion of history to which Delacroix is partial partakes of unevenness, irregularity, and unpredictability. The growth and decline of an individual talent is disrupted and interrupted at every stage: "Indépendamment de cette carrière . . . (à savoir: de commencer faiblement, de s'accroître, de paraître dans toute sa force et de s'éteindre par degrés), il subit toutes les intermittences de la santé, de la maladie, de la disposition de l'âme, de sa gaieté ou de sa tristesse. En outre, il est sujet à s'égarer dans le plein exercice de sa force; il s'engage dans des routes trompeuses; il lui faut alors beaucoup de temps pour en revenir au point d'où il était parti, et souvent il ne s'y retrouve plus le même" (Supplement; III, 436).

the following epoch, and the succession of great political events is thus joined together in this way.[33]

Discovering the law of historical development, the narrative linking the multiple fragments of history, was the object, as Durkheim argued, of Saint-Simon's sociology overall. A society could be understood only by tracing those earlier ones which gave rise to it, reconstructing the genealogy which determined it: "True explanation consists in linking together, in moving further back into the past, the successive forms of civilization one to the other, and showing how they were engendered."[34] Without a working narrative, history for Saint-Simon is a useless collection of facts, "not linked in order of the consequences," thus lacking any prescriptive power: "It does not give . . . the means to conclude what will happen from what has happened."[35]

For Saint-Simon's disciple and sometime collaborator, Auguste Comte, the past and present are a mere preparation for the future, a "prehistory," a childhood prelude to a future, definitive state of mental and moral "virility."[36] Delacroix scathingly ridicules this idea in 1850: "Fourier does not even do the human species the honor of finding it adult. We are still no more than great children; in the time of Pericles and Augustus we were in diapers; under Louis XIV with Racine and Molière we were just prattling" (22 March; I, 352). Fourier, of course, was a vehement critic of the doctrine of progress, which he called an "indecent boast," and of the Saint-Simonians too; since antiquity, humanity had had the means to establish a harmonious social order and had not been able to do so.[37] But his utopian social formulas were still based on a linear model, progressing from the failures of past and present to the radical change of the future, in

[33] "On ouvre le grand livre du passé, on observe avec une scrupuleuse attention la marche suivie jusqu'à ce jour par les progrès de la civilisation. Quand on observe avec un esprit suffisamment philosophique la marche suivie par le progrès de la civilisation, le tableau de ce progrès devient un tableau généalogique dans lequel chaque époque engendre l'époque suivante et la succession des grands événements politiques se trouve alors enchaînée de cette manière" (I. Manfredini, *Henri Saint-Simon: Ecrits sur le progrès de la civilisation publiés d'après les manuscrits*, 31, 45).

[34] E. Durkheim, *Le Socialisme; sa définition, ses débuts, la doctrine saint-simonienne*, 129.

[35] *Mémoire sur la science de l'homme* (quoted in Durkheim, *Le Socialisme* 130). Narrative history, like prose, is associated with directed, purposeful action, non-narrative history with waywardness and confusion: "La connaissance des peuples pourra vraiment servir à éclairer l'avenir, tandis qu'aujourd'hui nous errons à l'aventure, ne sachant même pas ce qui est devant et ce qui est derrière."

[36] *Oeuvres* VII, 299 (quoted in Georg Maag, "Fortschrittsidee und Historismus bei Saint-Simon und bei Comte," 38f.)

[37] Jonathan Beecher, *Charles Fourier: The Visionary and his World*, 212, 337.

which humanity would realize its full potential through a liberation of the passions and the extinction of poverty.

Delacroix's conception of the ongoing, haphazard reversals of history denies not only such a linear view of history, but also its contemporary counterweight, a cyclical pattern in which cycles of growth and decline are subsumed into an overall upward movement or progressive spiral.[38] His view owed perhaps less to nineteenth-century theories of decadence, which represented history in terms of the birth, maturity, and death of a living organism, than to the source from which they derived, Montesquieu's *Considérations sur les causes de la grandeur des Romains et de leur décadence* (1734). He read this work in October of 1849, just a few months prior to beginning the ceiling; in its loose, almost essayistic form, "full of hints," as Voltaire called it, "less a book than an ingenious *table des matières* writ in an odd style," it would have had definite interest for the writer of the *Journal* and the *Dictionnaire des Beaux-Arts*.[39] As F. Gentile points out, Montesquieu's conception of history rejected the notion of a continuous, causal line of development. History was not seen as a movement in which the past is the condition for the present, progressing teleologically toward an end, but rather as a kind of expanded present, in which different historical moments are confronted, compared, and contrasted.[40] Such a view of history reflects the temporality of the *Journal*, the ongoing juxta-

[38] For examples, see Peter Bowler, *The Invention of Progress: The Victorians and the Past*; W. Drost, "Du Progrès à rebours. Fortschrittsglaube und Dekadenzbewusstsein im 19. Jahrhundert: Das Beispiel Frankreich," 14; Theodore Olson, *Millennialism, Utopianism and Progress*, 253.

[39] See Voltaire's letter to Thieriot, D 803. Of the *Esprit des lois*, he wrote: "Tout le monde est convenu que ce livre manque de méthode, qu'il n'y a nul plan, nul ordre, et qu'après l'avoir lu on ne sait guère ce qu'on a lu" (*Dictionnaire philosophique*, article "Lois, Esprit des," *Oeuvres complètes de Voltaire* XX, 13). Of the same work, cf. Voltaire's *Siècle de Louis XIV*, article "Montesquieu": "Le défaut continuel de méthode . . . , la singulière affectation de ne mettre souvent que trois ou quatre lignes dans un chapitre, et encore de ne faire de ces quatre lignes qu'une plaisanterie, ont indisposé beaucoup de lecteurs; on s'est plaint de trouver trop souvent des saillies où l'on attendait des raisonnements" (ibid. XIV, 108). As we have seen, Delacroix was interested in Montesquieu's personal style (see above, chapter 3, 97). Cf. Baudelaire's testimony to this (*L'Oeuvre et la vie d'Eugène Delacroix, Oeuvres complètes* II, 755): "Il ne vous paraîtra donc pas surprenant . . . que Delacroix eût une sympathie très prononcée pour les écrivains concis et concentrés, ceux dont la prose peu chargée d'ornements a l'air d'imiter les mouvements rapides de la pensée, et dont la phrase ressemble à un geste, Montesquieu, par exemple."

[40] "Il Paradigma di Roma nella prospettiva storica del Montesquieu," 107. Gentile argues that a progressive conception of history, in which "each historical phase would have meaning only in so far as it is linked to what came before and to what will follow, is incompatible with the concept of history as a field of experimentation, for it would exclude any possibility of confronting diverse epochs," a procedure necessary for verifying or altering one's hypotheses.

position of present and past effected by Delacroix's cross references and rereadings, commenting on earlier entries and copying from one entry into another; it likewise recalls the purpose of the *Dictionnaire des Beaux-Arts'* form, which Delacroix justifies on the basis of the possibilities it affords of bringing together different entries, including contradictory ones. For Montesquieu, as for Delacroix, such a fragmented and non-narrative history is linked to the seemingly haphazard and unforeseeable (although not arbitrary) character of historical events: "The majority of effects come to be through such singular channels, or depend on such imperceptible and distant causes, that one can hardly foresee them . . . if each person interrogates his memory, he will find that almost all the things he has seen, in his life, ahead of time, have not happened; and that if, on the other hand, one consults histories, one will everywhere find only great unforeseen events."[41] Events are "accidental," subject to chance and human error. For Montesquieu, there is of course a law to the waywardness of history—the "esprit" or "âme" of a society which governs its development and the actions of those within it, however much these seem to contradict it; but the chain of causality is "infinite," combinatory and permutational, and thus unpredictable.[42] Even the most apparently absolute power is subject to it: "It is a mistake to believe that there is in the world a human authority despotic in all respects; there has never been one, and there never will be one; the most immense power is always limited in some aspect. . . . There is in each nation a general spirit on which power itself is founded; when it offends that spirit, it offends itself, and it necessarily ceases."[43]

In the nineteenth century, Montesquieu's views were frequently used to shore up theories of decadence and degeneration. As Wolfgang Drost documents, the territorial expansion, moral degradation, and political corruption to which Montesquieu attributed the decline of Rome were commonly matched with contemporary aspects of French political and social life.[44] The *Journal* is full of quotations from, and reflections on, these theories, mostly in the context of Delacroix's conversations with one of the most extreme proponents of the doctrine of progressive decadence, Paul Chenavard. But his relationship with Chenavard brings out the com-

[41] *De la politique*, in Montesquieu, *Oeuvres complètes* I, 112; cf. Gentile, "Il Paradigma di Roma nella prospettiva storica del Montesquieu," 109.

[42] *De la politique*, in *Oeuvres complètes*, I, 114f. Cf. *L'Esprit des lois* XIX, 4 (in ibid., II, 558); and *Considérations sur la grandeur des Romains* (in ibid., II, 173).

[43] *Considérations sur la grandeur des Romains* (in ibid., II, 202f.).

[44] Such as the expansion into North Africa and Indonesia, the increasing materialism of French society, political and economic scandals ("Du Progrès à rebours. Fortschrittsglaube und Dekadenzbewusstsein im 19. Jahrhundert: Das Beispiel Frankreich," 18).

plexity, indeed moderation, of his own historical thought. He is at once fascinated and repelled by Chenavard's theory, with which he engages at length, only to reject as too absolute and unqualified. For Chenavard, the ages of human history are linked together in a chain which comes full circle, starting and ending in barbarism; as Sloane shows, there is no turning back and no repetition.[45] The decline set in when society reached its peak at the dawn of the Christian era; now "the man of the future will revert to the beast."[46] Chenavard's plans for decorating the Panthéon in 1848–51 trace this history in religion, politics, art, and learning. The reign of industry, democracy, and scientific materialism represents the contemporary stage of degradation in this "social palingenesis."

Delacroix's conversations with Chenavard, recorded in diary entries ranging from 1849 to 1857, reveal a sympathy for some of his principles— the suspicion of science, materialism, and progress, the preference for simplicity over detail in a work of art—but at the same time a visceral dislike of Chenavard's defeatism and fatalism. Baudelaire gives a humorous portrait of this antithetical relationship:

> But however far apart they were from one another, and even because of this, they liked to come together, and like two boats attached by grappling-irons, they could no longer separate. . . . It was truly a pleasure to see them move about in an innocent struggle, the speech of one marching ponderously like an elephant in full war gear, that of the other quivering like a fencing foil, equally sharp and flexible.[47]

Delacroix himself said of Chenavard: "He is always the same man who attracts you and repulses you" (27 November 1854; II, 304); and elsewhere: "One day I am drawn to him, . . . the next day, his unsympathetic side comes back to me" (8 September 1854; II, 259). These entries are marked by ambivalence and wry humor, such as Delacroix's account of Chenavard's deflating effects on his own enthusiasm and happiness, for example after a day of stimulating work: "It was in this mood that I went . . . to the Cours Bourbon to dine with Chenavard. I thought that we would have a good dinner, in the first place, and that the dinner would be pleasant. The dinner itself was detestable, and the lugubrious predic-

[45] Joseph C. Sloane, *Paul Marc Joseph Chenavard, Artist of 1848*, 67.

[46] Ibid., 172. Cf. Baudelaire, *L'Art philosophique* (*Oeuvres complètes* II, 603).

[47] *L'Oeuvre et la vie d'Eugène Delacroix*, (*Oeuvres complètes* II, 765f.): "Mais si éloignés qu'ils fussent l'un de l'autre, et à cause même de cet éloignement, ils aimaient à se rapprocher, et comme deux navires attachés par les grappins d'abordage, ils ne pouvaient plus se quitter. . . . C'était vraiment plaisir de les voir s'agiter dans une lutte innocente, la parole de l'un marchant pesamment comme un éléphant en grand appareil de guerre, la parole de l'autre vibrant comme un fleuret, également aiguë et flexible."

tions of my companion did nothing to cheer it up" (8 September 1854; II, 258f.). Although he often complained of decadence in moral, social, and aesthetic values (see 13 January 1857; III, 20–21), his conversations with Chenavard always provoked a violent reaction against the latter's views of progressive decline, and led Delacroix to express a less regular and more nuanced view of historical development. After a long evening of intense discussion with Chenavard, he writes:

> It was today that he spoke to me again about his famous system of decadence. He decides things too absolutely. He also fails to value at their true worth all the qualities to be valued. Although he says that people of two hundred years ago are not on a level with those of three hundred years ago, and that people today are not on a level with those of fifty or a hundred years ago, I believe that Gros, David, Prud'hon, Géricault, and Charlet are admirable men like Titian and Raphael; I also think that I have done certain things which would not be disdained by these gentlemen, and that I have made certain discoveries that they did not make. (31 August 1854; II, 248)

> [C'est aujourd'hui qu'il m'a reparlé de son fameux système de décadence. Il tranche trop absolument. Il lui manque aussi d'estimer à leur juste valeur toutes les qualités estimables. Bien qu'il dise que les gens d'il y a deux cents ans ne valent pas ceux d'il y a trois cents ans, et que ceux d'aujourd'hui ne valent pas ceux d'il y a cinquante ou cent ans, je crois que Gros, David, Prud'hon, Géricault, Charlet sont des hommes admirables comme les Titien et les Raphaël; je crois aussi que j'ai fait de certains morceaux qui ne seraient pas méprisés de ces messieurs, et que j'ai eu de certaines inventions qu'il n'ont pas eues.]

Nor are the dark ages of history definitive. Piqued by the memory of the previous day's discussion, he exclaims:

> In the evening I declined Chenavard: I felt tired from his diatribe of last night. Wittingly or unwittingly, he practices the enervation of minds as a surgeon practices incision and bloodletting. What is beautiful is beautiful, in no matter what period, no matter for whom . . . I will admire until the day I die what deserves to be admired, and if I am the last of the species, I will tell myself that after the darkness which is to follow me on the hemisphere that I inhabit, day will dawn again somewhere, and that since man always has a heart and a mind, he will still find delight through these two faculties. (1 September 1854; II, 249)

> [Le soir, j'ai décliné Chenavard: j'avais l'esprit fatigué de sa diatribe

d'hier soir. Il pratique naïvement ou sciemment l'énervation des es-
prits comme un chirurgien pratique la taille et la saignée. Ce qui est
beau est beau, n'importe dans quel temps, n'importe pour qui . . . Je
mourrai en admirant ce qui mérite de l'être et si je suis le dernier de
mon espèce, je me dirai qu'après la nuit qui me suivra sur l'hémi-
sphère que j'habite, le jour se refera encore quelque part et que
l'homme ayant toujours un coeur et un esprit, il jouira encore par ces
deux côtés.]

Delacroix analyzes Chenavard's "lugubrious predictions" as a possible
sign of frustration at the inability to make use of a prodigious knowledge
and talent. The doctrine of decadence would thus be a projection of his
own powerlessness:

> My devil of a companion never exalts anything but what is beyond
> our reach. Kant, Plato, there you have men! They are almost gods! If
> I mention a modern . . . he immediately strips him bare, makes me
> touch his sores and leaves nothing standing . . . ; that mind has re-
> ceived some deep wound; perhaps, unable to bear the feeling of his
> own impotence, he tries to fool himself by finding nothing but impo-
> tence everywhere? He has all manner of talent, and yet all of that is
> dead. (8 September 1854; II, 259–60)

> [Mon diable de compagnon n'exalte jamais que ce qui est hors de
> notre portée. Kant, Platon, voilà des hommes! ce sont presque des
> dieux! Si je nomme un moderne . . . il le déshabille à l'instant, me
> fait toucher ses plaies et ne laisse rien debout . . . ; cet esprit a reçu
> quelque profonde blessure; peut-être ne pouvant se souffrir, dans le
> sentiment de son impuissance, cherche-t-il à se donner le change en
> ne trouvant qu'impuissance partout? Il a toutes sortes de talents, et
> tout cela est mort.]

Even when Delacroix cannot hold out intellectually against the force of
Chenavard's arguments, he continues to resist: "His depressing doctrine
on the necessary decadence of the arts is perhaps true, but one must forbid
oneself even from thinking about it. We must do like Roland, who throws
the firearm, the terrible invention of the perfidious Duke of Holland, into
the sea, to bury it forever in its depths; we must hide from the knowledge
of men these debatable [*sic?*] truths, which can only make them more
unhappy or more lax in their pursuit of the good" (7 September 1854; II,
256).[48]

[48] The allusion is to *Orlando furioso* IX (91), where Roland throws Cimosco's ar-
quebus, that "cursed, abominable device," into the sea so that it may never again be used

For Delacroix, the narrative of decadence has the same flaws as that of progress: absolutism, dogmatism, false consistency, a single point of view. The visual image recounts neither of these exclusively or without qualification. In posing the struggle, it presents a more flexible history, irregular and unpredictable, subject to decline but also to the kind of rapid and brilliant flash which constituted the Renaissance, or the achievements of more recent artists whom Chenavard, in Delacroix's view, so misjudges— those, for example, who have used the language of their time to say something new to their contemporaries, and to posterity:

A man lives in his century and does well to speak to his contemporaries in a language that they can understand and which can move them. . . . What holds the attention in his works is not conformity with the ideas of his time . . .; it is by making use of the language of his contemporaries that he should, so to speak, teach them things which that language did not express before, and, if his reputation deserves to endure, it will be because he was a living example of taste in an age when taste was unrecognized. (ibid.; II, 256–7)

[Un homme vit dans son siècle et fait bien de parler à ses contemporains un langage qu'ils puissent comprendre et qui puisse les toucher. . . . Ce qui fixe l'attention dans ses ouvrages n'est pas la conformité avec les idées de son temps . . .; c'est en se servant de la langue de ses contemporains qu'il doit, en quelque sorte, leur enseigner des choses que n'exprimait pas cette langue, et si sa réputation mérite de durer, c'est qu'il aura été un exemple vivant du goût dans un temps où le goût était méconnu.]

Accordingly, in the *Journal* the record of Chenavard's oppressive fatalistic predictions is broken, and countered, by experiences of glorious and dazzling sensual beauty, such as the choir of peasants singing the Mass at Saint Jacques, which so moves Delacroix in between two conversations with Chenavard.[49] Or the sight of a boat arriving into port in the moonlight which, after the dinner fiasco mentioned above, inspires a drawing:

against man. "Debatable" ("contestables") seems to me a misreading (the original manuscript is missing); "inévitables" or "incontestables" would make more sense in context, the truth being perhaps undeniable but also unbearable.

[49] "Les enfants m'ont touché. La voix de l'enfant-homme est bien autrement pénétrante que celle des femmes que j'ai toujours trouvée criarde et peu expressive; il y a ensuite dans ce naïf artiste de huit ou dix ans quelque chose de presque sacré; ces voix pures s'élevant à Dieu, d'un corps qui est à peine un corps, et d'une âme qui n'a point encore été souillée, doivent être portées tout droit au pied de son trône et parler à sa toute bonté pour notre faiblesse et nos tristes passions" (7 September 1854; II, 254).

I leave him at ten o'clock and go to the jetty to shake off this obsession a little. I see a fine brig enter in the moonlight on a rather rough sea. It is a beautiful sight. . . . The moon was just opposite and gave superb effects in the water, detaching the mass[50] and the riggings of the ships. (8 September 1854; II, 259)

[Je le quitte à dix heures . . . et vais jusqu'à la jetée pour secouer un peu cette obsession. Je vois entrer un beau brick, par la lune et une mer suffisamment agitée. C'est un beau spectacle. . . . La lune était en face et donnait de superbes effets dans l'eau et en détachant la masse et les agrès des bâtiments.]

Such experiences recur constantly in the *Journal*'s dialogue with Chenavard, providing Delacroix not only with a respite from his friend's unbearable narrative, but also with subjects for the "travail d'esprit" which combats it—writing in the *Journal*, sketching or painting a picture. For it is what Delacroix calls the "material" side of life—the activity of painting, the energy to express oneself—which breaks the decline, arresting and reversing, temporarily at least, the downward movement. Chenavard's philosophy, in contrast, leads to paralysis:

Why doesn't he write, why doesn't he draft something? He believes himself capable of doing so . . . but he admits that he has to take too much trouble to express his ideas. That excuse betrays his weakness. (8 September 1854; II, 260)

[Que n'écrit-il, que ne rédige-t-il? Il se croit capable de le faire . . . mais il avoue qu'il lui faut prendre trop de peine pour exprimer ses idées. Cette excuse trahit sa faiblesse.]

. . . This discouragement that he confesses seems to me, as to him, the cause of his lack of success. . . . How could he interest people to the same extent as those minds gifted equally with elevation, but at the same time with the energy which one draws from the desire, and the assurance, of reaching the first rank? (17 September 1854; II, 268)

[. . . ce découragement qu'il confesse me para[ît], comme à lui, la cause de son peu de succès. . . . Comment intéresserait-il au même degré que des esprits doués aussi d'élévation, mais en même temps de l'énergie qu'on puise dans le désir et l'assurance d'arriver au premier rang?]

God put the mind into the world as one of the necessary forces. It is

[50] Earlier editions print "masse," possibly a misreading of *mâts*, "masts."

not everything, as those famous idealists and Platonists say; it is there like electricity, like all the imponderable forces which act upon matter. (18 September 1854; II, 269–70)

[Dieu a mis l'esprit dans le monde comme une des forces nécessaires. Il n'est pas tout, comme le disent ces fameux idéalistes et platoniciens; il y est comme l'électricité, comme toutes les forces impondérables qui agissent sur la matière.]

In the evening, met Chenavard at seven o'clock. . . . Always the same thing about the preeminence of literature, on which he rests firm. Also metaphysics. He tells me that I am of the family of men like Napoleon, people who see only ideologues in those who are not men of action. (18 September 1854; II, 270)

[Le soir, trouvé Chenavard à sept heures. . . . Toujours sur la prééminence de la littérature pour laquelle il tient bon. Aussi sur la métaphysique. Il me dit que je suis de la famille des Napoléon, des gens qui ne voient qu'idéologues dans ceux qui ne sont pas des hommes d'action.]

On this last point, Chenavard was right, in part: the social prophecies— of decadence or progress, of reaction or socialism—were for Delacroix exercises in ideology, systems removed from the human experience they were meant to describe. Writing may have permitted this (the conversation takes place in the context of Chenavard's doctrine of the superiority of literature over painting); the visual image would not. Written history, he suggests in 1853, always desires "sharp contrasts"; human nature is otherwise.[51]

Thus for all its reliance on a clearly ideological iconography, the *Apollo* painting could not fulfill the same function that the allegory had in Le Brun's time. In contemporary reactions to it, this political message—what Gustave Planche called Le Brun's "bended-knee flattery"[52]—is indeed passed over in favor of a broader social and cultural interpretation: the luminous future vanquishing the medieval past of ignorance and back-

[51] 15 May 1853 (II, 49). Delacroix makes the remark after reading an article about Charles V, which presented a different portrait from the one offered by history: "Ce n'est pas sous cet aspect que l'histoire prise en gros le considère; on le croit communément un être froid et perfide. . . . Charles-Quint a eu, comme un autre, ses faiblesses; il était très brave aussi et plein de bonté et d'indulgence pour ceux qui l'approchaient."

[52] "Il ne s'est pas inquiété des flatteries agenouillés qui se cachaient sous le projet de Le Brun. Peu nous importe, en effet, qu'Apollon vainqueur du serpent Python signifie Louis XIV vainqueur de l'Europe" (quoted in Sérullaz, *Peintures murales*, 121).

wardness;[53] intelligence and science defeating barbarism and ignorance.[54] But the inclusiveness of Delacroix's image, expressing not only his belief in the power of enlightened thought, but also his reservations about the progress of history, calls these more general ideological divisions, too, into question. Like narrative, propaganda—whatever its message—will not easily tolerate two points of view, the very essence of painting.

[53] Auguste Vacquerie, *L'Avènement du peuple*, 17 October 1851 (quoted in Johnson V, 122).

[54] Elisa de Mirbel, *La Révolution littéraire*, 1852 (quoted in Johnson V, 124).

The Treasure of the Temple: Saint-Sulpice

DELACROIX'S NOTION of the inclusiveness of the image, and of a more nuanced pictorial narrative, plays a crucial role in his last decorative series, the Chapel of the Holy Angels at the church of Saint-Sulpice. The cycle consists of three large paintings featuring the triumphant struggles of the holy angels.[1] On the ceiling is *Saint Michael Defeating the Devil* (fig. 45) from Rev. 12:7–9, in which the victorious archangel casts the devil and his angels out into the world—a subject familiar to French viewers from two versions by Raphael in the Louvre, notably the well-known one of the same title, from 1518 (fig. 46). The west wall contains *Heliodorus Driven from the Temple,* the story of the Syrian officer sent to confiscate the treasure of the temple of Jerusalem (II Maccabees 3:1–40); as he was committing this sacrilege, a divine horseman and two angels appeared in answer to the prayers of Onias, the high priest, to punish Heliodorus for his outrage (fig. 47). Even more than the previous example, this subject was equated with the name of Raphael, whose spectacular version in the Stanza d'Eliodoro in the Vatican was well known both through engravings and, more recently, through copies by the Balze brothers exhibited in the Panthéon from 1847 (fig. 48).[2] The east wall depicts *Jacob Wrestling with the Angel* (Gen. 32:24–9), in which Jacob, after wrestling with the angel the whole night long, is defeated only when the angel touches him on the thigh and lames him (fig. 49). From this episode Jacob demands, and receives, God's blessing and is renamed Israel, "one who has striven with

[1] For a full study of the decorations which discusses sources, Delacroix's sketches, and the context of religious commissions in the period, see the fine monograph by Jack Spector, *The Murals of Eugène Delacroix at Saint-Sulpice* (henceforth *Murals*).

[2] Spector (*Murals,* 111) notes that copies of Raphael's Stanze by Paul and Raymond Balze were on view in the Panthéon from 1847 to 1873; Delacroix saw them in February of 1847 and was enthusiastic. See *Corr.* II, 303.

God . . . and has prevailed" (Gen. 32:28). In his own commentary on the paintings, Delacroix specifies: "This struggle is considered by the holy scriptures an emblem of the trials which God sometimes sends to his chosen ones."[3]

All three images are structurally and thematically related in depicting a combat between two principal figures, one of whom is physically marked, in a sign of defeat, by the other. All present the defeat of those who have the impudence and impertinence to rise up against the authority of God: Saint Michael triumphing over the demon, who, like Lucifer, with whom he is traditionally equated, aims to make himself "like the Most High" (Isaiah 14:14); the horseman and angels overwhelming Heliodorus, who learns the lesson that "he who has his dwelling in heaven watches over [the temple] himself and brings it aid, and he strikes down and destroys those who come to do it injury" (II Maccabees 3:39); and the angel finally overcoming Jacob, who "strove with God" and, as Delacroix specifies, is "reduced to impotence." But this seemingly unified meaning of the chapel as a whole is called into question by the ambiguity of the Jacob story, which Delacroix took care to emphasize in his commentary: Jacob's defeat is a sign of divine election—"an emblem of the trials which God sometimes sends to his chosen ones"—, the mark on his thigh which lames him a blessing. Jacob's larger moral victory, transcending the defeat of the moment, is the central point of the traditional story and was clearly understood by viewers of the picture at the time. As one critic put it, "God lets himself be conquered by man . . . Struggle is man's condition on earth; but if he sustains it, the crown will be his prize."[4] Into this cycle representing the defeat of those who challenge the divine, Delacroix injects an image of "one who struggled with God and did prevail," and was blessed *because of* the struggle. The similarity of the three images means that the radically different interpretation of the *Jacob* must be brought to bear on the other two, to qualify and complicate their apparently single sense: in them as well, the mark of defeat and punishment may constitute a blessing. Delacroix's series seems to

[3] The invitations to view the chapel carried the following descriptions of the latter two works: "Héliodore chassé du temple. S'étant présenté avec ses gardes pour en enlever les trésors, il est tout à coup renversé par un cavalier mystérieux: en même temps, deux envoyés célestes se précipitent sur lui et le battent de verges avec furie, jusqu'à ce qu'il soit rejeté hors de l'enceinte sacrée." "La Lutte de Jacob avec l'Ange. Jacob accompagne les troupeaux et autres présents à l'aide desquels il espère fléchir la colère de son frère Esaü. Un étranger se présente qui arrête ses pas et engage avec lui une lutte opiniâtre, laquelle ne se termine qu'au moment où Jacob, touché au nerf de la cuisse par son adversaire, se trouve réduit à l'impuissance. Cette lutte est regardée, par les livres saints, comme un emblème des épreuves que Dieu envoie quelquefois à ses élus" (reprinted in Johnson V, 191 and 192).

[4] Hurel, *L'Art religieux contemporain* (quoted in Johnson V, 171).

depict the humbling of pride, the crushing of hubris, the damnation of those who outrage divine authority or pillage the forbidden treasures of the temple. But it also presents an alternative, and to some extent contradictory, view: not defining, but *questioning* the division between divine and satanic, good and evil, piety and impiety, election and damnation, heroism and sacrilege, angel and demon.

Interpretations of the cycle have either taken it as an unproblematic narrative of divine victory over those who revolt,[5] thus ignoring the evident ambiguity of the Jacob story, or have treated the paintings as wholly separate because of the inconsistency between the first two and the third.[6] But this position is inadequate too, for connections between the *Jacob* and the other two paintings abound. With the *Heliodorus*, in particular, the formal parallels are remarkable, as others have pointed out:[7] the paintings face one another like mirror images; the elaborate and massive architecture of the *Heliodorus* corresponds to the *Jacob*'s luxuriant and monumental vegetation, the agitated curtains to the curling, undulating branches of the trees; the splendid wealth of the treasure arrayed in the foreground matches the pile of arms and clothing, the famous still-life of the *Jacob*; the staircases and high balconies in the background of the *Heliodorus* are like the rising ground and the distant mountains of the *Jacob*; the figure with the star-studded headdress reverses the foreground figure in the *Jacob*'s caravan. The images should thus be read in terms of one another, but not according to a single narrative order: rather, the narrative reverses and the contradiction of the *Jacob* rebounds onto the other two, to qualify an apparently unequivocal meaning.

Delacroix explores the reversibility and interchangeability of the chapel's oppositions—divine and demonic, blessing and sacrilege,—by establishing formal, coloristic, and iconographical connections among the

[5] E.g. Emile Galichon, *Gazette des Beaux-Arts*, 1 December 1861 (quoted in Sérullaz, *Peintures murales*, 171).

[6] Sérullaz (*Peintures murales*, 181) notes the "singular contrast" between the *Heliodorus* and the *Jacob* but does not discuss it. Most critics of the period took the works separately, but some did comment on the contradiction. See Olivier Merson, *Revue contemporaine* 16, 15 March 1862 (quoted in Sérullaz, *Peintures murales*, 174): "Mais cet adversaire est un agent divin; il doit nous apparaître comme l'image sensible d'une force supérieure à tous les obstacles matériels. Eh bien, le commentaire du peintre est loin de satisfaire mon esprit et ma croyance, s'il montre la force divine prête à succomber sous les assauts répétés de la force humaine"; and Hurel, *L' Art religieux contemporain* (quoted in Johnson V, 171): "L'ange résiste et cède à la fois." Anatole France (*La Révolte des anges*, 39ff.) has one of his characters distinguish the angel of the Jacob story from the others, despite Delacroix's presenting them all as "heralds of celestial anger, . . . ministers of divine vengeance."

[7] Beginning with Théophile Thoré, *Le Temps*, 9 August 1861 (quoted in Johnson V, 165); Spector, *Murals*, 171ff.; Johnson V, 162.

three images and by blurring the distinctions within each image. In contrast to the ugliness and the slightly grotesque features of Raphael's Heliodorus, which signal his evil as against the classical nobility of the horseman, Delacroix's has the youth and beauty of the angelic horseman himself.[8] The color scheme of the latter's dress (reddish-orange and gold) is repeated in the helmet of Heliodorus; the blue drapery under Heliodorus's head recurs in the blue band of the horseman's helmet. Delacroix had earlier conceived of a more redoubtable and terrible horseman, in keeping with the avenging rider of the original story, who "with frightening mien" rushes furiously at the blasphemer; this is clear from the early sketches, such as the one at Chantilly (fig. 50). But he altered this to a calmer, more serene figure, making him closer to his victim, and also to the more beneficent angel wounding and *blessing* Jacob on the opposite wall.[9] The violet drapery of the *Jacob*'s angel is matched by that of the diving angel beating Heliodorus.[10] Similarly, in an early sketch in Grenoble, the angel of the *Jacob* has a demonic face similar to the Lucifer of the *Saint Michael*, a fact that has puzzled more than one commentator (fig. 51).[11] But such a conception reflects the ambiguities of the chapel's subject itself: the angel has the demonic character of Lucifer; Lucifer was an angel too.[12] The seemingly clear dualism of the *Saint Michael* becomes increasingly blurred as we are plunged, following the horizontal axis of the painting, from the heavenly battle of the angels on the ceiling down into the worldly dramas on the walls. The angelic struggle of the *Jacob* is as much a challenge to the power and authority of God, a demonic revolt like Satan's; the serpent under the latter's legs in the right foreground of the *Saint Michael* corresponds to the tassle of the dagger under Jacob's. Jacob's special talent was of course deception, the craft and cunning which made him outwit Esau and Laban—precisely the characteristic of Satan, the "deceiver of the world," as the Revelation passage defines him (12:9). And the demonic, sacrilegious struggle of Heliodorus may be as much a blessing, a sign of divine election.

[8] In fact, Raphael's Heliodorus bears a noticeable resemblance to the overturned demon at the right of Delacroix's Saint Michael.

[9] Conversely, the angel of the *Jacob* once showed the same alarm as Heliodorus. See the sketch in Spector, *Murals*, no. 35.

[10] Johnson V, 188.

[11] E.g. Spector: "The impulse which prompted Delacroix to characterize the wrestlers in this demonic way is difficult to determine. . . . We can only admire the powerful expressiveness of this image and wonder at its personal meaning to the artist" (*Murals*, 56). Horns are of course signs of divinity.

[12] The archangel was originally conceived as much larger, dominating Lucifer all the more, in keeping with Raphael's, but was later greatly reduced. See Sara Lichtenstein, *Delacroix and Raphael*, 230, 232.

From the moment the paintings were unveiled in July of 1861 the struggle of the *Jacob* was interpreted according to the Romantic myth of the artist who wrestles with the divine, with his materials, with the "insurmountable difficulties" of art.[13] It is an easy, conventional reading, promoted by Delacroix's own commentary on the painting and consistent with his notion of this long, twelve-year enterprise, his last major work, as a struggle and a challenge. "My heart beats faster when I find myself faced with great walls to paint," he writes in the *Journal* after a session at Saint-Sulpice in 1854 (30 June 1854; II, 209); his correspondence is full of references to his "harsh labor," his "terrible task," the "nightmare of [his] days," his "colossal entreprise," the "infernal work at Saint-Sulpice."[14] And with reason: of all his mural paintings, the chapel presented Delacroix personally with the greatest difficulties, greater even than those of more apparently demanding projects like the huge space of the Palais Bourbon library, or the limited choice of subject and the extraordinary exposure of the Apollo Gallery. First commissioned in 1849 and not completed until 1861, it acquired over the twelve years of its execution an increasingly monumental stature, as he deferred it time and again, each new start being interrupted by some pressing major project or his deteriorating health: the Apollo ceiling in 1850–51, the Salon de la Paix in 1852–54, the Universal Exhibition of 1855, his serious illness for the whole of 1857 and half of 1858. From the beginning, his work on the chapel was marked with a sense of the personal: "Tuesday, 2 October 1849. It's today that I decided with the curate . . . that I would do the holy angels; and I notice in writing this that it is on their very feast-day that I made up my mind to do this" (I, 310). It is as though fixing the subject was itself an engagement with the angels, a struggle with them undertaken under their protection. At work on the *Heliodorus* in 1858, he is reduced to the same next-

[13] See Gautier, *Moniteur universel*, 3 August 1861: "C'était une difficulté presque insurmontable que de remplir un si vaste espace avec deux figures. M. Eugène Delacroix l'a surmontée." Gautier also suggests that the metaphor may apply to the painter's struggle with the stone, with decoration of monuments, which has paralyzed many an artist: "Sa brosse ne perd rien de sa fougue sur la pierre, qui tranquillise, jusqu'à refroidir, beaucoup de talents inestimables. Là il est vraiment maître et souverain." See also M. Barrès, "Le Testament d'Eugène Delacroix," who calls the painting "cette page d'autobiographie suprême" (quoted in Sérullaz, *Peintures murales*, 182, and Johnson V, 172); Escholier, *Eugène Delacroix* (III, 111): "Certes, c'est lui, Jacob. C'est le jeune romantique du temps de *Faust* et de *Cromwell*, c'est le chef de bande qui entend forcer la fortune et porter la main sur tout ce qui est royal et divin"; Sérullaz, *Peintures murales*, 181: "Ce combat avec Dieu . . . Delacroix n'y a-t-il pas vu aussi le combat du peintre solitaire avec l'art, cette émanation de Dieu?"; Joubin, *Corr.* IV, 111: "Emouvant spectacle que celui de ce malade qui se raidit contre la maladie et combat avec la mort: la *Lutte de Jacob et de l'Ange* qu'il peint sur une des murailles de sa chapelle!"; Jean Cassou, *Delacroix*, n.p.: "ce travail qui peint une bataille et qui est lui-même une bataille."

[14] *Corr.* III, 338; IV, 120, 123; IV, 197; IV, 218; IV, 44.

day *impuissance* as that experienced by Jacob (11 September 1858; III, 215). And an oft-quoted remark in the *Journal* describes his work on the chapel in the metaphor of the *Jacob:* "This eternal struggle, instead of beating me down, raises me up" (1 January 1861; III, 317).[15]

Yet if, as I argue, the message of the *Jacob* must be read back into the other two, and theirs into it, and if, as a result, all three paintings reflect the same ambiguity of divine and demonic, election and damnation, then the same applies to the Romantic myth of the artist. Reversing and interconnecting the images in this way makes the artist a Lucifer, a Heliodorus; painting is a pillaging of the temple.[16] But into this Romantic, specifically Byronic, conception comes the message of the *Jacob:* such an outrage brings a kind of blessing, solace, pleasure, and happiness, providing that delight for the eye and that activity for the mind which alone save humankind from living death. "One must be very bold. Without boldness, and an extreme boldness, there is no beauty" (21 July 1850; I, 394): the artist/Heliodorus boldly plundering the temple releases for human eyes the hidden treasures of nature, permits the sensuous delight in matter and color that the viewer feels before the extraordinary riches spilled out in the foreground of the painting, and which is for Delacroix the condition for creative thought. "The primary merit of a painting is to be a feast for the eye," he noted just six weeks before he died (22 June 1863; III, 335). The artist has the impertinence of Heliodorus—the large, bold signature "Delacroix–1861," just seven feet from the floor, the closest thing to the viewer's eye, is unmistakable, flanking the blasphemer it seems to name, and placed alongside the rich treasure it seems to mark. This, the signature indicates, is the handiwork of the artist—this challenge to the divine order, this profanation of the temple, this revelation of the treasure, indeed the treasure itself. The picture that should recount a lesson in humility carries everywhere the mark of a Heliodoran audacity and self-assertion, of which the signature may be only one example: for the evident brushwork, the visible hatchings, the heavy impasto make the painted surface itself the boldest statement of the artist as Heliodorus, leaving on the temple—this temple, Saint-Sulpice—the mark of his challenge to the divine.[17]

[15] Cf. *Corr.* IV, 49f.: "Ce travail si fatigant m'a, chose extraordinaire, donné des forces."

[16] Delacroix was interested in the theme of the sacrilegious plundering of the temple from early on. The *Journal* entry for 5 October 1822 (I, 15) notes an idea for a painting on Belshazzar's feast, and the profanation of the holy vases stolen from the temple of Jerusalem.

[17] Delacroix himself joked about the "sacrilege." When his request to work in the chapel on Sundays was refused, he wrote in the diary: "L'Empereur, l'Impératrice, Mon-

Neither the original story, nor Raphael's illustrious precedent has this sumptuous treasure in which Delacroix takes such evident painterly delight; the money mentioned in the Biblical account[18]—the small, discreet urn overturned on the right in Raphael's painting—are no preparation for the lavish splendors of Delacroix's. Nor does Raphael include a signature, the bold, impenitent response of the artist/Heliodorus faced with inevitable defeat. In Delacroix's version, these are prominent: only the blasphemy of ravishing the treasure reveals it to our eyes, providing the "food for thought" which saves us from *ennui*. Indeed he increased the display of riches as the work went on, emphasizing more and more overtly their importance to the sense of the painting; several of the sketches have only the relatively discreet pile on the left. At a certain point he added the jewel box on the right, and then in the last year magnified this, doubling its size and adding to the gems which spill from it. And only in March of 1861, just four months before the chapel opened, did he add the overturned censer on the step, with its gold chain falling languidly over the dais, as a sketch in the Louvre attests (fig. 52). Similarly, the still life of the *Jacob* was added at a very late stage,[19] and given unprecedented lavishness and prominence. This may be measured by comparing it not only to its first appearance in a sketch in the Fogg Museum (fig. 53), but also to an earlier usage of the same materials—the quiver and arrows, the spear, the hat, the drapery and tassle—in the *Abduction of Rebecca* of 1846[20] (fig 54). What is there a mere accessory, providing visual interest and pointing inward from the edge of the frame which it defines, becomes in the *Jacob* a crucial part of the painting, raised from the frame and occupying a large area of the foreground, pointing directly at the main action, and linking this material, earthly feast for the eye with the spiritual struggle itself. *Concupiscentia oculorum:* in painting, this cardinal sin is also, as the *Jacob* suggests, a blessing, a victory over humanity's "terrible enemy," its own special demon, the "phantom" of *ennui* (11 August 1854; II, 242). In the richness and variety of their colors and the bold materiality of their execution, the treasure of the *Heliodorus* and the still life of the *Jacob* call attention to themselves as color and paint, thus func-

seigneur conspirent pour qu'un pauvre peintre comme moi ne commette pas le sacrilège de donner cours, le dimanche comme les autres jours, à des idées qu'il tire du cerveau pour glorifier le Seigneur" (3 August 1854; II, 225).

[18] II Maccabees 3:11 specifies four hundred silver and two hundred gold coins, six hundred talents' worth.

[19] Johnson V, 164.

[20] Metropolitan Museum of Art, New York (Johnson 284). Delacroix may have retrieved the still life for the *Jacob* as a result of his return to the subject of *The Abduction of Rebecca* in 1858 (Johnson 326; now in the Louvre).

tioning as metaphors of painting within the paintings themselves: feasts for the eye within that "feast for the eye" by which Delacroix defines painting; filling an empty space within an art which for him fills another kind of emptiness, as the *Journal* repeatedly reminds us, the mental and spiritual void of *ennui*.[21] As Baudelaire put it in another context, "Delacroix's painting is like nature, it has a horror of emptiness."[22] The paintings thus boldly broke with the practice increasingly prescribed for church decoration, namely to serve as maxims or captions to the edifice, stating an idea or commemorating an event, not as a distraction or an "amusement for the eye": "a church is not like a museum, a tilt-yard open to vanities, eager to do battle for the applause of the spectator-judges."[23] It followed, rather, the Venetian decorative tradition of the sensual purpose of color, and of pleasure as the object of art.[24]

For the colorist Delacroix, with his palette, as one contemporary critic put it, a "jewel composed of precious stones,"[25] painting is the jewels of the temple too, the material richness of color which provokes a sacrilegious pleasure. The palette employed for Saint-Sulpice is one of the most sumptuous and extensive in the history of painting: twenty-seven pure colors plus twenty-three mixed ones, not to mention the half-tone, reflection, and shadow of each, in contrast to the usual seventeen for David and Corot, five for El Greco, eleven for Renoir and Whistler, fourteen for Rubens, nine for Titian, eighteen for Van Dyck.[26] Moreover, Delacroix's choice of an oil and wax medium (painted directly onto the two walls, but onto canvas for the ceiling) emphasizes this sensual richness, in contrast to the lightness, simplicity, and purity of fresco. In terms of the great debates of the period concerning the relative merits of fresco and oil for church decoration, the choice was topical: oil painting was too close to nature, too splendid, with its play of reflections and highlights, too seductive; fresco was less material, less brilliant, lighter, clearer, more noble and religious, more morally edifying, more idealizing.[27] Delacroix's

[21] Critics of the period recognized the point of the *Jacob*'s still life, especially, as filling a great space which would otherwise remain empty (see Johnson V, 168). Filling an immense space with two figures was for Gautier the great challenge of the *Jacob* (see above, n. 13).

[22] *Salon de 1846, Oeuvres complètes* II, 439.

[23] J. P. Schmit, *Manuel Roret de l'Architecture des monuments religieux*, 1845, quoted in Foucart, *Le Renouveau de la peinture religieuse en France*, 56f.

[24] See above, Introduction, n. 24. On the history of the philosophical tradition linking color to sensuality, see J. Lichtenstein, *La Couleur éloquente*.

[25] Thoré, *Le Temps*, 9 August 1861 (quoted in Sérullaz, *Peintures murales*, 166).

[26] See Piot, *Les Palettes de Delacroix*.

[27] See Foucart, *Le Renouveau de la peinture religieuse en France*, 53, 56, 58ff.; Quatremère de Quincy (quoted in ibid., 185).

many notes on fresco in the *Journal* defend the "effect" obtainable in oil, its variety and richness, against the dominant taste for fresco's alleged simplicity.[28] And effect, as J. Lichtenstein suggests in a different context, is proper to painting, to that which, in painting, cannot be explained and controlled by words, to the perhaps unaccountable but nonetheless intelligible action of the image upon the observer.[29]

Baudelaire, for one, understood the sensual power of the chapel, the heretical pleasure—he calls it *volupté*—which it led the viewer to take in the treasure of its color; likewise he perceived the interconnection of materiality and spirituality, color and idea, that it implied. In his review of the decorations, he emphasizes the materiality of Delacroix's interpretation of the stories, but then ironizes the terms to invert their ordinary connotations: this is a materiality that communicates the spiritual, a pleasure that is "primitive," resounding in the depths of the human soul and in the mythical origins of mankind, a sensual pleasure marked by the transcendent ("volupté surnaturelle"), a delight that is luminous and illuminating, a materiality that is "enchanting," "magical," "supernatural."[30] Those who ignore the material and call themselves spiritualists are in fact the most densely materialistic of all—Baudelaire calls them "masons," "vulgar, materialist minds," remaining at the surface rather than penetrating to the soul, their supposedly immaterial thought having a "concreteness" distant from the shadowy region which is the source of true thought:

> According to those people, color does not dream, does not think, does not speak. It would appear that, when I contemplate the works of one of those men specifically called colorists, I am indulging in a pleasure which is not of a noble nature; they would gladly call me a materialist, reserving for themselves the aristocratic epithet of spiritualist. Those superficial minds do not imagine that the two faculties can never be wholly separated.[31]

In the *Journal* Delacroix, too, criticizes those who consider color only

[28] 5 January 1857 (III, 6–8) and above, 115, 119. Cf. his sardonic remark on Victor Mottez and Amaury Duval, proponents of the fresco revival: "Ces gens-là ne jurent que par la fresque; ils parlent de tous les noms gothiques de l'Ecole italienne primitive, comme si c'étaient leurs amis" (12 April 1849; I, 287).

[29] *La Couleur éloquente*, 238f.

[30] *Peintures murales d'Eugène Delacroix à Saint-Sulpice, Oeuvres complètes* II, 751ff.

[31] "Selon ces gens-là, la couleur ne rêve pas, ne pense pas, ne parle pas. Il paraîtrait que, quand je contemple les oeuvres d'un de ces hommes appelés spécialement coloristes, je me livre à un plaisir qui n'est pas d'une nature noble; volontiers m'appelleraient-ils matérialiste, réservant pour eux-mêmes l'aristocratique épithète de spiritualistes. Ces esprits superficiels ne songent pas que les deux facultés ne peuvent jamais être tout à fait séparées" (ibid, 752).

"low" and "earthly".[32] On the contrary, for him the material and sensual are necessary for the spiritual, and indeed sometimes are themselves alone the source of true value: "As one grows older, one must recognize that there is a mask on almost everything, but one becomes less indignant about that false appearance and gets used to being satisfied with what *is seen*" (24 June 1849; I, 298, my emphasis). In a letter thanking Baudelaire for his favorable review, particularly his remarks on the spirituality of painting's material aspects, Delacroix wrote:

> I thank you very sincerely, both for your praises and for the reflections which accompany and confirm them on those mysterious effects of line and color, which have, alas, only a few faithful followers. That mysterious, arabesque part is nothing for many people who look at a picture the way the English look at the countryside when they travel: that is to say that they have their nose in the *Travellers' Handbook* so as to learn conscientiously about what the area yields in wheat and other products, etc. In the same way, well-behaved critics want to understand in order to be able to demonstrate something. . . . They feel cheated in front of a picture which demonstrates nothing and which gives nothing but pleasure.[33]

It is precisely this interrelation of material and spiritual, blasphemy and blessing, earthly and divine, damnation and election, which the chapel proposes, justifying the material as the means, and perhaps the only means, by which to know the spiritual.

The artist's plundering brings *both* defeat and triumph, and Delacroix insists on the two: matter represents mankind's subjection to death—*dust thou art*—and also provides a liberation from it, that delight which sustains and gives life to the imagination. The serpent and shield in the right foreground of the *Saint Michael* metamorphose, formally speaking, into the glorious still life of the *Jacob*, with its brilliant straw hat and its floating ribbons: the mark of death becomes a visual, material feast pointing directly to the high spiritual drama of the central struggle. More specifically, the challenge of painting confronts the artist with the sure prospect

[32] 5 January 1857 (III, 5–6).

[33] "Je vous remercie bien sincèrement, et de vos éloges et des réflexions qui les accompagnent et les confirment, sur ces effets mystérieux de la ligne et de la couleur, qui ne sentent, hélas! que peu d'adeptes. Cette partie musicale et arabesque n'est rien pour bien des gens qui regardent un tableau comme les Anglais regardent une contrée quand ils voyagent: c'est-à-dire qu'ils ont le nez dans le *Guide du voyageur*, afin de s'instruire consciencieusement de ce que le pays rapporte en blé et autres denrées, etc. De même les critiques bons sujets veulent comprendre afin de pouvoir démontrer. . . . Ils se trouvent volés devant un tableau qui ne démontre rien et qui ne donne que du plaisir" (*Corr.* IV, 276f.).

of defeat—one can never rival nature, only find equivalents[34]—and with his ultimate subjection to time, but also provides the means by which to triumph over time by giving it value.

1st of January 1861—I began the year by pursuing my work at the church, as usual; I paid no visits except by cards . . . and I went to work for the whole day. Oh happy life, what a celestial compensation for my supposed isolation! . . . Painting harasses me and indeed torments me in a thousand ways like the most demanding of mistresses; for the last four months I have fled at daybreak and have run to this enchanting work, as though to the feet of the most cherished mistress; what from afar appeared to me easy to overcome now presents me with horrible and incessant difficulties. But how is it that this eternal struggle, instead of beating me down, raises me up, and instead of discouraging me, consoles me and fills my moments when I have left it? What a happy compensation for what the good years have carried off forever; what a noble use of the moments of my old age, which already besieges me from a thousand directions, but leaves me still the strength to surmount the pains of the body and the afflictions of the soul. (III, 317)

[1er janvier 1861—J'ai commencé cette année en poursuivant mon travail de l'église, comme à l'ordinaire; je n'ai fait de visites que par cartes . . . et j'ai été travailler toute la journée. Heureuse vie, compensation céleste de mon isolement prétendu! . . . La peinture me harcèle et me tourmente de mille manières à la vérité, comme la maîtresse la plus exigeante; depuis quatre mois je fuis dès le petit jour et je cours à ce travail enchanteur, comme aux pieds de la maîtresse la plus chérie; ce qui me paraissait de loin facile à surmonter me présente d'horribles et incessantes difficultés. Mais d'où vient que ce combat éternel, au lieu de m'abattre, me relève, au lieu de me décourager, me console et remplit mes moments, quand je l'ai quitté? Heureuse compensation de ce que les belles années ont emporté avec elles; noble emploi des instants de la vieillesse qui m'assiège déjà de mille côtés, mais qui me laisse pourtant encore la force de surmonter les douleurs du corps et les peines de l'âme.]

Written just a few months before the chapel was completed, and just two years before Delacroix died, this passage from the *Journal* applies to his own enterprise the metaphor not only of the *Jacob* (the struggle that uplifts, the artist wrestling with the divine), but of the *Heliodorus* too—a

[34] *O.L.* I, 60. Cf. *Corr.* IV, 363f.: "Il me paraît presque impossible, en présence de la perfection que [la nature] offre toujours, de ne pas se croire inférieur."

qualification rarely quoted and whose implications have been completely ignored. Painting is that strength which raises up the artist/Heliodorus "besieged from a thousand directions" by old age and death, exalts him through the "horrible and incessant difficulties" with which it presents him, and provides in the revelation of its treasures a *celestial* compensation for both artist and viewer, the same kind of blessing which is Jacob's reward. Heliodorus will of course not prevail; the corpses strewn round the edge of the *Saint Michael* remind us of that death which goes hand in hand with humanity's struggle against time. But his revolt may have an effect similar to Jacob's, who in fact triumphs over time even in seeming defeat, through the lineage of the chosen people which the blessing ensures will issue from him. Painting triumphs over time too, not through the traditional formula of immortality, but by restoring the sensual pleasure, the "ardor" and "passion" of youth,[35] provoking the imagination to an activity which defeats *ennui* and defers death: "I do not have a single moment of emptiness or *ennui*."[36]

Such a message—that sensuality, materiality, and painting are the "blessing" by which humanity defeats death—not only contradicts the one which the images are supposed to represent, but also affronts the doctrines of the sponsoring body. If, as the various critics of the time pointed out, Jacob wrestling with the angel represents the struggle of matter and spirit,[37] it also confirms the vindication of matter, its "blessing" by God. In studying the politics of state commissions of religious painting in the late 1840s, Spector has pointed out the ideological connotations of the Heliodorus story, established since Raphael—the victory of the Church over its enemies.[38] But applied to the whole, such an interpretation fails to account for the triumph of Jacob, and also gives to the cycle a narrative consistency and exclusiveness that it patently refuses. For the Church,

[35] Cf. *Corr.* IV, 229: "La peinture me donne une santé d'homme de trente ans"; 214: "J'y cours comme un jeune homme bien portant court chez sa maîtresse"; 204: "L'intérêt, la passion pour mon travail m'animent . . . Je vous assure que je cours à mon église avec une ardeur que nous mettions autrefois à courir dans de tout autres lieux." He maintains repeatedly that his health improved immeasurably as a result of his work at Saint-Sulpice. See *Corr.* IV, 204, 285, 229. Even Vitet, while rather critical of Delacroix in this work, acknowledged: "Aussi j'oserais dire qu'à son contact, à son exemple, on se sent rajeunir soi-même" (*Revue des deux mondes* 38, 1 April 1862, 715).

[36] Such remarks occur frequently in his letters from the autumn of 1860 (*Corr.* IV, 204; cf. 202, 200).

[37] Louis Brès, *Moniteur des arts*, 31 August 1861 (quoted in Johnson V, 166). Merson, for one, was troubled by this (*Revue contemporaine* 16, 15 March 1862, quoted in Sérullaz, *Peintures murales*, 174); see above, n. 6.

[38] *Murals*, 109. Dussler (*Raphael. A Critical Catalogue of his Pictures, Wall-Paintings, and Tapestries*, 79) describes Raphael's *Heliodorus* as an allegory of papal authority over rebellious cardinals within the church during the reign of Julius II.

Delacroix's rapprochement of divine election and pillaging the temple—that is, revolting against God, delighting in materiality, providing a feast for the eye, painting—would have been nothing short of heresy. The criticism of the time seems to have sensed the unorthodox implications of the chapel: a certain uneasiness with the decorations betrays a deep-seated doubt about the message they impart, and a vague intimation of their unconventional meaning. Even while defending them, Vitet conceded: "It is neither prayer nor renunciation of the things of this world that such painting teaches us."[39] The sumptuous colors, the flamboyancy of the lines, the "thrilling" drama,[40] the materiality of the paint—all suggested a sensuality that bordered on blasphemy, as opposed to the spirituality associated with line and finish.[41] *Ebauche/débauche*—the pun applied to Delacroix in 1859[42]—sums up the attitude of the negative critics to his colorism, which gave to the painting a sketchiness and materiality tantamount to moral debauchery. One hostile conservative critic came remarkably close to grasping the point: "M. Delacroix should have understood that in a church it is not above all the eyes that he must charm or dazzle, it is the soul that it is necessary to touch by the nobility of the forms and the elevation of the style."[43] For another, Delacroix's color appeals to pure sensualism and paganism of thought, and, instead of bringing tranquillity of spirit, charms the eyes[44]—precisely the "feast for the eye" that Delacroix argued painting should be. His color was described in the language of eroticism as "piquant," "seductive," "enervating."[45] Significantly, for Vitet, Delacroix has been led astray by his color, away from the "chastened" style of his writing and the monochrome grisailles of the four decorative angels in the corner pendentives:

[39] *Revue des deux mondes* 38, 1 April 1862, 715.

[40] A. Cantaloube, *Eugène Delacroix, l'homme et l'artiste, ses amis et ses critiques* (1864), quoted in Spector, *Murals*, 166.

[41] Nearly all commentators, both for and against, emphasized Delacroix's "material" treatment of the stories. See Merson, *Revue contemporaine* 16, 15 March 1862 (quoted in Johnson V, 169); Hurel (quoted in Johnson V, 171); Baudelaire, *Peintures murales d'Eugène Delacroix à Saint-Sulpice, Oeuvres complètes* II, 730; L. Vitet, *Revue des deux mondes*, 1 April 1862, 714.

[42] Used by Paul de Saint-Victor of the second *Abduction of Rebecca*, of 1858. See Johnson 326.

[43] A. Gruyer, *Gazette des Beaux-Arts*, 1 March 1862 (quoted in Spector, *Murals*, 165).

[44] Merson, *Revue contemporaine* 16, 15 March 1862 (quoted in Sérullaz, *Peintures murales*, 175): "Des formes, des étoffes, des accessoires, toujours en relief, des lumières partout éclatantes peuvent donner satisfaction au sensualisme pur, au paganisme de la pensée, mais rien de plus. Il ne suffit pas de charmer les yeux, il faut aussi tranquilliser l'esprit, toucher le coeur."

[45] Merson, *Revue contemporaine* 16, 15 March 1862 (quoted in Sérullaz, *Peintures murales*, 175, and Johnson V, 169).

Just as, when it moves him to write criticism, and instead of a brush it is a pen that he handles, his precepts become chastened, one could almost say classical, so here, in these grisailles, color being put aside, he seems to write instead of paint. If I dare speak in this way, it is his palette that intoxicates him, or at the very least suggests to him seductions and temptations of color over which his reason is no longer master.[46]

Good is not clearly distinguished from evil: the figures of the *Saint Michael* are still tied to the earth rather than suspended wholly in space.[47] Similarly, the angel of the *Jacob* is "too human"; critics had difficulty determining who had the upper hand in the struggle.[48] Jacob has a "belligerence" which likens him to the rebellious positions of Heliodorus and the demon.[49] The heavenly fire behind Saint Michael illuminates the all-too-interesting treasures of the realm of Lucifer: "One would say that the celestial fire setting the zone of Pluto ablaze in fact makes its treasures shine brightly. The abyss seems to reflect, by inverting it, the azure, starry vault of the firmament."[50]

The outrageousness of the *Heliodorus*, in particular, was brought out by frequent comparisons with Raphael. Raphael's version clearly separated good from evil, with the worshippers on the left and the blasphemous Heliodorus being punished on the right; the empty center, leading the eye deep into the background to the high priest Onias at the altar, underscores the piety and prayer that bring about the miracle of heavenly intervention.[51] For the critics, Raphael's linear manner conveys tranquillity, nobility, and spirituality, abstracted from the earthy matter of color. And the message it states is supported, not contradicted, by the accompanying images. As one hostile critic wrote, "In Raphael's Stanza, the instructive defeats of Heliodorus and Attila confront one another: from the beginning the Church has won its battles, and each time the combats are renewed, the divine hand crushes the enemy and re-establishes the reign of justice and peace. Those who outrage the tiara and cross are blasted by

[46] *Revue des deux mondes*, 1 April 1862, 713.

[47] Galichon, *Gazette des Beaux-Arts*, 1 December 1861 (quoted in Sérullaz, *Peintures murales*, 171); also Vitet, *Revue des deux mondes*, 1 April 1862 (quoted in ibid., 176).

[48] For example, for Merson the angel was about to succumb (*Revue contemporaine* 16, 15 March 1862, quoted in Sérullaz, *Peintures murales*, 174), while for Baudelaire (*Oeuvres complètes* II, 730) and Vitet (*Revue des deux mondes*, 1 April 1862, quoted in Sérullaz, *Peintures murales*, 178), it resisted effortlessly.

[49] Vitet, *Revue des deux mondes*, 1 April 1862, 712.

[50] P. de Saint-Victor, *La Presse*, 4 February 1862 (quoted in Sérullaz, *Peintures murales*, 174).

[51] Vitet, *Revue des deux mondes*, 1 April 1862, 710.

divine blows."[52] In Delacroix's version, rather, the blasting by divine blows leaves the blasphemy intact—the treasure displayed before the viewer's avid eyes—and even validates it, likening it to the election of Jacob opposite. The clear, narrative legibility of Raphael's tripartite composition and the sharp division between good and evil which it presents are confounded in Delacroix's, where Heliodorus resembles the divine horseman, and has a youth and nobility that evoke sympathy more than indignation. Once again, the criticism seems to have sensed this, complaining that the angels have a demonic agitation, the ugliness of the insane—a visage close to the grimace of the defeated Lucifer on the ceiling; one critic remarked the perverse pleasure which the angels appear to take in punishing Heliodorus, another their all-too-human fury, attributing to them the "perversion" of Heliodorus himself.[53]

Delacroix's color in the painting is likened to the treasure of the temple, and his use of it to a violation of the temple's mysteries: "The jewels, the vases strewn on the floor of the Temple, the sumptuous fabrics, . . . are the work of a colorist who knows all the riches, all the secrets of the palette."[54] Another critic was even more explicit: "The color, always magnificent, is scattered like the treasure of the sanctuary."[55] The rhetoric of decadence predominates: such painting is art for art's sake, enervating,[56] with a "barbarism of expression,"[57] rooted in the world and the senses, suited less to a holy sanctuary than to the decor of that most blasphemous of arts, opera: "a pure opera painting, not of an artist but a decorator."[58] Delacroix would not have wholly objected to the comparison, since, except for its length, opera was for him the art which had the greatest potential to

[52] C. Lavergne, *Le Monde*, 28–29 September 1861 (quoted in Spector, *Murals*, 163). Lavergne belonged to the new school of militantly orthodox Catholic criticism, yet did admit the talent of Delacroix. See Foucart, *Le Renouveau de la peinture religieuse en France*, 156f.

[53] Vitet, *Revue des deux mondes*, 1 April 1862, 708; Merson, *Revue contemporaine* 16, 15 March 1862 (quoted in Sérullaz, *Peintures murales*, 175); Cantaloube, *Eugène Delacroix, l'homme et l'artiste* (quoted in Spector, *Murals*, 166).

[54] Galichon, *Gazette des Beaux-Arts* 11, 1 December 1861 (quoted in Sérullaz, *Peintures murales*, 171).

[55] P. de Saint-Victor, *La Presse*, 4 February 1862 (quoted in Sérullaz, *Peintures murales*, 173). Cf. Merson's "tons *chatoyants*," below, n. 56.

[56] O. Merson, *Revue contemporaine* 16, 15 March 1862 (quoted in Sérullaz, *Peintures murales*, 175).

[57] Galichon, *Gazette des Beaux-Arts* 11, 1 December 1861 (quoted in Sérullaz, *Peintures murales*, 171); cf. P. de Saint Victor, *La Presse*, 4 February 1862 (quoted in Sérullaz, *Peintures murales*, 172), who compares Delacroix to a great poet "hérissé de termes barbares"; and Vitet (*Revue des deux mondes*, 1 April 1862, 716) who notes an "extérieur de décadence."

[58] Vitet, *Revue des deux mondes*, 1 April 1862, 714.

charm the mind and the senses (13 April 1860; III, 291), and thus to amplify and augment the aesthetic experience as it was the purpose of all art to do. Unlike Raphael's, the image opposite Delacroix's *Heliodorus* does not simply reinforce the message, but opens it up, interrogates it, presents another way of reading it: the parallel struggle of Jacob makes the defeat of Heliodorus a blessing and perhaps even a victory too. Far from humbling the proud, the moral for which at least two of the stories are usually invoked, Delacroix's chapel represents a Heliodoran or Luciferian self-assertion—in the conception of the subjects, in the unmistakable markings of the painter on the surface, in the bold and expressive coloring, in the shameless and unashamed display of the painter's talent and materials that we see in the array of treasure and the still life, and of course in the prominent signature itself. All commentators, of whatever persuasion, agreed on one trait of the paintings—their boldness, Delacroix's *hardiesse* and *audace*.[59] Critics indeed complained of the obtrusive presence of the artist's personality: "Already one no longer says the Chapel of the Holy Angels, but the Chapel of Monsieur Delacroix."[60] Those most hostile to the work came perhaps closest to Delacroix's sense, without acknowledging its purpose: the decorations undermined that same Christian art of which they purported to be an example, plummeting the viewer away from spirituality into the deepest abyss of "imaginative excess."[61]

The evident allusions to Raphael in these works suggest, moreover, another way in which painting is a sacrilege, a pillaging of the temple: "You see me in these various subjects rubbing shoulders with some very imposing masters":[62] Delacroix certainly conceived of his enterprise as a kind of rivalry with the great masters, to whose stature he constantly aspired. Describing in this same letter his commission for the central panel of the Apollo Gallery, he wrote: "It is a very important work which will be placed in the finest spot in the world, next to the beautiful compo-

[59] E.g. Galichon, *Gazette des Beaux-Arts* 11, 1 December 1861 (quoted in Sérullaz, *Peintures murales*, 172); Vitet, *Revue des deux mondes*, 1 April 1862 (quoted in Sérullaz, *Peintures murales*, 177); Gautier, *Moniteur universel*, 3 August 1861 (quoted in Johnson V, 164); Pharès, *L'Indépendance belge* (in Johnson V, 166).

[60] Lavergne, *Le Monde*, 28–29 September 1861 (quoted in Spector, *Murals*, 163).

[61] Merson, *Revue contemporaine* 16, 15 March 1862 (quoted in Sérullaz, *Peintures murales*, 175): "Avec son écrin de tons chatoyants, ne semble-t-il pas que M. Delacroix, au lieu de répondre aux conditions essentielles de l'art sacré, n'a seulement rempli que celles de l'art pour l'art, système énervant et fatal, qui tend à nous précipiter d'inconséquences en fantaisies, jusqu'aux derniers excès de l'imagination?" Cf. Lavergne, *Le Monde*, 28–29 September 1861 (quoted in Spector, *Murals*, 162); Galichon, *Gazette des Beaux-Arts* 11, 1 December 1861 (quoted in Sérullaz, *Peintures murales*, 172); and Vitet, *Revue des deux mondes*, 1 April 1862, 714: "rien de moins religieux que la Chapelle des Saints-Anges."

[62] *Corr.* III, 37.

sitions of Le Brun. You see that it is slippery ground and that one has to hold firm."[63] The artist/Jacob indeed holds his ground and keeps his foot from slipping. The metaphor of the *Jacob* recurs frequently in commentaries on the chapel: "In the [*Heliodorus*] panel, M. Eugène Delacroix has, like his Jacob with the angel, struggled with an Angel, and he too can say, "I have seen Raphael face to face and yet I have not died," this last parodying Jacob's own words after the encounter (Gen. 32:30); and of the Saint Michael, "Here Eugène Delacroix encountered Raphael a second time; but the embrace was tighter and the defeat flagrant."[64]

But the gesture is Heliodoran too, challenging the authority of tradition and giving to the story a new and different interpretation. This holds not only for the individual paintings, in which Delacroix reworks the motifs of Raphael, "sacrilegiously" altering these icons of line according to the tenets of color, but also for the cycle as a whole: the Raphaelesque subjects of *Saint Michael* and *Heliodorus* are themselves subjected to a radical revision by virtue of the one work *not* based on a major work by that artist, the *Jacob*, which disturbs the Raphaelesque clarity, the instructive narrative of divine versus demonic, or spiritual versus material, which they might otherwise represent.[65] In his review of the chapel, Gautier discusses the painter's use of tradition in the moral terms of the *Heliodorus:* "This subject was treated by Raphael with his *celestial* superiority; but art is so complex . . . that one can *without sacrilege* take up the theme used by one of the *gods* of painting and vary it in one's own manner."[66]

Gautier of course rejects the idea of sacrilege, but his metaphor is telling. For Louis Vitet, the Saint Michael is an "unfaithful" copy of Raphael's— the word is *infidèle*, the work of an "infidel."[67] Vitet notes the many people

[63] Ibid., 36.

[64] P. de Saint Victor, *La Presse*, 4 February 1862 (quoted in Sérullaz, *Peintures murales*, 173). Cf. Vitet (*Revue des deux mondes*, 1 April 1862, 706, 707), who says of the *Heliodorus:* "C'est encore avec Raphael que la lutte va s'engager"; cf. "cette lutte contre un chef d'oeuvre." Some critics use the metaphor of the *Jacob* to bring out Delacroix's defeat: he struggles with the great masters of religious painting on the terrain of traditional principles, but fails and must succumb (Merson, *Revue contemporaine* 16, 15 March 1862, quoted in Johnson V, 169).

[65] Vitet notes that the *Jacob* is wholly Delacroix's own: "J'ai hâte d'être en face de son *Jacob*, c'est-à-dire de n'avoir plus affaire qu'à lui" (*Revue des deux mondes*, 1 April 1862, 711). S. Lichtenstein, however, draws attention to a monochrome *Jacob and the Angel* by the workshop of Raphael in one of the window embrasures in the Vatican Loggia, an etching of which (by Bartoli) he seems to have copied (*Delacroix and Raphael*, 227). And Eve Kliman ("The Figural Sources of Delacroix's 'Jacob Wrestling with the Angel'") proposes three medieval sources for the image, which Delacroix might have known from contemporary engravings. See also Johnson V, 163.

[66] *Moniteur universel*, 3 August 1861 (emphasis mine).

[67] *Revue des deux mondes*, 1 April 1862, 705 (quoted in Johnson V, 170).

offended by Delacroix's audacity, an audacity comparable to that of Helio-
dorus in stealing the treasure: "Heliodorus and Saint Michael! these two
subjects on which the king of painters has placed his seal and created two
immortal works! How dare anyone try to seize them like a piece of untitled
property! I saw people incensed at this audacity."[68] The artist's struggle
with the gods of painting represents a Heliodoran or Luciferian blasphemy
and self-assertion, imprinting upon the tradition his own interpretation,
and leaving the signs of the revolt in full view—the painting before our
eyes, like the treasure of the temple: "Religious subjects have the attraction,
among the many that they present, of giving full scope to the imagination,
*so that everyone finds in them something to express one's own particular feel-
ing.*"[69] Delacroix brings together the three images, reminding the viewer
of the "blessing" and the "raising up" which the "sacrilege" has the power to
effect: the spiritual force of this most material art, an endless source of
delight and thought, which thus marks a human victory over time, and over
death.

[68] Ibid. (quoted in Sérullaz, *Peintures murales*, 176).
[69] *Corr.* III, 37 (my emphasis).

CONCLUSION

Of all the books of history which antiquity has passed down to us, those that are most deservedly sought after are those rare and precious books escaped from the leisure moments of superior men, gifted at once with the genius that conceives and executes great things, and with the genius that can discuss them.[1]

DELACROIX spoke little, in the later *Journal*, of his own position as a diarist. Instead, consistent with his method in the diary generally, his self-representation in this regard takes place obliquely, *en biais*, through the myriad remarks on, and quotations from, others which run through the work. He was fascinated by the memoirs of the great, by accounts of their habits of writing, their reasons for writing, the effects of that writing.[2] The passage quoted above from Bourrienne's *Mémoires sur Napoléon* states, by analogy, the high value which Delacroix placed on the *Journal*'s reflections in particular, its trifles, "brimborions," written similarly in haste, in his leisure time, "on the wing" (11 March 1854; II, 147)—a rare and precious work, a long and indirect commentary on the "great things" for which he is most renowned, painting.

Indeed Delacroix values writing less "in itself" than as an extension of thought, and as such, a pendant to one's life work; otherwise it becomes merely "an intellectual industry skilfully practiced" (Supplement; III, 420). A quotation from Cousin reflects this belief and suggests the crucial importance of writing to Delacroix's work:

A serious man only writes out of necessity and because otherwise he cannot reach his goal. . . . The greatest writers have not been authors by profession. . . . As soon as a man writes just to write, to shine in

[1] "De tous les livres d'histoire que nous a légués l'antiquité, ceux que l'on recherche à plus juste titre sont ces livres rares et précieux échappés aux loisirs des hommes supérieurs, doués en même temps du génie qui conçoit et exécute de grandes choses, et du génie qui sait les raconter." Unpublished quotation, copied by Delacroix, from the *Mémoires de M. de Bourrienne sur Napoléon*, facsimile in Thierry Bodin, *Lettres et manuscrits autographes*, sale catalogue, Hôtel Drouot, 23 April 1993.

[2] He had a similar fascination for personal letters, as not only the *Journal*, but also his essays on Poussin and Charlet, attest.

front of others or to make a fortune, he writes badly, or at least he writes without any greatness, because true greatness can only come from a soul which is naturally great, and which is roused to a great cause. (Supplement; III, 419–20)

[Un homme sérieux n'écrit que par nécessité et parce qu'autrement il ne peut atteindre son but. . . . Les plus grands écrivains n'ont pas été des auteurs de profession. . . . Dès qu'un homme écrit pour écrire, pour briller ou faire fortune, il écrit mal ou du moins il écrit sans grandeur, parce que la vraie grandeur ne peut sortir que d'une âme naturellement grande qui s'émeut pour une grande cause.]

Descartes, Pascal, Bossuet, Caesar: these are Cousin's examples. But the *Journal* has its own recurrent favorites—Voltaire, Napoleon, Leonardo da Vinci, Michelangelo, Joshua Reynolds, to name only a few, philosophers, artists, statesmen, and soldiers who wrote because writing was a source of ideas and an aid to thought. "When he wished to get very clear on his ideas, Napoleon put them on paper, *knowing, like all men who have been given to thought, that to write up one's ideas is to fathom them more deeply.*"[3] He quotes Voltaire's letter on his own "shapeless" reading notes: "They are an account that I do freely for myself of my readings, the only way to learn well and to get clear on your ideas; for when you limit yourself to reading, you almost never have anything more in your mind than a confused picture."[4] Voltaire scribbling his ideas into his agenda or onto the first scrap of paper which came his way (25 February 1857; III, 64); Reynolds jotting down, in brief and rapid notes, his reflections on the theory and practice of his art;[5] such are the models through which Delacroix imagined himself, negating the cliché, applied to Reynolds, for example, by the author of the passage quoted above, that action and meditation were separate domains, incompatible with one another within a single talent.

"Great men write well":[6] for Delacroix, writing was a major element, perhaps the crucial one, in the versatility by which he defined genius, the "vast imagination" which embraced a plurality of domains. A note on the "ridiculous" delimitation of genres states the point clearly: "The greatest

[3] 8 November 1857 (III, 143–44). Quotation copied into the diary from Thiers' *Histoire de l'Empire* (the emphasis is Delacroix's).

[4] Unpublished note, 10 November 1857, copied from Voltaire's "Lettre à M. de ***, Professeur en histoire," *Essai sur les mœurs*, II, 865.

[5] Unpublished quotation from an article on Reynolds by "M. P. G.," in *Les Beaux-Arts* 43 (1844), 212–13; facsimile in Thierry Bodin, *Lettres et manuscrits autographes*, sale catalogue, Hôtel Drouot, 23 April 1993.

[6] 13 January 1857 (III, 15). Cf. 27 January 1853: "un homme supérieur écrit toujours bien."

men have done something of everything when they wanted to."[7] Michel-angelo was a painter, architect, sculptor, and poet (16 January 1860; III, 252); Cellini, a goldsmith, architect, and writer (Supplement; III, 367); Voltaire, "a bold and fecund genius . . . who overlooked neither the abstract sciences, nor politics, nor the customs of peoples, nor their opinions, their histories, nor even their languages";[8] Leonardo "discovered everthing," "foresaw everything," as his notebooks showed.[9] In the modern world, such universality was more difficult, even impossible, resulting, for example, in the superficial knowledge of the professional critic. But the impossibility of "encyclopedic" knowledge did not stop Delacroix the painter from writing, and from writing a dictionary of the fine arts, ranging from Homer to Chopin, translation to tragedy, distraction to daguerreotype, acting to architecture; only the posture of the writer, and the writing itself, had changed, to make clear the limitations and constraints, the personal and singular, freeing him to write "at the inclination of the author's disposition, sometimes of his laziness" (13 January 1857; III, 26). Rarely would an artist wander so freely again; the remarkable discussions of music by Klee represent, comparatively speaking, only a fraction of Delacroix's vast reflection on topics outside the strict limits of painting. This reflection, particularly on the relations of painting to writing itself, was, as I have argued here, crucial to his art and thought, and notably to his conception of painting's special place within human society.

What Delacroix the reader of memoirs discovers is a kind of consolation and reassurance, an affirmation of the humanity of the great, a sense of community with them. "Reading memoirs . . . consoles one for the ordinary troubles of life by the picture of the errors and troubles of humanity" (19 August 1858; III, 212). Two weeks later, engrossed in the memoirs of Saint-Simon, he remarks, "All those deaths, all those incidents for so long forgotten, console one for the empty state in which one feels oneself" (3 September 1858; III, 212). Reading his own diaries fulfilled this function too: "The occupations that I am finding here [in Champrosay] will soon interrupt these writings; I regret that. They fix something of what passes so quickly, of all those emotions of each day in which one later finds encouragement and consolation" (30 October 1853; II, 107–108). In this context, even the "photographic" privileging of detail has some value: "Great men seen *en déshabillé* and studied through a magnifying glass, if they do not dignify human nature much in

[7] Supplement (III, 367). "La ridicule délimitation" is wrongly transcribed in both Joubin ("le ridicule de limitation") and Louvre 1758 ("le ridicule de l'imitation").

[8] 25 February 1857 (III, 68–69). Quotation copied into the diary from Vauvenargues' *Réflexions et maximes*, no. 265.

[9] 10 March 1849 (I, 174); 3 April 1860 (III, 284).

its most noble specimens, at least console those men who are dissatisfied with themselves, out of too much modesty or too great an idea of perfection, for their own weakness" (15 May 1853; II, 49). The introduction to his essay on Raphael analyzes this "natural" desire to know the daily lives of the great: "We would like to get to know their personality, and even more their eccentricities and passions; we would at least like to find in them people like ourselves in the common aspects of life. Perhaps it is a secret feeling of jealousy which makes us want to bring them nearer to ourselves, by lowering them to our level."[10]

But the reassurance is positive too, confirming the self of the reader through an encounter with "analogous" minds, either through agreement or disagreement. Delacroix copies out a passage from *Obermann* in which the narrator makes this point:

> I have just found in Montaigne a passage so analogous to the idea with which I was occupied that I was struck and satisfied by it. There is in this conformity of thoughts a secret joy: it is that which makes man necessary to man, because it makes our ideas fruitful, *because it lends assurance to our imagination and confirms in us the opinion of what we are.* (22 April 1857; III, 94)

> [Je viens de trouver dans Montaigne un passage si analogue à l'idée dont j'étais occupé que j'en ai été frappé et satisfait. Il y a dans cette conformité de pensées une joie secrète: c'est elle qui rend l'homme nécessaire à l'homme, parce qu'elle rend nos idées fécondes, parce qu'elle donne l'assurance à notre imagination et confirme en nous l'opinion de ce que nous sommes.]

For the artist in the modern world, this "meeting of analogous minds" was especially crucial: Delacroix adds to the quotation a remark of his own, on the paradoxically "imperious" need for such confirmation in original minds, those who, in rejecting the accepted view, forfeit the assurance which comes from habit and convention, in order to say something new; or perhaps, as he once remarked, to see and say something differently, as it had never been seen or said before.

It is surely this question of originality which accounts for the extraordinary place occupied by the "analogous" quotation of diarylike memoirs in the *Journal*, as Delacroix sought confirmation for one of his most original and innovative acts, the writing of the *Journal* itself: the development of a painter's writing, a writing proper to painting, adequate to painting, true to a painter's conception of the world. Such a writing is consistent, as I have argued, with the kind of painting Delacroix produced, its color,

[10] *O.L.* II, 3.

movement, energy, and life, its fullness, tension, and complexity, its "two sides," its "broader view." The exercise worked, renewing the diarist/ reader and overcoming *ennui:* "I am surrounded by my diaries and notebooks from previous years; the nearer they get to the present, the more I see becoming rarer in them that eternal complaint against the *ennui* and emptiness that I formerly used to feel" (15 November 1853; II, 112). But one encounters in the *Journal* Delacroix's sense of the philosophical implications of this experiment too, the importance of a pictorial vision— multiple and material, diverse, integrated, and real, productive of both pleasure and thought—in a world dominated increasingly by "literary" abstraction, dangerously distant from truth. The passage quoted above about Reynolds's hasty notes posed a definite challenge to the author of the *Journal*'s *pensées détachées* and the "philosophical" reflections of the *Dictionnaire des Beaux-Arts*, the painter of the complex meditations on culture, history, and painting itself which adorned the buildings of the mid-nineteenth-century public: "Reynolds is in this respect a striking example of the truth of that remark which could have been made in any age, that men who have been endowed with the faculty of producing works having force of life, are rarely capable of engaging in the sustained and profound ideas which seem the exclusive domain of what has been called the philosophical mind, as if action excluded thought, or at least limited it."[11] To this Delacroix's work provided an effective response: a "philosophical" writing imbued with the kind of action indicated here—the mobile writing of the *Journal* and the *Dictionnaire*—and a painting corresponding to it, which, as Baudelaire noted from the start, "opens up broad avenues to the most adventurous imagination."[12]

[11] "Reynolds est à cet égard un exemple frappant de la vérité de cette remarque qui a pu être faite dans tous les temps, que rarement les hommes qui ont été doués de la faculté de produire des oeuvres ayant force de vie, sont capables de se livrer aux idées étendues et profondes qui semblent être le domaine exclusif de ce qu'on a appelé l'esprit philosophique, comme si l'action excluait la pensée ou du moins la bornait." Unpublished quotation (see n. 5), facsimile in Thierry Bodin, *Lettres et manuscrits autographes*, sale catalogue, Hôtel Drouot, 23 April 1993.

[12] *Salon de 1846, Oeuvres complètes* II, 431.

BIBLIOGRAPHY

Abel, Elizabeth. "Redefining the Sister Arts: Baudelaire's Response to the Art of Delacroix." *Critical Inquiry* 6, 3 (Spring 1980): 363–84.

Alberti, Leon Battista. *On Painting and On Sculpture. The Latin Texts of* De Pictura *and* De Statua. Ed. and trans. Cecil Grayson. London: Phaidon, 1972.

Angrand, Pierre. "Genèse des travaux d'Eugène Delacroix à la Bibliothèque de la Chambre." *Archives de l'art français* 25 (1978): 313–33.

Aristotle. *Poetics.* Trans. Richard Janko. Indianapolis: Hackett Publishing Co., 1987.

Athanassoglou-Kallmyer, Nina. *Eugène Delacroix. Prints, Politics and Satire 1814–1822.* New Haven: Yale University Press, 1991.

Aubrun, Marie-Madeleine. *Henri Lehmann, 1814–1882. Catalogue raisonné de l'oeuvre.* 2 vols. Nantes: Association Les Amis de Henri Lehmann, 1984.

Auroux, Sylvain. *La Sémiotique des encyclopédistes. Essai d'épistémologie historique des sciences du langage.* Paris: Payot, 1979.

Austin, Lloyd J. "Baudelaire et Delacroix." In *Actes du colloque de Nice,* 13–23. Paris: Minard, 1968.

Bal, Mieke. *Reading Rembrandt: Beyond the Word-Image Opposition.* Cambridge: Cambridge University Press, 1991.

Ballas, Giulia. "La Signification des Saisons dans l'oeuvre de Delacroix." *Gazette des Beaux-Arts* 106 (July 1985): 15–21.

Barry, James. *An Account of a Series of Pictures in the Great Room of the Society of Arts, Manufactures, and Commerce at the Adelphi.* London, 1783.

Barthes, Roland. "Délibération." *Tel Quel* 82 (Winter 1979): 8–18.

Batteux, Charles. *Les Beaux-Arts réduits à un même principe.* Paris, 1747.

Baudelaire, Charles. *Correspondance.* Ed. Claude Pichois. 2 vols. Paris: Gallimard, 1973.

———. *Oeuvres complètes.* Ed. Jacques Crépet. 19 vols. Paris: Louis Conard, 1922–53.

———. *Oeuvres complètes.* Ed. Claude Pichois. 2 vols. Paris: Gallimard, 1975–76.

Baur-Heinhold, Margarete. *Schöne alte Bibliotheken. Ein Buch vom Zauber ihrer Räume.* Munich: Verlag Georg D.W. Callwey, 1972.

Baxandall, Michael. *Giotto and the Orators: Humanist Observers of Painting in Italy and the Discovery of Pictorial Composition 1350–1450.* Oxford: Clarendon Press, 1971.

———. *Patterns of Intention: On the Historical Explanation of Pictures.* New Haven: Yale University Press, 1985.

Bayle, Pierre. *Dictionnaire historique.* Paris: Desoer, 1820.

Beaujour, Michel. *Miroirs d'encre: Rhétorique de l'autoportrait.* Paris: Seuil, 1980.

Becq, A. "Rhétoriques et littérature d'art en France à la fin du XVIè siècle. Le Concept de couleur." *Cahiers de l'Association Internationale des Etudes Françaises* 24 (1972): 215–32.

Beecher, Jonathan. *Charles Fourier: The Visionary and his World.* Berkeley and Los Angeles: University of California Press, 1986.

Benveniste, Emile. *Problèmes de linguistique générale.* Paris: Gallimard, 1966.

Berger, Robert W. *Versailles: The Château of Louis XIV.* College Art Association of America Monographs on the Fine Arts, 40. University Park: Pennsylvania State University Press, 1985.

Bernier, R. R. "The Subject and Painting: Monet's 'Language of the Sketch.'" *Art History* 12, 3 (September 1989): 298–321.

Berthier, Philippe. "Des Images sur les mots, des mots sur les images: A propos de Baudelaire et Delacroix." *Revue d'histoire littéraire de la France* 80, 6 (1980): 900–915.

Bessis, Henriette. "L'Inventaire après décès d'Eugène Delacroix." *Bulletin de la Société de l'Histoire de l'Art Français* (1969): 199–222.

Billaz, André. "Littérature et peinture: le cas limite des *Peintures* de Victor Segalen." In *Des Mots et des couleurs* I, ed. P. Bonnefis and P. Reboul (q.v.), 89–117.

Blanc, Charles. *Les Artistes de mon temps.* Paris: Firmin Didot, 1876.

Blanchot, Maurice. "Recherches sur le journal intime." *Nouvelle Revue française* 3 (1955): 683–91.

Boime, Albert. *The Academy and French Painting in the Nineteenth Century.* London: Phaidon, 1971; New Haven: Yale University Press, 1986.

Bonafoux, Pascal. *Les Peintres et l'autoportrait.* Geneva: Skira, 1984.

Bonnefis, Philippe, and Pierre Reboul, eds. *Des Mots et des couleurs: Etudes sur le rapport de la littérature et de la peinture aux XIXè et XXè siècles.* Vol. 1. Lille: Publications de l' Université de Lille, 1979.

Borreil, Jean. "Légende et apothéose de l'humanité." In *Les Sauvages de la cité. Auto-émancipation du peuple et instruction des prolétaires au XIXè siècle,* 202–27. Paris: Editions du Champ Vallon, 1985.

Bouillon, J.-P. "Mise au point théorique et méthodologique." *Revue d'histoire littéraire de la France* 80, 6 (1980): 880–900.

————, Nicole Dubreuil-Blondin, Antoinette Ehrard, and Constance Naubert-Riser. *La Promenade du critique influent. Anthologie de la critique d'art en France 1850–1900.* Paris: Hazan, 1990.

Bouverot, Danielle. "La Rhétorique dans le discours sur la peinture ou la métonymie généralisée." In *Rhétoriques, sémiotiques,* ed. Arpad Vigh et al. *Revue d'esthétique.* Paris: 10/18, 1979.

Bowler, Peter. *The Invention of Progress: The Victorians and the Past.* Oxford: Basil Blackwell, 1989.

Bruyas, Alfred. *La Galerie Bruyas.* Paris: J. Claye, 1876.

Bryson, Norman. *Tradition and Desire: From David to Delacroix.* Cambridge: Cambridge University Press, 1984.

Busch, Günter. "Synästhesie und Imagination. Zu Delacroix's kunsttheoristichen Äusserungen." In *Beiträge zur Theorie der Künste im 19. Jahrhundert,* ed. Hel-

mut Koopmann and J. Adolf Schmollgen-Eisenwerth, 240–55. Frankfurt am Main: Klostermann, 1971.

Carrier, David. "Blindness and the Representation of Desire in Poussin's Paintings." *RES* 19/20 (1990–91): 31–52.

———. *Principles of Art History Writing.* University Park: The Pennsylvania State University Press, 1991.

Cassou, Jean. *Delacroix.* Paris: Editions du Dimanche, 1947.

Catalogue des livres anciens et modernes curieux et rares composant la bibliothèque de feu M. E. Delacroix dont la vente aura lieu à Paris les lundi 30 et mardi 31 mars, et mercredi 1er et jeudi 2 avril 1868. Paris: A. Aubry, 1868.

Certeau, Michel de. *L'Ecriture de l'histoire.* Paris: Gallimard, 1975.

Chaudonneret, Marie-Claude. "Historicism and 'Heritage' in the Louvre, 1820–40: From the Musée Charles X to the Galerie d'Apollon." *Art History* 14, 4 (December 1991): 488–520.

Chennevières, Philippe de. *Notice historique et descriptive de la Galerie d'Apollon au Louvre.* Paris: Pillet fils, 1851.

Christin, Anne-Marie. "L'Ecrit et le visible: le dix-neuvième siècle français." In *L'Espace et la lettre,* 163–92. Cahiers Jussieu no. 3. Paris: 10/18, 1977.

———, ed. *Ecritures: Systèmes idéographiques et pratiques expressives.* Actes du colloque international de l'Université de Paris VII. Paris: Le Sycomore, 1982.

———, ed. *Ecritures 2.* Paris: Le Sycomore, 1985.

Clark, John Willis. *The Care of Books. An Essay on the Development of Libraries and their Fittings from the Earliest Times to the End of the Eighteenth Century.* Cambridge: Cambridge University Press, 1901.

Clark, T. J. *The Absolute Bourgeois: Artists and Politics in France 1848–51.* London: Thames and Hudson, 1973.

Clément, Claude. *Musei sive bibliothecae.* Lyon: Jacob Prost, 1635.

Cocheyras, Jacques. "La Place du journal intime dans une typologie linguistique des formes littéraires." In *Le Journal intime et ses formes littéraires,* ed. Victor Del Litto (q.v.), 225–33.

Coke, Van Deren. *The Painter and the Photograph: From Delacroix to Warhol.* Albuquerque: University of New Mexico Press, 1972.

Coste, Didier. "Autobiographie et auto-analyse, matrices du texte littéraire." In *Individualisme et autobiographie en Occident,* 249–63. Centre culturel international de Cerisy-la-Salle: Editions de l'Université de Bruxelles, 1983.

Craig, George. *Moy qui me voy: The Writer and the Self from Montaigne to Leiris.* Oxford: Clarendon Press, 1989.

Damiron, Suzanne, and Henriette Bessis. "Journal de Pierre Andrieu." *Bulletin de la Société de l'Histoire de l'Art Français* (1975): 261–80.

Delacroix, Eugène. *Correspondance générale.* Ed. André Joubin. 5 volumes. Paris: Plon, 1935–38.

———. *Further Correspondence.* Ed. Lee Johnson. Oxford: Clarendon Press, 1991.

———. Journal. Ed. A. Joubin. 3 vols. Paris: Plon, 1931–32. Rev. ed. R. Labourdette, preface by H. Damisch. I vol. 1981.

———. *Lettres intimes. Correspondance inédite.* Ed. A. Dupont. Paris: Gallimard, 1954.

————. *Oeuvres littéraires*. Ed. Elie Faure. 2 vols. Paris: G. Crès, 1923.

Del Litto, Victor, ed. *Le Journal intime et ses formes littéraires*. Actes du colloque de septembre 1975 (Grenoble). Geneva: Droz, 1978.

Demoris, René, ed. *Les Fins de la peinture. Actes du colloque organisé par le Centre de Recherches Littérature et Arts visuels (9–11 mars 1989)*. Paris: Editions Jonquères, 1990.

Dictionnaire de l'Académie des Beaux-Arts. 6 vols. Paris: Firmin Didot, 1858–1910.

Diderot, Denis. *Essais sur la peinture*. In *Oeuvres esthétiques*, ed. P. Vernière. Paris: Garnier, 1968.

————. *Pensées détachées sur la peinture*. In *Oeuvres esthétiques*, ed. P. Vernière. Paris: Garnier, 1968.

————. *Oeuvres complètes*. Ed. John Lough and Jacques Proust. Paris: Hermann, 1976.

————. *Salons*. Ed. Jean Seznec and Jean Adhémar. 4 vols. 2nd ed. Oxford: Clarendon Press, 1975.

Diderot, Denis, and Jean Lé Rond d'Alembert, *Encyclopédie, ou Dictionnaire raisonné des sciences, des arts et des métiers*. Paris: Briasson et al., 1751.

Didier, Béatrice. *Le Journal intime*. Paris: Presses Universitaires de France, 1976.

————. "Les Blancs de l'autobiographie." In *Territoires de l'imaginaire: pour Jean-Pierre Richard*, ed. Jean-Claude Mathieu (q.v.), 137–56.

————. "Pour une sociologie du journal intime." In *Le Journal intime et ses formes littéraires*, ed. Victor Del Litto (q.v.), 245–65.

————. *Stendhal autobiographe*. Paris: Presses Universitaires de France, 1983.

Dolce, Lodovico. *Aretin: A Dialogue on Painting*. Trans. W. Brown. Scolar Press, 1970.

Drost, Wolfgang. "Du Progrès à rebours. Fortschrittsglaube und Dekadenzbewusstsein im 19. Jahrhundert: Das Beispiel Frankreich." In *Fortschrittsglaube und Dekadenzbewusstsein im Europa des 19. Jahrhunderts*, ed. Wolfgang Drost, 13–29. Heidelberg: Carl Winter, 1986.

Durkheim, Emile. *Le Socialisme; sa définition, ses débuts, la doctrine saint-simonienne*. Paris: Bibliothèque de la sociologie contemporaine, 1971.

Dussler, Luitpold. *Raphael. A Critical Catalogue of his Pictures, Wall-Paintings and Tapestries*. London: Phaidon, 1971.

Escholier, Raymond. *Delacroix, peintre, graveur, écrivain*. 3 vols. Paris: Floury, 1926–29.

————. *Delacroix et les femmes*. Paris: Fayard, 1963.

Félibien, André. *Conférences de l'Académie Royale de Peinture et de Sculpture*, in *Entretiens sur les vies et sur les ouvrages des plus excellents peintres anciens et modernes*. 6 vols. Trévoux, 1725; repr. Farnborough: Gregg Press Ltd, 1967.

Fischer, Uve. "Das literarische Bild im Werk Eugène Delacroix." Ph.D. diss., University of Bonn, 1963.

Foucart, Bruno. *Le Renouveau de la peinture religieuse en France 1800–1860*. Paris: Arthéna, 1987.

France, Anatole. *La Révolte des anges*. Paris: Calmann-Levy, 1914.

Fréart de Chambray, Roland. *Idée de la perfection de la peinture*. Le Mans: Jacques Isambart, 1662.

Gamboni, Dario. "Pour une étude de la critique d'art au XIXè siècle." *Romantisme* 71 (1991): 9–17.

Ganeval, Claudine, and Pierre Lamicq. *Eugène Delacroix aux Pyrénées: 1845.* Lourdes: Les Amis du Musée, 1975.

Gautier, Théophile. *Histoire du romantisme.* Paris: Charpentier, 1874.

Genevay, A. *Le Style Louis XIV: Charles Le Brun, décorateur. Ses oeuvres, son influence, ses collaborateurs et son temps.* Paris: Librairie de l'Art, Jules Rouam, 1886.

Gentile, Francesco. "Il Paradigma di Roma nella prospettiva storica del Montesquieu." In *Storia e ragione*, ed. Alberto Postigliola, 91–112. Naples: Liguori, 1987.

Girard, Alain. *Le Journal intime.* Paris: Presses Universitaires de France, 1963.

Grafton, Anthony, ed. *Rome Reborn: The Vatican Library and Renaissance Culture*, exh. cat. New Haven: Yale University Press, 1993.

Guiffrey, Jean. *Le Voyage d'Eugène Delacroix au Maroc.* 2 vols. Paris: André Marty, 1909.

Guillerm, Jean-Pierre. *Couleurs du noir. Le Journal de Delacroix.* Lille: Presses Universitaires de Lille, 1990.

———. "Matières et musiques: la peinture ancienne et le texte critique à la fin du XIXè siècle." In *Des Mots et des couleurs* I, ed. Philippe Bonnefis and Pierre Reboul (q.v.), 1–47.

———, ed. *Des Mots et des couleurs: Etudes sur le rapport de la littérature et de la peinture aux XIXè et XXè siècles.* Vol. 2. Lille: Presses Universitaires de Lille, 1986.

Herding, Klaus. "Fortschritt und Niedergang in der bildenden Kunst: Nachträge zu Barrault, Baudelaire und Proudhon." In *Fortschrittsglaube und Dekadenzbewusstsein im Europa des 19. Jahrhunderts*, ed. Wolfgang Drost (q.v.), 239–58.

Hersey, George L. "Delacroix's Imagery in the Palais Bourbon Library." *Journal of the Warburg and Courtauld Institutes* 31 (1968): 383–403.

Hesse, M. "Eugène Delacroix 1798–1863. Deckenbild in der Galerie d'Apollon des Louvre: Realitätsstruktur und Bildaussage." *Zeitschrift für Ästhetik und allgemeine Kunstwissenschaft* 25 (1980): 88–107.

Hopmans, Anita. "Delacroix's Decorations in the Palais Bourbon Library: A Classic Example of an Unacademic Approach." *Simiolus* 17, 4 (1987): 240–69.

Horner, Lucy. *Baudelaire, critique de Delacroix.* Geneva: Droz, 1956.

Howell, Joyce B. "Eugène Delacroix and Color. Practice, Theory and Legend." *Athanor* 2 (1982): 37–43.

Hustin, A. "Les Peintures d'Eugène Delacroix au Sénat." *Les Arts* 191 (November 1920): 1–19.

Huyghe, René. *Delacroix.* Paris: Hachette, 1963.

Johnson, Lee. "A New Oil Sketch by Delacroix for 'Apollo Slays Python.'" *Burlington Magazine* 130 (January 1988): 35–36.

———. *Delacroix.* London: Weidenfeld and Nicolson, 1963.

———. *Delacroix*, exh. cat. Art Gallery of Toronto, 1962.

———. *The Paintings of Eugène Delacroix: A Critical Catalogue.* 6 vols. Oxford: Clarendon Press, 1981–89.

Joly, Jules de. *Plans, coupes, élévations et détails de la restauration de la Chambre des*

Députés, de sa nouvelle salle de séances, de sa bibliothèque et de toutes ses dépendances. Paris: Imprimerie d'Adrien Le Clerc, 1840.

Jouin, Henry. *Charles Le Brun et les arts sous Louis XIV.* Paris: Imprimerie Nationale, 1889.

———, ed. *Conférences de l'Académie Royale de Peinture et de Sculpture.* Paris: A. Quantin, 1883.

Jullian, Philippe. *Delacroix.* Paris: Albin Michel, 1963.

Jullian, René. "Delacroix et la musique du tableau." *Gazette des Beaux-Arts* 87 (March 1976): 81–88.

Jurgensen, Manfred. *Das fiktionale Ich: Untersuchungen zum Tagebuch.* Bern: Francke, 1979.

Kemal, Salim, and Ivan Gaskell, eds. *The Language of Art History.* Cambridge Studies in Philosophy and the Arts. Cambridge: Cambridge University Press, 1991.

Kemp, Martin. *The Science of Art.* New Haven: Yale University Press, 1990.

Kliman, Eve. "The Figural Sources of Delacroix's 'Jacob Wrestling with the Angel.'" *RACAR* 10, 2 (1983): 157–62.

Kuspit, Donald. *The Critic is Artist: The Intentionality of Art.* Ann Arbor: UMI Research Press, 1984.

Laborde, Léon Emanuel Simon Joseph, comte de. *De l'organisation des bibliothèques dans Paris.* Paris: A. Franck, 1845.

Lane, James W., and Kate Steinitz. "Palette Index." *Art News* (December 1942): 23–35.

Larousse, Pierre. *Grand Dictionnaire universel du dix-neuvième siècle.* Paris: Administration du Grand Dictionnaire Universel, 1865.

Larue, Anne. "Byron et le crépuscule du 'sujet' en peinture. Une Folie littéraire du jeune Delacroix." *Romantisme* 19, 66 (1989): 23–40.

———. "Fragments ou pensées détachées? Etude de quelques romantiques." *La Licorne* 21 (1991): 239–53.

Lavin, Marilyn Aronberg. *The Place of Narrative. Mural Decoration in Italian Churches 431–1600.* Chicago: University of Chicago Press, 1990.

Lebel, Gustave. "Bibliographie des revues et périodiques d'art parus en France de 1746 à 1914." *Gazette des Beaux-Arts* 38 (1951): 9–64.

Leduc-Adine, Jean-Pierre. "Des règles d'un genre: la critique d'art." *Romantisme* 71 (1991): 93–100.

Lee, Rensselaer. *Ut pictura poesis: The Humanistic Theory of Painting.* New York: W.W. Norton, 1967.

Lejeune, Philippe. *Bibliographie des études en langue française sur la littérature personnelle et les récit de vie.* Nanterre: Centre de sémiotique textuelle, 1984.

———. *Le Pacte autobiographique.* Paris: Seuil, 1975.

Leonardo da Vinci. *Leonardo on Painting.* Ed. Martin Kemp. New Haven: Yale University Press, 1989.

Lessing, Gottfried Ephraim. *Laokoon, oder über die Grenzen der Malerei und Poesie.* Stuttgart: Philipp Reclam, 1964.

———. *Laokoon, oder über die Grenzen der Malerei und Poesie.* Ed. Hugo Blümner. Berlin: Weidmannsche Buchhandlung, 1880.

Levine, Neil. "The Book and the Building: Hugo's Theory of Architecture and Labrouste's Bibliothèque Sainte Geneviève." In *The Beaux-Arts and Nineteenth-Century French Architecture*, ed. Robin Middleton, 139–73. London: Thames and Hudson, 1982.

Lichtenstein, Jacqueline. *La Couleur éloquente. Rhétorique et peinture à l'âge classique.* Paris: Flammarion, 1989.

Lichtenstein, Sara. *Delacroix and Raphael.* New York: Garland, 1979.

Lotman, Juri. *Semiotics of Cinema.* Ann Arbor: Michigan Slavic Contributions no. 5, 1976.

Maag, Georg. "Fortschrittsidee und Historismus bei Saint-Simon und bei Comte." In *Fortschrittsglaube und Dekadenzbewusstsein im Europa des 19. Jahrhunderts*, ed. Wolfgang Drost (q.v.), 35–43.

Mainardi, Patricia. *Art and Politics of the Second Empire. The Universal Expositions of 1855 and 1867.* New Haven: Yale University Press, 1987.

Manfredini, Irene. *Henri Saint-Simon: Ecrits sur le progrès de la civilisation publiés d'après les manuscrits.* Milan: Giuffrè, 1988.

Marin, Louis. *Etudes sémiologiques. Ecritures, peintures.* Paris: Klincksieck, 1971.

———. "Towards a Theory of Reading in the Visual Arts: Poussin's 'The Arcadian Shepherds.'" In *Calligram: Essays in New Art History from France*, ed. Norman Bryson. Cambridge: Cambridge University Press, 1988.

Marmoz, C. "The Building of the Ecole des Beaux-Arts." In *The Beaux-Arts and Nineteenth-Century French Architecture*, ed. Robin Middleton, 125–37. London: Thames and Hudson, 1982.

Marty, Eric. *L'Ecriture du jour: Le Journal d'André Gide.* Paris: Seuil, 1985.

Masson, André. *Le Décor des bibliothèques du moyen âge à la Révolution.* Geneva: Droz, 1972.

———. *The Pictorial Catalogue: Mural Decorations in Libraries.* Oxford: Clarendon Press, 1981.

Mathieu, Jean-Claude, ed. *Territoires de l'imaginaire: pour Jean-Pierre Richard.* Paris: Seuil, 1986.

Matsche, Franz. "Delacroix als Deckenmaler: 'Apollon vainqueur du serpent Python.'" *Zeitschrift für Kunstgeschichte* 47 (1984): 465–500.

May, Georges. *L'Autobiographie.* Paris: Presses Universitaires de France, 1979.

McWilliam, Neil. *A Bibliography of Salon Criticism in Paris from the July Monarchy to the Second Republic, 1831–51.* Cambridge: Cambridge University Press, 1991.

———. "Opinions professionnelles: critique d'art et économie de la culture sous la Monarchie de Juillet." *Romantisme* 71 (1991): 19–30.

———, Vera Schuster, and Richard Wrigley. *A Bibliography of Salon Criticism in Paris from the Ancien Régime to the Restoration, 1699–1827.* Cambridge: Cambridge University Press, 1991.

Meisel, Martin. *Representations: Narrative, Pictorial, and Theatrical Arts in Nineteenth-Century England.* Princeton: Princeton University Press, 1983.

Mémorial de l'Exposition Eugène Delacroix. Ed. Maurice Sérullaz. Paris: Editions des Musées Nationaux, 1963.

Montagu, Jennifer. "The Early Ceiling Decorations of Charles Le Brun." *Burlington Magazine* 105 (August 1963), 395–408.

———. "Lebrun et Delacroix dans la Galerie d'Apollon." *Revue du Louvre* 5 (1962): 233–36.

Montaigne, Michel de. *Essais*. Ed. Maurice Rat. 2 vols. Paris: Garnier, 1962.

Montesquieu, Charles de Secondat, baron de. *Oeuvres complètes*. Ed. Roger Caillois. 2 vols. Paris: Gallimard, 1949–51.

Moreau, Adolphe. *Eugène Delacroix et son oeuvre*. Paris: Librairie des Bibliophiles, 1873.

Moreau-Nélaton, Etienne. *Delacroix raconté par lui-même*. 2 vols. Paris: Renouard, 1916.

Morse, Samuel F.B. *Lectures on the Affinity of Painting with the Other Fine Arts*. Ed. Nicolai Cikovsky, Jr. Columbia, Missouri: University of Missouri Press, 1983.

Moss, Armand. *Baudelaire et Delacroix*. Paris: Nizet, 1973.

Mras, George P. *Eugène Delacroix's Theory of Art*. Princeton: Princeton University Press, 1966.

Musée de Versailles. *Charles Le Brun 1619–1690: Le Décor de l'Escalier des Ambassadeurs à Versailles*, exh. cat. Paris: Réunion des Musées Nationaux, 1990.

Musée du Louvre. *Centenaire d'Eugène Delacroix 1798–1863*, exh. cat. Paris: Ministère d'Etat. Affaires Culturelles, 1963.

Musée du Louvre, Cabinet des Dessins. *Inventaire général des dessins. Ecole française. Dessins d'Eugène Delacroix*. Ed. Maurice Sérullaz, A. Sérullaz, L.-A. Prat, and C. Ganeval. 2 vols. Paris: Réunion des Musées Nationaux, 1984.

Nivelon, Claude. *Vie de Charles Le Brun et description détaillée de ses ouvrages*. Bibliothèque Nationale, Paris. Ms. 12987.

Olson, Theodore. *Millennialism, Utopianism and Progress*. Toronto: University of Toronto Press, 1982.

Onians, John. "On How to Listen to High Renaissance Art." *Art History* 7, 4 (December 1984): 411–37.

Park, Roy. "*Ut pictura poesis:* The Nineteenth-Century Aftermath." *Journal of Aesthetics and Art Criticism* 28, 2 (Winter 1969): 155–64.

Parsons, Christopher, and Martha Ward. *A Bibliography of Salon Criticism in Second Empire Paris*. Cambridge: Cambridge University Press, 1986.

Pichois, Claude, ed. *Lettres à Charles Baudelaire*. Neuchâtel: La Baconnière, 1973.

Piot, René. *Les Palettes de Delacroix*. Paris: Librairie de France, 1931.

Piron, E. A. *Eugène Delacroix. Sa Vie et ses oeuvres*. Paris: Jules Claye, 1865.

Planet, Louis de. *Souvenirs de travaux de peinture avec M. Eugène Delacroix*. Ed. André Joubin. *Bulletin de la Société de l'Histoire de l'Art Français* 2 (1928): 368–473.

Pool, Phoebe. *Delacroix*. New York: Hamlyn, 1969.

Pressly, William. *The Life and Art of James Barry*. Paul Mellon Centre for Studies in British Art. New Haven: Yale University Press, 1981.

Proust, Jacques. "Diderot et le système des connaissances humaines." *Studies on Voltaire and the Eighteenth Century* 256 (1988): 117–27.

Puttfarken, Thomas. *Roger de Piles' Theory of Art*. New Haven: Yale University Press, 1985.

Raoul, Valerie. *The French Fictional Journal: Fictional Narcissism, Narcissistic Fiction*. Toronto: University of Toronto Press, 1980.

Raser, Timothy. *A Poetics of Art Criticism: The Case of Baudelaire*. North Carolina Studies in the Romance Languages and Literatures. Chapel Hill: University of North Carolina Press, 1989.

Reynolds, Joshua. *Discourses on Art*. Ed. Robert R. Wark. Paul Mellon Centre for Studies in British Art. New Haven: Yale University Press, 1975.

Ribner, Jonathan. *Broken Tablets: The Cult of the Law in French Art from David to Delacroix*. Berkeley and Los Angeles: University of California Press, 1993.

Roger-Marx, Claude, and Sabine Cotté. *Delacroix*. New York: Braziller, 1971.

Romantisme 71 (1991), issue on "Critique et art."

Rosand, David. "Ekphrasis and the Renaissance of Painting." *Florilegium Columbianum: Essays in Honor of P. O. Kristeller*, ed. Karl-Ludwig Selig and Robert Somerville. New York: Italica Press, 1987.

Roskill, Mark. *Dolce's "Aretino" and Venetian Art Theory of the Cinquecento*. College Art Association of America Monograph 15. New York: New York University Press, 1968.

Roudaut, Jean. "Larges Cocardes de guipures sur des souliers noirs." In *Territoires de l'imaginaire: pour Jean-Pierre Richard*, ed. Jean-Claude Mathieu (q.v.), 23–36.

Rousset, Jean. "Pour une poétique du journal intime." In *Literary Theory and Criticism. Festschrift presented to René Wellek in Honor of his Eightieth Birthday*, ed. Joseph P. Strelka. Vol. 2, 1215–28. New York: Peter Lang, 1984.

Sagne, Jean. *Delacroix et la photographie*. Paris: Herscher, 1982.

Saint-André, A. J. Renard de. *La Petite Galerie du Louvre du dessein de feu M. Le Brun*. Paris, 1695.

Sandblad, Nils Gösta. "Le Caton d'Utique de la Bibliothèque du Sénat." *Acta Universitatis Upsaliensis. Figura*, n.s. 1 (1959): 181–203.

Scharf, Aaron. *Art and Photography*. London: Allen Lane, 1968.

Schawelka, Karl. *Eugène Delacroix: sieben Studien zu seiner Kunsttheorie*. Mittenwald: Maander, 1979.

Scott, David. *Pictorialist Poetics: Painting and the Visual Arts in Nineteenth-Century France*. Cambridge: Cambridge University Press, 1988.

Senancour, Etienne Pivert de. *Obermann*. Ed. Gustave Michaut. 2 vols. Société de Textes Français Modernes. Paris: Edouard Cornély, 1912.

Sérullaz, Maurice. *Les Peintures murales de Delacroix*. Paris: Editions du Temps, 1963.

Shearman, John. "The Vatican Stanze: Function and Decoration." *Proceedings of the British Academy* 57 (1971): 369–424.

Sieber-Meier, Christine. *Untersuchungen zum "Oeuvre littéraire" von Eugène Delacroix*. Bern: Francke, 1963.

Silvestre, Théophile. *Histoire des artistes vivants français et étrangers*. Paris: L. Blanchard, 1856.

———. *Eugène Delacroix. Documents nouveaux*. Paris: Michel Levy, 1864.

Sloane, Joseph C. *French Painting Between the Past and the Present: Artists, Critics, and Traditions from 1848 to 1870*. Princeton: Princeton University Press, 1951.

———. *Paul Marc Joseph Chenavard, Artist of 1848*. Chapel Hill: University of North Carolina Press, 1962.

Sobieszek, Robert. "Photography and the Theory of Realism in the Second Empire:

A Reexamination of a Relationship." In *One Hundred Years of Photographic History*, ed. Van Deren Coke, 145–59. Albuquerque: University of New Mexico Press, 1975.

Spector, Jack J. *Delacroix. The Death of Sardanapalus*. London: Allen Lane, 1974.

———. *The Murals of Eugène Delacroix at Saint-Sulpice*. College Art Association Monograph 16. New York: College Art Association of America, 1967.

Spencer, John R. "*Ut rhetorica pictura*: A Study in Quattrocento Theory of Painting." *Journal of the Warburg and Courtauld Institutes* 20 (1957): 26–44.

Summers, David. *Michelangelo and the Language of Art*. Princeton: Princeton University Press, 1981.

Tourneux, Maurice. *Eugène Delacroix devant ses contemporains: ses écrits, ses biographes, ses critiques*. Paris: Jules Rouam, 1886.

Trapp, Frank Anderson. "The Art of Delacroix and the Camera's Eye." *Apollo* 83, 50 (April 1966), 278–88.

———. *The Attainment of Delacroix*. Baltimore: The Johns Hopkins University Press, 1970.

Ubersfeld, Anne. *Théophile Gautier*. Paris: Stock, 1992.

Vachon, Marius. *L'Ancien Hôtel de Ville de Paris*. Paris: A. Quantin, 1882.

Vapereau, A. *Dictionnaire des contemporains*. Paris, 1858.

Varry, Dominique, ed. *Histoire des bibliothèques françaises*. Vol. 3, *Les Bibliothèques de la Révolution et du XIXè siècle*. Paris: Editions du Cercle de la Librairie-Promodis, 1991.

Veltrusky, Jirí. "Comparative Semiotics of Art." In *Image and Code*, ed. Wendy Steiner, 109–32. Ann Arbor: University of Michigan Press, 1981.

Véron, Eugène. *Les Artistes célèbres: Eugène Delacroix*. Paris: Librairies de l'art, 1887.

Voltaire, François-Marie Arouet de. *Dictionnaire philosophique*. Paris: Garnier, 1954.

———. *Essai sur les moeurs*. Ed. René Pomeau. 2 vols. Paris: Garnier, 1963.

———. *Oeuvres complètes*. 52 vols. Paris: Garnier, 1878.

Watelet, C. H., and P. C. Levesque. *Dictionnaire des arts de peinture, sculpture et gravure*. 5 vols. Paris: Prault, 1792.

Wellbery, David. *Lessing's Laocoon: Semiotics and Aesthetics in the Age of Reason*. Cambridge: Cambridge University Press, 1984.

Whistler, James McNeil. "Ten O'Clock Lecture." London: Chatto and Windus, 1888.

White, Harrison, and Cynthia White. *Canvases and Careers: Institutional Change in the French Painting World*. New York: John Wiley and Sons, 1965.

Wilson-Smith, Timothy. *Delacroix. A Life*. London: Constable, 1991.

INDEX

Addison, Joseph, 65, 97
Alembert, Jean le Rond d', 100
Angrand, Pierre, 134
Apollo Gallery, 91, 122, 127, 161–80, 185, 196
Apollo Slayer of the Serpent Python: and Delacroix's view of history, 169–80; critics on, 167–70, 179–80; horses of the sun in, 165–66; interpretations of, 162–63, 179–80
Le Brun's plan for, 162–63, 163–64, 166–67
motif of time, 163–64, 165–66
restoration of, 161
Ariosto, Ludovico, 8, 74, 80
Aristotle, 13, 14, 150
L'Artiste, 124
Augustine of Hippo, Saint, 18
Auroux, Sylvain, 103

Bacon, Francis, 103
Balzac, Honoré de, 28, 31, 36
Barbey d'Aurevilly, Jules, 123
Barry, James
"The Progress of Human Culture," 135–36, figs. 12–14
Baudelaire, Charles, 8–9, 86 n. 40, 90 n. 63, 123, 174, 203
compares Delacroix to Poe, 113–14
on Delacroix's writing, 93, 107
on *Ovid Among the Scythians*, 140–41
on Saint-Sulpice, 189
WORKS: *Le Spleen de Paris*, 21–22; *Salon de 1846*, 89, 123, 124
Baudet, Etienne, 167
Bayle, Pierre, 102
Beethoven, Ludwig van, 79, 110
Bernis, Cardinal de, 81
Bibliothèque Impériale, 159
Blanc, Charles, 123, 133
Bossuet, Jacques Bénigne, 7

Bourrienne, Louis Antoine Fauvelet de, 199
Bryson, Norman, 137
Bury, Richard de, 159
Byron, Lord (George Gordon), 4, 7, 8, 20, 70, 71

Caesar, Julius, 7
Casanova de Seingalt, Giovanni Giacomo, 7
Cellini, Benvenuto, 201
Cervantes y Saavedra, Miguel de, 8
Chateaubriand, François René de, 8, 140–41, 142 n. 41
Chenavard, Paul Marc Joseph, 23–24, 62–63
Delacroix's relations with, 173–79
Panthéon project, 20, 136, 174
theory of decadence, 173–74
Chennevières, Philippe de, 123, 161, 166, 167
church decoration, 188
Cicero, 13
Clément de Ris, L., 133
color, 14–15, 41, 87–89, 189–90
Comte, Auguste, 170, 171
Condorcet, Marie Jean Antoine Nicolas de Caritat, marquis de, 170
Cooper, James Fenimore, 30
Corneille, Pierre, 62, 74, 80
Corot, Camille, 44, 90, 122, 188
Cousin, Victor, 199–200
criticism, journalistic, 122–25, 126
Custine, Adam Philippe, comte de, 144, 170

Dante, 8, 112, 147, 156, 157
Inferno, 129, 148, 150
David, Jacques Louis, 24, 86, 188
decadence, theories of, 172–74
Decamps, Alexandre Gabriel, 23

Delaborde, Henri, 135
Delacroix, Eugène
 against archaism, 116–17, 119
 and dialogue form, 96, 101
 and fresco, 118–19
 and Lessing, 7 n. 11, 45–51
 and reading, 18–19
 as "literary" painter, 8–9
 as conversationalist, 29
 concept of *liaison*, 87
 concept of pictorial narrative, 10–11,
 16–17, 91–92
 concept of time, 18–20
 concept of truth, 67, 92
 concept of unity, 74–78
 critique of realism, 36
 critique of socialist philosophy, 43
 difficulty in writing, 28, 44–45, 94,
 107–108
 function of art, 21, 51
 ideal of writing, 10, 28, 44, 65–67,
 70–71, 94–96, 108–109
 and improvisation, 70, 81–82, 89–91
 interest in memoirs, 7, 199–203
 library decoration, 128–60
 and literary sources, 8
 literature versus painting in, 9, 23–54,
 95
 on anecdotes, 69
 on barbarism, 134, 136–60, 163, 169–
 70
 on Baudelaire's criticism, 113–14
 on civilization, 128–60, 163, 169–70
 on color, 47, 189–90
 on contradiction, 37–38
 on critics, 122–25
 on decadence, 141–44, 175–79
 on finish, *q.v.*
 on fresco, 116, 118–19, 188–89
 on imitation of model, 63–64
 on materiality. *See* painting
 on nature, *q.v.*
 on opera, 195–96
 on photography, 20, 82–87
 on progress, 19, 50, 142–44, 147,
 169–70, 174, 179
 on revolution, 51, 91
 on social behavior, 29–30, 36
 on the antique, 116
 on the modern novel, 29, 36, 37

 on the sublime, 79–82, 90, 109–111
 on Titian, 45, 115–17, 157
 on truth, 87
 on versatility of genius, 148, 200–201
 philosophical criticism of, 114–15
 preference for short works, 28–29
 public murals, 20–21, 126–27
 relations with Chenavard, 173–79
 repetition of subjects by, 68
 self-representation of, 199–200
 transitional moments in, 91–92
 use of color, 87–89
 value of writing for, 7, 199–201
 view of Baudelaire's criticism, 113–14
 view of history, 19, 50, 91–92, 169–
 70
 visit to Museum of Natural History,
 55–57, 58–59, 73
 voyage to Morocco, 20, 86
 WORKS: *Abduction of Rebecca* (1846),
 187; *Death of Marcus Aurelius*, 152;
 "Des critiques en matière d'arts,"
 123; "Des Variations du beau," 79;
 Greece on the Ruins of Missolonghi,
 91–92; *Liberty Leading the People*,
 91; *Ovid Among the Scythians*
 (1859), 140–41; "Poussin," 45,
 107–111; "Questions sur le beau,"
 79; "Raphael," 202; Salon de la
 Paix, 91, 185; Salon du Roi, 156;
 Women of Algiers, 150; *See also*
 Apollo Gallery, *Dictionnaire des
 Beaux-Arts, Journal*, Luxembourg
 Library, Palais Bourbon Library,
 Saint-Sulpice
Delaroche, Paul, 112, 160
Denis, Maurice, 94
description, 33–37, 87
Desgoffe, Alexandre, 158, 159
detail, 5, 9, 35–37
diary, generic features of, 3–5, 57, 60–
 62, 91
Dickens, Charles, 94
dictionary form, 17, 97–98, 103, 119
 Delacroix's conception of, 98–101. See
 also *Dictionnaire des Beaux-Arts*
Dictionnaire de l'Académie des Beaux-Arts,
 118–19
Dictionnaire des Beaux-Arts, 3–4, 17, 18,
 21, 65, 86, 93–127, 201, 203

and *Dictionnaire de l'Académie*, 118–19
and Larousse, 120–22
as painter's writing, 95, 126–27, 105–106
as personal, 111–12, 116, 118, 120, 122, 125, 126–27
as philosophical, 111–12, 114–15, 118
and contemporary issues, 116–17, 119
critical purposes of, 111–13
entries: "Execution," 64; "Fresco," 118–19; "Modern beauty," 117; "On the antique and the Dutch school/Titian," 116; "Sublime," 109; "Titian," 115–17, 126; "Touch," 90; "Unity," 75
modeled on Montaigne, 94–95
participation of reader in, 107
precedents for, 101–105
Diderot, Denis, 100, 102, 103–105
disproportion, 78–80, 90, 109–111
distraction, 30
Dolce, Ludovico, 15, 42, 101–102
Drost, Wolfgang, 173
Duban, Félix, 160
Dumas, Alexandre, 36
Dupin, André Marie Jean Jacques, 44
Dürer, Albrecht, 122
Durieu, Eugène, 83, 85
Dutilleux, Constant, 82

Ecole des Beaux-Arts, library of, 160
El Greco [Domenikos Theotocopolous], 188
Encyclopédie, 100, 103–105
ennui, 10, 17, 19, 27, 36, 42, 48, 59, 73, 83, 187–88, 192, 203
Delacroix's concept of, 11–13
and writing, 29–30, 38, 60
and distraction, 30–31
as barbarism, 143

finish, 5, 38, 71–74, 90, 109–111
and perfection, 79–80
Flandrin, Hippolyte, 112
Flaubert, Gustave, 100
Fourier, Charles, 171–72
fragmentation, unity in, 21–22, 74–78
French Academy, 116, 118
fresco, 118–19, 188–89

Gautier, Théophile, 40, 112, 123, 197
Gazette des Beaux-Arts, 124
Genevay, A., 168
Gentile, Francesco, 172
Gericault, Théodore, 62–63
Girardin, Emile de, 43
Goethe, Johann Wolfgang von, 8
Grand Dictionnaire universel du dix-neuvième siècle, 120–22

Haussard, Prosper, 133
Heine, Heinrich, 40
Hesiod, 151
Homer, 39, 81, 156, 157
Iliad, 150, 155
Hopmans, Anita, 90
Horace, 13
Hunt, William Holman, 112

image. *See* painting
imagination, 73, 158
temporality of, 4, 48, 51–54, 84, 92
improvisation, 70, 81–82, 89–91
Ingres, Jean Auguste Dominique, 44, 67, 112, 167

Jakobson, Roman, 39
Janin, Jules, 123
Janmot, Louis, 112
Johnson, Lee, 87, 137, 151, 166
Joly, Jules de, 158
Jouin, Henry, 168–69
Journal
and color, 87–89
and contradiction, 6, 10, 66, 86
and Delacroix's style, 87–92
and *Dictionnaire des Beaux-Arts*, q.v.
and memory, 17–19, 53–54, 60
and photography, 86–87
and unity, 4–5, 21–22, 74–78, 81
as improvisational writing, 70, 81–82, 89–91
as non-narrative, 6, 9–10, 22, 58, 65, 92
as non-progressive, 67
as pictorial writing, 6, 10–11, 20, 21, 45, 55–92, 94, 202–203
as work, 11–13, 178
concept of self in, 4, 20, 57–59, 69, 81

Journal (cont.)
 cross-referencing in, 6, 20, 62–63, 173
 detail in, 5
 discontinuity of, 5, 20, 86
 disruption of hierarchy, 91
 early versus late, 5–6, 55–59, 60,
 65
 effect of simultaneity in, 10, 18, 20, 65
 fragmentary writing of, 5, 21–22, 60,
 74–75
 inspires thought, 12, 60
 lack of finish of, 70–71, 74
 models for, 10–11, 65–66, 199–203
 multiple perspective of, 6, 10–11
 paradoxes of, 3–5
 public value of, 3, 7
 publication of, 6–7
 quotation in, 18, 69, 202
 repetition in, 67–68, 86
 rereading in, 6, 61–63, 68, 173
 reserve of, 11–13
 temporality of, 9–10, 11, 18, 20, 54,
 60, 61–65, 172–73
 textual "paraphernalia" in, 6
 thematic order of, 62–65
Journal des débats, 124

Kant, Immanuel, 41
Karr, Alphonse, 41
Klee, Paul, 201

La Rochefoucauld, François de, 80
Laborde, Léon Emanuel Simon Joseph,
 comte de, 129, 131
Labrouste, Henri, 158–59
Lamarck, Jean-Baptiste de Monet, che-
 valier de, 170
Larousse, Pierre, 120–22
Lasteyrie, Ferdinand de, 161
Le Brun, Charles, 15, 162–63, 179
 Apotheosis of Louis XIV, 167
 Escalier des Ambassadeurs, 162–63,
 167
 plans for Apollo Gallery, 163–64, 166–
 67
Lecomte, Jules, 135
Lehmann, Henri, 20–21, 134–35
Leonardo da Vinci, 7, 19, 34, 39, 42,
 48, 200, 201
 Treatise on Painting, 25–27

Lessing, Gotthold Ephraïm, 7–8, 16,
 45–51
library decoration, 128–31, 158–60. *See
 also* Delacroix
 and Alexander subject, 130, 159–60
 and Tarquin subject, 159–60
Lichtenstein, Jacqueline, 87, 189
line, 14–15, 87
literary, the
 French taste for, 24–5
literature. *See* Delacroix, narrative,
 writing
Louis XIV, 162, 163, 165
Louis-Napoléon. *See* Napoleon III
Luxembourg Library, 128–30, 147–58,
 160
 alternative subjects for, 149 n. 55
 Alexander Preserves the Poems of Homer,
 147, 149–50, 151, 154, 155
 cultural renewal in, 149, 155–58
 Dante and the Spirits of the Great, 147–
 48, 149, 150–51, 155, 156
 Dante group, 150–51, 155, 158
 Greek group, 148, 150–51, 151–52,
 154, 158
 Orpheus group, 150, 151, 158
 Roman group, 148, 150–51, 152–54,
 155
 theme of civilization in, 126, 148,
 151–55, 160
 theme of nature in, 157–58

Maine de Biran, F.P.G., 51–52
Marcantonio [Marcantonio Raimondi],
 85, 86
Marcus Aurelius, 7, 65, 152
Marin, Louis, 92 n. 69
materiality. *See* painting
Matsche, Franz, 162
McWilliam, Neil, 123–24
memory, 17–18, 30, 38, 53–54, 60
Mercey, Frédéric de, 117
Mercure galant, 162
Michelangelo, 62, 79, 110, 127,
 201
 as writer, 200
microcosm, theory of, 75–76
Millais, John Everett, 112
Molière [Jean-Baptiste Poquelin], 80–81
Moniteur universel, 65, 159, 160

Montaigne, Michel Eyquem de, 7, 70, 81, 94–95, 97, 159
 Essais, 11, 65–66, 95
Montesquieu, Charles Louis de Secondat, baron de la Brède et de, 29, 97, 172–73
monumental painting, 20–21
Mozart, Wolfgang Amadeus, 71, 74, 80, 110

Napoleon III [Louis-Napoléon Bonaparte], 160, 163, 165
Napoleon [Napoléon Bonaparte], 7, 200
narrative, 5, 9–10, 13–17, 19, 37, 47–51, 163, 177, 180, 192. See also *Journal*, writing.
nature, 50–51, 74–76, 86, 89
 "barbarism" of, 145
 as inspiration, 157–58
 metaphor of dictionary, 86, 115
Nivelon, Claude, 166, 167

Ovid, 140, 141, 164

painting
 amplifies experience, 42, 196
 and charm, 11, 30
 and effect, 189
 and temporality, 53
 and unity, 32–33, 51
 as distraction, 31
 as improvisation, 44, 70
 as mistress, 31
 complexity of, 10, 17
 concentration of effect in, 9, 28–29, 49, 52–53, 107
 defeats *ennui*, 30, 192
 discretion of, 9, 27, 29–30
 fragility of, 40
 importance of *ensemble* in, 63
 inadequacy of prose to, 23, 25, 35
 inclusiveness of, 180, 181
 instantaneity of, 9, 11, 14, 25–28, 32, 33, 48, 51, 52–53
 material and spiritual, 40–42, 47, 125–26, 189–190
 materiality of, 9, 26, 39, 40–42, 49, 84, 188–90
 multiple perspective of, 17, 49–50, 87, 92, 177, 177, 180

panoramic view of, 32, 35, 47, 53, 66, 92
pleasure of, 11, 30, 38, 41, 53–54
presence of, 14, 45, 47, 48, 49, 53–54
provokes thought, 29, 30, 38
renewable quality of, 30, 38, 49
shows complexity of subject, 10, 17, 49–50, 91–92
simultaneity of, 19, 49, 53, 63, 65
subservience to literary, 24
painting, theory of, 13–16
Palais Bourbon Library, 128–47, 185
 Adam and Eve Driven from Paradise, 91, 135, 140, 145
 Alexander and the Poems of Homer, 139, 140, 141
 alternative subjects for, 134, 139, 140 n. 37, 146 n. 50, 151 n. 60, 153 n. 66, 154
 Archimedes Killed by the Soldier, 139
 Aristotle Describes the Animals, 139, 145
 Attila and his Hordes Overrun Italy and the Arts, 137, 138–39, 140, 144, 147
 The Babylonian Captivity, 135, 140
 The Chaldean Shepherds, Inventors of Astronomy, 145
 Cicero Accuses Verres, 140, 153, 154
 The Death of Pliny the Elder, 145
 The Death of Seneca, 139, 155
 Delacroix's description of, 131
 Demosthenes Declaiming by the Seashore, 145, 153
 The Education of Achilles, 145
 Herodotus Consults the Magi, 145
 Hesiod and the Muse, 145
 Hippocrates Refuses the Gifts of the Persian King, 139
 John the Baptist Beheaded, 135, 140
 Lycurgus Consults the Pythia, 145
 Numa and Egeria, 145–46
 order of subjects, 132
 Orpheus Civilizes the Greeks, 136, 137, 138–39, 140–41, 145–47
 Ovid Among the Scythians, 140–41, 145
 Socrates and his Genius, 139–40
 theme of civilization in, 126
 The Tribute Money, 135, 140
Pascal, Blaise, 65, 67
Peisse, Louis, 123
perfection. *See* sublime

photography, 82–87, 111
picture gallery, metaphor of, 9, 10, 48, 49
Pierret, Jean-Baptiste, 110
Piles, Roger de, 16
Pindar, 74, 80
Planche, Gustave, 167, 168, 179
Plato, 46
Plutarch, 153
Poe, Edgar Allan, 113–14
Poussin, Nicolas, 24
progress. *See* Delacroix
Proudhon, Pierre Joseph, 122
Proust, Jacques, 103, 104, 105

Quatremère de Quincy [Antoine Chrysostome], 16, 158
Quintilian, 13

Racine, Jean, 74, 80, 81, 110, 159
Raphael [Raffaello Sanzio], 85, 86, 87, 115, 130, 158, 159
 Heliodorus Driven from the Temple, 181, 184, 187, 194–95, 196–97
 Saint Michael, 181, 197
Rembrandt van Rijn, 38, 87
Renard de Saint-André, Antoine, 166–67
Renoir, Pierre Auguste, 188
repetition, 67–68
Revue des deux mondes, 124
Reynolds, Joshua, 94, 105–106, 200, 203
Rossini, Gioachino, 77, 116
Rousseau, Jean-Jacques, 7, 29, 109
Rubens, Peter Paul, 29, 35–36, 38, 45, 116, 188
 as "poetic" painter, 24
 as sublime, 71, 79
 WORKS: *Life of Achilles*, 39, 71; *Raising of the Cross*, 85, 122

Sainte Geneviève library, 158
Sainte-Beuve, Charles-Augustin, 7, 123
Saint-Simon, Louis de Rouvroy, duc de, 7, 81
Saint-Simon, Henri de, 170–71
Saint-Sulpice, 127, 181–198
 and Raphael, *q.v.*

critics on, 183, 185, 188, 189, 193–98
formal parallels among the images, 182–84, 190
 Heliodorus Driven from the Temple, 181–98
 Jacob Wrestling with the Angel, 181–98
 Saint Michael Defeating the Devil, 181–98
 sketches for, 181, 184
Sand, George [Aurore Dupin Dudevant], 7, 8, 36, 67
Scott, Walter, 7, 8, 29, 30, 34, 62
Senancour, Etienne Pivert de, 11 n. 19, 18 n. 53, 52 n. 93, 65, 96–97, 202
Shakespeare, William, 6, 8, 20, 62, 73
 as "imperfect" artist, 76–78, 79, 81, 110
 as initiator, 80, 157
Signac, Paul, 94
Silvestre, Théophile, 6–7
Simonides, 128
sketch, 38, 73
Sloane, Joseph C., 124, 125, 174
Spector, Jack, 192
sublime, the, 79–82, 90, 109–111

Tasso, Torquato, 8
Thierry, Edouard, 159
Thoré, Théophile, 87
Titian (Tiziano Vecellio), 45, 126, 157, 188
 Delacroix on, 115–17

unfinished, the. *See* finish
unity. *See* fragmentation
ut pictura poesis, 25, 128

Van Dyck, Anthony, 188
Vatican library, 130 n. 7, 158
Veronese, Paolo, 45, 116
Vinet, Ernest, 168
Virgil, 74, 80
Vitet, Louis, 21, 123, 135, 193–94, 197–98
Voltaire [François Marie Arouet], 7, 28, 30, 67, 111, 200, 201

Delacroix's critique of, 81
on Montesquieu, 172
on Shakespeare, 81
 WORKS: *Dictionnaire philosophique*, 65,
 102–103; *Questions encyclopédiques*,
 85–88

Wellbery, David, 45, 46, 47, 50
Whistler, James MacNeill, 188
writing. See also *Journal*, narrative
 abstraction of, 9, 38–39, 42, 46–49,
 51, 84, 203
 analogy with line, 14–15, 87
 and consistency, 37–38
 and ideology, 179
 and rhetoric, 44–45, 107, 109

as "talkative" art, 29–30
as dismemberment, 21–22, 25, 48, 108
as exclusive, 19, 48, 87
as importunate, 27, 30, 73, 87–88
as indiscreet, 9, 30, 36, 126
as mechanical, 42–45
as passion, 30–32
fragility of, 40
impossibility of sketch in, 38
linearity of, 9, 19, 32, 44, 65, 87, 89
single point of view of, 32–33, 87
temporality of, 11, 19, 25, 28–29,
 51

Ziégler, Jules Claude, 20